THIS LONG PURSUIT

THIS LONG PURSUIT

REFLECTIONS OF A
ROMANTIC BIOGRAPHER

Richard Holmes

PANTHEON BOOKS

NEW YORK

Acknowledgments for previously published material appear on pages
341 and 342.

Library of Congress Cataloging-in-Publication Data
Name: Holmes, Richard, [date] author.
Title: This long pursuit : reflections of a romantic biographer /
Richard Holmes.
Description: First American edition. New York : Pantheon Books, 2016.
Includes index.
Identifiers: LCCN 2016040528 (print). LCCN 2016053039 (ebook).
ISBN 9780307379689 (hardcover : alk. paper).
Subjects: LCSH: Holmes, Richard, [date]. Authors, English—
Biography—History and criticism. Authors—Biography—History and
criticism. Biographers—Great Britain—Biography. Biography as a
literary form.
Classification: LCC PR6058.O455 Z465 2016 (print).
LCC PR6058.O455 (ebook). DDC 809/.93592—dc23
LC record available at lccn.loc.gov/2016040528

www.pantheonbooks.com

Jacket design by Oliver Munday

Printed in the United States of America
First United States Edition

2 4 6 8 9 7 5 3 1

To Arabella Pike,

my wonderful editor for more than twenty years

Contents

AFTERLIVES

CONFESSIONS

1

Travelling

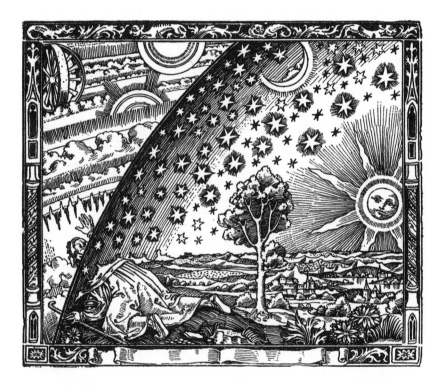

Every so often I close one of my working notebooks (there are nearly two hundred of them now, dating from 1964, the earliest in soft blue crumpled cardboard from Woolworths, the most recent in glossy black spiral-bound A5 hardback, from Black n' Red) and begin to reflect on the whole journey, and the time left, and what if anything I have learned along the way. I look back at the highways and byways of biography, my own *Footsteps* and my *Sidetracks*, and most of all on my strange, unappeased sense of some continuous, intense and inescapable pursuit.

I remember, for instance, the early summer of 1974, when I had just finished my first book, a biography of the Romantic poet Percy Bysshe Shelley. It was eight hundred pages long and I was nearly thirty. I had travelled in England, Scotland, Ireland, France and Italy in search of my fiery, footloose poet. I felt like a veteran after a long campaign in the field. I felt grizzled, anecdotal, displaced. What's more, I found that I had returned with two conclusions about writing biography that were certainly not taught back home in academia.

The first was the Footsteps principle. I had come to believe that the serious biographer must *physically* pursue his subject through the past. Mere archives were not enough. He must go to all the places where the subject had ever lived or worked, or travelled or dreamed. Not just the birthplace, or the blue-plaque place, but the temporary places, the passing places, the lost places, the dream places.

He – or she – must examine them as intelligently as possible, looking for clues, for the visible and the invisible, for the history, the geography and the atmosphere. He must feel how they once were; must imagine what impact they might once have had. He must be alert to 'unknown modes of being'. He must step back, step down, step inside the story.

The second was the Two-Sided Notebook concept. It seemed to me that a proper research notebook must always have a form of 'double accounting'. There should be a distinct, conscious divide between the objective and the subjective sides of the project. This meant keeping a double-entry record of all research as it progressed (or, as frequently, digressed). Put schematically, there must be a right-hand side and a left-hand side to every notebook page spread.

On the one (the right) I would record the objective facts of my subject's life, as minutely and accurately as possible (from the letters, the diaries, the memoirs, the archives). But on the other (the left) I would also record my most personal responses, my feelings and speculations, my questions and conundrums, my difficulties and challenges, my travels and my visions. Irritation, embarrassment, puzzlement or grief could prove as valuable as excitement, astonishment, inspiration or enthusiasm. The cumulative experience of the research journey, of being in my subject's company over several years, thus became part of the whole biographical enterprise. Only in this way, it seemed to me, could I use, but also hope to master, the biographer's most valuable but perilous weapon: empathy.

One incident from long before the Shelley days, during my novice pursuit of Robert Louis Stevenson in the Cévennes a decade previously, became an unlikely talisman. It never got into *Footsteps*, but lay quietly on the left-hand page of my very first notebook for over twenty years. Only much later, when I began to lecture about biography, did I find myself unexpectedly retelling it. To my surprise, it went through various versions, until it had finally metamorphosed

from a traveller's tale into a kind of biographer's parable. In its developed form it went like this.

I first explained that I was eighteen, and in following Stevenson through the wild Cévennes, I usually slept out deliberately like him under the stars, in a small sleeping bag without a tent, *à la belle étoile*. But sometimes I was reluctantly forced (by the spectacular Cévennes storms) to spend a night at one of the little remote country inns or hostels. In those days you had to present a passport to be entered in the *fichière*, with your name, age and occupation included in the details. Under occupation, I had specified with great optimism 'Writer'. Of course I had published absolutely *nothing* at that point.

When I handed over my passport to Madame at the reception desk, the same thing always seemed to happen. 'Ah, Monsieur 'Olmez,' she would exclaim grimly as she filled in the little buff index card, 'I see you are a waiter.' I reflected painfully on this for some days, and then thought of putting in 'Travel Writer'. But then I could immediately hear the even grimmer response. 'Ah, Monsieur 'Olmez, I see you are a table waiter.'

This tale, suitably embellished with Gallic accents and hand gestures, became known as my 'travelling waiter joke'. Yet it gradually revealed to me a serious lesson in professional humility. Because in a sense that's exactly what a biographer is: someone who waits, who *awaits*, who pays attention, who is constantly alert, who attends upon his subjects, who is *at their service* for a long period of faithful employment. Waiting done well, I reflected, involves a lot of legwork.

Accordingly, my next pursuit, in the service of the poet Samuel Taylor Coleridge, lasted, on and off, for nearly fifteen years and progressed through some thirty two-sided notebooks. It took me to the English West Country and Lake District, to Germany, to Italy, to Sicily, to Malta, and finally to a quiet garden on Highgate Hill in London. It ended in nine hundred pages over two volumes. We both aged considerably in the process.

Coleridge was himself the master of the notebook – over seventy of them survive, thanks to the life's work of the Canadian scholar Kathleen Coburn. The first was begun in Bristol in 1794, when he was twenty-one; the last was left incomplete at his death in Highgate in 1834. They provide a wonderful underground river for the biographer, an entry into Coleridge's mind and heart, his inner life, not least in his relations with William and Dorothy Wordsworth, and his secret beloved or *femme fatale*, his 'Asra', Sara Hutchinson.

The notebooks are as multifarious, elusive and incorrigible as the man. They contain his fantastic reading lists, his extraordinary nightmares, his brilliant lecture notes, his hectic fell-walking diaries, his endless self-psychoanalysis sessions, his battles with opium addiction, his excruciating medical symptoms (teeth, lungs, bowels), his sexual hauntings and obsessions, his labyrinthine thoughts about science and religion, his ghastly puns and his moving prayers.

They are also full of wonderful oddities: the draft of a comic novel, the recipe for making waterproof shoe polish, accounts of erotic dreams (partially in Greek and usually connected with food), the sayings of his child Hartley, notes on the sounds of different bird-song, or observations on different kinds and modalities of rainfall. All the time, like the underground river of 'Kubla Khan', there is a continual bubbling up of images that would appear in both his poetry and his later criticism; but also a continuous stream of self-definition.

I remember discovering, like a sudden gold-strike, this description of a tiny waterfall on the River Greta, which he wrote when he first came to the Lake District in 1800: 'Shootings of water threads down the slope of the huge green stone ... The white Eddy-rose that blossomed up against the Stream in the scollop, by fits and starts, Obstinate in resurrection – It is the Life that we live.'

It instantly struck me that Coleridge was describing himself – 'obstinate in resurrection'. Now I can never see a stream flowing over a stone, with that bubbling backwash of foam (so brilliantly defined

as the 'Eddy-rose'), without thinking of his biography. There is his complex, mysterious and in many ways disastrous life, which was nevertheless perpetually renewed, miraculously foaming back in words, 'obstinate in resurrection'. It was indeed the life that he lived. I gradually realised it was also the Life that I needed to write.

Coleridge's travels were geographical as well as metaphysical, and true to the Footsteps principle I followed him faithfully. In exchange, Coleridge taught me many lessons about biography during these research trips or solitary pursuits. I followed his walk over the wild Quantock Hills and down to the tiny seaport at Watchet where he began *The Ancient Mariner* with Wordsworth in 1797. Here the Bristol Channel surges out towards the Atlantic, producing one of the most astonishing tidal swings in the whole of northern Europe, rising and falling over thirty feet in twelve hours. Watching the fishing boats locked in its muscular grasp, I understood something new about the submarine 'Polar Spirit' of the deep, that pursued the Mariner after he had killed the albatross; and more than that, something of the huge tides that had always swept through Coleridge's own life.

I went out to Göttingen in Germany, where he had attended the scientific lectures of Johann Friedrich Blumenbach in 1799, read the *Naturphilosophie* of Friedrich Schelling, from which his own ideas about Nature, Form and the Unconscious would eventually develop in 'genial coincidence'. He became fascinated by the story of the *Walpurgisnacht* (or Witching Night) on the nearby Brocken mountain, which later appears in Goethe's *Faust* (1808). Typically, Coleridge had climbed the Brocken to interview the legendary 'Brocken spectre' for himself, in a mixed spirit of scientific and poetic enquiry. Clambering up after him through the dark colonnades of the Harz forest, I came across a different kind of witchcraft.

Panting up through a clearing of pine trees, I burst upon a sort of surreal Faustian theatre set. It was decked with skull-like signs

announcing 'Halt! Hier Grenze!', and promising imminent death. I had stumbled upon the huge, sinister double border fence, sown with landmines and automatic machine-guns, dividing East and West Germany. Like the moment twenty years before, when, naïvely retracing Robert Louis Stevenson's *Travels with a Donkey in the Cévennes*, I had come down to his symbolic river bridge at Langogne, and to my profound dismay found that it was broken and impassable, his time literally divided from my time. This was another sharp lesson in the irrecoverability of the past.

Another trip took me to Malta, where, in the unlikely role of wartime civil service secretary, Coleridge promulgated by-laws, visited military hospitals (appalled by the syphilitic cases, several to a bed), wrote political propaganda, and clean-copied the last despatches from Governor Admiral Ball to Nelson before the Battle of Trafalgar.

His shape-shifting during this period, 1804–05, is extraordinary, yet characteristic. At Valletta, I found that his lonely rooms in the Governor's Palace directly overlooked the harbour. Having borrowed a naval telescope, the bustling secretary somehow disappeared for hours, studying the many ships arriving and departing, dosing his homesickness with opium and erotic poetry, and writing learned notes on 'organic form'.

It was here I found Coleridge unexpectedly praying to the moon. His strange, metaphysical account of 'Sabaism', or sun- and moon-worship, had previously gone unnoticed. But it told me something crucial about his religious beliefs, always suspended – 'a willing suspension of disbelief' – between a punishing Christianity and pure, exhilarating Pantheism. It also reminded me how central the moon is to all his poetry, from *The Ancient Mariner* to 'Limbo'.

In looking at objects of Nature while I am thinking, as at yonder
Moon dim-glimmering through the dewy window-pane, I
seem rather to be seeking, as it were *asking*, a symbolical

language for something within me that already and forever exists ... the dim Awaking of a forgotten or hidden Truth of my inner Nature ... the Creator! the Evolver!

Back in England, I located the little lost house in Calne, Wiltshire, opposite the churchyard, where he went to ground in 1813, given up by almost all his friends – even by Wordsworth – as a hopeless opium addict who would achieve nothing. On the hillside above his house I saw the symbolic Cherhill White Horse, carved in the chalk around 1780, galloping towards London, which always gave him hope. Two years later he re-emerged with a draft of his prose master-piece the *Biographia Literaria*, a fantastic mixture of humorous auto-biography, brilliant psychological criticism, and plagiarised German philosophy. So much of this, like his lectures, is best read in frag-ments. For instance this inspired lecture note – a mere four words – summarising the opening of Shakespeare's *Hamlet*. 'Suppression prepares for Overflow'. I came to think that this contained, or rather anticipated, all Freud.

Yet some of the most vivid lessons came from his childhood at Ottery St Mary in Devon, which reappears in so many of his best early poems, like the 'Sonnet to the River Otter' and 'Frost at Midnight'. In the sonnet, he explores the infinitely subtle shifts of feeling between the immediate experience of the child and the recol-lections of the adult. The recreation of this movement remains one of the greatest challenges to biographical narrative. Coleridge succeeds in catching it with wonderful simplicity, using the stone-skimming children's game of ducks and drakes, and the 'bedded sand' of memory:

> What happy and what mournful hours, since last
> I skimm'd the smooth thin stone along thy breast,
> Numbering its light leaps! yet so deep imprest
> Sink the sweet scenes of childhood, that mine eyes

I never shut amid the sunny ray,
But straight with all their tints thy waters rise,
Thy crossing plank, thy marge with willows grey,
And bedded sand that vein'd with various dyes
Gleam'd through thy bright transparence!

Then there was the time as a small boy that he ventured into a deep cave near the banks of the River Otter. This was a haunted place known locally as 'the Pixies' Parlour'. Greatly daring, he carved his initials in the stone at the very back. A decade later he returned as a young man, to crawl in again and admire these initials, as he put it, 'cut by the hand of childhood'. After another two decades, now nearly forty, the physical fact had become a metaphysical one. In a poem, 'A Tombless Epitaph' (1809), he compared his crawling into this dark cave with his later exploration of the cave of philosophy. The mineral glitter of this reimagined mental cave, the cave of his own mind and imagination, adds a whole new dimension to the 'caverns measureless to man' of 'Kubla Khan':

... Yes, oft alone,
Piercing the long-neglected holy Cave,
The haunt obscure of old Philosophy,
He bade with lifted torch its starry wall
Sparkle, as erst they sparkled to the flame
Of odorous lamps tended by Saint and Sage.

When I crawled into that same sandstone cave almost exactly two hundred years later, I made a surprising discovery. Raising my trembling lighter, I spied at the very back of the cave the carved initials 'STC'.

What actually happened, as recorded in my notebook, was that I was so delighted that I sprang up and almost knocked myself out on the low stone ceiling. A large sliver of sandstone came down. As I

crouched there, seeing stars in the darkness, I suddenly realised that the cave stone was too soft to retain the original initials. Something else had happened to them, equally interesting. They had been *recarved*. I reflected on the implications of this idea in my notebook, and my eventual footnote read: 'Such carvings and recarvings of his initials, ceremoniously repeated by generation after generation of unknown memorialists, suddenly seemed to me like a symbol of the essentially cumulative process of biography itself.'

Another informative place for me was Coleridge's house at Greta Hall, Keswick, where he lived close to the Wordsworths at Grasmere between 1800 and 1804. Suitably enough, it had once been an observatory. The top-floor study has astonishing views of Derwentwater and the high fells spreading all round. He would climb out of the window and sit on the 'leads', or flat roof, gazing at the expanse and writing. One eloquent letter begins: 'From the leads on the house top of Greta Hall, Keswick, Cumberland, at the present time in the occupancy and usufruct-possession of ST Coleridge Esq, gentleman poet and Philosopher in a mist.' Another offers to send his friend, the young chemist Humphry Davy, the whole Lake District panorama wrapped up in a single pill of opium.

Here he wrote the famous 'Dejection: an Ode' (1802), which we now know exists in two drafts, the first as a secret love letter to Sara Hutchinson; the second as a formal ode on the powers of Nature and the Imagination to heal personal grief and depression. Sara was the sister of Wordsworth's wife, Mary Hutchinson; no melting Muse, but a small, handsome, capable woman who strode about the fells, looked after the Wordsworth children, and copied both poets' manuscripts. She had a determined chin, kindly eyes and thick auburn hair. Coleridge (who had married in 1795) had fallen fatally in love with her at first sight in 1799, and given her the dreamy soubriquet 'Asra' in his notebooks and poetry.

There she remains as a fantasy figure for the next twenty years, though she never quite went to bed with him. Instead she did secre-

tarial work, accompanied him on walks, nursed him when ill, and tried to prevent him taking opium, which led to their eventual estrangement in 1812.

In the formal ode, Sara is simply an unnamed 'virtuous Lady'. In the draft verse letter (not published in full until 1988) she is 'O Sister! O Beloved! ... dear Sara ... My Comforter! A Heart within my Heart.' In a memorable bird image, Coleridge also describes her voluptuously as 'nested with the Darlings of [her] Love', and feeling in her embracing arms

> Even what the conjugal & mother Dove
> That borrows genial warmth from those she warms,
> Feels in her thrill'd wings, blessedly outspread! ...

Here too, in pursuing him, I had an instructive experience. I discovered that Greta Hall had become a small girls' boarding school, so I wrote to the headmistress asking permission to visit. It turned out that Coleridge's study on the top floor was now the sixth-form dormitory. Accordingly I was granted a half-hour afternoon inspection, under Matron's watchful eye, while the girls were safely away, out in the fields playing hockey.

After we had inspected the room, I asked Matron if I might climb out of the dormitory window onto the flat roof, where Coleridge had often sat writing. As I stood examining the magnificent view, and thinking of his secret beloved Asra, I suddenly saw at my feet two bottles of Vladivar vodka, and a box of Black Russian cigarettes carefully wrapped in cellophane against the weather.

When I climbed back in, Matron asked if I had found 'anything biographically interesting'. As I prepared to answer – 'A biographer is an artist upon oath' – an angelic-looking blonde sixth-former appeared in the doorway behind Matron, and fixing me with a mute appeal, silently shook her head. 'Yes, Matron,' I replied gravely. 'Clear signs of artistic inspiration.' Still standing behind Matron, the girl

14

mouthed a silent 'Thank-you' at me, spread her arms in a strange airborne gesture, and slipped away.

Of course I felt the subversive spirit of Coleridge's Asra had been in close attendance. Yet, on reflection, not merely as the angel, but also as the kindly Matron, who possibly knew more than she was letting on. This reminded me that Asra was both angel and nurse to Coleridge. Much expanded, almost to the length of a short story (named, after one of Coleridge's own poems, 'An Angel Visitant'), this incident went down in the left-hand side of my notebook as a warning against both the charms and the perils of romanticising. Places of 'inspiration' might genuinely retain something of their force over time, and it was vital to capture this. But the biographer should also be on guard against vodka.

A different kind of alchemy transfused Coleridge's friendship with the young chemist Humphry Davy. When they were both in their twenties, Coleridge volunteered to take part in Davy's early experiments with the intoxicating nitrous oxide (laughing gas) at the Bristol Pneumatic Institute. Davy's scientific account of gas euphoria turned out to have extraordinary parallels with Coleridge's poetic account of opium hallucinations, as described in 'Kubla Khan'.

'I lost all connections with external things,' recorded Davy, 'trains of vivid visible Images rapidly passed through my mind ... With the most intense belief and prophetic manner, I exclaimed ... "Nothing exists, but Thoughts! – the Universe is composed of impressions, ideas, pleasures and pains!" ... I was now almost completely intoxicated ... I seemed to be a sublime being, newly created and superior to other mortals ...'

Davy and Coleridge also corresponded about the nature of pain, and the possibilities of gas-based anaesthetics for use in surgical operations. Coleridge later went to his friend's chemistry lectures, and enthused: 'I attended Davy's lectures to enlarge my stock of metaphors ... Every subject in Davy's mind has the principle of Vitality. Living thoughts spring up like Turf under his feet ...' To

Davy himself he made a crucial connection: 'Science being necessarily performed with the passion of Hope, it was *Poetical*.'

This led me to look at Davy's biography, and more generally at the relations between science and literature. For the first time I began to consider how a scientific biography might differ from a literary one. In particular, in my own field of Romantic literature, the connection between Coleridge and Davy made me wonder why the poets and writers of the Romantic period were always presented as hostile to science. Had we unknowingly imported twentieth-century ideas about the notorious split between the 'Two Cultures' into Romantic biography? Was there in fact such a thing as Romantic science, and a vital new form of biography to go with it? This is what I began to explore in my next book, *The Age of Wonder*.

The left-hand side of my notebook became crowded with questions and speculations, many naïve. Did the Romantic men of science ('men in white coats') have inner emotional lives comparable in intensity to those of the poets; and if so, what kind of writings would bear witness to this? It seemed possible that scientific biography should be less about individual 'genius', and more about teamwork and the social impact of discovery. This might demand something closer to group biography, and a sense of the extended 'ripple effect' of science throughout a community. It also raised the pressing question – in the figures of the astronomer Caroline Herschel, the novelist Mary Shelley and the mathematician Mary Somerville – of why women had been excluded from science, in contrast to the way they were establishing themselves in literature.

So from a narrow initial study of Coleridge and Davy, *The Age of Wonder* (2009) expanded to become the biography of a whole generation, including over sixty writers and scientists, and the very moment when the word and concept of 'scientist' itself actually emerged in 1833.

I have subsequently come to feel that the meeting of the two great modes of human discovery – imaginative literature and science –

has become one of the most urgent subjects for modern biography to study and understand. I believe this is particularly so in both Britain and America. You could say that if our world is to be saved, we must understand it both scientifically and imaginatively.

I often think of something Sylvia Plath once said: 'If a poem is concentrated, a closed fist, then a novel is relaxed and expansive, an open hand.' This leads me to suppose that biography is something else again: 'a handshake'. A handshake across time, but also across cultures, across beliefs, across disciplines, across genders, and across ways of life. It is a simple act of complex friendship.

It is also a way of keeping the biographer's notebook open on both sides of that endless mysterious question: *What was this human life really like, and what does it mean to us now?* In this sense, biography is not merely a mode of historical enquiry. It is an act of imaginative faith. That is what I believe. Putting my hand on my Black n' Red notebook, that is what I swear to.

Experimenting

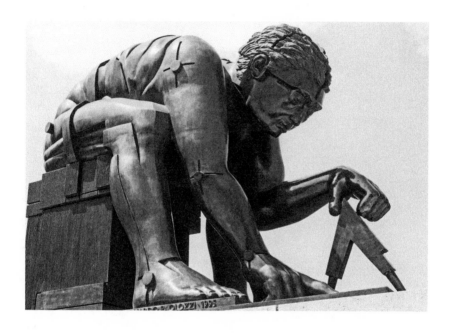

1

After completing my two-volume life of Coleridge, I continued to wonder about scientific discovery during the period of his lifetime, between 1772 and 1834. This was the high-water mark of British Romanticism, one of the best-known and best-loved periods in the whole of English literature. So why was so little known about the science, and the scientists, of this same era? Was the divisive influence of C. P. Snow's 1959 lecture 'The Two Cultures' still at work? In 1999 I gave a speculative lecture at the British Academy entitled 'Coleridge Among the Scientists'. It had a mixed reception.

Most people could quote the names of at least a dozen poets and writers of this period. Yet the only scientific name popularly known between Isaac Newton and Charles Darwin was – probably – that notorious and fictional bio-engineer Victor Frankenstein. Was science – were scientists – so entirely irrelevant to the huge imaginative achievement of Romanticism? After all, one of Coleridge's greatest friends was the chemist Sir Humphry Davy, who eventually became President of the Royal Society. Coleridge had once promised Davy, in a memorable moment of scientific enthusiasm, that he would 'attack Chemistry like a shark'. Later he suggested that he and Davy – together with Wordsworth – should set up a chemical laboratory together in the Lake District. Finally he wrote to Davy that most brilliant, seminal and provoking

remark which had so struck me, that the passion of Hope made Science '*Poetical*'.

Nevertheless, it was still traditionally assumed that all the poets – like William Blake – hated and distrusted science; while all the scientists – like Isaac Newton – despised and disdained to talk to the poets. The antagonism, so to speak, was mutual. As Blake famously exclaimed: 'Bacon and Newton, sheathed in Dismal Steel'.

This position was vividly illustrated by Blake's powerful picture of Newton, drawn in 1795, a demonic figure bent grimly over his measuring compasses, reducing the entire world to geometry and mathematics. Here, it was argued, began the fatal division between Imagination and Reason, between Arts and Sciences. Indeed, two hundred years later a modern version of this figure, an enormous bronze statue of Blake's Newton by Eduardo Paolozzi (1995), but now with explicit suggestions of Frankenstein's monster, was solemnly placed in the courtyard of the new British Library in Euston Road, London, thus guarding Cerberus-like the entrance to one of the great centres of learning in the Western world.

So fifteen years ago I became increasingly fascinated by what we now call 'the public understanding of science'. I began to ask, what was the real impact of science on poets and writers of the British Romantic period? Who were the scientists that influenced them, and what sort of science were they doing? I aimed to look at a period of roughly sixty years, or two generations (1770–1830). This was exactly the 'lost period' of British science, between Newton and Darwin, when European figures (like Cuvier, Lavoisier and Laplace) seemed to dominate the field. I found that there were two historic British voyages of exploration that framed almost exactly this time span: Captain James Cook's first circumnavigation through the Pacific, starting out in 1768, and young Charles Darwin's voyage to the Galapagos, starting in 1831. These became my points of departure and arrival, and set the experimental ambitions of the whole book.

One of the first things I learned was that at this time there was no such word as 'scientist'. It was only coined in 1833, at a historic meeting of the newly founded British Association for the Advancement of Science, held that year in Cambridge. Nevertheless, I came up with a main cast list of over sixty scientists and writers. Among the former were Joseph Banks, explorer, botanist and anthropologist; William and Caroline Herschel, astronomers; Jean-Pierre Blanchard and Laetitia Sage, balloonists; Mungo Park, African explorer; Humphry Davy, chemist; William Lawrence, surgeon; and several young pre-Victorian scientists, Michael Faraday, Mary Somerville and Charles Lyell, for example. Among the poets and writers were Erasmus Darwin, Coleridge, Wordsworth, Keats, Shelley, Mary Shelley, Anna Barbauld and Lord Byron.

The women had an important role in the story. I felt that conventional science historians had rather ignored them. But they help us to look at the development of science in a different, and often surprising, way. For example, Anna Barbauld was Dr Joseph Priestley's assistant during his great experiments on the nature of air in Birmingham in the 1770s. He was testing the effect of lack of oxygen on laboratory animals, like birds and mice. One evening, when she was clearing up the laboratory for the next day's work, Anna left a long poem on a piece of paper stuck between the animals' cages, which she entitled 'The Mouse's Petition to Dr Priestley, Found in the Cage where he had been Confined all Night' (1773). It is written from the point of view of the mouse, and here is an extract:

> For here forlorn and sad I sit,
> Within the wiry grate,
> And tremble at th' approaching morn
> Which brings impending fate.

The cheerful light, the vital air,
Are blessings widely given;
Let nature's commoners enjoy
The common gifts of Heaven.

The well-taught philosophic mind
To all compassion gives;
Casts round the world an equal eye,
And feels for all that lives.

Barbauld describes the laboratory animal as a 'freeborn mouse', so this becomes arguably the first ever animal-rights poem. One could compare it with the subsequent opening of Blake's 'Auguries of Innocence': 'A robin redbreast in a cage, Puts all heaven in a rage ...'

Taking my cue from Coleridge, the book began to explore the hope and wonder of science, but also its fearfulness and menace, a double-edged sword that we are all more than conscious of today. The constant ambiguity was finally expressed in my polarised sub-title: *How the Romantic Generation Discovered the Beauty and Terror of Science*. These two terms – beauty and terror – are also central to the underlying Romantic theory of 'the Sublime', as developed in the famous 1757 essay by Edmund Burke, 'A Philosophical Enquiry into the Origin of our Ideas of the Sublime and Beautiful'. I was arguing that not only literature, but also science, could be 'sublime' in this technical, philosophical sense, and would lead to a new perception of 'the Sublime' in nature.

2

Above all, it was the story of Newton's apple that haunted the Romantics with a notion of science as poetic revelation. Perhaps the earliest account of this symbolic, and possibly legendary, Newtonian 'thought experiment' appears in the memoir by the young William

Stukeley FRS, when he took tea with the ageing Newton in 1724, and recorded their conversation:

> After dinner, the weather being warm, we went into the garden, & drank tea under the shade of some apple trees, only he, & myself. Amidst other discourse, he told me, he was just in the same situation, as when formerly, the notion of gravitation came into his mind.
>
> 'Why should that apple always descend *perpendicularly* to the ground,' thought he to himself: occasion'd by the fall of an apple, as he sat in a contemplative mood. 'Why should it not go sideways, or upwards? But constantly to the earths centre? Assuredly, the reason is, that the earth draws it. There must be a *drawing power* in matter, & the sum of the drawing power in the matter of the earth must be in the earths centre, not in any side of the earth. Therefore does this apple fall perpendicularly, or toward the centre. If matter thus draws matter; it must be in proportion of its quantity. Therefore the apple draws the earth, as well as the earth draws the apple.'
>
> Thus by degrees he began to apply this property of gravitation to the motion of the Earth, and of the heavenly bodies; to consider their distances, their magnitudes, their periodical revolutions ...

When Voltaire attended Newton's state funeral at Westminster Abbey in 1727, the apple story was already current, and he retold it enthusiastically in his *Letters on the English Nation* in 1734: 'Having retired in 1666 to the countryside near Cambridge, he was walking one day in his garden when he noticed the fruit falling from a tree, and slipped into a profound meditation on the concept of *weight*, the exact cause of which all natural philosophers had sought for so long in vain, and the mystery of which most ordinary people did not even suspect.'

A magnificent statue of Isaac Newton was put up at Trinity College, Cambridge, thirty years after his death, in 1757, at the dawn of the Romantic age. An undergraduate at St John's, the college next-door to Trinity over the wall, could see it from his window, and was deeply impressed. William Wordsworth remembered long after in *The Prelude*:

> And from my pillow, looking forth by light
> Of moon or favouring stars, I could behold
> The Antechapel where the Statue stood
> Of Newton, with his prism and silent face,
> The marble index of a Mind for ever
> Voyaging through strange seas of Thought, alone.

So, by the time the story of Newton and the apple reached Byron, it had already become the most famous and romantic 'eureka moment' in science history. This allowed Byron to give it a neat, mischievous twist in *Don Juan* (1821):

> When Newton saw an apple fall, he found
> In that slight startle from his contemplation –
> 'Tis said (for I'll not answer above ground
> For any sage's creed or calculation) –
> A mode of proving that the earth turn'd round
> In a most natural whirl, called 'gravitation';
> And this is the sole mortal who could grapple,
> Since Adam, with a fall or with an apple.

Byron asked whether Newton's 'apple of knowledge' was a Biblical or a scientific fruit. He also wondered if the fruit would be good or bad for mankind:

Man fell with apples, and with apples rose,
If this be true; for we must deem the mode
In which Sir Isaac Newton could disclose,
Through the then-unpaved Stars, the turnpike road,
A thing to counterbalance human woes:
For ever since, immortal man hath glow'd
With all kinds of *mechanics*, and full soon
Steam-engines will conduct him to the moon.

Byron was a little premature about journeys to the moon, though not about steam engines. But his remark about Newton constructing a 'turnpike road' of scientific knowledge through the stars with his law of gravity contained another hidden joke, and even a prophecy. For although turnpikes revolutionised coach travel in his day, they no longer provided free transport. All turnpikes charged road tolls to the traveller. Similarly, Byron implied, scientific knowledge might perhaps have to be *paid for* sometime in the near future.

3

Byron was certainly right that the Romantic age was full of '*mechanics*' – meaning technical inventions and discoveries. It is often not fully appreciated, especially by students and scholars of literature, that between 1770 and 1830, the high period of literary Romanticism, there was an explosion of new *physical and scientific* knowledge. This was not just a question of canals, turnpikes and steam pumps. Indeed, the catalogue of scientific discoveries and inventions at this time is truly astonishing.

The technological inventions, so often overlooked, include Thomas Harrison's No. 1 Sea Watch, or chronometer, which allowed the calculation of longitude at sea, and which was refined throughout the 1770s; high-powered reflector telescopes were also devel-

oped during the same period; and James Watt's steam engine and condenser pump, based on the experiments of Joseph Black, were first put into full production in 1776. The first man-carrying balloons date from 1783; the first Ordnance Survey maps using contour lines from 1791; and the first flush water-closet from 1795. The systematic application of the new Voltaic battery pile, which revolutionised chemical analysis, and with it the early study of magnetic fields, both belong to the turn of the century; together with the detection of infra-red and ultra-violet 'rays', that is, forms of electro-magnetic energy lying beyond the visible spectrum of sunlight. The first steam-powered ship, the *Charlotte Dundas*, was launched in 1801; the first gas street-lighting was installed in 1807; the electric arc lamp was invented in 1810; and the miner's safety lamp in 1816. The first polarised lighthouse lens was fitted in 1822; and the earliest successful photographic plates, using bitumen and then silver salts, began to appear from 1826.

In a more philosophical vein, there were the momentous strides in cosmology. These sprang from the discovery of the first new planet since the time of Ptolemy, Uranus, in March 1781; the asteroid belt between Jupiter and Saturn, and within it the planetoid Ceres, in 1801; and the gradual refinement of the 'nebular hypothesis', concerning the gravitational evolution of our entire solar system, and by implication of all star systems. From this arose the radical hypothesis of galaxies evolving *outside* our own Milky Way – for example, Andromeda – and thus the notion of a continuous 'natural creation', following an original cosmic Big Bang (specifically proposed by Erasmus Darwin). The delicate question of whether this was the direct handiwork of the Divine Intelligence, or of some more remote First Cause, or simply of Nature herself, was a debate that launched modern 'cosmology' as a truly independent scientific discipline, rather than as a branch of theology. One may date this from the published papers of William Herschel at the Royal Society in the 1780s, and of Pierre-Simon Laplace at the Académie des Sciences in

the 1790s. The intellectual significance of these developments was considered in *A Preliminary Discourse on the Study of Natural Philosophy*, by William Herschel's brilliant son Sir John Herschel, in 1831.

In what was in effect the signature science of the age, there were fundamental advances in chemistry. These finally dispersed the lingering delusions of alchemy, and the ancient theory of the four irreducible 'prime elements' of earth, air, fire and water. The whole concept of 'matter' itself was revolutionised. Starting with the decomposition of water by 'electrolysis' (using the Voltaic battery), which revealed separately quantifiable components of oxygen and hydrogen, there swiftly followed the resolution of a host of new chemical elements such as sodium, potassium, chlorine, calcium, barium and magnesium, between 1808 and 1820. Parallel with this went the analysis of fire as the 'combustion' of oxygen, not as the production of mysterious 'phlogiston'. Air itself was now further analysed, yielding alongside hydrogen and oxygen a whole range of previously unsuspected new 'gases' ('artificial airs'), such as carbon dioxide, carbon monoxide, nitrogen and nitrous oxide (the famous laughing gas), and an early concept of anaesthesia by Humphry Davy in 1799. From all this arose early atomic theory, and the first published Periodic Tables by John Dalton, naming five elements in 1803, twenty elements in 1808, and thirty-six elements in 1827. Again, much of this work was summarised in the first ever 'popular science' classic of the Romantic age – written significantly enough by a woman, and a mathematician – Mary Somerville's *On the Connexion of the Physical Sciences* (1834).

This was also a great age of geographic exploration. Many men of science, who eventually became distinguished travel writers, pressed far beyond Europe, and especially to Africa, the Pacific and South America. Among these remarkable scientific and literary travellers were Antoine de Bougainville, James Cook, Johann and Georg Forster, and Joseph Banks, all of whom left vivid and gripping

accounts of the Pacific and the South Seas. Similarly, Mungo Park wrote of West Africa, John Franklin of the Arctic, and Charles Waterton of South America.

Mungo Park, for example, a dauntless Scottish doctor from Selkirk, was sent out by the Africa Association to trace the course of the River Niger, and discover the legendary Timbuctoo. A strange and romantic figure, he made two epic trips, the first totally alone in 1794–97; and the second (with forty troops) in 1804–05 – from which no one returned alive. Having glimpsed (but not entered) the walls of Timbuctoo, he was killed by suspicious tribesmen on his return journey, ambushed in a defile of the river at Boussa, five hundred miles from the coast. But he left behind an extraordinary and haunting bestseller, *Travels in the Interior of Africa* (1799), later published with fragments of his last journal.

Joseph Banks is usually remembered as the august scientific President of the Royal Society, a landlocked position he occupied for forty-two years. Yet as a young man Banks accompanied Cook's first circumnavigation of 1768–71, acting as HMS *Endeavour's* official botanist, and quickly establishing himself as the expedition's most reckless and romantic adventurer, notably in the three months spent on the isle of Tahiti (where he was the first to record the South Seas sport of surfing), and in the risky exploration of the east coast of Australia. The thousands of botanical specimens he brought back with him formed the basis of the Royal Botanic Gardens at Kew, which under his superintendence became the most famous botanical collection in the world.

But of all the romantic science travellers, none was more influential than Alexander von Humboldt (1769–1859). Born in Berlin, he befriended Goethe at Jena, and (like Coleridge ten years later) studied under Blumenbach at Göttingen University. He set out on his South American journey at the age of twenty-nine in 1799, effectively disappearing for the next five years. On his return he began work on his epic *Personal Narrative of a Journey to the Equinoctial*

Regions of the New Continent, which was published (in French) in three volumes between 1814 and 1825, and quickly translated into most European languages. It defined a new inclusive discipline that he called '*la géographie générale*', which influenced all subsequent scientific explorations by Europeans, including those by Charles Lyell, Charles Darwin and Alfred Russel Wallace.

Since the fine new Humboldt biography by Andrea Wulf, *The Invention of Nature* (2015), all this has become far better-known. But perhaps still underappreciated is the way Humboldt invented a new, intimate style of personal travel writing. Around the pure scientific data he can be vividly descriptive, conversational, rambling, even confessional. Darwin said he could recite whole passages of Humboldt by heart. The pains, and even the minor irritations, of the journey become equally informative as the epic high spots and delights, as in this passage from Chapter 23 of Humboldt's *Personal Narrative*:

> We left Turbaco on a fresh and very dark night, walking through a bamboo forest. Our muleteers had difficulty finding the track, which was narrow and very muddy. Swarms of phosphorescent insects lit up the tree-tops like moving clouds, giving off a soft bluish light … We waited nearly the whole day in the miserable village of Mahates for the animals carrying our forty crates of specimens to the landing stage on the Magdelena river. It was suffocatingly hot; at this time of year there is not a breath of wind. Feeling depressed we lay down on the ground in the main square. My barometer had broken and it was the last one I had … Lucky are those who travel without instruments that break, without dried plants that get wet, without animal collections that rot; lucky are those who travel the world to see it with their own eyes, trying to understand it, and recollecting the sweet emotions that nature inspires!

4

To write a book of the kind I intended also raised problems of chronology and structure. I wanted it to be a group biography, but one spaced over some sixty years, covering several disciplines, many locations in Britain (as well as some in France and Germany), and linking several diverse sets of friends and colleagues. I wanted the driving effect of a single narrative – the creation of Romantic science – but built out of diverse biographies, with strong local colour and rich in digressions. Above all, I wanted to include the lives of the scientists themselves, their emotional and subjective experiences, their own hopes and beliefs, within the objective achievement of the science they were making. One immediate and important consequence of this was that the book became concerned with scientific error and failure as much as with success. It became a book about science as a human endeavour.

It was important to show, for example, that William Herschel – who first discovered Uranus, the seventh planet in the solar system – also believed that there was life on the moon, and very probably on the sun; or that Jean-Pierre Blanchard, who first crossed the English Channel in a hydrogen balloon – also believed that balloons could be steered with silken wings or bamboo oars; or that Humphry Davy – who invented the life-saving miner's safety lamp – also missed the chance of preventing untold suffering by making surgical anaesthesia available during the terrible butchery of the Napoleonic Wars.

So I wanted to tell a complex human story, with a strong sense of both comedy and tragedy, within the progressive advance of cumulative scientific knowledge. Great discoveries were passed on from hand to hand (the central collaborative triumph of science), but often at great cost and suffering and despair. I came to think of this unity in diversity as taking the form of a 'relay race' of scientific stories.

But the question of 'telling stories' was itself problematic. This had been first explored in a brilliant but little-known collection of essays, *Telling Lives in Science* (1996), edited by Michael Shortland and Richard Yeo. The notion of any scientific discovery taking the neat, closed form of a literary story, with a precise beginning, a progressive middle, and a definite triumphant end, seemed misleading. I associated this traditional type of 'eureka' story with the improving genre of Victorian science writing, often for children – as for example in Henry Mayhew's *The Wonders of Science, or Young Humphry Davy* (1856). The actual work of scientific discovery rarely followed this pattern, as even Mayhew admitted in his Foreword:

> I have found some difficulty in developing my object, which was to show youths how one of the greatest natural philosophers had, when a lad, like themselves, made himself acquainted with the principles of science ... I found it was impossible to follow literally the scientific history of Davy's mind, since he had begun by adopting the most flighty theories. To have evolved all his visionary notions when a lad, in a work that was meant to have an educational tendency, would have been merely to have taught error ...

Hesitations, misconceptions, dead ends, rivalries and collaborations, long-drawn-out trials over years, and sudden chance breakthroughs over days, were nearer the truth. Nevertheless, this contingent nature of discovery could well be caught in narrative form. By going back to original sources – diaries, laboratory notebooks, contemporary letters, and early or rejected drafts of scientific papers and lectures – a vivid picture of the actual processes of science could be obtained. And equally important, the feelings and imaginative struggles of the scientists involved.

For example, I explored a technique that I came to think of as the 'vertical footnote'. This worked as follows. While my main narrative

moved forward in a largely conventional chronological form, a 'horizontal' progress as it were, the footnotes provide sudden 'vertical' or vertiginous plunges *down* into past history, or *back up* into contemporary science. For example, when describing the Herschels' prolonged nights of star-gazing in the 1780s, I wanted to bring home to the reader what this might really have felt like. I described contemporary conditions – the ink freezing on the nib of Caroline's pen, the layers of woollen undergarments – and then tried to surprise the reader with the same experience as viewed by quite different people at quite different times.

I leaped forward to a late-nineteenth-century British novel, and then forward again to one of the greatest twentieth-century American astronomers. I then broke my own rule about never using the personal pronoun, and added a memory from my researches at Cambridge, in order to emphasise the profound psychological impact of the night sky. After various tinkerings, this is the footnote I finally came up with:

> Standing under a night sky observing the stars can be one of the most romantic and sublime of all experiences. It can also be oddly terrifying. A hundred years later, Thomas Hardy took up amateur astronomy for a new novel, and in his description of Swithin and Lady Constantine sharing a telescope in *Two on a Tower* (1882) he captured something of the metaphysical shock of the first experience of stellar observation. 'At night ... there is nothing to moderate the blow which the infinitely great, the stellar universe, strikes down upon the infinitely little, the mind of the beholder; and this was the case now. Having got closer to immensity than their fellow creatures, they saw at once its beauty and its frightfulness. They more and more felt the contrast between their own tiny magnitudes and those among which they had recklessly plunged, till they were oppressed with the presence of a vastness they could not cope with even

as an idea, and which hung about them like a nightmare.' My own first experience with a big telescope, the 'Old Northumberland' at Cambridge Observatory, an eleven-inch refractor built in 1839, left me stunned. We observed a globular star cluster in Hercules, a blue-gold double star, Beta Cygni, and a gas cloud nebula (whose name I forgot to record, since it appeared to me so beautiful and malignant, according to my shaky notes like 'an enormous blue jellyfish rising out of a bottomless black ocean'). I think I suffered from a kind of cosmological vertigo, the strange sensation that I might fall down the telescope tube into the night and be drowned. Eventually this passed. The great Ewin Hubble used to describe an almost trance-like, Buddhist state of mind after a full night's stellar observation at Mount Wilson in California in the 1930s. See Gale Christianson, *Edwin Hubble* (1995).

Finally, to unify the book I eventually chose four key figures, in the three dominant sciences of the period: botany, astronomy and chemistry (which then included the study of electricity). They were Banks, the two Herschels, and Davy. These were not only great scientists, but people who changed the perception of science itself for a general public, and especially for the writers of the period.

Shortly before publication, in autumn 2008, I was asked to present *The Age of Wonder* to the Royal Society, in front of an audience of two hundred scientists. (As W. H. Auden once wrote on a similar occasion, I felt like a provincial clergyman shuffling into a room full of dukes.) I wondered how to catch their attention. So I began like this: 'This book is 485 pages long, weighs 0.598 kilograms, is five centimetres thick, and has seventy-two footnotes. It has four main protagonists, one of whom is a woman. It has a cast list of sixty characters, 30 per cent of whom are French, German, or American. It contains no mathematical formulae, but over 307 lines of quoted poetry.'

These unflinching statistics appeared to excite a first flicker of interest, and even of amusement. I then gave them what I thought would be the most paradoxical and unlikely combination: the poet Lord Byron waxing lyrical – itself a provoking phrase – on the subject of universal scientific knowledge. Again, the stanza comes from Byron's epic poem of wanderlust and eroticism, *Don Juan* (1819). 'Byronic science' could be looked on as an oxymoron. But in fact, I assured my audience, this was actually a very good summary of the contents of my entire book:

> He thought about himself, and the whole Earth,
> Of Man the wonderful, and of the Stars,
> And how the deuce they ever could have birth;
> And then he thought of Earthquakes, and of Wars,
> How many miles the Moon might have in girth,
> Of Air-balloons, and of the many bars
> To perfect Knowledge of the boundless Skies;
> And then he thought of Donna Julia's eyes.

So here was one of the leading poets of the Romantic age freely celebrating the sciences of astronomy, geology, physics, aeronautics, meteorology ... and even possibly the 'erotic chemistry' of Donna Julia's eyes. Indeed, did they know that Byron was himself elected a Fellow of the Royal Society? He even had strong views on vivisection ... So I wanted them to think again about what science, in general, signified for Romantic writers and poets.

To my surprise the scientists were particularly delighted with Byron's last line. It suggests, of course, the paradox that human love, the impact of a single heartbeat, might be as great as the impact of that entire body of universal scientific knowledge. I have to say the scientists were very indulgent. I survived the occasion, and the book eventually went on to win the Royal Society Science Books Prize for 2009.

5

It was the young botanist Joseph Banks who provided my unifying figure, in both a scientific and a literary sense. His story runs through the whole relay race of the book. After his great voyage with Captain Cook he was elected President of the Royal Society in 1778, when he was thirty-five, remaining in that office until his death in 1820, when he was in his late seventies. His career provided intellectual continuity, as well as a narrative gravity.

Banks's adventures begin the book and take it through to its last decade. Each chapter starts with him inaugurating a new project. Each of my subjects walks in – either literally or metaphorically – to one of Banks's famous planning breakfasts in Soho Square, London. Banks also grows old with the book; his views of the function of science, and its connection with empire and religious belief, change. So he became my presiding genius, or Virgilian guide.

The central scientific story emerged as that of William and Caroline Herschel. Born in 1738, William Herschel was a German émigré from Hanover who trained as a musician, and settled in Bath in 1766, where he became fascinated by the study of stars and planets, initially as an amateur hobby. In 1772 he brought his much younger sister Caroline (born in 1750) to join him, thereby releasing her from domestic bondage. Together they began the construction of home-made reflector telescopes, and their observations quickly opened a new chapter in astronomy.

William's discovery of Uranus, the seventh planet in the solar system, on 13 March 1781, doubled the size of the observable solar system, and subsequently led to a whole new conception of the structure of the universe. Caroline was not present on the actual night of the first sighting of Uranus, but she helped with all of William's subsequent observations over the next thirty years, and herself became one of the most renowned comet-hunters in Europe.

She was also the first woman in British science to be granted an official salary, a £50 annuity from the Crown, which was enough to live on independently at that date. This was itself a notable watershed.

From 1782 the two Herschels continued their work at a new observatory outside Slough, close to the King's country residence at Windsor Castle. Here they built a series of telescopes, ranging up from ten to twenty feet in length, and finally produced a forty-foot giant, with a metal speculum mirror weighing over a ton. This last became a local landmark and tourist attraction, even being recorded on one of the new Ordnance Survey maps.

Their observation established the idea of 'deep space', but also of 'deep time', and first identified the discus shape of our Milky Way. Herschel also proposed, in a series of revolutionary papers to the Royal Society, the existence of galaxies *outside* the Milky Way – such as Andromeda – and at previously unimagined distances. He called such galaxies 'the laboratories of the universe', in which new stars were constantly being formed, and described them not as static creations, in the Biblical sense, but as dynamic structures with identifiable patterns of stellar formation, growth and decay, not unlike plants. These new 'organic' theories of what was in effect an 'evolving' universe transformed contemporary notions of the cosmos.

Besides tracing the scientific relationship between William and Caroline Herschel, I also wanted to show the extraordinary imaginative impact of their work in several other fields. To do this I looked particularly at the reactions of the poets Shelley and Keats to the new discoveries, and also of the musician Joseph Haydn. One of the most remarkable things was the very different kinds of conclusions they each drew from it.

Shelley had been inspired to buy his own (extremely expensive) telescope while an undergraduate at Oxford University. He made astronomy, and an imaginary journey through the stars, a central theme of his first major poem, *Queen Mab*, published in 1813 (still

within both Herschels' lifetimes). Attached to it were a series of deliberately provoking prose notes on a variety of scientific and political subjects, including free love, vegetarianism and climate change. Inspired by William Herschel's 'deep space' theories, he wrote a particularly fierce note 'On the Plurality of Worlds' – that is, the existence of extra-terrestrial life on what we would now call 'exoplanets'. He drew from this an atheist conclusion which would have delighted Professor Richard Dawkins:

> The indefinite immensity of the universe is the most awful subject of contemplation. He who rightly feels its mystery and grandeur is in no danger of seduction from the falsehoods of religious systems, or of deifying the principle of the universe. It is impossible to believe that the Spirit that pervades this infinite machine begat a son upon the body of a Jewish woman ... All that miserable tale of the Devil and Eve and an Intercessor, is irreconcilable with the knowledge of the stars. The works of His fingers have borne witness against him ... Millions and millions of suns are ranged around us, all attended by innumerable worlds, yet calm, regular, and harmonious, all keeping the paths of immutable Necessity.

Three years later, the reaction of the equally young John Keats was utterly different. Keats was twenty years old, and attending a full-time medical course at Guy's Hospital in London. He wrote his sonnet 'On First Looking into Chapman's Homer' very early one autumn morning in October 1816. It celebrates a deeply Romantic idea of exploration and discovery. Without actually naming Herschel, it picks out the finding of Uranus, thirty-five years before, as one of the defining moments of the age. Although combining many sources of inspiration (it is possible that Keats may have attended Charles Babbage's 1815 'Lectures on Astronomy' at the Royal Institution), the poem itself was written in less than four hours. It ends:

... Then felt I like some watcher of the skies
When a new planet swims into his ken;
Or like stout Cortez when with wond'ring eyes
He stared at the Pacific – and all his men
Look'd at each other with a wild surmise –
Silent, upon a peak in Darien.

Keats's vivid idea of the 'eureka moment' of instant, astonished recognition celebrates the Romantic notion of scientific discovery. But the efforts of other European astronomers, like Charles Messier (1730–1817) and Anders Johan Lexell (1740–84), in fact took weeks, if not months, to confirm the true planetary identification of Herschel's 'comet' in 1781. Yet it is also true that Herschel too, despite the evidence of his own observation journal, gradually convinced himself that precisely such a moment of instant, sublime discovery had occurred in his garden at New King Street in Bath. So the paradox emerges that the scientist Herschel in the end may have remembered that night exactly as the poet Keats imagined it.

A third and much older artist who responded creatively to the Herschels' work was the great composer Joseph Haydn (1732–1809). Once again his reaction was revealingly, even astonishingly, different. It has long been accepted that Haydn's famous and beautiful oratorio *The Creation* was the religious work that crowned his career. Completed in 1798, when Haydn was sixty-six, it was based on a pious libretto obtained by the London-based musical impresario Johann Peter Salomon.

This libretto was inspired by the traditional scriptural words from the King James Bible, the opening of the Book of Genesis: 'In the beginning God created the Heaven and the Earth. And the Earth was without form, and void; and the Darkness was on the face of the Deep. And the spirit of God moved upon the face of the Waters. And God said, Let there be Light: and there was Light.' Some additional elements were taken from Milton's *Paradise Lost*. So the oratorio is

fundamentally a religious work, as Haydn himself later movingly testified: 'Never was I so pious,' he wrote, 'as when composing "The Creation". I felt myself so penetrated with religious feeling that before I sat down to the pianoforte I prayed to God with earnestness that He would enable me to praise Him worthily.'

It is often said that in the lives of the great eighteenth-century composers there is only one parallel to this frame of mind – the religious fervour in which Handel composed *Messiah*. And that Haydn had set out to rival him in piety, as well as in musical brilliance.

Yet it is also possible that the highly unusual musical ideas for the first two parts of *The Creation* – the orchestral 'Representation of Chaos' with which it opens, and the recitative for the Archangel Raphael which follows – were strongly influenced by the new cosmological theories and discoveries of William Herschel. It is a strangely paradoxical idea that *The Creation* was also inspired by a distinctly secular, and potentially atheist, science.

Haydn's eighteen-month visit to London in 1791–92, the first of two he made to the English capital, was the first time he had voyaged outside Austria in his life. Although he was already in his late fifties when he arrived in England, he engaged with this new world with immense intellectual excitement. Among many adventures and expeditions recorded in his London diary, one high point was his visit to the Herschels' famous astronomical observatory at Slough in June 1792.

By now, the brother-and-sister astronomical team were renowned throughout Europe. Their enormous forty-foot reflector telescope, the biggest in the world, was one of the wonders of the age. Both the Herschels were also musicians. William was an accomplished composer and one-time organist and *Kapellmeister* of the Octagon Chapel, Bath. Caroline had trained as an opera singer, and had successfully performed in Handel oratorios. Moreover, as the Herschels originally came from Hanover, they and Haydn had German as a common language.

William's diary shows that he himself was absent from the Slough observatory during much of this month. But Caroline's journal records Haydn's visit as one of the highlights of their summer. One of the things they had to discuss was the generosity of their English patrons in the financing of both telescopes and symphonies – finances and accounting being Caroline's special department. But above all, Caroline was able to describe their astronomical work in detail to Haydn, while explaining her brother's discoveries with the utmost enthusiasm and pride.

Haydn was an immensely hard worker – he would produce no fewer than twelve symphonies while in England – and he was evidently impressed by the punishing (not to say Teutonic) routine of the Herschels, who, as Caroline explained, worked all day on astronomical calculations, and then could spend 'six hours at a time on freezing winter nights' carrying out their observations. But as this was high summer, Haydn had plenty of leisure to look through all the telescopes – ten-, twenty-, and forty-foot – and discuss with Caroline her brother's theories of stars, planets and musical composition.

As I have indicated, Herschel's theories explored new and radical ideas about the formation of our own solar system and the galaxies beyond it. They had been published in a number of scientific papers in the journal of the Royal Society, the *Philosophical Transactions*, and had also been popularised in the work of the poet and physician Erasmus Darwin (1731–1802), a leading member of the Lunar Society. They spread widely, and were taken up in France by the atheist astronomer Pierre-Simon Laplace (1749–1827), who developed them as 'the nebular hypothesis' and published them in his own massive study of astronomy in 1796, *Exposition du Système du Monde*.

Laplace argued that there were millions of other solar systems besides our own. Other suns had spun out clusters of individual planets which circled around them, again through the force of universal gravity. There must be innumerable such 'solar systems'

even in our own Milky Way. So the whole universe was a laboratory. Clearly, these ideas of Herschel and Laplace moved away from the traditional six-day Creation 'myth' of Genesis, and came much closer to modern ideas of evolutionary cosmology. They were also supported by the 'deep time' ideas of the British geologist James Hutton (1726–97).

It seems likely that the early sections of Haydn's oratorio reflect something of such revolutionary speculations. This was emphasised by his giving such unusual and inventive attention to the idea of 'chaos' at the opening of the work. Nothing that he – or indeed Handel – had ever previously written is remotely like these extraordinary passages. Haydn's use of unresolved musical phrases, unsettling shifts from major to minor chords, sudden bursts of melody broken off by unexpected dissonance, all seem to suggest the vision of a highly active, explosive, cosmological chaos: the whirling, colliding and condensing of truly vast nebulae. It does not seem anything like the passive 'brooding' darkness of the Book of Genesis. What it so vividly summons up are the luminous celestial 'laboratories' of Herschel and Laplace.

6

There are many other subjects that I attempted to explore in *The Age of Wonder* – for example, the speculative impact of Davy's chemical lectures on Mary Shelley's *Frankenstein*; the idea of flight launched by the early ballooning experiments of Blanchard and the American John Jeffries; or the heroic concept of geographical exploration pioneered by the expeditions of Mungo Park. All of them seemed to offer a fascinating new way of looking at the dynamic interface between the arts and the sciences in the Romantic period, and radically to call in question the old, tired idea of the 'Two Cultures' division.

Essentially, I wanted to experiment: to take risks and break conventions. First, by exploring the possibilities of 'group biography', especially as it can explain and illuminate the particular nature of teamwork in science. Next, to use literary *narrative*, accurate and vivid storytelling, to demonstrate the step-by-step (and often *step-by-misstep*) of the actual process of scientific discovery. In doing this, I wanted to discover the human face of science, the hearts and minds behind the 'white coats'. My real subject was always scientific *passion* in all its manifestations. It was not only the poets, I found, who have the passion. Beyond all this, I wanted to prove that late-eighteenth- and early-nineteenth-century European history is still important for understanding the twenty-first century, and not only in the West. One of my proudest reflections is that *The Age of Wonder* has recently been translated into popular Arabic, Russian and Chinese editions. Now that really is an experiment, and I do not yet know the result.

3

Teaching

1

As he set out to wreak havoc on his four *Eminent Victorians* in 1918, Lytton Strachey tenderly suggested that English biography might eventually rediscover its true calling as 'the most delicate and most humane of all the branches of the art of writing'. Some three generations later, the form has certainly expanded out of all recognition, gained a broad new readership, and achieved considerable (though not unchallenged) intellectual authority. At its best, I think, biography can indeed now call itself a true 'art of writing', and also perhaps a humanist discipline. It is 'the proper study of mankind' – and womankind too. But is it an art and a discipline that can also be taught? Is it a proper subject for an *academic* course?

It has always seemed to me that the essential spirit of biography – of English biography at least – has been a maverick and unacademic one. (The French, German and American traditions are different, for interesting historical and institutional reasons.) For some three hundred years, from John Aubrey and James Boswell onwards, much of its most exciting and innovative work – among which I would now include certain books by Michael Holroyd, Claire Tomalin, Peter Ackroyd, Hilary Spurling, Frances Wilson and Alexander Masters – has been done outside the established institutes of learning, and beyond the groves of academe. It has retained an uncloistered and anarchic spirit. As Somerset Maugham once

remarked: 'There are three rules for writing biography, but fortunately no one knows what they are.'

In a letter of June 1680, Aubrey mischievously teased the Oxford historian Anthony à Wood with the essentially improper and extra-curricular nature of his biographical researches for *Brief Lives*: 'I here lay downe to you (out of the conjunct friendship between us) the Trueth, the naked and plain trueth ... which is here exposed so bare, that the very *pudenda* are not covered.' Wood donnishly retaliated by calling Aubrey 'a shiftless person, roving and maggotie-headed, and sometimes little better than crazed'.

Yet even Aubrey regretted not being able to continue his studies at Oxford. This is one of the themes of his own perceptive, third-person entry in *Brief Lives*: 'When a boy, he did ever love to converse with old men, as Living Histories.' Here he quotes Horace on what he had missed by being forced to leave the university: '*Atque inter sylvas Academi quarere verum/Dura sed amovere loco me tempora grato*' (And so among the groves of Academe to seek the Truth/But harsh times drove me from that pleasant spot).

So I began to ask whether the moment had come for biography formally to return to 'that pleasant spot', the Academy. And if so, on what terms? For me, this question took on a peculiar autobiographical twist. If I were writing my own Brief Life, I would record that for thirty-five years I worked outside academia. I had been freelance and footloose, and revelled in it. But in autumn 2000, out of the blue, I was unexpectedly invited to pioneer and teach a postgraduate university course in 'Biographical Studies'. Should I accept the invitation?

2

Frankly, for a long time I really did not know. Could my beloved biography, which I thought of as a vocation rather than a profession, really be turned into a university subject, based on an organised series of book lists, seminars, lectures, and of course a *body of theory*? What would be its content, what would be its aims, what would be its benefits to the student? Was I being asked to do something quite humble, like teaching the basic methods of sound biographical research – working with archives, public records, letter collections – and carefully constructing life chronologies, character portraits and social contexts? Or something more ambitious, as in the now fashionable Creative Writing courses, to launch a new generation of young biographical practitioners who were really committed to biography as a profession, as well as an 'art of writing'?

I returned to these questions more urgently: on what grounds could one claim biography as – at least potentially – a genuine humanist discipline? It is certainly a recognisable literary genre, although that is not quite the same thing. Yet its intellectual independence was proclaimed at least as early as Plutarch, writing in Greece around AD 110, and thus at roughly the same period as the later Gospel writers (who had very different ambitions). In the opening of his *Life of Alexander*, Plutarch distinguished Biography convincingly from History, and gave it both an ethical and a psychological dimension:

It must be borne in mind that my design is not to write Histories, but Lives. And the most glorious exploits do not always furnish us with the clearest discoveries of virtue or vice in men; sometimes a matter of less moment, an expression or a jest, informs us better of the characters and inclinations, than the most famous sieges, the greatest armaments, or the blood-

iest battles whatsoever. Therefore as portrait-painters are more exact in the lines and features of the face, in which character is seen, than in the other parts of the body, so I must be allowed to give my more particular attention to the marks and indications of the souls of men, and while I endeavour by these to portray their lives, may be free to leave more weighty matters and great battles to be treated by others.

Roger North, that subtle seventeenth-century memoir writer (not to be confused with Plutarch's Tudor translator, Thomas North), crisply summarised the argument as follows: 'What signifies it to us, how many battles Alexander fought. It were more to the purpose to say how often he was drunk.' Plutarch's chilling description of Alexander's drunken rages, or equally of his post-battle gallantry and good humour, fully bears out this claim to peer behind the mask of public behaviour and events, into an individual 'soul'. Who can forget the wonderfully funny and unexpected description of Alexander (after the bloody defeat of his great Persian enemy) sardonically examining the luxury fittings of Darius's bathroom, with its ornate and ridiculous 'waterpots, pans and ointment boxes, all of gold curiously wrought'. And then how Plutarch clinches the scene, with Alexander's stinging jest: 'So this, it seems, is royalty!'

John Dryden, while preparing his edition of Plutarch (1683), defined the genre similarly as 'Biographia, or the histories of Particular Lives'. But he chose to emphasise even further its unique quality of human intimacy:

There [in works of history] you are conducted only into the Rooms of State; but here you are led into the private lodgings of the hero: you see him in his undress, and are made familiar with his most private actions and conversations. You may behold a Scipio and a Lelius gathering cockle-shells on the shore, Augustus playing at bounding-stones with boys, and

Agesilaus riding on a hobby-horse among his children. The pageantry of life is taken away; you see the poor reasonable animal, as naked as ever Nature made him; are made acquainted with his passions and his follies, and find the demy-God a man.

This touching vision of 'the poor reasonable animal', shorn not only of divine but even of heroic status, ushered in the first great age of English biography. Intimacy is subversive of grandeur and ceremonial, though not necessarily of greatness, or indeed goodness. This notion of a popular, even a subversive discipline, which celebrates and studies a *common* human nature (shared by criminals as well as kings), would seem to me crucial. It is central to the claim that the English form has become progressively greater than hagiography, formal obituary, modish gossip, or historical propaganda. It suggests a profound humanist ambition, which could indeed provide the basis for true study.

Samuel Johnson gave this theoretical weight and intense personal conviction in his remarkable *Rambler* No. 60, 'On Biography' (1750). Here, arguably, is the first deliberate statement of a biographical poetics:

No species of writing seems more worthy of cultivation than biography, since none can be more delightful or more useful, none can more certainly enchain the heart by irresistible interest, or more widely diffuse instruction to every diversity of condition ... I have often thought that there has rarely passed a Life of which a judicious and faithful narrative would not be useful. For, not only every man has, in the mighty mass of the world, great numbers in the same condition with himself, to whom mistakes and miscarriages, escapes and expedients, would be of immediate and apparent use; but there is such an uniformity in the state of man, considered apart from adventitious and separable decorations and disguises, that there is

scarce any possibility of good or ill, but is common to human kind … We are all prompted by the same motives, all deceived by the same fallacies, all animated by hope, obstructed by danger, entangled by desire, and seduced by pleasure.

It is no coincidence that, in practice, the first short eighteenth-century masterpieces of English biography were about marginal and disreputable figures, not kings or kaisers. These were Daniel Defoe's biographical study of the housebreaker and incorrigible escape-artist Jack Sheppard (1724), and Johnson's own brilliant *Life of Mr. Richard Savage* (1744), an account of the indigent poet and convicted murderer. Both works turn conventional moral judgements – and traditional social hierarchies – upside down, by insisting on the value and interest of common humanity, the universal 'possibilities of good or ill', wherever they are to be found. Johnson wrote: 'Those are no proper judges of his conduct who have slumber'd away their time on the down of plenty, nor will a wise man presume to say, "Had I been in Savage's condition, I should have lived, or written, better than Savage."'

Boswell's *Life of Johnson* (1791) gave this notion of common humanity the proportions of an epic – Johnson as Everyman. And the powerful idea of the marginal figure who is still representative of 'human kind' (in this case specifically 'woman kind') recurs in William Godwin's strikingly dramatic and candid life of his wife Mary Wollstonecraft, the *Memoirs of the Author of a Vindication of the Rights of Woman* (1798).

By the early nineteenth century, the cultural significance of biography's growing popularity was broadly recognised, and was already receiving some study, though not necessarily favourable. Coleridge wrote about it in his journal *The Friend* (1810), calling it the product of 'emphatically an Age of Personality'; and Wordsworth attacked the use of ungentlemanly revelations in a contemporary *Life of Burns* (1828). But in fact Romanticism embraced the ideas of both 'person-

ality' and of personal 'revelations'. In 1813 Robert Southey clinched his appointment as Poet Laureate by writing a short and wonderfully vivid biography of Nelson, which eventually became by far the most successful work he ever published. It enshrined the dead wartime naval commander as a new kind of national hero, a people's hero with the common touch, flawed of course (Emma Hamilton), but open-hearted and irresistibly courageous, and above all *familiar*: 'The death of Nelson was felt in England as something more than a public calamity; men started at the intelligence, and turned pale, as if they had heard of the loss of a dear friend.'

Similarly, in 1818 Mary Shelley chose to educate Frankenstein's monster in the complex ways of human civilisation by making him read biography ('a volume of Plutarch's *Lives*') as well as Goethe's fashionable novel *The Sorrows of Young Werther* and Milton's *Paradise Lost*. While fiction seems to emphasise the creature's isolation and sense of exclusion, biography consoles him. Hidden in his woodshed, the monster reflects: 'I learned from Werther's imaginations despondency and gloom: but Plutarch taught me high thoughts; he elevated me beyond the wretched sphere of my own reflections, to admire and love the heroes of past ages.'

One cannot help wondering which exemplary biography Mary Shelley would have chosen to give the monster for uplift and study today. Currently some 3,500 new titles are published in Britain a year. (However, this figure includes autobiography, ghosted books, and many pictorial show-business biographies which are surely closer to the older forms of hagiography or demonology.) Virtually all bookshops have a Biography section which is larger than any other non-fiction genre, and is still quite separate from History. This seems to emphasise the continuing notion of a popular pantheon, a kind of intimate collective memory of 'common human kind', which offers ever-expanding possibilities for serious study.

Yet commercially the genre of biography is still regarded as ephemeral and utilitarian, rather than a permanent art form. It is

strongly content-orientated, and it is shelved alphabetically by subject, not by author. Even Boswell is shelved under 'J', for Johnson. This seems to imply that most biographies are defined crucially by their subject-matter, and don't really have a significant authorial status for the reading public. Essentially, biographies are understood to write themselves, self-generated (like methane clouds) by their dead subjects. This popular misconception still affects much contemporary newspaper reviewing of new biography, which tends to consist of a lively critical *précis* of the whole life, with perhaps one brief mention of the actual author of the book, tucked away somewhere in the penultimate paragraph.

Yet, if biography is to provide a genuine academic course, it must surely concern itself primarily with the outstanding biographers, as literary artists, and their place in the changing history of the form. This would imply an agreed canon of classic works, and of classic biographical authors, as it does in the novel. But has such a canon ever been put forward or generally accepted? Does biography have a widely acknowledged Great Tradition, in the same way that the novel does?

There has been a considerable growth in modern biographical theory, especially since Leon Edel's *Writing Lives: Principia Biographica* (1984). But surprisingly little has been written about the specific question of a canon, between Harold Nicolson's *The Development of English Biography* of 1927 and Paula Backscheider's *Reflections on Biography* of 1999. Indeed, Backscheider concludes that the need to establish and teach a canon is a paramount requirement for the future evolution of the genre as a whole: 'If biography is to come closer to reaching its potential either as an art or a cultural force, then readers must demand art, collect the books, think in terms of canons and schools, and biographers must have the daring to accept the calling.'

But what about the daring to propose a canon? Leaving aside classical and Renaissance precursors, and concentrating on the early

modern English tradition only, there are perhaps fewer than half a dozen names which would immediately spring to mind. These might be Johnson's *Lives of the Poets*, Boswell's *Johnson*, Mrs Gaskell's *Charlotte Brontë*, and Strachey's *Eminent Victorians* – though technical objections can be made to all of them as 'impure' biography. Johnson, it could be argued, was writing critical essays; Boswell a dramatised memoir; Mrs Gaskell a romantic novel; and Strachey a social satire.

However, let me propose for argument's sake a possible canon of twenty-seven classic English works written between 1670 and 1970, which might form the basis for postgraduate study. I give abbreviated working titles, though the full original versions are often revealing, as when Godwin omits to mention his wife's name but describes her only as 'the Author' of her most controversial book.

Izaak Walton, *Lives of John Donne* and *George Herbert* (1640, revised 1670)

John Aubrey, *Brief Lives* (1670–88, first published selection 1813)

John Dryden, *Plutarch's Parallel Lives* (translations edited 1683–86)

Daniel Defoe, *The History of John Sheppard* (attributed, 1724)

Samuel Johnson, *The Life of Mr. Richard Savage* (1744)

James Boswell, *The Life of Samuel Johnson LL.D.* (1791)

William Godwin, *Memoirs of the Author of a Vindication of the Rights of Woman* (1798)

Robert Southey, *Life of Nelson* (1813)

William Hazlitt, *The Spirit of the Age* (pen portraits, 1825)

Thomas Moore, *Life and Letters of Lord Byron* (1830)

John Gibson Lockhart, *The Life of Sir Walter Scott* (1837–38)

Thomas Carlyle, *Life of John Sterling* (1851)

Elizabeth Gaskell, *Life of Charlotte Brontë* (1857)

G. H. Lewes, *Life of Goethe* (1855, revised 1863)

Alexander and Anne Gilchrist, *Life of William Blake* (1863)

John Forster, *Life of Charles Dickens* (1872–74)

David Brewster, *Life of Sir Isaac Newton* (1855, revised 1880)

J. A. Froude, *Life of Thomas Carlyle* (1882–84)

Lytton Strachey, *Eminent Victorians* (1918)

Geoffrey Scott, *Portrait of Zélide* (1925)

A. J. A. Symons, *The Quest for Corvo* (1934)

Cecil Woodham-Smith, *Florence Nightingale* (1950)

Leon Edel, *Henry James* (1953–72)

Richard Ellmann, *James Joyce* (1959, revised 1982)

George D. Painter, *Marcel Proust: A Biography* (1959, 1965)

Michael Holroyd, *Lytton Strachey* (1967–68, revised 1994)

All these books could be justified on grounds of literary quality, the historic pictures they achieve of their subjects, and their significance within the development of the form. Yet one is immediately aware of several objections to their place in a canon for study. First, there is the simple problem of length, upon which Virginia Woolf expatiated with such eloquent irony in *Orlando* (1928): 'documents, both private and historical, have made it possible to fulfil the first duty of a biographer, which is to plod, without looking to right or left, in the indelible footprints of truth; unenticed by flowers; regardless of shade; on and on methodically till we fall plump into the grave and write *finis* on the tombstone above our heads'.

This is particularly evident in the nineteenth-century convention of inflating a chronological narrative with enormous excerpts from original letters and diaries, which by modern scholarly convention would now be published separately. For example, Froude's *Carlyle* (though one of the greatest studies of Victorian marriage) is in four volumes; Lockhart's *Scott* is in seven. How are these dinosaurs to be recovered? Perhaps by editing?

Next, there are certain obvious biases within the selection. There are few American, Irish or Australian lives. There is the large

predominance of literary biography over scientific, political or military. Equally, there is the overwhelming predominance of men over women, either as biographers or as subjects. This seems historically unavoidable. Aubrey included only three women in his *Brief Lives*, though one was the remarkable Countess of Pembroke; Johnson wrote nothing about his large circle of brilliant bluestocking friends; Hazlitt included no women in *The Spirit of the Age*. It was only with the late recognition of the mid-Victorian heroine – Caroline Herschel, Charlotte Brontë, Florence Nightingale, Harriet Martineau, Mary Somerville – that the biography of women began to emerge, and only with modern feminism that it began to have serious impact on the form after 1970, with work by Claire Tomalin, Hilary Spurling, Nancy Milford, Judith Thurman, Stacy Schiff and others.

But there is a wholly different level of objection. How can the term 'classic' (in the sense of unique and enduring) be applied to even the greatest of these biographies, when their facts and interpretations will always be altered by later research? This crucial question of the superannuating of any biography raises several issues. At the simplest level, it is a matter of factual accuracy. This is an obvious problem in the case of Thomas Moore, who altered and spliced so many of Byron's letters and journal entries; or Boswell, who could not fully come to terms with Johnson's early, unsettled years in London; or Mrs Gaskell, who suppressed much of Charlotte Brontë's amorous life and correspondence with her Belgian mentor Monsieur Héger. (These letters, largely unsent, were published after Brontë's death, though they had been partly used in her novel *Villette*.)

This leads on to a larger, almost philosophical question about the apparently ephemeral nature of biographical knowledge itself. If no biography is ever 'definitive', if every life story can be endlessly retold and reinterpreted (there are now more than ten lives of Mary Wollstonecraft, thirty lives of Johnson, two hundred lives of Byron, four hundred lives of Hitler, and literally countless lives of Napoleon), how can any one Life ever hope to avoid the relentless process of

being superseded, outmoded, and eventually forgotten – a form of auto-destruction which has no equivalent in the novel?

This would also seem to imply that as 'factual content' grows out of date, the artistic structure is fatally weakened from within. When we learn of the young actress Ellen Ternan and her place in Dickens's life, from the modern biographies by Peter Ackroyd (1990) and then Claire Tomalin (1991), doesn't this fatally superannuate John Forster's *Life*? (Forster mentioned Ellen Ternan only once – in an Appendix with reference to Dickens's will.) Or when we discover from Richard Westfall's magisterial *Never at Rest* (1980, abridged as *The Life of Isaac Newton*, 1993) the real extent of Newton's alchemical and astrological interests, and their impact on his concept of universal gravity, doesn't this weaken the authority of Sir David Brewster's great two-volume *Life, Writings, and Discoveries of Sir Isaac Newton* (1855)?

In fact, one might suggest that precisely here lies one of the greatest arguments in favour of the disciplined, rigorous academic study of biography as a developing form. It is exactly in these shifts and differences – factual, formal, stylistic, ideological, aesthetic – between early and later biographies that students could find an endless source of interest and historical information. They would discover how reputations developed, how fashions changed, how social and moral attitudes moved, how standards of judgement altered, as each generation, one after another, continuously reconsidered and idealised or condemned its forebears in the writing and rewriting of biography.

Here one is considering virtually a new discipline, which might be called comparative biography. It is based on the premise that every biography is one particular interpretation of a life, and that many different interpretations or reassessments are always possible. (If there can be innumerable different interpretations of a fictional character – Hamlet, Moll Flanders, Mr Pickwick, Tess – then surely there can be as many of a historical one.) So, in comparative bio-

graphy the student examines the handling of one subject by a number of different biographers, and over several different historical periods. In the case of Shelley, for example, one might compare the biographies by his contemporaries Hogg and Peacock (1858) with the late-Victorian one by Professor Edward Dowden (1886), the jazz-age one by André Maurois (1924), and the American New Deal biography by Newman Ivey White (1940). The 'Shelley' that we have inherited has grown out of all these versions, and he in turn reflects back a particular picture of each generation which has, alternately, been inspired or bored or scandalised by him.

Some comparative work has already begun. Sylva Norman has written about the strange shifts in Shelley's posthumous reputation in *The Flight of the Skylark* (1954); Ian Hamilton about the cumulative influence of literary executors in *Keepers of the Flame* (1992); and Lucasta Miller in her study of the increasingly exotic literary cult of Haworth parsonage in *The Brontë Myth* (2001).

The notion of comparative biography also raises the question of the perceived limits of the traditional form. Ever since Edmund Gosse wrote a second, child's-eye, version of his father's biography (1890) as *Father and Son* (1907), and Virginia Woolf transformed a biography of Vita Sackville-West into the historical romance *Orlando* (1928), the boundaries between fact and fiction have become controversial and perilous. These experimental novel-biographies also form part of the tradition that might be usefully taught and studied. No critical account of modern ideas about biographical narrative could ignore Julian Barnes's *Flaubert's Parrot* (1984) or A. S. Byatt's *Possession* (1990).

The subtle question of the nature of non-fiction narrative, and how it differs from fiction, offers one of the most fascinating and fruitful of all possible fields for students. It is different from the conventional discipline of historiography. All good biographers struggle with a particular tension between the scholarly drive to assemble facts as dispassionately as possible and the novelistic urge

to find shape and meaning within the apparently random circumstances of a life. Both instincts are vital, and a biography is dead without either of them. We make sense of life by establishing 'significant' facts, and by telling 'revealing' stories with them.

But the two processes are rarely in perfect balance or harmony. Indeed, with some post-modern biography the two primal identities of the biographer – the scholar and the storyteller – may seem to split completely apart, and fragment into two or more voices. This happens at unexpected, diverting moments in Peter Ackroyd's *Dickens* (1990), or in a rich, continuous, polyphonic way with Ann Wroe's *Pilate: The Biography of an Invented Man* (1999), or in a deliberately sinister, insidious, disconcerting manner with Andrew Motion's *Wainewright the Poisoner* (2000). Yet this too is part of an older tradition already explored in Woolf's *Flush* (1933), the playful biography of Elizabeth Barrett Browning's dog (with its genuine scholarly notes). Indeed, I believe it goes back through certain texts as far as the eighteenth century, and I have tried to investigate the roots of these bipolar forces (which may also be described as 'judging versus loving') in *Dr. Johnson & Mr. Savage* (1993). It is, of course, tricky terrain, the impossible meeting of what Woolf herself called 'granite and rainbow'. But for that very reason, and because it requires a growing degree of critical self-knowledge, it could be rewarding for students to explore further.

Equally, the close textual study of biography could throw much more light on the unsuspected role of rhetorical devices such as 'suspense', 'premonition', 'anecdote' and 'ventriloquism' in the apparently transparent narrative forms of life-writing. And this in turn could reflect on the way that we are all, continuously, reinterpreting our own lives with story-based notions such as 'success', 'failure', 'chance', 'opportunity' and 'achievement'. So biography could have a moral role, though not exactly the naïve exemplary one assigned to it by the Victorians. It may never teach us how to behave, how to self-help, how to find role models. But it might teach us simply how

to understand other people better. And hence, through 'the other', ourselves. This, too, is part of the potential humanist discipline.

So, finally, I returned to the fundamental question: what would students be studying biography *for*? To discover and appreciate a great literary tradition: certainly. To learn both the values and the limitations of accuracy and historical understanding: without doubt. To grasp something of the complications of human truth-telling, and to write well about them: yes, with any luck. But above all, *to exercise empathy*, to enter imaginatively into another place, another time, another life. And whether that could be taught, I still had no idea at all.

<div align="center">3</div>

So it was, in the spirit of enquiry more than anything else, that in 2001 I signed a contract to design and then teach a new Master's degree in biography as part of the celebrated Creative Writing course at the University of East Anglia. My theories now required strictly practical and immediate application. This was my first and only academic appointment, and I took it on with proper trepidation. But I decided to be ambitious, and to design a course that would begin with the Greeks and run to the twenty-first century. I spent most of the summer of 2001 reading Plutarch in an olive grove on the tiny island of Paxos, where an ancient legend said a voice was once heard at dusk, calling from the sea: 'The great god Pan is dead.'

For the next five years I was responsible for about sixteen new postgraduate biography students every autumn. The first thing that delighted and astonished me was the evident appeal of the course to a hugely disparate group of people, whose ages ranged from twenty-two to sixty-seven, and whose backgrounds, life experiences and professions differed wildly. My notebooks record an Irish poet, an American Mormon, a general practitioner from Oxford, a Pakistani

air force pilot, a Japanese businesswoman, a TV researcher, the ex-headmistress of an English girls' school (not Greta Hall), a human rights barrister from London, a Vassar literature graduate, a Canadian TV executive, a financial journalist from the City, a Norfolk asparagus farmer, a Birmingham social worker, and a mother of three from Sussex whose sailor husband (I eventually discovered) was dying of cancer.

The central discipline of the MA was indeed my idea of 'comparative biography'. In practice this established itself in two ways. First, we would look at how the form had developed historically – classical, medieval, Renaissance, Augustine, Romantic, Victorian, modernist, post-modern. We would compare the different ideas of evidence, narrative, sources and appropriate subject, which were assumed. At the same time, we would take particular biographical subjects, and compare the various versions of their Lives which had been written over time. Of course, some ran into literally hundreds – Napoleon, Byron, Lincoln, Queen Victoria. This also gave rise to interesting reflections on the shifting fashions in biographical popularity. But most of all it called into question the whole idea of one, *definitive* Life.

A particularly effective example was that of the early Anglo-Irish writer and feminist Mary Wollstonecraft. Her first biography was written by her husband, the anarchist philosopher William Godwin, in 1798 – a work so shockingly frank that it was said to have destroyed her reputation for the next hundred years. But many others followed in the twentieth century, among the best being those written by Emily Sunstein, Claire Tomalin, Janet Todd, William St Clair (a group biography over two generations), Lyndall Gordon and Diane Jacobs.

Each was outstanding in its own way, yet each made very varied assessments of Wollstonecraft's character, her achievement and the nature of her feminism. They also gave strikingly different accounts of many key episodes: her stormy relations with her brutal and

abusive father; her passionate and possibly lesbian friendship with Fanny Blood; her disastrous love affair with the American Gilbert Imlay; her illegitimate child; her two suicide attempts; and finally her tragic death in giving birth to her second child, the little girl who would become Mary Shelley, the author of *Frankenstein*.

According to her biographers, Mary Wollstonecraft's historical standing had fluctuated wildly between that of a tragic heroine, a feminist martyr, a dauntless travel writer (Ireland, Scandinavia, France), a visionary educationalist, 'a female Werther', or 'a hyena in petticoats'. What emerged from these comparisons was the very complex notion of human and historical truth, the importance of social context, and the unexpectedly controlling force of the narrator's point of view, or bias.

One scene in particular seemed to entrance my seminars. This was the surprising way William Godwin introduced his first encounter with Mary in Chapter 6 of his classic 1798 biography. He met her at a literary dinner given by the radical publisher Joseph Johnson in November 1791, in honour of Thomas Paine. Paine was about to take up his seat in the revolutionary Convention in Paris, and Godwin was agog to meet him. He knew very little about 'Mrs Wollstonecraft'. Of course my students expected a proper moment of sentimental revelation, even perhaps love at first sight. But this is the biographical scene that Godwin actually wrote:

> My chief object was to see the author of *The Rights of Man*, with whom I had never before conversed. The evening was not fortunate. Mary and myself parted, mutually displeased with each other. I had not read her *Rights of Woman*, I had barely looked into her *Answer to Burke*, and was displeased, as literary men are apt to be, with a few offenses against grammar ... I had therefore little curiosity to see Mrs Wollstonecraft, and a very great curiosity to see Thomas Paine. Paine, in his general habits, is no great talker, and though he threw in occasionally some

shrewd and striking remarks, the conversation lay principally between me and Mary. I, of consequence, heard her very frequently, when I wished to hear Paine ... We made a very small degree of progress towards a cordial acquaintance.

This is a wonderful, paradoxical moment in Godwin's unfolding of his narrative, especially as he will later take such care in describing how they each, slowly but inevitably, fall deeply in love. Not only do we see with a shock Mary's forthright style, and her refusal of polite conventions; but Godwin subtly implies his own tetchiness and male intellectual snobbery. As we see by the end of the biography, Mary will transform all these attitudes of his, in a way that was wholly characteristic of her genius.

A good deal of time was spent examining such narrative techniques, and the different styles of experiment, especially in twentieth-century biography. In a sense this was the traditional classical discipline of 'rhetoric'. One revealing exercise was simply to look at the opening sentences of several major modern biographies, and see how immediately they suggested a particular line of biographical approach. My notebook records many examples.

For instance, there is the headlong way in which Robert Caro launches his magnificent *Lyndon Johnson: The Path to Power* (1982):

On the day he was born, he would say, his white-haired grandfather leaped on his big black stallion and thundered across the Texas Hill Country, reining in at every farm to shout: 'A United States Senator was born this morning!' Nobody in the Hill Country remembers that ride or that shout, but they do remember the baby's relatives saying something else about him, something which to them was more significant ...

Here is the announcement of a mighty action epic (the biography will eventually run to five volumes), a wide-screen panoramic opening in cowboy country, and yet immediately and carefully undercut by subtle reservations – 'he would say ... nobody remembers ... something more significant' – which give a first clue to the fantastic thoroughness and diligence of Caro's scholarly research.

Another memorable example is Alexander Masters's opening to his strikingly original biography of a dysfunctional homeless Cambridge man, Stuart Shorter, in his witty, tender, outspoken *Stuart: A Life Backwards* (2006):

> Stuart does not like the manuscript.
> Through the pale Tesco stripes of his supermarket bag I can see the wedge of my papers. Two years' worth of interviews and literary effort.
> 'What's the matter with it?'
> 'It's bollocks boring.'

This shock opening immediately announces a new kind of personal confrontation between biographer and subject. It will be fraught, informal, no holds barred, but with extraordinary possibilities of good humour and even, eventually, mutual understanding. The development of this strange duet, between Masters the clever young Cambridge academic and Stuart the streetwise but deeply damaged down-and-out, is at once established as the central narrative drive of the whole biography. Even so, there are traditional parallels for the student to recognise and ponder: not so much with Boswell's *Johnson*, but more with Johnson's own eighteenth-century down-and-out story, *The Life of Mr. Richard Savage*.

A third equally challenging, but utterly different, narrative voice takes immediate control in the thoughtful and provocative first paragraph of Hermione Lee's superb biography of *Virginia Woolf* (1996):

'My God, how does one write a Biography?' Virginia Woolf's question haunts her own biographers. How do they begin? 'Virginia Woolf was a Miss Stephen.' 'Virginia Woolf was a sexually abused child: she was an incest-survivor.' 'Was Virginia Woolf "insane"?'... Or: 'Yet another book about Bloomsbury.'

Here is a different kind of surprise, a post-modern daring in which the biographer immediately breaks the narrative convention of biographical objectivity. Is the form possible at all, she asks. Even her subject – especially when her subject is Woolf – seemed to doubt it. So Lee instantly takes the reader into her confidence, shows herself at work, apparently vulnerable and self-questioning, and acknowledges the great body of previous Woolf biography she has to contend with. By this very gesture of transparency, Lee skilfully captures her reader and establishes new intellectual intimacy with her formidable subject. From the admission of doubt comes a new authority. Now both are on equal terms: a new sort of biographical dialogue can begin, and will be continued triumphantly for eight hundred pages.

Parallel with the study of 'texts' (a term I still find oddly alienating) ran the practicalities of the students researching and writing their own work. One topic we frequently considered was the impact of the internet on biographical source-hunting. On the one hand it made original archives astonishingly more accessible; on the other hand it threatened to drown the researcher in a raging sea of second-hand, unchecked materials (as with a Wikipedia entry). But above all it demonstrated the need for the biographer to create his or her own, clear narrative structures – to check the evidence and take command of the story.

We discussed the difference between 'inventing' a fictional character and 'entering' into a biographical one. From this arose the question of whether the biographer's self, the biographical 'I', could be introduced into the narrative. Should autobiography be allowed to impinge on biography (as, for example, Boswell had done with

such signal success)? Should the pronoun 'I' be allowed to slip into the text? Or remain abstemiously in the footnotes? Or merely lurk in the Introduction?

But always we returned to discussing the value of an individual human life, and how it should be assessed. What constituted success or failure? Was this the same in a man's or a woman's life? Was this the same in all societies? Where did biography melt into social history? Much discussion ranged round Virginia Woolf's mischievous remark (in *Orlando*) that 'the true length of a person's life, whatever the *Dictionary of National Biography* may say, is always a matter of dispute.'

In a properly ecological manner, we even considered the span of human life in comparison with other life forms on earth. This produced an interesting document which became known as the 'Lifespan Litany', and was pinned up on many study walls, as an act of biographical humility:

The Lifespan Litany
1. American redwood tree – 500 years
2. Galapagos tortoise – 190 years
3. African elephant – 90 years
4. European *Homo sapiens* – 75 years (20 years asleep)
5. Canadian grizzly bear – 25 years
6. German shepherd dog – 12 years
7. Cloudy yellow butterfly – 1 year
8. Worker bee – 5 weeks
9. Adult mayfly (ephemera) – 1 day

As the MA course became established, I found myself asking a different and more practical kind of question. What did these particular students each *expect* to gain from studying biography? My original concept of a 'humane discipline' seemed increasingly abstract. What was really important to them? Obviously, many

wanted to write biographies themselves, and already had specific individual projects. These ranged from personal heroes drawn from history (Martin Luther King, Janis Joplin, Charlotte Brontë, Yuri Gagarin) to the recovery of intimate family tales, lost relatives and mysterious traditions. The title 'What My Grandmother Did During the War' became iconic.

Others wanted to catch up on post-university education, after a lapse of a decade or more, and regarded biography – with its mixture of history, psychology, sociology, literary criticism, archival research, and what we called 'fieldwork' – as an ideal mode of re-entry into the world of scholarship. It also took them sideways, into related documentary areas in the visual arts – portraiture, photography, film, video, and of course the whole world of YouTube and the internet.

But behind these two broad motives I often discerned a third, which only became clear over the course of the year, and usually among the older students. It was what I can only call a need for personal 'reorientation'. They had reached a point in their lives, often marked by some sort of crisis – a loss of employment, the departure of children from the family home, illness or death, divorce, even a crisis of faith – which required a new kind of taking stock of their lives, a standing back to consider the ground, to consider the shape of their own story so far.

The remarkable thing was that biography, by taking them out of their own lives into someone else's, allowed them to do just that. It gave them a different kind of overview. I rewrote in my notebook: 'Another person, another time, another place.' Not as an act of therapy, but as a deliberate discipline. I remember one student saying she had reached 'a new landing-point' in her life. She had climbed the stairs, and 'biography was the banister helping me up'. This was the woman whose husband was dying of cancer. She wrote a brilliant biographical essay on the marriage of the beautiful Virginia Stanley and the daring seventeenth-century sailor and adventurer Sir Kenelm Digby. It was one of the best things written during my entire

time teaching the MA. It gave me new respect for Strachey's claim about biography: 'the most delicate and most humane of all the branches of the art of writing'.

4

Clearly, such neo-Romantic aspirations for teaching biography require an ironic postscript. So here are my Ten Commandments for any other practising biographers who are already bravely teaching in the postgraduate seminar rooms of life-writing (or of Life).

1. Thou shalt honour Biography as living, experimental, and multifarious in all its Forms.
2. Thou shalt not covet thy neighbour's Novel, for there are as many rooms in the Mansion of Non-Fiction as there are in the House of Fiction.
3. Thou shalt recognise that Biography is always at best a Celebration of Human Nature, and all its glorious Contradictions.
4. Thou shalt demand that it be greater than Gossip, because it is concerned with Historical Justice and Human Understanding.
5. Thou shalt require that it chronicles an outward story (the Facts) only to reveal an inward life (a Comprehensive Truth).
6. Thou shalt see that this Truth can be told, and re-examined, again and again unto each Generation.
7. Thou shalt greet it as a Life-giving form, as it is concerned with Human Struggle and the Creative Spirit, which we all share.
8. Thou shalt relish it as a Holiday for the Human Imagination – for it takes us away to another place,

another time, and another Identity – where we can begin quietly to reflect on our own Lives and come back refreshed.

9. Thou shalt be immodestly Proud of it, as it is something that the English have given to the World, like cricket, and parliament, and the Full Cooked Breakfast.

10. And, lastly, thou shalt be Humble about it, for it demonstrates that we can never know, or write, the Last Word about the Human Heart.

4

Forgetting

1

There is a goddess of Memory, Mnemosyne; but none of Forgetting. Yet there should be, as they are twin sisters, twin powers, and walk on either side of us, disputing for sovereignty over us and who we are, all the way until death.

2

For example, right now I am a sixty-nine-year-old biographer, and writing this at a tin table under an olive tree, on the banks of a tiny streamlet known as La Troubadore. In April La Troubadore gushes over a bed of shimmering white shingle, through the young vine fields, until it vaults into the River Droude, a minor tributary of the Gardon.

Actually the Gardon is several rivers – *Les Gardons* – though no one can agree on quite how many. But they all flow out of the wild hills of the Hautes Cévennes, the two main branches emerging at Anduze and Alès (famed for its municipal fountains). Both are much subject to spring and autumnal flooding (*la crue*), and regularly carry off the cars and houses of the plain. They join forces further south, near Avignon, and as one mighty waterway sweep under the Pont du Gard, the noble Roman bridge built by the Emperor Augustus, with its fifty-three striding stone arches, one row balan-

cing airily upon another, like some brilliant troupe of performing circus elephants, those creatures that never forget.

Paradoxically, this famous Roman bridge is really an aqueduct, and the river beneath it never becomes the Gard. Indeed, there is no River Gard at all, except possibly, momentarily, at the point where it goes under the Pont du Gard. I have heard a local fisherman quote Heraclitus on this subtle question. Certainly, when it comes out the other side, the river is still Le Gardon, and flows on down to join the stately Rhône near Arles and Tarascon, and so out into the Mediterranean, untroubled by its many identities.

Yet they change constantly. By August my sparkling young Troubadore is quite dry and silent. Its shingle is hot and dusty, like a line of white bones laid along a ditch. The cheerful Droude has dwindled to a fretful ghost, green and malodorous, skulking under the trees. Even the two muscular Gardons have fallen into a brown study, a long slack chain of slumbering rock pools, barely threaded together by a trickle of live water, marooning thousands of tiny distracted fish. So, it seems, are the seasons of Memory and Forgetting, forever alternating between flood and drought.

3

Here at my tin table, with the cicadas beating their jazzy Django Reinhardt sound, I am flooded with memories of the Cévennes of fifty summers ago. I arrived on the night train from Paris, with its dark, creaking woodwork and circular windows, and the pink dawn coming up over Pont-Saint-Esprit and Orange. Getting out at Avignon, I was told that all the autocars were 'en Grève'. I studied my map for some time to find this desirable place, Grève. Later it was explained to me that Grève was not a location, but a condition. To be en grève meant to be 'on strike'. It now occurs to me that to be en grève could also be a state of mind.

So I hitch-hiked instead to Uzès, getting a lift in the van from the Cave Co-operative. We drove past the *cimitière*, to the Mas Saint-Quentin, where Monsieur Hugues was ploughing between his vine rows with his grey horse called Mistral. He completed his row and came over to the side of the field, pushing his cap onto the back of his head, and shook my hand with a certain caution. '*Un jeune Anglais, pardée!*' I stayed with his family in the *mas* for the next five months, and, in a series of long walks westwards, discovered the Cévennes.

But just here memory falters, and runs dry. I see Monsieur Hugues so clearly at that moment at the field's edge: the walnut-brown face, the outstretched arm, the shy glance from under the cap, the big old leather belt with the army buckle, and the red-check handkerchief pulled out to wipe his face. But red-check – was it? Or did that belong to the other farmer who, weeks later, I met in a high alpine field near Mont Lozère in the Cévennes, under a burning midday sun? The farmer who stopped his hay-making to give me an ice-cold swig of water from his canteen, tucked under the tractor seat, and wrapped in a damp cloth to keep it cool. A red-check cloth perhaps? Was it his?

Or was it even the neckerchief that belongs to Monsieur Rolland, the farmer who lives across the track from us now, an eighty-year-old who adores his vines, his dog and his grandchildren, and shakes my hand across the stone wall, bringing us grapes? Whose red-check handkerchief, whose walnut-brown face, whose eternal shy kindness of the Midi, am I actually remembering? And was that horse that I used to groom in the evenings in the courtyard of the Mas Saint-Quentin, to the smell of roasting chicken and rosemary, really called Mistral?

So here is Memory mixed with Forgetting, and maybe combined with what the neuroscientists call 'confabulation', or unconsciously making it up. Two sparrows dive down and brawl in the dust under the apricot tree. Little bursts of hot wind from the south scrape the

big, heart-shaped leaves of the *murier d'Espagne* across the terrace. I listen to this drowsy orchestration of the leaves, the cicadas, the fountain, the tractor, the mid-afternoon bell from the village striking the Angelus. I fall asleep for a few moments while making these notes. I dream, something about rivers and flooding. But when I wake I cannot remember what it was. I find myself wondering if the rivers used to dry up like this fifty years ago, when I was young.

<div align="center">4</div>

Later I discovered the answer in my battered copy of Napoléon Peyrat's *Pasteurs du Désert* (1842). This was Robert Louis Stevenson's favourite book about the Cévennes, which forms the haunting background to his *Travels with a Donkey*. Peyrat vividly recounts the history of the Camisard rebellion of 1702–05, and the memoirs of the visionary young soldier-prophets who came down from the hills to fight against their royalist oppressors on the plain. It was a Protestant insurrection against Catholic authority, but also a mountain people's insurrection against the centralised power of the city and the plain.

In the opening chapter of Volume Two there is a passage describing the dashing Camisard leader Jean Cavalier. It recounts his successful ambush of the King's dragoons at the Pont de Ners, just five kilometres from my olive tree, where the Droude meets the Gardon below Anduze. Peyrat also makes a remarkable observation about the fluctuating state of the rivers, and what it might symbolise:

> In springtime during *la crue*, the Gardon often bursts its banks and sweeps like an inland sea towards the village of Boucarain. But in the growing heat of summer, all this mighty torrent shrinks back again to expose a huge dry plain of sand and pebbles. Its panting ardour expires upon the banks of shingle

[*grève*, once again], until it is little more than a tiny pulse of water which the burning sun of the Midi soon dries up completely. So the Gardon is symbolic of the Cevenol revolt, as excessive in its triumphs as in its defeats. Moreover, the river would never countenance a bridge to be maintained at Ners. It would ruthlessly wash away each successive set of arches, as soon as they were built. Beside their eternally ruined stone-work, a simple ferry boat, plying between one bank and the other, remained the most reliable method for travellers.

So the Gardon had always fluctuated violently; and sometimes even become the River Lethe too.

5

Here is something one of my students at the University of East Anglia, Marisse Clarke, told me about forgotten memories. Marisse was completing her MA in Life-Writing, and working on a project to reconstruct the domestic history of pre-war Norfolk. It was a jump-back of sixty years or more to 'the pre-fridge era', as she called it. There was lots of written material, especially letters and diaries, in the Norwich archives, but she was interested in something more direct and intimate, an oral history. Her main source became groups of old-age pensioners, many of them women, who met once a week for 'reminiscence sessions'. Initially they were shy, their memories were very scattered, and it was difficult to get more than a few well-worn tales. On subjects such as 'Christmas', Marisse suspected many memories were made up of 'fanciful images', unconsciously adapted from popular Christmas tales, films or Christmas cards (confabulation again).

Then a colleague told her about the 'memory boxes' that had been taken along to other reminiscence sessions. A memory box typically

consisted of a large suitcase containing a number of perfectly humdrum domestic objects from the 1930s – a bar of Lux soap, a box of Swan Vesta matches, an Ovaltine tin, a tortoise-shell hairclip, a small mangle, and so on. For a 'Wash Day and Bath Night' session, things like stone hot-water bottles and men's traditional cut-throat razors were added – and the memory box itself became an old zinc bath.

According to Marisse, what many of us would regard as 'old junk' now became 'little treasures' of stored-up memory, with a high symbolic value. The effect of the memory boxes was often magical. The old women, many in their eighties, slowly began to handle, identify (eyesight not always so good) and discuss these familiar objects. Amazement was soon followed by laughter, delight, and not infrequently indignation, and even some tears. Each physical object would 'trigger' a long chain of recollections. Gradually an extraordinary stream of shared memories, anecdotes, jokes and stories would emerge. The flow – the flood – soon became unstoppable. It was quite unlike anything Marisse or her colleagues had heard before, and the memories had a knock-on or chain-reaction effect, each memory setting off another. Sometimes, it seemed, the evenings would explode into a party, a memory party.

This was the starting point for a brilliant MA dissertation on oral history, old age and community memory: *Wash Day and Bath Night: Uncovering Women's Reminiscences* (2003). What did it demonstrate? Certainly that Marisse was a very good researcher, and knew how to wait, how to listen, and how to gain trust, like all good potential biographers. But also that memory and forgetting are subject to the law of association.

6

The concept of the association of ideas is at least as old as Aristotle in the fourth century BC. The argument was taken up by Hobbes and Pascal, and later elaborated by David Hume in his *Treatise on Human Nature* (1738). Hume suggested that ideas were naturally linked by three qualities: 'resemblance, contiguity in time or place, and cause and effect'. But it took an eighteenth-century doctor to transform these metaphysics into a scientific theory of memory.

One of the great, forgotten books of English Romanticism is David Hartley's *Observations on Man, His Frame, His Duty and His Expectations*, first published in 1749. Hartley was a successful physician who turned his hand to philosophy and psychology. Born in Yorkshire, he practised largely in London and Bath, where he developed a theory of consciousness based on his own medical observations of his patients. Hartley's great originality was to consider memory primarily as a physiological process. It was something that occurred not only in the 'mind', but physically in the structure of the brain. Combining the empirical philosophy of Locke with his own views of the human nervous system, he argued that all memories were formed by 'clusters' or sequences of associated impressions and ideas. These were physiologically encoded in the brain in an enormous network of medullary 'vibrations', or smaller 'vibratiuncles', similar to electrical impulses moving through the brain tissue or 'medullary substance'.

Although Hartley had not carried out dissections of the cerebral cortex, and had no effective map of the human brain (as we do today), his theories strikingly anticipate much speculative modern neuroscience. For example, Francis Crick's study *The Astonishing Hypothesis* (1994), with its characteristically provocative subtitle *The Scientific Search for the Soul*, proposes '40-Herz oscillations' within the brain, and 'reverberations' within the cortex, as the possible basis

of human consciousness: 'Consciousness depends crucially on thalmic connections within the cortex. It exists only if certain cortical areas have reverberatory circuits ... that project strongly enough to produce significant reverberations.'

In their most basic form Hartley's associative clusters were linked to simple impressions of pleasure or pain, but they eventually organised themselves hierarchically. They evolved into all the higher forms of remembered knowledge, learning and reason. They evolved into notions of imagination, ambition, conscience and love. They even evolved into a belief in God, which Hartley called 'theopathy'.

Hartley was a philanthropist, a vegetarian, a Christian and a believer in a mystical kind of Paradise. Yet in effect he was putting forward a theory of the entirely physical or 'material' evolution of the human brain. He saw no sign of the traditional division between mind and body. He detected no separate interjection of a 'spirit', a 'divine spark' or a soul. Memory was a form of electrical or chemical motion. As he put it in his famous Proposition 90: 'All our voluntary powers are of the nature of Memory.'

Hartley also had an unusual theory of dreams. Far from being coded messages from the unconscious, they were simply part of the brain's system of waste disposal. When we dream, we abandon the useless memories and associations of the day. Dreaming is a functional form of forgetting, which prevents the machinery of the brain from becoming overloaded. Without forgetfulness, we would become mad: 'The wildness of our dreams seems to be of singular use to us, by interrupting and breaking the course of our associations. For if we were always awake, some accidental associations would be so cemented by continuance, as that nothing could afterwards disjoin them; which would be madness.'

These ideas strongly attracted the eighteenth-century scientist and free-thinker Joseph Priestley. Priestley was fascinated by various forms of chemical and electrical energy, and suspected that the human brain contained both. (He had a taste for daring innovations,

and was the first to isolate, though not to identify, oxygen gas consumed in combustion.) In 1774 he edited a new edition of Hartley's *Observations* with his own Preface. 'Such a theory of the human mind ... contains a new and most extensive *science*,' he wrote. 'It will be like entering upon *a new world*, affording inexhaustible matter for curious and useful speculation.'

But others were profoundly shocked. Thomas Reid, a Professor of Moral Philosophy from Edinburgh, observed that 'the tendency of Hartley's system is to make all the operations of the mind mere mechanism, dependent on the laws of matter and motion'. The horrific idea of human memory as a 'mere mechanism' inspired Reid to unleash a superb passage of polemic science fiction in his *Essays on the Intellectual Powers of Man* (1785): 'If one should tell of a telescope so exactly made as to have the power of feeling; of a whispering gallery that had the power of hearing; of a cabinet so nicely framed as to have the power of memory; or of a machine so delicate as to feel pain when it was touched; such absurdities are so shocking to common sense that they would not find belief even among savages ...'

It does not weaken Reid's metaphysical outrage to observe that three hundred years later, most of these 'absurd' and incredible machines do exist. Certainly one could argue that the laparoscope (introducing carbon-fibre optics within the body), the mobile phone, the desktop computer and the MRI scanner demonstrate respectively many of the impossible features Reid describes.

7

More surprisingly, Hartley's *Observations* deeply impressed a Romantic poet. In his extraordinary effusion of 1796 entitled 'Religious Musings' (a sort of intellectual *tour d'horizon* written at the age of twenty-three), Coleridge grouped David Hartley with

Newton and Priestley as one of the three visionary English scientists who had truly glimpsed a 'renovated Earth'. He described Hartley as the 'wisest' among scientific thinkers, who had fearlessly explored the human mind, and become (in a prophetic image)

> ... The first who marked the ideal tribes
> Up the fine fibres through the sentient brain.

Many of Coleridge's most subtle early poems, such as 'Frost at Midnight' (1798), with its complex patterns of memory association, are explorations of Hartley's theories. Like a memory box, this poem contains a series of physical objects and sensations – an owl's cry, a flickering fire, a baby's cradle, the sound of church bells – which reverberate into an ever-expanding orchestration of memories. These also produce, like complex harmonies, several layers of past and future identity. The adult Coleridge becomes a child again; while the child remembers he has become a father; and the father blesses the child. It is no coincidence that the actual baby in this poem is Coleridge's eldest son, Hartley, born near Bristol in 1796 and named in honour of the philosopher-doctor.

Coleridge's later *Notebooks* have many passages exploring the phenomenon of memory association, such as those connected with his beloved 'Asra', Sara Hutchinson. In an agonised notebook entry for 5 March 1810, when she was preparing to leave him, he wrote down an enormous catalogue of all the objects which by 'the Law of Association' reminded him of her – from a piece of music to a waterfall, from a bedroom door ajar to the delicious white sauce on a joint of meat. He described them as forming a powerful cluster of ideas, almost unbearably strong and vivid, 'that subtle Vulcanian Spider-web Net of Steel – strong as Steel yet subtle as the Ether – in which my soul flutters enclosed with the Idea of your's'.

Here Hartley's 'vibrations' have been subtly transformed back into a 'flutter' of the soul; a word that also occurs at a key place in 'Frost

at Midnight'. In this beautiful and observant passage, Coleridge uses the faint flicker of convected air above his fire (the mirage-like 'film', not the visible flame) to produce a remarkable image of human consciousness itself. It is essentially unstable, dynamic and playfully inventive.

> ... the thin blue flame
> Lies on my low-burnt fire, and quivers not;
> Only that film, which fluttered on the grate,
> Still flutters there, the sole unquiet thing.
> Methinks, its motion in this hush of nature
> Gives it dim sympathies with me who live,
> Making it a companionable form,
> Whose puny flaps and freaks the idling Spirit
> By its own moods interprets, every where
> Echo or mirror seeking of itself,
> And makes a toy of Thought.

Coleridge would go on to dedicate three entire chapters of his *Biographia Literaria* (1817) to the history of Associationism 'traced from Aristotle to Hartley'. In one place in Chapter 6, he remarked that Hartley's theory of memory could be compared to 'a broad stream, winding through a mountainous country with an indefinite number of currents, varying and running into each other according as the gusts chance to blow from the opening of the mountains'.

8

In one form or another, the theory of Associationism remained hugely influential throughout the Romantic period. The radical idea of memory as a physiological process was seen to provide a possible link between human consciousness and the rest of the living world,

however remote. Coleridge had written of 'dim sympathies' with 'companionable forms'. More than seventy years after Hartley's *Observations*, the great chemist Sir Humphry Davy was exploring Associationism in connection with freshwater fish in his book *Salmonia, or Days of Fly-Fishing*, published in 1828.

He was investigating the mysterious memories of fish, which he regarded as quite as interesting a phenomenon as those of human beings. For example, once a trout was caught and thrown back into the river, could it remember being hooked? Could it remember *the pain* of being hooked? Could it feel – or remember – pain at all? And if so, was trout-fishing inherently cruel? This seems an astonishingly modern question: 'But do you think nothing of the torture of the hook, and the fear of capture, and the misery of struggling against the powerful rod?'

Davy debates these issues in a series of dialogues, which gain an added poignancy from the fact that he himself was ill, in pain and near death at the time he wrote them. 'My only chance of recovery is in entire repose,' he wrote from the shores of Lake Constance in July 1827, 'and I have even given up angling, and amuse myself by dreaming and writing a very little, and studying the natural history of fishes ... I now use green spectacles, and have given up my glass of wine per day.'

He concludes that although a trout may not feel pain in a human sense, it does remember being hooked, and afterwards may subsequently 'refuse an artificial fly day after day, for weeks together'. Davy thought the reason for this was that the trout associated the pain with the place: 'The memory seems local and associated with surrounding objects; and if a pricked trout is chased into another pool, he will, I believe, soon again take the artificial fly. Or if the objects around him are changed, as in Autumn, by the decay of weeds, or by their being cut, the same thing happens.'

9

One afternoon about five years ago I was walking around a favourite flowerbed in Norfolk, which my beloved Rose and I had dug and planted from scratch. Every plant and shrub was an old friend – iceberg roses, Hidcote lavenders, blue hydrangeas, magnolia, purple berberis, red-tipped photinia, Japanese anemones, scarlet crocosmia, white potentilla. Then I came to a pleasant, green-tufted shrub which had once been the size of a modest pincushion and was now more like that of a plump *chaise-longue*. I had often fed it, clipped it, hoed uxoriously under its skirts. I had, frankly, often wished to sprawl full length on its springy, inviting mattress of minute green foliage and tiny white flowerets.

But on this particular afternoon I gazed down at its familiar, cheery, hospitable shape and realised that I had totally forgotten its name. For several uncomfortable minutes I stared blankly at it, reaching into the pocket of my memory and finding it alarmingly empty, just as if I had suddenly lost a set of car keys. Only when I turned to walk back up the lawn, and was momentarily distracted by the flight of a pigeon above the beech trees, did the name 'hebe' spring effortlessly to mind.

Of course this is a common phenomenon among the late-middle-aged. (Is it called 'nominative aphasia'? *I can't remember.*) It applies particularly to the names of specific things – people, places, books, or – as in my case – plants. It can be combated, especially by child-like mnemonic devices. 'Hebe-jeeby' has rarely failed me since. Nevertheless, it tends to spread steadily and insidiously once it has begun. No one has quite explained its causes. I know a computer expert who calls it the 'disk full' effect; while others speak of 'senior moments', or hardening cerebral arteries, weakened synaptic links, alcohol, tea-drinking, metaphysical distraction, existential anxiety, incipient dementia, or just the middle-aged

mind generally 'on other things' – though not necessarily higher ones.

This kind of forgetting certainly belongs to the goddess who has no name. Yet it is not so much a failure to remember – more a failure to *recollect*. The missing word, the absent object, has not really disappeared; rather, it has become temporarily and mysteriously *unavailable*. Moreover, the act of recollection works in a curious way. When I actively tried to recollect, it was as if I was constantly on the brink of remembrance, or stuttering with a word, or slipping back from the last few inches of a rope-climb. But the moment I stopped trying, the moment I looked up and admired the pigeon in his evening swoop over the beech trees, the word 'hebe' arrived without effort, without strain, like a free gift.

Coleridge was one of the first to describe this phenomenon of 'active and passive recollection', in his *Biographia*. It also appears in the remarkable Chapter 6, where he compares the mental law of Association with that of the physical law of gravitation: 'it is to Thought the same, as the law of gravitation is to locomotion'. Sometimes we actively strive for memory, sometimes we passively yield to forgetfulness. When someone is 'trying to recollect a name', he uses 'alternate pulses of active and passive motion'. The surprising analogy Coleridge gives for this mental process is that of a tiny water-beetle paddling its way up the surface of a stream. He adds that a very similar active-passive is at work in the composing of poetry. The passage, with its impression of Coleridge himself bending over the surface of the water (or the mind), minutely observant, half poet and half scientist, is itself a kind of mnemonic image:

Now let a man watch his mind while he is composing; or, to take a still more common case, while he is trying to recollect a name ... Most of my readers will have observed a small water-insect on the surface of rivulets, which throws a cinque-spotted shadow fringed with prismatic colours on the

sunny bottom of the brook; and will have noticed how the little animal *wins* its way up against the stream, by alternate pulses of active and passive motion, now resisting the current and now yielding to it in order to gather further strength and a momentary *fulcrum* for a further propulsion. This is no unapt emblem of the mind's self-experience in the act of thinking. There are evidently two powers at work ...

10

The power of what has been forgotten can sometimes be as great as that which has been remembered. In Edward Thomas's poem 'Old Man', the unnamed bush that stands outside his cottage door has a tiny leaf with a dark, bitter, haunting smell. It evokes something he can never quite place or explain. Each time he rubs it between his fingers, the scent sweeps him back to the borders of a primitive memory, which is never quite rediscovered:

> As for myself
> Where first I met the bitter scent is lost.
> I, too, often shrivel the grey shards,
> Sniff them and think and sniff again and try
> Once more to think what it is I am remembering,
> Always in vain. I cannot like the scent,
> Yet I would rather give up others more sweet,
> With no meaning than this bitter one.
> I have mislaid the key. I sniff the spray
> And think of nothing; I see and hear nothing;
> Yet seem, too, to be listening, lying in wait
> For what I should, yet never can, remember ...
> Only an avenue, dark, nameless, without end.

Thomas's poem also reminds one of the peculiar power of smell to summon up – to call back – specific memories (especially of places). I have an aftershave which instantly recalls a certain room in a motel in Pacific Grove, near Monterey, in California.

Marcel Proust observed in *À la Recherche du Temps Perdu* that the smell and taste of things are 'more faithful' than visual images. They remain suspended in the mind for a long time, 'like souls ready to remind us, waiting and hoping for their moment to come amid the ruins of all the rest; they bear unfaltering, in the tiny and almost impalpable drop of their essence, the vast structure of recollection'.

That was written in 1913, as Proust reflected in Paris on the extraordinary power of the madeleine dipped in the *tisane* to call back the memories of his country childhood in Combray. It has become the classic literary reference to the power of smell and taste to summon memories. But five years earlier, in a dark lane near the River Thames, another equally powerful summons – with the force of 'an electric shock' – had already been recorded:

> We others, who have long lost the more subtle of the physical senses, have not even proper terms to express an animal's inter-communication with his surroundings, living or otherwise, and have only the word 'smell' for instance, to include the whole range of delicate thrills which murmur in the nose of the animal at night and day, summoning, warning, inciting, repel-ling. It was one of those mysterious fairy calls from out of the void that suddenly reached Mole in the darkness, making him tingle through and through with its very familiar appeal, while as yet he could not clearly remember what it was. He stopped dead in his tracks, his nose searching hither and thither in its efforts to recover the fine filament, the telegraphic current, that had so strongly moved him.

This of course is the Mole from Kenneth Grahame's *The Wind in the Willows* (1908), trudging along one freezing December night on his way back to Ratty's snug riverside burrow, when suddenly ambushed by olfactory memory. He too does not know for some moments what he is smelling, only that its associations are bewilderingly strong. Then finally comes 'recollection in the fullest flood'. What he is smelling is 'Home!' and his own past life there (back in the spring). 'Now, with a rush of old memories, how clearly it stood up before him in the darkness!'

Smell can be piercingly direct in its transporting power. In his autobiography, *Something of Myself* (1937), Rudyard Kipling describes a very particular, pungent kind of woodsmoke, made up of burning tar, old ammunition boxes and railway-sleepers, with which he says he could move an entire battalion of men (and a lion cub) to the veldt of South Africa, by reactivating their memories of the Boer War. Yet the precise action of smell on the human memory still remains mysterious.

In October 2004 the Nobel Prize for Physiology was presented to two American scientists, Richard Axel and Linda Buck, for a brilliant paper on the connection between the nose and the brain. They established that the human nose has nearly a thousand separate 'receptors' (ten times more than a fish, though forty times less than a dog). These have complex connections with the cortex, involving no less than 3 per cent of our genes. They form unique clusters, or 'olfactory patterns', which are capable of holding 'memories of approximately 10,000 different odours', a truly astonishing resource. Yet when asked, in the course of an interview for the BBC World Service, what light their prize-winning work threw on Proust's experience, Richard Axel answered simply, 'None at all.'

In her popular science book *The Human Brain: A Guided Tour* (1997), Susan Greenfield concludes, in a way that David Hartley would surely have recognised, that 'memory is a cornerstone of the mind'. But, writing as a Professor of Pharmacology, she still empha-

sises how little can be said definitely about the relationship between its 'phenomenological and physical' functioning. There is no generally accepted theory of how the brain produces the mind, or the mind generates consciousness, or of how consciousness depends on memory. The human brain has one hundred billion cells, and their infinitely complex interaction remains much more mysterious than the functioning of an entire galactic star system. Perhaps there is something oddly reassuring about this.

Neurological experiments have proved that there is a short-term memory (which seems to be connected to the hippocampus, and lasts up to thirty minutes). There is also a separate long-term memory, which may last over ninety years, and seems to be distributed throughout the cerebral cortex. Amazing feats of memory have also been accurately studied and measured in the performance of chess-players, musicians, actors, sports aficionados (entire *Wisdens* committed to memory) or autistic patients. One vividly recalls the sweating Memory Man's public performance in the dramatic finale to Alfred Hitchcock's film *The Thirty-Nine Steps* (1935); though it is easy to forget that he does not in fact appear in the original novel (1915) by John Buchan.

Nevertheless, the actual way in which a single, discrete memory (if there is such a thing) is 'recorded' in the human brain remains bafflingly obscure. Writing of Wilder Penfield's open-brain surgical experiments in Canada in the 1950s, Greenfield observes, 'The clinical cases reported by Penfield would also suggest that memory is not stored simply: it is not laid down directly in the brain. Rather, as seen in Penfield's studies, a cache of memories would be more like a nebulous series of dreams. One immediate problem was that the memories themselves were not like highly specific recordings on a video and were a far cry from the memories on a computer. Another problem was that if the same area was stimulated by Penfield on different occasions, different memories were elicited. Conversely, the same memories could be generated from stimulating different areas.

No one has yet shown definitively how these phenomena can be explained in terms of brain functioning.'

Nevertheless, the basis of all memory still seems to be conceived as the establishment of 'associations' through clusters or 'networks' of neuronal links: 'We know that long-term memory is accompanied by an increase in the number of presynaptic terminals, and we know that memory involves establishing new associations.' Chemical transmitters, voltage changes and synaptic 'circuits' have partly replaced Hartley's speculative 'vibrations', although the old imagery of flood and drought is still hauntingly present. Explaining the role of calcium in forming a neuronal connection, Greenfield writes of the glutamate receptor cell 'opening the channel for calcium ions to flood in', and subsequently of the 'large influx of calcium' strengthening the synapse by releasing 'a chemical cascade within the target cell'.

Neuroscience also recognises many types of forgetting, though most of these are pathological. They include numerous kinds of brain damage; various forms of post-traumatic amnesia; Korsakoff's syndrome (based on severe dietary deficiency); alcoholic blackouts and lapses; Wernicke's aphasia, in which speech itself is unlearned; Parkinson's (in which the brain forgets physical coordination); and of course Alzheimer's, which is not a natural consequence of old age, but a very specific degenerative disease of the medial temporal lobe.

Forgetting as a more positive, constructive, or even healing process – both for individuals and for whole societies, such as post-Apartheid South Africa – has begun to receive more attention. And then there is always the 'benign protective amnesia' of old age, as reflected in Groucho Marx's memorable aside: 'I never forget a face, but in your case I'm prepared to make an exception.'

11

Old age brings one particularly enigmatic feature of the lifelong exchange between Memory and Forgetting. It is the striking, but apparently paradoxical, fact that as old people begin to forget their immediate past, they often begin to remember their distant childhood with startling vividness. What possible metaphysical or physiological explanation can be given for this phenomenon?

Susan Greenfield calls it, among all the common processes of human memory, 'the most mysterious issue of all'. Characteristically, she sees the problem in terms of cellular loss and renewal: 'We know that some people can remember what happened to them ninety years ago, but by then every molecule in their body will have been turned over many times. If long-term changes mediating memories are occurring continuously in the brain, how are they sustained?' This paradox had already been observed by Leonardo da Vinci, in one of his notebooks known as the *Codex Atlanticus*, at the beginning of the sixteenth century: 'Things that happened many years ago often seem close and proximate to the present time, and many things that happened recently seem as ancient as the long-gone days of youth.'

Coleridge saw the problem in psychological terms. He suggested shrewdly that memories of childhood have a high visual content, with strong associated moods, but lack linguistic or spoken elements: 'If I were asked how it is that very old people remember *visually* only the events of early childhood, and remember the intervening spaces either not at all or only verbally, I should think it a perfectly philosophical answer that old age remembers childhood by *becoming a second childhood!*'

Coleridge expanded on this in a letter to his friend Robert Southey in August 1803: 'I hold that association depends in a much greater degree on the recurrence of resembling *states of feeling* than in trains

of ideas; that the recollection of early childhood in latest old age depends on and is explicable by this.' He added that if flows of feelings, rather than discrete chains of ideas, formed the essential structure of memory, then Hartley's system was too atomistic and passive: 'Hartley's system totters.'

In fact Coleridge came to consider (like Bergson, like Proust) that perhaps nothing was really ever forgotten. Perhaps movements of feeling, vibrations of emotion, were capable of resurrecting almost anything from our past lives. He wrote in a notebook of 1803: 'For what is Forgetfulness? Renew the state of affection or bodily Feeling, same or similar – sometimes dimly similar – and instantly the trains of forgotten thought rise up from their living Catacombs!'

12

Yet in the Preface to his unfinished 'Kubla Khan' (1816), Coleridge described the most famous incident of creative forgetting in English literature. Retired to a lonely farmhouse near Exmoor in the autumn of 1797, he took opium and dreamed a poem of 'not less than from two to three hundred lines'. On awaking he wrote down the first fifty-four lines (as we now know 'Kubla Khan'), but was interrupted by 'a person on business from Porlock'. He could never recall the rest of the poem.

The analogy Coleridge uses for this moment of forgetfulness is, once again, water: '... On his return to his room, [he] found, to his no small surprise and mortification, that though he still retained some dim recollection of the general purport of the vision, yet, with the exception of some eight or ten scattered lines and images, all the rest had passed away like the images on the surface of a stream into which a stone had been cast, but, alas! without the after restoration of the latter!'

Most modern critics and biographers think that Coleridge invented the person on business from Porlock, to hide the fact that he simply could not finish the poem. But I think he was visited first by Mnemosyne, and then by the other goddess. It was just that he could not remember her name.

5

Ballooning

1

In restless middle-age, I became crazy about hot-air balloons. Gazing from my study window in Norfolk at their stately shapes, as they float at dusk over the beech trees down the line of the River Yare valley, fills me with pleasure and longing. I watch the twinkling flame of their gas-burners, like celestial pilot lights in the sky, and catch the distant thunder of their propane breath. My heart leaps up when I behold these dragons in the sky.

Travelling aboard them I find little short of a visionary experience. In the words of Jacques-Alexandre Charles, who took off in the first-ever man-carrying hydrogen balloon from Paris on 1 December 1783: 'Nothing can ever match the sensation of euphoria that filled my whole body as we made our ascent. I felt that the Earth and all its troubles were silently dropping away ...'

Of course, there's a reasonable view that all balloon travel is insane. Balloons are brilliant at departures, but useless at arrivals. What the earliest eighteenth-century balloonists discovered was that they could always leave A, but never – despite endless experiments with wings, oars, airscrews, silken paddles – be sure of arriving at B. Or anywhere else, for that matter.

It's not that they couldn't travel remarkable distances – from A to X, as it were. In 1785, Jean-Pierre Blanchard and an American, Dr John Jeffries, ballooned thirty-five miles across the English Channel

from Dover to Calais. Though admittedly they did not actually touch down at Calais, but in an unknown wood, having abandoned everything to avoid drowning on the way. They departed in fur coats and arrived in underwear (an experience, I'm told, common for Ryanair passengers).

Balloon fact and balloon fiction are inextricably entwined, which makes them peculiarly interesting to a biographer. In 1870–71, sixty-seven air-mail balloons escaped the Prussian siege of Paris, the first carrying a letter of complaint to *The Times*, the last landing with three mailbags on a snowy mountainside in Norway. They delivered 2½ million letters, keeping the morale of the besieged population alive. This is largely fact. Seven years before, three Englishmen ballooned from Zanzibar to Senegal, overflying an erupting volcano and being attacked by condors on the way. This is fiction: Jules Verne's *Cinq Semaines en Ballon*.

My own best balloon moments float similarly between factual and fictional travel. I can never be sure if they really happened. They include flying over Lake Burley Griffin in Canberra, Australia, and trying to land on the front lawn of the national Parliament, until waved off by a security attendant – 'You can't park here, mate.' Or joining the Mass Dawn Ascent at Albuquerque, New Mexico, alongside four hundred other hot-air balloons, and gently (but surely fatally) colliding with another balloon at one thousand feet. As we bounced apart, in dreamlike slow-motion, it revolved, revealing its name-banner: 'Jesus Saves'. And He did.

How can I explain all this? Probably I'm experiencing a sort of second childhood. I remember seeing Albert Lamorisse's miraculous film *The Red Balloon* when I was ten or eleven. I identified with the small boy carried away over the Paris rooftops by a multi-coloured cluster of helium balloons, to some heavenly destination X in the clouds. Perhaps I still do. But then, I also love the way all balloonists encourage the ascent from fact into fiction, even among biographers.

2

It may be imagined that I had many dreamlike encounters, both airborne and otherwise, while researching my balloon book *Falling Upwards: How We Took to the Air* (2013). I have for example held in my hands a fragment of the legendary 'Silk Dress Balloon' flown by the rebel South during the American Civil War in 1862. I have stood in the basket of *Le Géant* (at Le Bourget), in which Félix Nadar flew through the night from France to Germany before the Prussian siege of Paris. I have knelt at the gravestone of the great British aeronaut Charles Green in Highgate Cemetery, with its beautiful balloon bas-relief, only to discover that his body had quite literally *flown elsewhere*. However, among my most dreamlike discoveries, accompanied by not a little intellectual vertigo, must be that of a hitherto unknown balloon flight undertaken by Coleridge in 1814. It is astonishing that no previous scholar has fallen upon this curious item.

The account appears in an unsigned newspaper article in the *New York Sun* of 1845, entitled 'STC Ascends in an Inflammable Gas Balloon'. This purports to describe how Samuel Taylor Coleridge, 'poet and opium addict, metaphysician and mystic', embarked on a yet more fantastic journey than even his Ancient Mariner, when he 'took to the aerial regions in an immense aerostatic balloon filled, not as might be supposed *with hot air*, but with hydrogen gas'.

At ten thousand feet above the 'Exmoor confines of Devon', where fifteen years previously he had written – or dreamed – his celebrated poem 'Kubla Khan', Coleridge 'underwent a new series of visionary experiences'. Most intriguing of all, it appears that this unsigned newspaper article may have been written by none other than Edgar Allan Poe.

I had of course become aware in my researches of Poe's fascination with flight, and his curious obsession with balloons. One of his very earliest stories was 'The Unparalleled Adventure of one Hans

Pfaall' (1835), about a Dutch, or double-Dutch, aeronaut who balloons as far as the moon.

Another was his brilliant account of the first-ever successful balloon flight across the Atlantic, in summer 1844. This historic crossing was made aboard a massive hydrogen balloon flying east to west, from Ireland to Newfoundland, piloted by that same famous British aeronaut Charles Green. Green had previously flown nearly five hundred miles from London to Nassau in Germany, in around eighteen hours. Now, accompanied by the thriller writer Harrison Ainsworth as his observer, and equipped with a special kind of airscrew steering system, Green completed the 3,200-mile trans-atlantic journey in just three days.

Replete with technical details, and extracts from Ainsworth's flight-log, Poe's gripping account was published in three successive issues of the *New York Sun*, and caused a sensation that tripled the circulation of that newspaper. It was only subsequently that Poe revealed that the whole thing was a complete invention, and had the story reprinted as 'The Trans-Atlantic Balloon Hoax'. Charles Green had never flown in a balloon across the Atlantic. He had never even set out. In fact a manned balloon would not cross the Atlantic until 1978. Poe could claim prophecy, but not history.

This much is known to modern Poe scholars. What seems to have escaped their attention is the third balloon piece which appeared in the same paper, the *New York Sun*, the following 1 April 1845, concerning 'STC'. Although the article is unsigned, Poe's admiration for Coleridge (as opposed to Wordsworth) is well attested in his other writings: 'Of Coleridge I cannot but speak with reverence. His towering intellect! his gigantic power!' In reading Coleridge's poetry, Poe characteristically felt *vertigo*: 'I tremble, like one standing on the edge of a volcano.' Furthermore, his fantastic tale of a wild sea voyage to the Antarctic, 'A Ms. Found in a Bottle', written in 1833 when he was twenty-four, is another youthful prose homage to Coleridge's haunting *Ancient Mariner*.

Equally, Poe's familiarity with the difficult circumstances of Coleridge's life, and his sympathy towards them – his opium addiction, his alcoholic episodes, his visionary euphorias, his restless travels, his unhappiness in love – is also well-established. Many of these circumstances found dark echoes in Poe's own career during the 1840s. So it seems quite possible that the article about Coleridge's hitherto unrecorded balloon flight over the Bristol estuary, off the west coast of England, though unsigned, is in fact an anonymous tribute by Poe. However, whether it is a genuine piece of reportage, or a fantasy omitted from his *Tales of the Grotesque and Arabesque* (1839), or simply another aeronautical hoax, remains to be seen.

Coleridge himself makes a significant balloon comparison in his notebooks of 1799, in which he describes a flock of starlings viewed in the dawn sky from his carriage window (he was travelling south from York to London, uncertain of his future career) as being like him, or like a runaway balloon, without control or direction: 'Starlings in vast flights drove along like smoke, mist, or anything misty without volition ... now a Globe, now from complete Orb into an Elipse & Oblong, now a balloon with the car suspended ... dim & shadowy, now thickening, deepening, blackening!'

Naturally, Poe could not have known of this notebook entry which remained unpublished until the twentieth century. But he would certainly have known of William Hazlitt's essays, in which balloon metaphors are frequently used to describe Coleridge's metaphysical tendencies – although usually for comic or disparaging effect. 'What right, then,' Hazlitt asks in a letter to the *Examiner* of March 1817, 'has Mr. Coleridge who is just going to ascend in a balloon, to offer me a seat in the parachute, only to throw me from the height of his career upon the ground, and dash me to pieces?'

3

Poe situates Coleridge's balloon flight in the early spring of 1814, when Coleridge's opium addiction had reached its height – so to speak. He also claims that it took place over Bristol, and the Avonmouth estuary, when Coleridge had indeed been secretly staying in the district with his indulgent friends Charles and Mary Morgan, attempting to combat his addiction, avoid creditors, and draft his *Biographia Literaria*.

Bristol was then a centre of hydrogen ballooning, just as now its Festival of Hot Air Ballooning has become world-famous, second only perhaps to Albuquerque, New Mexico's International Balloon Festival. Poe states that Coleridge flew not with Charles Green (still a teenager), but with the most celebrated British balloonist of the previous generation, James Sadler, who just two years previously, in 1812, had successfully ballooned across the Irish Sea from Dublin to Anglesey, and was certainly active in the region at this time.

As a further complication, Poe's account claims to draw on an unknown essay by Coleridge himself, published in *Felix Farley's Bristol Journal* in July 1814. Poe also appears to have had knowledge of a private letter that Coleridge wrote to Charlotte Brent, the young sister of his friend Mary Morgan, whose family patiently ministered to him in the worst period of his opium addiction at Bristol. Coleridge was romantically attracted to Charlotte, then in her twenties, and caused her many embarrassments during this troubled time. He would also write to her in a high-flown manner otherwise rare at this stage in his life. It was as if the battered man of forty-one had briefly become the visionary youth of twenty-one again.

How Poe came across this document is not explained, but it is possible that it was through a gift from Coleridge's old acquaintance, the American artist Washington Allston, whom he knew in

Bristol and who painted Coleridge's portrait there in exactly the same year, 1814. This painting is now held by the National Portrait Gallery, London, though Allston himself subsequently returned to New York, and was later buried in a little graveyard in the centre of Harvard. (I visited it in 2013, when I was giving a lecture entitled 'Knocking on Heaven's Door: Visionary Nineteenth-Century Balloon Flights'.)

The extraordinary thing is that part of this letter appears to have been written while Coleridge was actually airborne, when perched in the very balloon basket. If so, it would appear to be similar in inspiration to the famous one he wrote to his earlier beloved Sara Hutchinson ('Asra') from the perilous top of Scafell, the highest mountain in the Lake District. Both may be considered as 'visions from on high'. The earlier 'plein-air sketch' was written more than a decade previously, in the summer of 1802, but is now classed as one of the historic first accounts of the pursuit of fell-walking. Perhaps Coleridge's later 'airborne sketch from the clouds', at least in Poe's version, may come to be considered an equally historic early document in the sport of ballooning. Both pieces, says Poe, show Coleridge 'in an arabesque of ecstasy, riding on the clouds of existence, above abysms too fearful to contemplate, as he had once done in his poem *Kubla Khan*'.

4

Poe sets the scene as follows: 'The balloon flight was taken at the invitation of Mr. James Sadler, at a time when Mr. Coleridge was in deep melancholy after his quarrel with Mr. Wordsworth, and also in considerable debt. His heart too was entangled. He evidently sought both physical relief and metaphysical inspiration. The poet and the aeronaut ascended from a field outside Bridgwater, beside the River Parrot. The balloon arose swiftly, and drifted north westwards.'

Poe then quotes from a number of Coleridge's miscellaneous observations made, it would appear, during the ascent itself, or at least very shortly after:

Angelic ascent! Not a sound, not a quiver, not a breath of wind. Pure elevation! The landskip drops, spins, spreads. Mr. Sadler's restraining hand – *Sir! do not lean so far.*

A Hydrogen balloon suspends one of the primary Laws of Nature, nay of the whole Universe (according to Sir Isaac Newton) – that of Gravitation. It may thus properly be called a metaphysical instrument, and places us in a dimension of perception hitherto unknown to man ...

Now far far below I could glimpse my beloved Stowey nestling beneath Quantock's airy ridge! There the elms of Holford, and there the gleaming slates of Alfoxden, where Wordsworth and Dorothy once dwelt, a blessed time ... So it seems my journey is not merely upwards, but backwards, into the past. The vision is *historical,* as well as geographical ...

The sound of a dog barking in an empty farmyard, a startled deer crashing through the Exmoor bracken, a water mill-wheel turning, a labourer calling to his cows, the sea breaking on the Watchet shingle ... They rise to me, so singular and sharp, like the promptings of memory, or should I say the blessings of recollection. Oh, *obstinate in resurrection!!*

Poe gives this much of Coleridge's miscellaneous observations, suggesting that 'each glimpse, each glimmer' indicates poignantly that 'the poetic *afflatus* had not yet abandoned him'. He then adds three longer passages, more in the nature of philosophical reflections, in which he remarks that the poet and the metaphysician

become again like his Ancient Mariner, with his haunting experience of a journey and a '*traume*', and so 'holds us with his glittering eye'.

The first is one of Coleridge's striking observations on 'form', so characteristic of the later *Biographia*, yet here seen from an entirely novel perspective:

We gain what we may term 'altitude', and oversee a prospect with hitherto novel relations, in which pattern, design, Goethe's *morphologie* – the growth of forms both in man and nature – becomes paramount. So I saw the *serpentine* intentions of the river, the *marching* promise of the corn field, the *hospitable* embrace of cottages along a country lane, the *magnetic* influence of the little church *married* to its village (yet its spire strangely invisible from this Godlike height), the dark romantic chasm of the coombes ...

The next one, says Poe, reminds us of Coleridge the 'experimental man' from those earlier Bristol days, who once believed science was 'Hope and Poetry' combined in one force for good, but whose moral hopes were progressively darkened. Perhaps we catch here a premonition of Poe's own visionary science in his last, strange, cosmological work, *Eureka* (1849):

The balloon is comparable to a chemical substance, or one of the gases which I once inhaled with dear Davy, for it grants new Visions of the world ... yet even as it does so, like the nitrous oxide, it removes the concomitant power of Voluntary will. For as Mr. Sadler was at pains to impress upon us, no balloon can be truly navigated, but depends on aerial currents and atmospheric streams and tides not only invisible to man, but utterly beyond his power to command or predict. He may harness the winds for a brief interval, but he may never

command or control or subdue them. Thus we may all float through our own lives, never controlling our direction, never knowing our destination, our land fall or simply our Fall. *Ah, Charlotte, fly with me!*

Last, Poe presents a spiritual vision, wondering if Coleridge had read the work of Luke Howard (presumably he means *On the Moderation of Clouds*, 1804), or had subsequently seen the 'transcendent' cloud paintings of John Constable, a series done on Coleridge's own Hampstead Heath in 1821–22:

I never saw such Clouds before; or rather, I never saw Clouds before at all! So full, so luminous, so fleeting, so *prophetic*, so mysterious, so various. How could any Science of man ever account for their transformations, their luminosities, their illusions? Their shadows passing over the earth, seem to make it smile with pleasure or frown with fear, as if visited by a god? What mathematical formula could ever analyse or predict them? Perhaps in all this some strange analogies with the Deity himself.

After these wonders, Poe brings Coleridge unceremoniously back to *terra firma* ('if that is what it is') with a metaphysical touch which one might suspect had been taken from one of his own *Tales*. The words are Coleridge's, but the sentiment seems more like Poe's own:

When we come back to earth, the fields rise up round our heads, the woods crowd round, and seem ready to welcome us back. But when we strike (our basket turns over, my companion cries, and my brandy flask flies out with untimely precipitation), we seem to return to a harsher reality, *the world of contingencies and unforgiving shocks*, as if all had been an illusion, a dream.

Only then, at the very last, does Poe add his Gothic master-touch: 'Oh *inflammable* STC!' he exclaims. 'And was Miss Brent not with thee in the heights?'

5

There is one final oddity in this remarkable article. Poe never describes Coleridge actually getting out of his balloon basket. Nor how many people 'prepared to dismount from the aerial carriage': Mr Coleridge, Mr Sadler, and another slim shadow? All he gives us is the brandy flask gleaming in the couch grass of a Quantocks meadow, and the clouds posting away over the Bristol Channel ever westwards, towards America. So is Coleridge somehow still airborne … and still *aflame*?

On reflection, I have sometimes wondered myself if this whole unearthly encounter with Coleridge was not itself 'an illusion, a *traume*'. Perhaps it was just one more of Poe's ingenious, mischievous confabulations; or in plain terms, another brilliant hoax. Or come to that, perhaps it was something even stranger: a biographer's heady flight, a momentary loosening of the oppressive ties to fact and *terra firma*, an ascent of April fancy, a dream *within* a dream? Or a dragon in the sky.

RESTORATIONS

6

Margaret Cavendish

1

In December 1788 the Astronomer Royal, Dr Nevil Maskelyne, a leading Fellow of the Royal Society, wrote effusively to thirty-eight-year-old Caroline Herschel congratulating her on being the 'first woman in the history of the world' to discover not one, but two new comets. No woman since the renowned Greek mathematician Hypatia of Alexandria had had such an impact on the sciences. Her celebrity would, as the Director of the Paris Observatory, Pierre Méchain, noted, 'shine down through the ages'.

Nevertheless, observed Dr Maskelyne with jocular good humour, he hoped Caroline did not feel too isolated among the male community of astronomers in Britain. He trusted she would not be tempted to ride off alone into outer space on 'the immense fiery tail' of her new comet: 'I hope you, dear Miss Caroline, for the benefit of terrestrial astronomy, will not think of taking such a flight, at least till your friends are ready to accompany you.' Or at least until her achievements were recognised by his colleagues in the Royal Society. Curiously, no such recognition was immediately forthcoming; and this raises an obvious but extremely interesting question.

All through the year 2010, and all around the globe, the Royal Society of London celebrated its 350th birthday. In a sense, this was a celebration of science itself and the social importance of its history. The senior scientific establishment in Britain, and arguably in the

world, the Royal Society dates to the time of Charles II. Its early members included Isaac Newton, Edmond Halley, Robert Hooke, Robert Boyle, Christopher Wren, John Evelyn, and even – rather intriguingly – Samuel Pepys. But amid the year's seminars, exhibitions and publications, there was one ghost at the feast: the historic absence of women scientists from its early ranks.

Although it was founded in 1660, women were not permitted by statute to become Fellows of the Royal Society until 285 years later, in 1945. (An exception was made for Queen Victoria, who was made a Royal Fellow.) It will be recalled that women over the age of thirty had won the vote nearly thirty years earlier, in 1918. Very similar exclusions operated elsewhere: in the American National Academy of Sciences until 1925; in the Russian National Academy until 1939; and even in that home of Enlightenment science, the Académie des Sciences in France, until 1962. Marie Curie was rejected for membership of the Académie in 1911, the same year she won her second Nobel Prize.

The first original paper that might be considered as part of a scientific research programme conducted by a woman and published in the Royal Society's journal, *Philosophical Transactions*, had been submitted by Caroline Herschel. It appeared in August 1786, modestly entitled 'An Account of a new Comet, in a letter from Miss Caroline Herschel to Mr Charles Blagden MD, Secretary to the Royal Society'. But Caroline, as we have seen, was sister to William Herschel, the great Romantic astronomer and influential Fellow of the Royal Society, and this undoubtedly gave her a special advantage that no other woman of this period was granted.

Both Sir Joseph Banks, the President of the Royal Society, and Charles Blagden, the Secretary, knew that Caroline's brother was immensely proud of her, had built her special telescopes, and had helped her to obtain the first state salary for a female astronomer in Britain. William had also personally put forward her 'Account of a new Comet' to the Royal Society. Even so, he carefully annotated

this first historic paper: 'Since my sister's observations were made by moonlight, twilight, hazy weather, and very near the horizon, it would not be surprising if a mistake had been made.' By the end of her long life, Caroline's acknowledged speciality was the discovery of new comets, of which she eventually found eight, at a time when fewer than thirty were known. For this she was made an Honorary Fellow of the newly founded Royal Astronomical Society in 1835. But though she lived until 1848, she was never elected to the Royal Society itself.

It is true that by the turn of the twenty-first century there had been more than sixty distinguished women Fellows of the Society. Many have become household names, such as the brilliant crystallographer Dorothy Hodgkin, who famously won a Nobel Prize in 1964, and whose whirling portrait by Maggi Hambling (1985) now hangs in the National Portrait Gallery. Her heroic life – she mapped the structure of penicillin, and then dedicated thirty-five years to deciphering the structure of insulin – is told in a superb biography by Georgina Ferry. Yet in Victorian Britain, the very idea of women doing serious science (except botany and perhaps geology) was still widely ridiculed, and even botany (with its naming of sexual parts) could be regarded as morally perilous. Mary Anning (1799–1847), the great West Country palaeontologist, struggled for years to have her discoveries – such as the plesiosaurus – recognised as her own.

In March 1860 Thomas Henry Huxley FRS, famed as 'Darwin's bulldog', wrote privately to his friend, the great geologist Charles Lyell FRS: 'Five-sixths of women will stop in the doll stage of evolution, to be the stronghold of parsonism, the drag on civilisation, the degradation of every important pursuit in which they mix themselves – *intrigues* in politics and *friponnes* in science.' This can be taken as typical of certain (though not all) Victorian assumptions, including the idea that *physiologically* the female brain simply could not cope with mathematics, experimental proofs or laboratory procedures.

When the young Ada Lovelace, the future computer pioneer, began to study advanced mathematics in the 1830s, her tutor August de Morgan (Professor of Mathematics at the newly founded University College, London) wrote privately to her mother, Lady Byron, fearing that Ada would dangerously overtax her mental powers, and that the 'very great tension of the mind' involved in calculus would surely lead to a fatal breakdown. Certainly compared with their literary sisters, the scientific women of the mid-nineteenth century still appear invisible, if not actually non-existent. What female scientific names can be cited to compare with Jane Austen, Fanny Burney, the three Brontë sisters, George Eliot or Harriet Martineau?

Yet re-examination of the Royal Society archives suggests something that may require a subtle revision of the early history of science in Britain. This is the previously unsuspected degree to which women were a catalyst in the first discussion of the social role of science. More even than their male colleagues, they had a gift for imagining the human impact of scientific discovery, both exploring and questioning it. Precisely by being excluded from the Fellowship of the Society, they saw the life of science in a wider world. Observing from the outside, they saw the inside more clearly. They raised questions about the duties and moral responsibilities of science, its promise and its menace, in ways we can appreciate far more fully today.

2

The first woman to attend a meeting of the Royal Society was Margaret Cavendish, the Duchess of Newcastle, in May 1667. In her own lifetime she became known as 'Mad Madge'. But she was born plain Margaret Lucas, the daughter of a wealthy Essex farmer owning estates near Colchester, in 1623. She was the youngest of eight chil-

dren; her father died when she was only two years old, so the whole family were brought up by an independent-minded and highly ambitious mother. Shy but headstrong, Margaret grew up with a mind of her own, a taste for fashion, great determination and energy, and a healthy disregard for the opinions of others.

She was appointed maid of honour to Queen Henrietta-Maria at Oxford during the latter part of Charles I's reign, and a glittering place in English society and a handsome conventional marriage beckoned. But then in 1642 came the outbreak of the Civil War. It swept through English society 'like a Whirlwind', as Margaret later wrote, steadily destroying the world she had known. The Royalist Lucas family were soon in jeopardy, and Margaret's brother Charles went off to fight for the King. Margaret herself slipped away into Parisian exile with the remnants of the royal court in 1644, aged twenty-one. She was away for seventeen years, only returning when she was thirty-seven. Her unconventional character, her unusual philosophical ideas, and not least her remarkable dress, were to be powerfully shaped by this Continental exile, and her long immersion in European manners and culture.

Margaret's escape from England was timely. By 1647 the family house had been ransacked by passing Cromwellian troops. Both her mother and her sister were dispossessed and humiliated, and with their health and spirits broken by poverty, they died before the end of the year. Her brother Charles was arrested during the last desperate defence of Colchester, and executed in 1648. All the Lucas estates were seized, and even the family tomb was broken up. Finally, with the trial and execution of the King in 1649, it seemed that Margaret's world and all its old certainties were lost forever.

But Margaret Lucas was a survivor. In Paris she met and quickly fell in love with the widowed William Cavendish, thirty years her senior. Cavendish, then Marquis of Newcastle, was a handsome and heroic figure who had commanded the Royalist troops at the Battle of Marston Moor in 1644. After disastrous defeat he had also fled to

the Continent, and joined the Queen's exiled court at Saint-Germain, on the outskirts of Paris. Despite the fact that he was now largely penniless, he was welcomed as head of one of the great aristocratic dynasties of British science, with a mathematical brother, the hunch-backed Charles Cavendish, whom Margaret also came to admire.

By happy chance, twenty-one of Margaret's early love letters to William Cavendish in Paris have survived, and are now held in the British Library. They were written between their first meeting in April 1645 and their marriage in December 1645, evidence of a whirlwind romance to match the times. Only Margaret's side of the correspondence exists, so William evidently kept and treasured her letters all his life. They capture something of Margaret's reckless charm, her volatile mixture of shyness and steely determination, at the age of twenty-two. All the letters are short, and appear to have been written at great speed, with highly idiosyncratic spelling and an almost total disregard for punctuation, which are themselves extraordinarily expressive of Margaret's vehement character.

She later wrote: 'my Letters seem rather as a ragged Rout than a well-armed body, for the Brain being quicker in creating than the Hand in writing or the memory in retaining, many Fancies are lost, by reason they oft-times outrun the Pen ...'

The very first, written when they were evidently already lovers, begins abruptly and dramatically: 'my Lord there is but one Accident – which is Death – to make me unhappy ...' Margaret proceeds to pour scorn on those at court who have been attempting 'to untie the Knot of our affection'. It ends with a refusal to let anyone else inter-fere with the precious but perhaps perilous happiness she has achieved: '... And sure, my Lord, I threw not myself away when I gave myself to you, for I never did any act worthy of Praise before, but tis of the Nature of those that cannot be Happy to desire none else should be so, as I shall be in having you, and will be so, in spite of all Malice, in being, my Lord, your most humbell servant Margaret Lucas. Pray lay the fault of my Writing to my pen.'

Soon after, a more confident love letter begins flirtatiously: 'My Lord, I think you have a plot against my Health in sending so early, for I was forced to read your Letter by a Candle Light, for there was not day enough; but I had rather read your Letter than sleep, and it doth me more good ...'

Other letters discuss the constant shifts of political hopes and intrigues at the exiles' court in Paris; the unreliable attitude of the Queen towards their affair (William diplomatically gives Her Majesty a pair of gloves); Margaret's own lack of 'discretion' (already characteristic); the portrait and 'token of love' which William sends her; and their shared delight in the writing and exchange of love poems, in which they are both absorbed. Here Margaret for once assumes the position of command, criticising William's grasp of metre: 'My Lord, let your Ear limit your poetry.'

Margaret makes many explicit and tender declarations of love, which are clearly reciprocated. Yet sometimes she reveals more complicated feelings, expressing both her innocence and her ambition, simultaneously: 'I have not much Experience of the World, yet I have found it such as I could willingly part with it, but since I knew you, I fear I shall love it too well, because you are in it; and yet methinks you are not in it, because you are not of it; so I am both in and out of it, a strange Enchantment.'

Another unexpected revelation is Margaret's depressive side, her 'very Melancholy humour', which occasionally makes her 'look upon this world as a Death's Head for mortification, for I see all things subject to alteration and changing'. The image of the Death's Head is curiously self-conscious and even painterly. Yet her sense of the uncertainty of life, and the anxiety of exile, is evident throughout these letters; and perhaps this never quite leaves her. At such moments her hopes become, in a striking phrase, 'as if they had taken Opium'. She would be utterly lost in such dark thoughts if she had not met William, who 'restores me to my self again'.

In the last surviving letter of the series, she and William are looking forward to their imminent marriage in Paris. Margaret is cheerful again, and promising to behave: 'Be assured I will bring none to our wedding but those you please.' She also points out that by getting married they will appease the Queen, and make Her Majesty their 'good friend again'. Margaret's final declaration of love is heartfelt, and is delivered with a typical lift of her chin: 'My Lord, I desire nothing so much as the continuance of your Affection, for I think myself richer in having it than if I were a Monarch of all the World.'

It was an ambitious and successful match for Margaret, which soon established her place in a lively and high-spirited circle of thinkers and writers among the exiles. William and his brother Charles formed a philosophical salon whose participants included Marin Mersenne ('the father of acoustics', an expert on mathematics and harmonics); Pierre Gassendi (an astronomer and leading proponent of contemporary 'atomism'); the English philosopher and adventurer Kenelm Digby; and not least the political theorist Thomas Hobbes. Margaret was encouraged to attend and participate on surprisingly equal terms, in a way that would have been impossible back home in conventional English society. Indeed, it seems that even her 'good friend' Queen Henrietta-Maria was shocked by the freedom of manners among this group. It was said that they talked 'as soldiers as well as philosophers', and drank and swore with fine disregard for civilian proprieties – or even the presence of the handsome young Lady Cavendish.

It was at this time, and among this outspoken company, that Margaret began to experiment with dashing male 'cavalier' outfits, steadily adding to her conventional wardrobe a whole range of short, knee-length military-style 'jupes' or jackets, extravagant silk sashes and decorative belts, and a panoply of beribboned and stridently feathered hats. This evidently began as part of the theatrical games which the exiles loved to stage, and for which Margaret playfully learned a whole repertoire of sweeping masculine bows as a mock-

ing substitute for the traditional demure, courtly curtsey. She would later deploy these to scandalous effect in London. Cross-dressing, and theatrical self-presentation, would become a favourite theme in her writing. Surprisingly, the Queen soon seems to have become reconciled to her lady-in-waiting's strange transformations, and approved of her marriage into the headstrong, incorrigible Cavendish clan.

In 1648 the Cavendish group moved to Holland, where a £2,000 gift (then a formidable sum) from the Queen, and Cavendish's cavalier borrowing from friends, allowed them to set up home in the artist Rubens's old house in Antwerp. Here their circle of intellectual friends widened to include René Descartes and the mathematician Constantijn Huygens, whom Margaret got to know well. Throughout the 1650s she was also despatched on several delicate diplomatic trips to London in an attempt to secure William's inheritance from the Cromwellian government. She was only partially successful, but in the meantime William's social position was confirmed, and she thenceforth called herself the Marchioness of Newcastle. She finally returned permanently to England with William at the Restoration in 1660, full of French science, French manners and French dress fashions, all of which she would put to spectacular and frequently mischievous use.

By then she had already published her first book at the age of thirty and under her own name – a provocative step for a woman, even an aristocratic one. The title page ran: *Poems and Fancies, Written by the Right Honourable the Lady Margaret Cavendish Marchioness of Newcastle ... Printed in London at the Bell in Saint Pauls Church Yard, 1653.* The book was not dedicated to her husband, but to 'Sir Charles Cavendish, my Noble Brother-in-Law'. Her Epistle Dedicatory was characteristically teasing, and included a clever image drawn from dressmaking:

True it is, Spinning with the Fingers is more proper to our Sex, than studying or writing Poetry, which is Spinning with the brain. But having no skill in the Art of the first (and if I had, I had no hopes of gaining so much as to make me a Garment to keep me from the cold) made me delight in the latter, since all brains work naturally, and incessantly, in some kind or other, which made me endeavour to *Spin a Garment of Memory*, to lap up my Name, that it might grow to after Ages ...

To this she added a series of challenging Prefaces, addressed respectively 'To All Noble and Worthy Ladies', 'To Naturall Philosophers', and 'To the Reader'. She made no political references to the Cromwellian regime, but concentrated on attacking the currently subservient position of women in England. To the 'Noble Ladies' she remarked: 'I imagine I shall be censured by my own Sex; and Men will cast a smile of Scorne upon my Book, because they think thereby, Women encroach too much upon their Prerogatives, for they hold Books as their Crown, and the Sword and Sceptre by which they rule and govern.' Nevertheless, she begged women to support her, 'otherwise I may chance to be cast into the Fire, but if I burn, I desire to die your martyr'.

The book is divided into five sections, each linked by a different poem with the generic title of 'The Claspe', as if Margaret conceived of the collection as an artfully strung necklace of threaded beads. Her verse, unlike her breathless, florid prose, is plain, measured, heavily rhymed and carefully pointed. There is an early series of poems based on mathematics, and exploring the current theories of Gassendi concerning the atomic structure of the material world ('Motion directs, while Atoms dance'). These include philosophical reflections on what the concept of 'infinity' might mean in terms of space and time, and a vividly imaginative speculation on the possibilities of a microscopic world, entitled 'A World in an Ear-Ring'. Written in her deceptively direct, almost childlike style, it opens

with the idea of a miniaturised solar system (with the sun firmly at the centre):

> An Ear-ring round may well a Zodiac be,
> Where in a Sun goeth round, and we not see.
> And Planets seven about that Sun may move,
> And he stand still, as some Wise Men would prove.
> And fix-ed Stars, like twinkling Diamonds placed
> About this Ear-ring, which a World is vast …

In later sections of her poetic necklace come curious observations of natural phenomena, seen from unexpectedly scientific angles: 'Of Cold Winds', 'Of Stars', 'Of Shadow', 'What makes an Echo', 'Of Vacuum', 'The Motion of Thoughts', 'The Motion of the Blood', 'Of the Beams of the Sun', or 'What is Liquid'. Often these are explored through extended and ingenious similes, or structured around formal 'dialogues' between the elements. There is a further section on animals, birds and insects. Many of these pieces have a disconcerting wit, and are like comic aphorisms, or even provoking 'nonsense' rhymes. Here is the whole of her poem 'Of Fishes':

> Who knows, but Fishes which swim in the sea,
> Can give a Reason, why Salt it be?
> And how it ebbs and flows, perchance they can
> Give Reasons, for which never yet could Man.

She also displays sudden, surreal turns of humour or imagination. She delivers a long, learned poem entitled 'The Windy Giants', on the different natures of the winds from the four points of the compass. This is presented as a serious semi-scientific text, which draws on considerable meteorological knowledge. But then she unexpectedly follows this with a short poem called 'Witches of Lapland', which seems to be pure myth – or pure mischief:

Lapland is the place from whence all *Winds* come,
From Witches, not from Caves, as do think some.
For they the Air do draw into high Hills,
And beat them out again by certain Mills:
Then sack it up, and sell it out for gain
To *Mariners*, which traffick on the Main.

She includes many long poems against animal cruelty, among them
'The Hunting of the Hare' and 'The Hunting of the Stag'. In one of
her Prefaces she describes herself as a typical woman in her feelings,
being 'as fearful as a Hare'. But in another striking poem, 'Similizing
Fancy to a Gnat', she implies that as a poet her imagination is furious
and masculine, burning hot with thoughts that turn 'red':

Some Fancies, like small Gnats, buzz in the Braine,
Which by the hand of Worldly Cares are slaine.
But they do sting so sore the Poet's Head
His Mind is blistered, and the Thought turned red.
Nought can take out the burning heat, and pain,
But Pen and Ink, to write on Paper plain.
But take the Oil of Fame, and 'noint the Mind,
And this will be a perfect Cure, you'll find.

Poems and Fancies ran to three editions, the third being published in
1668. It was to be the first of no fewer than twenty-three volumes,
which included a steady stream of plays, essays, orations, fictions,
biography, autobiography and letters. Not least of the works written
in exile was a provoking mixture of prose tales and poetry, entitled
Nature's Pictures (1656). Here, for example, Margaret coolly raises
the question of what actually happens after death, mixing Christian,
classical and even atheist explanations, without preference or
prejudice:

There was a Man which much desired to know
When he was dead, whither his Soul should go:
Whither to Heaven high, or down to Hell,
Or to the Elesian Fields, where Lovers dwell;
Or whether in the Air to float about,
Or whether it, like to a Light, goes out.

Through the Cavendish connection, Margaret took full advantage of her new social position, meeting many of the leading Fellows of the newly formed Royal Society, like Robert Boyle, Samuel Pepys and John Aubrey. But knowledge of her satirical writing on scientific themes led her to be distrusted, and then openly mocked. Pepys, on his first attempt to meet her 'after dinner, at Whitehall', remarked dryly: 'The whole story of this Lady is a romance, and all she doth is romantic'. He added that her footmen were all dressed in extravagant black and white velvet, and even more irritatingly, she herself spectacularly failed to appear.

On 30 May 1667 she did appear, when she became the first woman to attend one of the Royal Society's formal meetings at Arundel House, now Gresham's College, off High Holborn. On this occasion she witnessed several optical and microscopic experiments (organised by Robert Hooke), and was 'full of admiration' – although, according to Pepys, her dress was 'so antic and her deportment so unordinary' that the Fellows were made strangely uneasy. He first describes the bustle surrounding the event in his characteristic gossipy style:

After dinner I walked to Arundell House, the way very dusty, the day of meeting of the Society being changed from Wednesday to Thursday, which I knew not before, because the Wednesday is a Council-day, and several of the Council are of the Society, and would come but for their attending the King at Council; where I find much company, indeed very much company, in expectation of the Duchesse of Newcastle, who

had desired to be invited to the Society; and was, after much debate, pro and con., it seems many being against it; and we do believe the town will be full of ballads of it.

He then archly records the scene:

Anon comes the Duchesse with her women attending her ... The Duchesse hath been a good, comely woman; but her dress so antick, and her deportment so [un]ordinary, that I do not like her at all, nor did I hear her say any thing that was worth hearing, but that she was full of *admiration, all admiration.* Several fine experiments were shown her of colours, loadstones, microscopes, and of liquors among others, of one that did, while she was there, turn a piece of roasted mutton into pure blood, which was *very rare.*

John Evelyn conceded that the Duchess dressed 'like a Cavalier', but his diary is rather more respectful, or at least more non-committal:

30th May, 1667. To London, to wait on the Duchess of Newcastle (who was a mighty pretender to learning, poetry, and philosophy, and had in both published divers books) at the Royal Society, whither she came in great pomp, and being received by our Lord President at the door of our meeting-room, the mace, etc., carried before him, had several experiments shown to her. I conducted her Grace to her coach, and returned home.

Dorothy Osborne remarked casually of the Duchess that 'there were many soberer People in Bedlam'. But Sir Robert Merivel, Physician to the Royal Dogs, noted kindly that 'My Lady Newcastle was greeted by much *yapping and barking* by the learned Fellows of the Society, but seemed to keep them all *at heel* in a very easy manner.'

Subsequently there were protests at her visit from many of the Fellows, while Pepys himself records the scandal with considerable relish. The dangerous experiment was not to be repeated by the Royal Society for another couple of centuries. Yet Margaret Cavendish was now more widely known (or notorious) than ever, and her many books, treatises and poems, began to be seen as championing the principle of free publication and 'popular' writing. In one of the linking 'Claspe' pieces in *Poems and Fancies*, she wrote:

> Give me the free and noble style
> Which seems uncurb'd, though it be wild:
> Though it runs wild about, it cares not where;
> It shows more Courage, than it doth of Fear.
> Give me a style that Nature frames, not Art:
> For Art doth seem to take the Pedant's part.

Closer examination of her works suggests why the Fellows of the Royal Society were so wary of her. In what is arguably the first-ever science-fiction novel, *The Blazing World*, published a year before her memorable visit in 1666, she had openly satirised the Society. She justified this in an interesting Preface to the Reader, as 'adding a piece of fancy to my serious philosophical observations'. In it she considered an alternative, dystopian future for science, presenting herself as a visiting Empress to a sinister, distorted, experimental world, and the Royal Society Fellows as various kinds of foolish and predatory animals: 'bird-men', 'fox-men' or 'spider-men', all busily and blindly at work on their particular obsessions.

In her role of royal *agent-provocateuse* she criticised the Fellows' confident reliance on new-fangled optical instruments like the telescope and the microscope. She suggested that these might be dangerously distorting, producing wholly false notions of scientific objectivity. She 'grew angry' at their telescopes, which might be 'false-informers' and cut astronomers off from the true wonders of

nature. She commanded them to break the lenses, 'and let the bird-men trust only to their natural eyes, and examine celestial objects by the motions of their own sense and reason'.

She added to this a vividly polemical account of Robert Hooke's grotesque microscopic enlargements contained in his celebrated illustrated book *Micrographia* (1665). These included a horrendously hairy flea and an enormous supine louse, 'so terrible that they put her into a swoon'. Hooke's magnified drawings made the louse appear 'as big as an elephant', and a mite 'as big as a whale'. Such magnifications were a kind of blasphemy against the beauty and proportion of Nature. Moreover, she asked, what were their practical benefits to mankind, especially to the 'poor infected beggars' on whom both louse and mite fed so ravenously and caused such unchecked torment? 'After the Empress had seen the shapes of these monstrous creatures, she desired to know whether their microscopes could hinder their biting ... To which they answered, that such arts were *mechanical* and below the noble study of microscopical observations.' She also attacked William Harvey's cruel anatomical dissections, carried out on hundreds of live animals, and causing an infinite world of useless pain.

In places her criticisms could become strangely poetic, even metaphysical: 'Notwithstanding their great skill, industry and ingenuity in experimental philosophy, they could yet by no means contrive such glasses, by the help of which they could spy out a *vacuum*, with all its dimensions, nor immaterial substances, *non-being, and mixed-being*, or such as are between something and nothing; which they were very much troubled at, hoping that yet, in time, by long study and practice, they might perhaps attain it.'

All of these provoking observations, many of which anticipate the satires of Jonathan Swift against scientific 'speculators' a generation later, seem aimed at what Margaret saw as the inhumane attitudes of the experimenters of the Royal Society, rather than at the actual sciences themselves. Her parodies of the new visionary power of the

telescope and the microscope, which she knew very well were revolutionising scientific observation at this date, were deliberately wilful and perverse. They aimed to shock and mock. Samuel Pepys – soon to become President of the Royal Society himself – easily concluded that the Duchess of Newcastle was 'a mad, conceited, ridiculous woman'. But that was a very short-sighted (and uncharacteristically humourless) dismissal. In retrospect it is clear that *The Blazing World* did raise for the first time some perennial questions about the humane purpose of experiment. Against this, her poems show a genuine fascination with the new emerging forms of scientific knowledge. If her satirical prose work is comparable in some ways to Swift, the quirky and enquiring turns of her poetry might remind us at moments of John Donne.

Elsewhere in her writings she produced a string of heterodox and often challenging remarks about the impact of science. In one of her *Playes* published in 1662, she observed: 'Nature behaves her selfe like a Huntress, and makes Mankind as her Hounds, to hunt out the hidden effects of unknown causes, leading Mankind ... by the string of observation, the string of conception, and the string of experience.'

She emphasised the need to retain a proper sympathy with Nature, in order fully to understand it. She conceived Nature as powerful, female, uninhibited and unconfined; in fact it had 'wild Inconstancy', just like herself. 'All Creatures, and so Matter, desire liberty', she wrote in her *Philosophical Letters* (1664). She always felt close emotional kinship with the natural world, and wrote in a late autobiographical fragment (1675): 'I am tender natured, for it troubles my conscience to kill a fly, and the groans of a dying beast strike my soul.'

This instinctive sympathy with animals, and precise scientific observation of them, appears most memorably in her long poem 'The Hunting of the Hare', from *Poems and Fancies*. In this she describes how a beautiful hare (who she calls tenderly 'poor Wat') lies up between the ridges of a ploughed field in absolute stillness,

'his Nose upon his two fore-feet', at peace with Nature. He quietly surveys his world, with his 'great grey eye' scanning the landscape 'obliquely'. He is intelligent and alert. He always turns himself into the wind so that his fur lies flat and snug against his body – he 'keeps his Coat still down, so warm he lies'. Yet none of this avails him against the predatory violence of mankind. Inevitably he is spotted, pursued and savagely killed. After the useless horror of the hunt ('The hornes keep time, the Hunters shout for joy') and the viciousness of the hounds, Margaret laments the innocent creature's inevitable and 'patient' death:

> Then tumbling downe, did fall with weeping Eyes,
> Gives up his ghost, and thus poor Wat he dies.

Her conclusion is fierce, and has a characteristically surreal touch. She bluntly declares that men are instinctively cruel, and essentially callous: 'Or else for Sport, or Recreations sake', they

> Destroy those Lives that God saw good to make;
> Making their stomaches *Graves*, which full they fill
> With *murdered* Bodies, that in sport they kill.
> Yet Man doth think himself so gentle mild,
> When he of Creatures is most cruel wild.

Her more general sense of mankind laying siege to Nature is explored in her painful 'Dialogue between an Oak and a Man about to cut Him down'. The oak is offered all the delights of being turned into a mighty ship 'to traffick on the Main', or into a stately house 'wherein shall Princes live of great renown'. But the noble tree sturdily rejects them all:

> Yet I am happier, said the Oak, than Man;
> With my condition I contented am.

Thus Margaret Cavendish emerges as a contradictory, but strikingly prophetic, figure at the very heart of the seventeenth-century scientific revolution. Poet, polemicist, feminist, satirist, aristocrat, naturalist, stylist, eccentric and survivor, she stands forever at the doors of the Royal Society demanding readmittance. She also knocks at the gates of scientific history, and of biography itself, doffing her wildly feathered cap, requesting better recognition. With an ironic bow perhaps, rather than a submissive curtsey.

She mocked the empirical worldview of the Fellows, clearly implying that it was damagingly male. She challenged an unfeeling attitude to the beauties of Nature; questioned the practice of vivisection; and wondered what *rational* explanation could be given for women's exclusion from learned institutions and societies. She interrogated, in her own flamboyant way, the Baconian notion of relentless scientific progress, suggesting alternative Stoic doctrines of patience, kindness and sensitivity. She did all this most effectively in her strange but inventive poems, and her outrageous polemical fiction, rather than in her more formal philosophical works such as *Observations on Experimental Philosophy* (1668).

Unconventional to the last, she published a proud and tender memoir of her husband, *The Life of William Cavendish*, relating the story of their exile and return. To this she added an autobiography, unblushingly under her own name, one of the earliest in women's literature: *A True Relation of my Birth, Breeding and Life* (1675). This includes wonderfully indiscriminate accounts of her views of science, taste in food, philosophy of life, preferences in love, attitudes to dress and cross-dressing, and favoured books and animals. Naturally, she analyses her own character at length, and obviously revels in its contradictions: 'I fear my ambition inclines to vain-glory, for I am very ambitious ... though I am naturally bashfull ... also in some cases I am naturally a coward, and in other cases very valiant ... I am not prodigal, but ... I am so vain (if it be vanity) as to endeavour to be worshipped, rather than not be regarded ...'

One of the final images she leaves of her public self involves her clothes, but in an unexpected way: 'And though I desire to appear to the best advantage, whilst I live in the view of the public world, yet I could willingly exclude myself, so as never to see the face of any creature (but my Lord) as long as I live, enclosing myself like an anchorite, wearing a frieze gown, tied with a cord about my waist ... But I hope my readers will not think me vain for writing my Life ...'

For all these things she earned the mocking soubriquet 'Mad Madge', a phrase which still clings to her biography, and will instantly summon her up on Google. Even Virginia Woolf described her dubiously in an essay as 'Quixotic and high-spirited, as well as crack-brained and bird-witted' (1925). Yet Margaret Cavendish clearly established herself as an alternative voice of sceptical wit and humane enquiry, unique among seventeenth-century women, and prophesying many others. There is something magnificent about her irrepressible eccentricity. In her own fashion she survived a social revolution, and bore witness to a scientific one.

She also somehow pulled off the posthumous feat of being buried in Westminster Abbey. The expectation of this must have appeased many memories of the ransacked Lucas family tomb in humble Colchester. Her splendid baroque monument, where she lies in state alongside her husband, occupies a well-chosen corner of the Abbey. Margaret Cavendish, the Duchess of Newcastle, is naturally arrayed in all her silks and lace, with an extravagant hat. But in her hand she holds a simple pen case, a notebook, and a remarkably capacious inkwell.

Zélide

1

In July 1764 a striking young woman was sitting at the window of a remote country château in Holland, carefully writing a secret letter. The château – with fairy-tale turrets, a deep moat, and lines of poplar trees stretching to a distant view of canals and windmills – was her family home: the seventeenth-century Castle Zuylen, hidden away deep in the peaceful farmlands near Utrecht.

The young woman was Isabelle de Tuyll, the eldest daughter of the aristocratic de Tuyl de Serooskerken family, governors of Utrecht. The secret letter she was writing was addressed to her newfound confidant, a glamorous Swiss aristocrat and career soldier, the Chevalier Constant d'Hermenches. Isabelle was twenty-three years old, headstrong and unattached. The Chevalier d'Hermenches was married, almost twice her age, and had the reputation of a libertine. He wore a dashing black silk band around his temples, to hide a war wound. Their clandestine correspondence was being smuggled in and out of Castle Zuylen via a compliant Utrecht bookseller.

If it was an unusual situation, then Isabelle de Tuyll (known by the local landowners as 'Belle de Zuylen') was a thoroughly unusual young woman. While not classically beautiful, she was extremely attractive, and drew glances wherever she went. She had a full, open face, with large green eyes and wild auburn hair brushed impatiently back from a high forehead. She was tall, commanding, full-bosomed,

and restless in all her movements. Not only an accomplished harp-sichordist (who composed her own music), she was also an expert shuttlecock player, quick and determined in her strokes, with an almost masculine speed and self-confidence.

Isabelle de Tuyll was also unusually well-educated. Her liberal-minded father, recognising the exceptional talents of his eldest daughter, had spared no expense. As a girl she was given a clever young governess from Paris, Mlle Prévost, and was soon studying French, Latin, Greek, mathematics, music, algebra and astronomy. Later she was tutored by a mathematics professor from Utrecht University. She took a particular delight in reading Voltaire and calculating conic sections. She once remarked nonchalantly: 'I find an hour or two of mathematics freshens my mind and lightens my heart.'

By the time she was twenty in 1760, Isabelle de Tuyll was being besieged by suitors, proving particularly attractive to rich Dutch merchant bankers and penniless German princelings. But she was too quick and clever for most of them. They bored or irritated her. The first time she ever saw the Chevalier d'Hermenches, at the Duke of Brunswick's ball in The Hague, typically she broke all the rules of etiquette by going straight up to him and asking, 'Sir, why aren't you dancing?' For a moment he was irritated and offended, but was then quickly charmed: 'At our first word, we quarrelled,' he said later, 'at our second, we became friends for life.' It was soon after that their clandestine correspondence began.

Though Isabelle was admired by her younger siblings (and adored by her brother Ditie), her parents thought of her with increasing anxiety. In the salons of Utrecht and The Hague she was getting the reputation of a *belle esprit*, an unconventional free spirit, a rational-ist, a religious sceptic – in short, a young person of 'ungoverned vivacity'. This was all very well for a man, but perilous for a young woman. She might never marry and settle down. Her name 'Belle de Zuylen' was now spoken with a certain *frisson*.

As if to confirm these worries, Isabelle began to write poems, stories and essays. In 1762 she published her first and distinctly rebellious short story, 'Le Noble', in *Le Journal Étranger*. It described a young woman eloping with her lover from a moated Dutch castle, under the disapproving gaze of the ancestral portraits. In fact the ancestral portraits are literally stamped underfoot when they are thrown down to form a pontoon bridge over the moat, across which the young woman dashes to freedom one summer night. This work set tongues wagging in Utrecht.

Next, more daring, she wrote and circulated among her friends her own deliberately provocative self-portrait. It was now that, perhaps inspired by Voltaire, Isabelle de Tuyll invented her own literary *nom-de-plume*: the sinuous, satirical and distinctly sexy 'Zélide'. (Like Voltaire's adaptation of his family name, 'Arouet', 'Zélide' seems to have been based on a sort of loose anagram of her nickname, 'Bel-de-Z'.)

She described Zélide as follows:

You ask me perhaps is Zélide beautiful? ... pretty? ... or just passable? I do not really know; it all depends on whether you love her, or whether she wants to make herself lovable to you. She has a beautiful bosom: she knows it, and makes rather too much of it, at the expense of modesty. But her hands are not a delicate white: she knows that too, and makes a joke of it ...

Zélide is too sensitive to be happy, she has almost given up on happiness ... Knowing the vanity of plans and the uncertainty of the future, she would above all make the passing moment happy ... Do you not perceive the truth? *Zélide is somewhat sensual.* She can be happy in imagination, even when her heart is afflicted ... With a less susceptible body, Zélide would have the soul of a great man; with a less susceptible mind, with less acute powers of reason, she would be nothing but the weakest of women.

This delightful tangle of self-contradictions, these 'feverish hopes and melancholy dreams', these struggles with role and gender, form the heart of Zélide's early correspondence with the Chevalier d'Hermenches. They are not exactly love letters. But they are highly personal, intense, and sometimes astonishingly confessional. They also leave room for a great deal of lively discussion of local Utrecht gossip, scandal, marriage schemes, reading, and what Zélide called her 'metaphysics'. Above all, they discuss the future – what is to become of Zélide?

In her remarkable summer letter of July 1764, Zélide set out two possible and radically different directions for her life. What she is most concerned about – this young woman of the European Enlightenment – is sexual happiness and intellectual fulfilment. The two do not necessarily coincide. She puts two alternatives before the Chevalier d'Hermenches.

First, she could be a sexually 'independent' career woman in some great city. For instance, she could model herself on the celebrated Parisian wit and beauty Ninon de Lenclos (1620–1705), live a self-sufficient urban life (Amsterdam, Geneva, London or Paris are all considered), take lovers as it pleased her, write books, keep a literary salon, and develop a circle of trusted and intimate female friends. Or second, she could be a married woman in the country. In this role, not at all to be despised, she could fulfil the wishes of her parents, make a good aristocratic marriage to 'a man of character', find emotional security in her family, have children, and look after a large country estate in Holland. This too could be immensely fulfilling, provided only that she found a truly loving and intelligent husband, who 'valued her affections', who 'concerned himself with pleasing her', and above all, who 'did not bore her'.

'You may judge of my desires and distastes,' she wrote to the Chevalier d'Hermenches. 'If I had neither a father nor a mother I would be a Ninon, perhaps – but being more fastidious and more

faithful than she, I would not have quite *so many* lovers. Indeed if the first one was truly lovable, I think I might not change at all ...'

This possibility sounds like Zélide setting her cap at the Chevalier, a thing that she would often contrive to do. But perhaps she was not entirely serious? She continued: 'But I *have* a father and mother: I do not want to cause their deaths or poison their lives. So I will *not* be a Ninon; I would like to be the wife of a man of character – a faithful and virtuous wife – but for that, I must love and be loved.'

But then, was Zélide entirely serious about marriage either? 'When I ask myself whether – supposing I didn't much love my husband – whether I would love no other man; whether the idea of duty, of marriage vows, would hold up against passion, opportunity, a hot summer night ... I blush at my response!' Here was a pre-monition of the choice that has increasingly faced so many women ever since: career or marriage, freedom or faithfulness, or some daring combination of the two.

The extraordinary fascination of Zélide's life story lies in how this choice worked out in practice over the next forty years. It was not by any means as she had planned it. She did marry and settle on a country estate, but she never had children, and she was desperately lonely for much of her life. Equally, she did write books, notably the influential and tragic love story *Caliste* (1787), and the proto-feminist novel *Three Women* (1795). And she did have her hot summer nights. But she was intellectually isolated, and ended by pouring much of her emotional life into letter-writing. The great social changes of the French Revolution came too late to save her. After her death in 1805, at the age of sixty-five, her books and her story were soon apparently forgotten.

Despite all her determination to direct her own life, Zélide's destiny was shaped and influenced by four very different men. The first was her older and clandestine correspondent the Chevalier d'Hermenches, a close friend of Voltaire's, the sophisticated familiar of the Swiss and Paris salons, whose powerful influence – both

emotional and literary – lasted until Zélide was past thirty. He was a clever man who understood her very well, but he was also an ambiguous friend, who like Valmont in *Les Liaisons Dangereuses* (1782) was perhaps ultimately planning to set her up as his mistress. Zélide may have colluded in this, enjoying what she called 'the salt' and flattering attention of his witty letters, flirting with him and cooperating in his mad matrimonial schemes (which seemed perilously like propositions of a *ménage-à-trois*). He may eventually have ruined her chances of making a happy and truly fulfilling marriage.

The second figure is one of the many rather preposterous suitors who were drawn like moths to Castle Zuylen. This was none other than the young Scottish law student, traveller on the Grand Tour, and would-be seducer, James Boswell Esquire. Boswell came to Utrecht in 1763, at the age of twenty-five, shortly after he had first met Dr Johnson in London. He was satisfactorily deep in his own emotional crisis, struggling with manic-depressive episodes: the mania provoking brief, unsatisfactory sexual encounters, and the depression producing long, soothing and reliable assignations with drink.

But amidst all this he was also discovering his true *métier* as biographer and autobiographer, and keeping his first secret *Journals*. Thus the encounter with Zélide struck literary sparks, and ignited one of her best and most scintillating correspondences, with Boswell playing the unlikely role of moral tutor. He undoubtedly brought a great deal of fun, charm and frivolity into her life. He even proposed marriage to her (also by letter) in 1768. She turned him down by return of post; rather exquisitely, on strictly literary grounds, since they disagreed on the way to translate a paragraph of his bestselling book about Corsica.

The third was the man she actually married in 1771 – to everyone's surprise and against everyone's advice, and to the Chevalier's acute irritation. Zélide had reached the critical age of thirty. Her suitor was her younger brother's tutor: the retiring, stammering,

genial, thoughtful, but largely silent and singularly unexpressive Charles de Charrière. He took Zélide away to live on his small country estate of Le Pontet, at Colombier on the Swiss border, surrounded by a walled garden and placid vineyards, and with a distant hazy prospect of Lake Geneva.

Here the youthful figure of Zélide largely disappears from view. Her childless marriage was accounted, perhaps wrongly, as a disaster. But the person who re-emerges some fifteen years later is Zélide transformed into the formidable, if disillusioned, Madame Isabelle de Charrière: moralist, social commentator, unquenchable letter-writer, and author of two lengthy epistolary novels, both published in 1784. *Letters Written from Neufchâtel* is a topical exploration of questions of birth, privilege and social injustice; while *Letters from Mistress Henley published by her Friend* is a slow, subtle, psychological study of loneliness in marriage.

It is at just this point that the fourth, most unexpected and most unaccountable of all the men in her life appears. He was the young, volatile, red-haired French intellectual Benjamin Constant. Madame de Charrière met him on a rare visit to Paris, either in 1785 or 1786. Now the positions were almost exactly reversed from the Zuylen days with the Chevalier d'Hermenches. Benjamin Constant was twenty, while Zélide was married, worldly-wise and forty-six. Zélide's influence over her protégé was to last for almost a decade, and to produce the last and most remarkable correspondence of her life. When she was finally supplanted in Constant's affections, it was by the turbulent figure of Madame de Staël. In many ways this finally brought an end to all Zélide's hopes and plans, and reduced her in the eyes of the world to a kind of tragic, but dignified, silence.

Yet even after her death in 1805, her influence continued to work powerfully, helping to shape both de Staël's famous novel of passionate awakenings, *Corinne* (1807), and Constant's autobiographical masterpiece *Adolphe* (1816). It was difficult to say whether Zélide (or

Madame de Charrière) had in the end failed or succeeded in her life's plan. Or perhaps it was simply too soon to draw an informed conclusion.

2

That question, like Zélide herself, was largely forgotten for more than a hundred years. Almost everything except her love story *Caliste* fell out of fashion and out of print. Despite the presence of both Boswell and Constant in her story, neither French nor English biographers of the nineteenth century were much interested in the lives of women of this period, unless they were saints or strumpets, or somebody's sister, or Joan of Arc or Queen Victoria. Sainte-Beuve alone considered her worthy of a short essay, commending Zélide for writing fine aristocratic French prose 'in the manner of Versailles', but mocking her infatuation with Constant.

But in 1919 Zélide found an unlikely champion. A young English architectural historian, Geoffrey Scott, was visiting Ouchy on Lake Geneva, and one rainy autumn afternoon he discovered copies of Zélide's books in the Lausanne University library. He was so struck by the paradoxes of her story, and certain resonances it had with his own complicated emotional life, that he began an intensive period of research, reading all her novels, visiting Zélide's estate at nearby Colombier, and digging out her unpublished letters. Scott later wrote: 'Today a sentimental journey to her home at Le Colombier, which thrilled me. There is a little secret staircase concealed in cupboards connecting her room with the one Benjamin used to have, which *would* be amusing ... [Madame de Staël's Château de] Coppet I also loved. Altogether I've fallen under the charm of these shores.'

Early in his research Scott unearthed a rare two-volume study of Zélide's work, *Madame de Charrière et ses Amis*, published in a

limited edition in Geneva in 1906. This remarkable book was a labour of love, which had been minutely compiled over a lifetime by a local Swiss historian of Neufchâtel, Philippe Godet. Godet might be described as the last of Zélide's protégés. He wrote tenderly in his Preface: 'Twenty years ago I fell in love with Madame de Charrière and her work ... for twenty years writing her biography has been my ruling passion ... and for those twenty years I have been gently mocked by my friends for the childish minuteness and unbelievable slowness of my researches.'

These two vast, shapeless, erudite, pedantic and loving tomes proved an added incitement to Scott's natural, and distinctly dandyish, sense of aesthetic form. He immediately set out to write exactly the opposite kind of biographical study of Zélide: a brief, elegant, highly stylised and distinctly sardonic 'portrait', partly inspired by the recent success of Lytton Strachey's *Eminent Victorians* (1918), which had risked one controversial account of a woman – that of Florence Nightingale. 'Perfect as workmanship,' enthused Scott, 'a book in ten thousand.'

Geoffrey Scott was greatly intrigued by Zélide's intense and unusual relationships, first with the Chevalier d'Hermenches and then with Constant. It turned out that they were uncle and nephew, and they offer to the biographer a tempting – though coincidental – symmetrical shape to Zélide's life, providing portraits to be 'hung on either side' of hers. In fact Scott (following Sainte-Beuve) deliberately gave most weight to the affair with Constant, so that the period of seven years when it flourished (1787–1794) actually occupies over half of his book. Yet this produces a psychological drama of such interest, told with such an engaging mixture of tenderness and malice, that the reader is barely aware of the skilful foreshortening involved. Scott explores the emotional significance of the age gap, the curious sexual currents behind their voluminous literary correspondence, their obsession with 'frankness and sincerity', and the profound intellectual impact of each upon the other.

He has a shrewd and witty awareness, so essential to the biographer, of the haunting difference between the written document and the lived life:

> It may confidently be asserted that the habit of letter-writing has estranged far more lovers than it has united ... To dip the quill in ink is a magical gesture: it sets free in each of us a new and sometimes a forbidding sprite, the epistolary self. The personality disengaged by the pen is something apart and often ironically diverse from that other personality of act and speech. Thus in the correspondence of lovers there will be four elements at play – four egoisms to be placated instead of two. And by this grim mathematical law the permutations of possible offence will be calculably multiplied.

Yet the biography never becomes laboured or abstract. Scott always envisaged Zélide's life in sharp, architectural outline, and executed this with wonderful graphic effects. He also viewed it sceptically. He presented the brief interlude with Boswell as high comedy, and the long marriage to Charles de Charrière as a relentless matrimonial satire, while the final irruption of Germaine de Staël in her daemonic coach on the road to Lausanne, at the opening of Chapter 13, is described with something approaching Gothic melodrama. De Staël's 'black and burning gaze' glares out fatally through the carriage window into Zélide's story.

Above all, Scott saw Zélide's determination to choose her own life, her own destiny, in the face of eighteenth-century social conventions, as both the crux of the biography and the source of its 'unadmitted but evident tragedy'. For Scott this was a terrible if heroic error, with the result that Zélide 'failed, immensely and poignantly' in her search for happiness.

This, at any rate, is the challenging note on which the biography opens. It is a proposition taken from Benjamin Constant, the young

intellectual enchanter, and the male figure in the story with whom Scott most closely identified. Constant later wrote of Zélide in *Adolphe*: 'Like so many others this woman had begun her career by sailing forth to conquer society, rejoicing in the possession of moral toughness and a powerful mind. But she did not understand the ways of the world and, again like so many others, through failing to adapt herself to an artificial but necessary code of behaviour, she had lived to see her progress disappointed and her youth pass joylessly away until, finally, old age overtook her without subduing her.' This was exactly what Scott, as Zélide's first modern English champion and biographer, apparently concluded of his heroine too.

Yet Geoffrey Scott's personal identification with his material was far greater than at first appears. It is partly this that makes the biography so subtly engaging and self-contradictory. Far from producing a coolly objective study of Zélide, the deliberately polished 'studio portrait' that he claimed, Scott was writing something perilously close to autobiography. This too makes the biography peculiarly modern in its shifting layers of symbolism and self-reflection.

For the previous decade (and through most of the First World War) Scott had been working as the personal assistant of the celebrated art historian Bernard Berenson, comfortably housed in his vast Florentine villa, I Tatti. Here Scott cultivated an intense platonic relationship with Berenson's wife, Mary, twenty years his senior, and upon whom he had become emotionally dependent.

Scott – handsome, clever and dilettantish (he had won the Newdigate Prize for poetry at Oxford) – could be devastatingly charming. But he was also disorganised, spoilt, selfish and decidedly rakish. In an effort to break away from Mary he embarked on a number of affairs, both platonic and otherwise: one with Berenson's young assistant Nicky Mariano, another with the elderly Edith Wharton in Paris. Then in 1918 he suddenly and unexpectedly married Mary Berenson's great friend, the aristocratic and neurasthenic Lady Sybil Cutting, who also had a grand house in Florence, the Villa Medici.

The marriage almost immediately ran into difficulties. Ironically, it was only held together (according to Lady Sybil's daughter, the writer Iris Origo) by their mutual interest in Zélide, discovered that autumn of 1919 on the shores of Lake Geneva, where Scott had taken Lady Sybil on a rest cure. Origo later wrote in her memoir *Images and Shadows*: 'Thus by a curious irony, a woman [Zélide] whose own emotional life had been singularly unhappy, brought for a few months, harmony to another woman's marriage. In the absorption of bringing Zélide and Boswell, d'Hermenches and Constant, to life again, Geoffrey and his wife suspended the relentless analysis of their own feelings; they laughed and worked together. Perhaps, too, there was in all this a certain process of self-identification.'

After the initial excitement of discovery, Scott's work on the biography, which he had intended to finish in a year, slowed down. Like Philippe Godet, he underwent the classic 'transfer experience' of the modern biographer, starting as the detached scholar but gradually being drawn hypnotically into all the domestic details and dramas of Zélide's world. As a result the historical story became increasingly an unsettling reflection of his own life and emotional entanglements.

In 1922 Scott wrote to Nicky Mariano: 'The thing that makes me stick in the mud with the book, is that [Zélide's] relations with Benjamin Constant, after his marriage, have an uncanny likeness to Mary [Berenson]'s feelings and actions four years ago. I understand it almost too well to write about it in the detached and light manner which the tone of the book requires ... The idea of Mary's reading the manuscript and drawing the inevitable parallels at each point embarrasses me a good deal in writing it.'

When not working on Zélide, Scott drifted away from Lady Sybil and his marriage. He spent the summer of 1923 in England, and embarked on a refreshing new affair, this time with Harold Nicolson's wife, the aristocratic novelist Vita Sackville-West. Vita was another powerful literary woman with a country estate, the beautiful manor

house of Long Barn in Kent (near her ancestral home of Knole). As an established writer she too encouraged Scott with his work on Zélide. He could confide in her without ceremony, and revealed his increasingly intense involvement with Zélide's story.

'I'm going to busy myself this week with Madame de Charrière,' he wrote to Vita in October 1923. 'I've dragged her by the scruff of the neck round two or three difficult corners. I've done the meeting with Benjamin and the first fantastic part of their friendship: it's good that part, I hope, and goes with a swing. I give it mostly through Monsieur de Charrière's eyes, bewildered and misunderstanding, watching rather breathlessly the spectacle of Zélide coming back to life. I've got Mme de Staël in the wings just ready to pop in … with her private theatricals, negroid beauty, her tramping insensibility and impeccable bad taste.'

He emphasised the daring speed he had set himself in the narrative: 'I've struck a very quick tempo, and can't afford now to slow it: the book will be quite shockingly short.' But above all he stressed his personal excitement with the work, and the way he was now inspired by Vita: 'It's fun, though, doing it. I do it for you.'

So the tangled web of Geoffrey Scott's relationships (not in fact unduly tangled by the standards of post-war Bloomsbury) generated an extensive correspondence about the biography, and curiously mimicked different aspects of Zélide's own story. Mary Berenson, Edith Wharton, Lady Sybil and Vita Sackville-West were each separately told by Scott that the biography was secretly and lovingly dedicated to them alone, and contained their own 'portrait' lovingly disguised as Zélide's.

Similarly, it was to be understood that Scott himself was sometimes the mercurial Constant, sometimes the worldly Chevalier d'Hermenches, and sometimes (though rarely) the long-suffering and inadequate M. de Charrière. On the other hand, he was *never* James Boswell. Mostly he identified with Benjamin Constant, writing to Mary Berenson that drawing Constant's portrait gave him the

most trouble: 'he is so many sided, so inexhaustible, it is difficult to bring him out fully within the compass of my small scale'.

3

Far from softening or sentimentalising the texture of the biography, this secret shimmer of subjectivity gives it an almost unnatural sharpness and stylistic brightness. From the opening Scott makes brilliant metaphoric use of the pastel portrait of Zélide by Maurice-Quentin de La Tour, and the contrasting monotonies of Dutch landscape – and society – stretching behind her. The whole book has a strong visual sense, and Scott continually presents Zélide's moods in terms of beautifully conjured landscapes or interiors. It is in effect a series of Dutch still lives.

Yet just as he planned, he moves the narrative forward at a dazzling pace, compressing and summarising the story, foreshortening perspective, and playing off the immobility of Zélide's life at Zuylen and Colombier against the frantic gyrations of Boswell or Constant. The arrival and departure of flying carriages in clouds of dust form a choric motif. This reaches its apotheosis in the fatal appearance of the carriage of Madame de Staël, which intercepts Constant in 1794: 'A hazy light quivers over the stretched lake of Geneva, on and on, monotonously. A carriage has halted by the wayside near Nyon, in the dust of a September afternoon. Through the window a lady, dressed in black, has looked out. Her black and burning gaze inspects the lanky figure of a young man striding on the Lausanne road ...'

Scott's whole attitude to Zélide is complex, shifting, and unexpectedly contradictory. From the outset he has pronounced her life a tragedy, yet he cannot prevent himself treating it gallantly, humorously, and even at times romantically. In fact, one suspects that he is always in two minds about Zélide, and that part of him

is always in love with her. The most beautiful and memorable images in the book are always dedicated to her: 'So Zélide lay, lost to the world, like a bright pebble on the floor of the Lake of Neufchâtel.'

Yet he ignores or distorts several elements in her story. He underplays the significance of her published writing (apart from its autobiographical aspect), and fails to see the importance of the later work for the feminist canon, notably the brilliantly plotted moral fable *Three Women* (1795). It is difficult to recall that Zélide was also the author of twelve short novels, twenty-six plays, several opera libretti, and much harpsichord music as well. Nor does he connect her extensive output with younger English writers addressing similar themes, like Mary Wollstonecraft, Amelia Opie or Fanny Burney. But this, perhaps, is a failure of historical rather than biographical perspective.

It is more problematic that Scott does not appear to sympathise – or should one say empathise? – with what Zélide called the difficulties of having a woman's 'susceptible body'. He does not seem to allow sufficiently for the devastating effect of her inability to have children with M. de Charrière, or relate this to her clandestine affair with a handsome but anonymous young man in Geneva sometime in 1784–85 (his identity still unknown to this day). Zélide was then in her mid-forties, feeling life slipping away, and was perhaps making her one last serious attempt to act like Ninon de Lenclos. As Benjamin Constant subsequently pointed out, this episode was perhaps Zélide's only real adulterous entanglement, and produced her masterpiece, *Caliste* (1787).

Above all, perhaps, Geoffrey Scott undervalues the happiness that her last circle of young women friends and protégées brought her after 1790, when she was fifty. They included the flirtatious and incorrigibly pregnant maid Henriette Monarchon, the handsome and talented Henriette l'Hardy (who became her literary executor), the dazzlingly beautiful Isabelle de Gélieu, the clever, sophisticated

Caroline de Sandoz-Rollin, and the 'wild, gorgeous, defiant' sixteen-year-old Suzette du Pasquier.

These produced Zélide's own kind of *salon des dames* at Colombier, and exchanges of letters, poems and confidences quite as full as her masculine ones. Such a circle was, after all, part of Zélide's original plan to consecrate her life to friendship as well as love. And who is to say that some of these young women, with their new independent ways, did not bring Zélide love as well as friendship?

For all these limitations of sympathy and perspective, Geoffrey Scott's biography remains a subtle triumph, and a considerable landmark. It changed forever the way English biographers wrote (or failed to write) about women. It recognised that women's lives had different shapes from men's, different emotional patterns of achievement and failure. It stressed the value of a psychological portrait over a mere chronology, but never descended to (then fashionable) Freudian reductionism. It suggested that from a woman's perspective, the very idea of 'destiny' was different. Zélide was both subject to men's careers within the existing frame of eighteenth-century conventions, and yet always, stubbornly and subversively, independent of them.

The Portrait of Zélide was a deserved success when finally published in 1925. It was widely praised by the reviewers, the *Times Literary Supplement* remarking that it was 'a biography as acute, brilliant and witty as any that has appeared in recent years'. Edmund Gosse in the *Sunday Times* added Scott to the group of 'three or four young writers' (including Strachey) who had put to flight the 'wallowing monsters' of Victorian biography, through 'delicacy of irony, moderation of range, refinement and reserve'. The book won the James Tate Black Memorial Prize, and ran to three editions in the next five years. Scott himself had the odd experience of appearing in the *Vogue* Hall of Fame for 1925.

Not surprisingly, there were different reactions from within his

own literary circle. Mary Berenson and Edith Wharton loyally praised the book, Wharton greeting it as 'an exquisite piece of work'. But Vita Sackville-West, perhaps inspired by her new passion for Virginia Woolf, felt it was too flippant, too flashy, and not sympathetic enough to Zélide as a woman writer. Francis Birrell, the voice of Bloomsbury, writing in *The Nation*, gently reproached it as 'very readable ... fashionable, cosmopolitan, and a trifle over-painted'. Years later Harold Nicolson, Vita's husband, described it with masterful ambiguity as a 'delicate biography'.

Nonetheless, it remains a memorable prologue to the full opening up of women's biography in the twentieth century. It is an early attempt to recover the importance of the woman writer's role in the culture of Europe, and particularly in the long and rich tradition of Dutch humanism. The early writings of Zélide represent a vivid response to Voltaire and his *contes philosophiques*. The emotional confrontation between Zélide (or rather Madame de Charrière) and Madame de Staël, and the consequent battle for Benjamin Constant's soul, is brilliantly deployed by Scott to sum up the intellectual confrontation between Enlightenment and Romantic values. Raymond Mortimer saw this as one of the book's most original features, the picture of 'a conflict between two centuries, two states of mind, almost one might say, two civilizations'. He also added shrewdly: '[Scott] is a little in love with Madame de Charrière, and so are you, before the book is done.'

Many of these judgements have proved remarkably perceptive. It is now becoming clear that Scott's work forms part of the 1920s' revolution in British biography, championing a briefer, more stylish and more inventive form. His *Portrait of Zélide* needs to be set beside Strachey's *Queen Victoria* (1921), André Maurois's *Ariel, ou la Vie de Shelley* (1925) and Harold Nicolson's *Some People* (1927). Scott himself put his claim modestly, but very well, in a note appended to the end of the book. He first gives full acknowledgement to the faith-

ful, plodding, heroic scholarship of Philippe Godet, and then adds: 'All I have here done is to catch an image of her in a single light, and to make from a single angle the best drawing I can of Zélide, as I believe her to have been. I have sought to give her the reality of fiction; but my material is fact.'

Madame de Staël

1

She was the only daughter of a Swiss banker, and one of the richest and cleverest young women of her generation in Europe. She wrote, among much else, one celebrated novel – *Corinne, or Italy* (1807) – which invented a new heroine for her times, outsold even the works of Walter Scott, and has never been out of print since. She personally saved at least a dozen people from the French Revolutionary guillotine. She reinvented Parisian millinery with her astonishing multi-coloured turbans. She dramatically dismissed Jane Austen as '*vulgaire*'. She snubbed Napoleon at a reception. She inspired Byron's famous chauvinist couplet, 'Man's love is of man's life a thing apart/'Tis woman's whole existence.' And she once completely out-talked Coleridge at a *soirée* in Mayfair. For these things alone she should be remembered.

Though married to the handsome Swedish ambassador (or possibly *because* she was so married) she took numerous lovers, and had four children, the most brilliant of whom – a girl, Albertine – was certainly illegitimate. She had a running and highly personal vendetta with Bonaparte, who hated bluestockings and once leaned over and remarked leeringly on her plunging cleavage: 'No doubt, Madame, you breast-fed your children.' He followed this up by censoring her books for being anti-French, actually pulping one of them in mid-printing (*On Germany*), and exiling her from France on at least three separate occasions between 1803 and 1812.

Yet her lifelong opposition to the Napoleonic tyranny remained undaunted, and conceived in the largest terms. Towards the end of her last exile, in November 1812, she wrote from Russia to Thomas Jefferson in New York, begging for American intervention with a plea that echoes to this day: 'You will tell me that America has nothing to do with the European continent, but has it nothing to do with the human race? Can you be indifferent to the cause of free nations, you, the most republican of all?'

Despite these alarums and excursions, for twenty years she turned her beautiful château at Coppet, on the banks of Lake Léman, into an intellectual powerhouse and an asylum for displaced writers and thinkers, the equivalent of Voltaire's Ferney. Then she died at the early age of fifty-one, having just married her second husband, an astonishingly handsome Hussar officer, young enough to be her son, whose love she described poignantly as 'nothing but a little Scottish melody in my life'.

2

Anne Louise Germaine de Staël-Holstein (*née* Necker) was altogether quite a girl. She was also quite a difficult one. Now known to history succinctly as Madame de Staël (1766–1817) – a name pronounced 'style', and a life containing a superabundance of that glamorous quality – she presents a formidable problem to any biographer trying to get, and keep, her life in any sort of order or perspective.

Her lovers found the same thing: 'I have never known a woman who was more continuously exacting ... Everybody's entire existence, every hour, every minute, for years on end, must be at her disposition, or else there is an explosion like all thunderstorms and earthquakes put together.' That from novelist, diarist and political writer Benjamin Constant (the father of de Staël's daughter

Albertine), who managed – unlike any other man in her life – to live with her for over a decade.

The term *mouvementée* seems perfectly designed for Madame de Staël. She led her whole existence, at least after her ultra-fashionable nervous breakdown in Paris aged twelve (she said she was in love with her father), in a turbulent, restless, hyperactive fashion that was exhausting simply to witness. When she visited England at the age of twenty-six – the first of her many exiles – she stayed at Juniper Hall deep in rural Surrey, and completely wore out her kindly provincial hosts by her ceaseless article-writing, endless coffee-drinking, and unstoppable high-volume late-night talk. A stunned young English country doctor noted:

This Staël is a genius, an extraordinary eccentric woman in everything she says or does. She sleeps only a few hours, and for the rest of the time she is uninterruptedly and fearfully busy … While her hair is being done, while she breakfasts, in fact for a third of the day, she just writes … and has not sufficient time even to look over what she has written …

He was too polite to mention her inconvenient and inexplicable timetable of surreptitious lovers arriving unannounced from the Continent. Nor her peculiar Parisian version of salon fox-hunting: the pursuit of her great friend and rival, the highly respectable novelist Fanny Burney, who was trying to live peacefully nearby.

Though this was the period of the French Revolution and the Napoleonic Wars, de Staël managed to visit (and write about) most of the states of Europe – France, England, Italy, Germany, Poland and Russia. She only just missed a much-planned visit to the fledgling United States, where she had wisely invested much of her inherited millions. Her arrival in Moscow, incidentally, anticipated – by a satisfactory few days – Napoleon's arrival with his *Grande Armée* in 1812. Hers was considerably more of a social success.

Her network of friendships embraced (often the *mot juste*) an amazing roll-call of political and literary celebrities, among whom were Talleyrand, Gibbon, Fanny Burney, Marie Antoinette, Constant, Goethe, Schiller, Byron, A. W. Schlegel, Sismondi, Châteaubriand, Juliette Récamier, and even (on her deathbed) the Duke of Wellington. But this was far more than the traditional salon network of the *ancien régime*. It was also a new kind of intellectual network, and Madame de Staël launched a tradition of French female *intellos* that eventually stretched to Simone de Beauvoir and beyond. Much of it depended on her astonishingly fluent letters, scrawled at immense speed and formidable length, *allegro con amore*. Eleven volumes of her *Correspondence Générale 1788–1809* have been published (Paris, 1962–93). Alas! she also exhausted her faithful modern editor Béatrice Jasinski, who died with at least eight years of letters to go.

There are many ways to attempt to make sense of de Staël's colourful, courageous, and frequently outrageous story. It clearly has many possible dimensions: literary, political, feminist, erotic, sartorial – and even spiritual. One of her most moving works, dated 1811 and now little read, is her *Reflections on Suicide*, which opens with this heart-stopping sentence, like a sigh: '*C'est pour les malheureux qu'il faut écrire ...*' It was perhaps her answer to the British feminist Mary Wollstonecraft, who twice tried to kill herself.

Indeed, de Staël's own life, for all its social and moneyed privilege, all its Romantic razzamatazz, has deep tragic elements of frustration and brooding loss. Much of this is prophesied in her novel *Delphine* (1802), whose heroine does indeed commit suicide. Far too long to appeal to modern readers, it nevertheless contains many haunting self-contained fragments, such as the five-page tale subtitled 'The Reasons why Leontine de Ternan decided to become a Nun'. This opens: 'I was once a very beautiful woman, and I am now fifty years old. These two absolutely ordinary facts have been the cause of everything I have ever felt in my life.'

3

One could do worse than begin with her most extrovert and flamboyant style signature – her famous turban. Madame de Staël adopted it as her brand mark, instantly recognisable in a crowd or in a picture. Created out of vividly coloured silks, often topped with declamatory ostrich or peacock feathers, it created both sensation and ridicule wherever she went. When she visited Germany, for example, the young poet Heinrich Heine gazed at her in amazement:

> She had an enormous turban on her head, and now wanted to present herself as the Sultana of Thought ... She asked our intellectuals, 'How old are you? What have you written? Are you a Kantian or a Fichtean?' and suchlike things, hardly waiting for an answer.

As Mary Wollstonecraft herself once said during her own Scandinavian travels: she shocked them because she asked 'men's questions'.

The turban features significantly in Madame de Staël's masterpiece, *Corinne*. It appears in a picture she finds at the Palazzo Borghese in Rome: the beautiful, passionate southern *Cumaean Sibyl* painted by Domenichino (circa 1620), with whom she immediately identifies. The Sibyl – intense, voluptuous, swathed in silks and manuscripts – of course wears a truly magnificent turban. De Staël suggests she is the incarnation of her alter ego. Domenichino's picture is shrewdly placed on the cover of the present Oxford World's Classics edition of *Corinne*.

The turban may also be playful, seductive and teasing. De Staël's beloved father, the banker Jacques Necker, invented a thrilling and consciously naughty childhood game with his daughter, which

'Minette' (his pet name for her) never forgot. It involved chasing each other round and round the dining table at Coppet, with shrieks of excitement 'like red Indians'. For this they always wore heavy starched napkins twisted around their heads – like turbans. It was a noisy, provoking game between father and daughter that Madame Necker (like Napoleon) was always trying to ban.

De Staël often and openly said that she had always been in love with her father, and if he had been younger, would have married him. Her most intimate and perhaps most revealing book is the brief, passionate study published at the end of her life (now long out of print), *On the Character of Monsieur Necker and his Private Life*. 'Sometimes it was a cruel situation to be in,' she wrote, 'loving so much a man older than yourself ... breaking your soul against this barrier ...'

<div align="center">4</div>

At the height of her fame, in 1814, the French memoir writer Madame de Chastenay summed up de Staël's life in a single epigram. There were, she wrote, three great powers struggling against Napoleon for the soul of Europe: 'England, Russia, and Madame de Staël'. A generation later Sainte-Beuve also praised her as 'a great Athenian orator' on behalf of freedom, but chose to emphasise the inward-looking poetic intensity of her circle at Coppet. In a mischievous phrase, he described her as self-entranced by *'la raquette magique du discours'*. *La raquette* was actually a form of shuttlecock and battledore, but the phrase might be best rendered as 'the magic ping-pong of their endless talk'.

These two interpretations – the historical and the psychological – were cunningly reconciled some hundred years later by the Czech-American scholar J. Christopher Herold, who steered carefully between them to produce his fine study *Mistress to an Age: A Life of*

Madame de Staël. It rightly won the National Book Award in 1958, and now reads like a classic, immensely scholarly in its detailing but quite unstuffy in manner, with a wonderful touch of flamboyance. Herold found the trick of somehow elevating de Staël in the very act of dethroning her: 'Thus Germaine ruled over Coppet, like Venus over the damned souls in the Venusberg, like Calypso over ship-wrecked travellers, like Circe over her menagerie.'

After that, increasing biographical interest has focused on the exact nature of de Staël's stormy fifteen-year affair with Benjamin Constant. It began dramatically enough in that 'chance encounter' on the road to Coppet, so fatal to Madame de Charrière's happiness. De Staël was already married and a published author of twenty-eight, with political connections and a roster of lovers. Constant was the gifted but disillusioned son of a Swiss army officer, still in thrall to the formidable but much older Dutch writer. Thus Madame de Charrière was in many ways doomed to be de Staël's avatar, rather than her rival.

The historian Sismondi declared: 'You have not known Madame de Staël at all if you have not seen her with Benjamin Constant.' Yet the correspondence between them is mainly lost or destroyed, and it is therefore impossible to recover the tenor of their conversational *raquette* (or indeed their sexual game-play). There remains of course Constant's obsessive diary-writing (the famous *Cahier Rouge*), and de Staël's alarming but lifelong habit of recounting her last lover's failings to her next prospective one. The combination produces a general air of *opéra comique*, and a curious lack of intimacy. By contrast, de Staël later idealised the affair in her novel *Delphine*, in which she described it as a 'union of souls, in perfect amity and companionship'.

Some modern biographers (like Renée Weingarten, 2011) believe de Staël was suffering from bipolar disorder, 'which made her virtually impossible to live with at Coppet'. In the circumstances, the long-suffering loyalty of the thin, pale, stooping, nail-biting,

red-headed Constant has a kind of neurotic male heroism about it. Few among de Staël's other 'menagerie' of faithless and unsuitable lovers endured beyond six months. Nevertheless, the salon at Coppet became a beacon among European intellectuals, first as a centre of resistance against Napoleonic tyranny, and later as a symbol of female independence and political liberalism. Its reputation eventually attracted admirers as diverse as George Eliot and Harriet Beecher Stowe. But it was de Staël's novel *Corinne* (1807) that first made Coppet famous.

5

Benjamin Constant shrewdly described *Corinne, or Italy* as simultaneously a new kind of novel about the female heart, and a new kind of travel guide to the Mediterranean. The book also creates a new kind of heroine for the age. In the figure of the self-dramatising, flamboyant poet and *improvisatore* Corinne, de Staël invented a fictional character who became an international symbol of Romanticism, quite as much as Goethe's Werther or Byron's Corsair. Beautiful, imperious, highly strung, she is simultaneously the independent woman artist, the lovelorn female victim of romance, and the hot-blooded irrepressible seductress of the warm South. It has also been suggested that the steamy affair between Corinne and the handsome, melancholy Scot Oswald Lord Nelvil (a name truly redolent of damp tweed) has a specific historical inspiration, being partly based on the notorious romance between Emma Hamilton and Lord Nelson in Naples.

Corinne's histrionic instincts are developed in a lavish series of set-pieces. She gives a devastating public performance of her poetry in Rome; she visits the erupting Vesuvius at night, where the paws of red-hot lava stealthily advance 'like royal tigers'; and she wanders dreamily through the voluptuous backstreets of Naples. On visiting

Verona, she goes to 'Juliet's balcony' (preserved for tourists to this day), where she analyses Shakespeare's *Romeo and Juliet* in brilliant dialectical terms that anticipate – or perhaps borrow from – Schlegel's literary criticism. (Schlegel accompanied de Staël through Italy, having written her a letter of total, slavish, hot-making devotion.) Finally she herself acts out a melodramatic performance as Juliet in front of the enraptured Lord Nelvil. In a memorable dénouement, this reduces him to a swooning wreck of emotions – his 'moans answered her cries' – and he has to be helped from the theatre.

The novel's timely appeal is marked by the large number of young women who began consciously to model themselves on Corinne after 1807, and refer to her in their letters and diaries. Among contemporaries these included Byron's Italian mistress Teresa Guiccioli; the restless Scottish wife of the scientist Humphry Davy, Jane Apreece; and rather surprisingly the patriotic British poet Felicia Hemans, author of 'Casabianca' ('The boy stood on the burning deck …'). Hemans rapturously exclaimed: 'Some passages seem to give me back my own thoughts and feelings, my whole inner being, with a mirror more true than ever friend could hold up'. She even wrote a heady poem inspired by the Roman scenes in the novel, 'Corinne at the Capitol'. Later, in America, according to Ralph Waldo Emerson, the journalist and women's rights advocate Margaret Fuller became known as 'the Yankee Corinne', and led a trail of female disciples in her wake.

6

If de Staël made her literary name with Corinne's fictional visit to Italy, she secured her intellectual reputation with a strictly non-fiction visit to Germany. The resulting book, plainly entitled *On Germany* (1811), was deliberately and significantly written *in propria persona*. It is difficult to think of any other woman of her time who

would have risked such an undertaking and such self-exposure. Mary Wollstonecraft's *Letters Written from Scandinavia* (1796), delightful as it is, hardly bears comparison for scope and ambition. In fact the nearest comparable work, though much more sociological in intent, is probably Alexis de Tocqueville's *Democracy in America* (1835–40).

De Staël's greatest intellectual achievement was first banned in France through Napoleon's good offices, and then triumphantly published, like Byron's poetry, by John Murray in London. He paid her 1,500 guineas for the privilege, an enormous sum at the time. The book circulated throughout Europe, quickly reaching America. Extending to three hefty volumes, it contains besides much else a disquisition on the darkness of German forests; a memorable portrait of Goethe; a historic distinction between Romantic and classical poetry; an intelligible account of Kant's philosophy (which compares very favourably to Coleridge's in the *Biographia Literaria*); a powerful series of reflections on 'The Romantic Disposition in Affairs of the Heart'; and finally – 'a summary of my whole book' – a passionate plea for 'enthusiasm' in all human relations. De Staël distinguished this quality carefully from 'fanaticism': 'The sense of this word, from the Greeks, was the noblest one: enthusiasm signifies *God in us*. In effect, when the existence of man is expansive, it contains something of the *divine*.'

Much of her material was gathered by what was, in effect, an early form of journalistic interviewing, a relatively novel technique partly pioneered by James Boswell when he visited Rousseau in 1764. The American traveller George Ticknor gave a memorably funny picture of de Staël working over the philosopher Fichte, and sorting out his entire metaphysical system in less than 'fifteen minutes or so'. This piece of intellectual ping-pong ends with de Staël delivering a convincing smash: '*Ah! c'est assez, je comprends parfaitement, Monsieur Fichté*. Your system is perfectly illustrated by a story in Baron Munchausen's travels.'

But de Staël was also an excellent, atmospheric travel writer, who could seize the 'spirit of place' from a single moment. Here is one brief but brilliantly evocative passage:

I had stopped at an inn, in a small town, where I heard the piano being played beautifully in a room which was full of steam from woollen clothes drying on an iron stove. That seems to be true of everything here: there is poetry in their soul but no elegance of form.

7

One way of assessing Madame de Staël is by placing her alongside Lord Byron. They first met in London in 1813, and then again at Coppet in 1816. Byron's first impressions were of de Staël's absurd combination of the formidable, the hysterical and the voluble: 'She writes octavos, and *talks* folios.' Her appearance (by now somewhat stout and rouged) was 'frightful as a precipice'. But to his publisher Murray he wrote: 'I have read all of her books and like all of them – and delight in the last [*On Germany*].' He added: 'I do not love Madame de Staël but depend upon it – she beats all your natives hollow as an *Authoress* – in my opinion – and I would not say this if I could help it.'

By the time he was invited to Coppet in July–August 1816, Byron had gone through the mill himself: married, separated, and driven by scandal into exile. Accordingly he found de Staël more engaging and far more sympathetic – she 'ventured to protect me when all London was crying out against me'. De Staël had suffered similarly from the publication of Constant's revelatory novel *Adolphe* (1816), which treacherously projected her as a dark, stormy dominatrix. By the time Byron left Coppet, de Staël had become 'the best creature in the world'. Later he placed her in the highest literary company, in a

clumsy yet oddly touching 'Sonnet to Lake Leman', written a year before de Staël's death. In it he proclaims that four great names would be forever associated with Geneva's lake and shoreline. He nostalgically recalls his own boating over the lake's 'crystal sea' (with Shelley), the 'wild glow' of past events, and the sense that de Staël at least will be one of the 'heirs of immortality'.

> Rousseau – Voltaire – our Gibbon – and de Staël –
> Leman! These names are worthy of thy shore,
> Thy shore of names like these! wert thou no more,
> Their memory thy remembrance would recall ...
>
> How much more, Lake of Beauty! do we feel,
> In sweetly gliding o'er thy crystal sea,
> The wild glow of that not ungentle zeal,
> Which of the heirs of immortality
> Is proud, and makes the breath of glory real!

8

But did her 'breath of glory' really endure? Why isn't Madame de Staël better remembered today? Immediately after her death, Byron again called her 'the first female writer of this, or perhaps any age'. *Blackwood's Edinburgh Magazine* published an obituary in December 1818 that stated:

> The sciences have always owed their origin to some great spirit. [Adam] Smith created political economy; Linnaeus, botany; Lavoisier, chemistry; and Madame de Staël has, in like manner, created the art of analysing the spirit of nations and the springs which move them.

The great French nineteenth-century *Biographie Universelle* called her '*le Voltaire féminin*'. Given the comparative obscurity of de Staël's current reputation (despite even the turbans), these surprising judgements merit further explanation.

It is clear that de Staël's immediate personal impact on those around her was formidable and lasting, if not necessarily favourable, and she was long remembered as a female life-force by her immediate contemporaries. Both *Corinne* and *On Germany* were regarded as historic landmarks. Yet there were no immediate biographies, no collection of letters, no vivid or scandalous memoirs. Perhaps this was simply because she was a woman; but perhaps also because her whole story became modulated and eventually absorbed by that of Benjamin Constant.

Her longer-term literary influence, its waxing and waning, remains mysterious. What about, for example, the influence of *Corinne* on Mary Shelley's novels, or on Elizabeth Barrett Browning's *Aurora Leigh*, or on British woman travel writers, or (for that matter) on American country-and-western singers? A classic version of the early blues song 'Corinne, Corinna' was recorded by Robert Johnson in 1937, and later by Bob Dylan, Joni Mitchell, Willie Nelson and Eric Clapton, among many others. Equally, no one raises the uneasy question of why *On Germany* has long fallen out of fashion.

For all that, a new crop of lively biographical studies (Weingarten, Francine du Plessix Gray, Angelica Gooden) might suggest that Madame de Staël's time is gradually coming around again. What they do magnificently confirm is that she was a truly extraordinary woman who courageously created a new role in society, one even larger than that of her irrepressible heroine Corinne. This role was that of the independent, freelance, female intellectual in Europe.

Around her crowd the shades of a noble company: Zélide, Madame du Châtelet, Mary Wollstonecraft, Madame Lavoisier, Sophie Germain, Fanny Burney, Maria Edgeworth, Mary Shelley, Charlotte Brontë, George Eliot, George Sand, Simone de Beauvoir

(who also adopted the turban). Her biography is slowly becoming part of a broader, more generous social history.

Even so, it is sad to think we may never quite greet Madame de Staël with the intense 'enthusiasm' she always championed, and once aroused. 'Immense crowds gathered to see her ... The first ladies of the kingdom stood on their chairs to catch a glimpse of that dark and brilliant physiognomy.' Or dance with her around the dinner table, wearing napkins on our heads.

9

Mary Wollstonecraft

1

It is often said that William Godwin's *Memoirs of the Author of a Vindication of the Rights of Woman* of 1798 destroyed Mary Wollstonecraft's reputation for over a hundred years. If that is true, it must count as one of the most dramatic, as well as the most damaging, works of biography ever published.

At the time of her death in London on 10 September 1797, Mary Wollstonecraft was certainly well-known and widely admired as an educational writer and champion of women's rights. She was renowned not only in Britain, but also in France, Germany and Scandinavia (where her books had been translated), and in newly independent America. Although only thirty-eight years old, she was already one of the literary celebrities of her generation.

The *Gentleman's Magazine*, a solid, large-circulation journal of record with a conservative political outlook, printed the following obituary in October 1797, with an admiring – if guarded – summary of her career and an unreservedly favourable estimate of her character:

In childbed, Mrs Godwin, wife of Mr. William Godwin of Somers-town; a woman of uncommon talents and considerable knowledge, and well-known throughout Europe by her literary works, under her original name of Wollstonecraft, and

171

particularly by her *Vindication of the Rights of Woman*, 1792, octavo.

Her first publication was *Thoughts on the Education of Daughters*, 1787 ... her second, *The Rights of Man*, 1791, against Mr. Burke on the French Revolution, of the rise and progress of which she gave an *Historical and Moral View*, in 1794 ... her third, *Elements of Morality for the Use of Children*, translated from the German, 1791 ... her fourth, *A Vindication of the Rights of Woman*, 1792 ... her fifth, *Letters Written during a Short Residence in Sweden, Norway and Denmark*, 1796.

Her manners were gentle, easy and elegant; her conversation intelligent and amusing, without the least trait of literary pride; or the apparent consciousness of powers above the level of her sex; and for soundness of understanding, and sensibility of heart, she was perhaps, never equalled. Her practical skill in education was even superior to her speculations upon that subject; nor is it possible to express the misfortune sustained, in that respect, by her children. This tribute we readily pay to her character, however adverse we may be to the system she supported in politicks and morals, both by her writing and practice.

Many other favourable articles appeared, such as her friend Mary Hays's combative obituary in the *Monthly Magazine*, which lauded her 'ardent, ingenuous and unconquerable spirits', and lamented that she was 'a victim to the vices and prejudices of mankind'. The *Monthly Mirror* praised her as a 'champion of her sex', and promised an imminent biography, though this did not appear. Friends in London, Liverpool, Paris, Hamburg, Christiania and New York expressed their shock at her sudden departure, one of the earliest premature Romantic deaths of her generation. It seemed doubly ironic that the champion of women's rights should have died in childbirth.

William Godwin, her husband, was devastated. They had been lovers for little over a year, and married for only six months. At forty-one he also was a literary celebrity, but of a different kind from Mary. A shy, modest and intensely intellectual man, he was known paradoxically as a firebrand philosopher, the dangerous radical author of *An Enquiry Concerning Political Justice* (1793) and the political thriller-novel *Caleb Williams* (1794). His views were even more revolutionary than hers. He proposed republican, atheist and anarchist ideas, attacking many established institutions, such as private property, the Church, the monarchy and (ironically) marriage itself – 'that most odious of monopolies'. Indeed he was notorious for his defence of 'free love', and their marriage in March 1797 had been the cause of much mirth in the press. Yet Godwin believed passionately in the rational power of truth, and the value of absolute frankness and sincerity in human dealings.

He was in a state of profound shock. He wrote bleakly to his oldest friend and confidant, the playwright Thomas Holcroft, on 10 September 1797, the very evening of her death: 'My wife is now dead. She died this morning at eight o'clock ... I firmly believe that there does not exist her equal in the world. I know from experience we were formed to make each other happy. I have not the least expectation that I can now ever know happiness again. When you come to town, look at me, talk to me, but do not – if you can help it – exhort me, or console me.'

Another of Godwin's friends, Elizabeth Fenwick, wrote two days later to Mary's younger sister, Everina Wollstonecraft, in Dublin: 'I was with [Mary] at the time of her delivery, and with very little intermission until the moment of her death. Every skilful effort that medical knowledge of the highest class could make, was exerted to save her. It is not possible to describe the unremitting and devoted attentions of her husband ... No woman was ever more happy in marriage than Mrs. Godwin. Whoever endured more anguish than Mr. Godwin endures? Her description of him, in the very last

moments of her recollection was, "He is the kindest, best man in the world."' Mrs Fenwick added thoughtfully, and perhaps tactfully: 'I know of no consolation for myself, but in remembering how happy she had lately been, and how much she was admired, and almost idolized, by some of the most eminent and best of human beings.'

To take advantage of this surge of interest and sympathy across the literary world, Wollstonecraft's lifelong friend and publisher, Joseph Johnson, proposed to Godwin an immediate edition of her most recent writings. This was to include her long, but unfinished, novel *Maria, or The Wrongs of Woman*, which had a strong autobiographical subtext. It was a shrewd idea to provide a fictional follow-up to Mary's most famous work of five years previously, *The Rights of Woman*. The two titles cleverly called attention to each other: 'The Rights' reinforced by 'The Wrongs'.

Though unfinished, *The Wrongs of Woman: A Fragment in Two Volumes* contained a celebration of true Romantic friendships, and a blistering attack on conventional marriage. The narrator Maria's husband has had her committed to a lunatic asylum, having first brought her to court on a (false) charge of adultery. The judge's summary of Maria's case, which comes where the manuscript breaks off, ironically encapsulates many of the male prejudices that Mary Wollstonecraft had fought against all her life:

The judge, in summing up the evidence, alluded to the fallacy of letting women plead their feelings, as an excuse for the violation of the marriage-vow. For his part, he had always determined to oppose all innovation, and the new-fangled notions that encroached on the good old rules of conduct. We did not want French principles in public or private life – and, if women were allowed to plead their feelings, as an excuse or palliation of infidelity, it was opening a flood-gate for immorality. What virtuous woman thought of her feelings? – it was her duty to love and obey the man chosen by her parents and relations ...

Johnson also suggested that Godwin should include some biographical materials. The idea for a short memorial essay by Mary's husband was mooted, as was the convention in such circumstances; and possibly a small selection from her letters.

Battling against his grief, Godwin determined to do justice to his wife by editing her *Posthumous Works*. Immediately after the funeral on 15 September he moved into Mary's own study at number 29 Polygon Square, surrounded himself with all her books and papers, and hung her portrait by John Opie above his desk for inspiration. He hired a housekeeper, Louisa Jones, to look after the two children who were now his responsibility: the little motherless baby Mary (the future Mary Shelley) and four-year-old Fanny, who was Wollstonecraft's earlier love child by an American, Gilbert Imlay.

Both as a father and as an author, Godwin regarded himself as fulfilling a sacred trust, and wrote: 'It has always appeared to me, that to give the public some account of a person of eminent merit deceased, is a duty incumbent on survivors ... The justice which is thus done to the illustrious dead, converts into the fairest source of animation and encouragement to those who would follow them in the same career.'

2

Godwin immersed himself in papers and memories for the next three months, and writing at speed, soon found that the short essay was expanding into a full Life. He turned all his cool, scholarly methods on the supremely emotional task in hand. He reread all Mary's printed works, sorted her unpublished manuscripts, and established a precise chronology of her life from birth. He dated and meticulously numbered the 160 letters they had exchanged. He interviewed her friends in London, like Johnson, and wrote to others

abroad, like Hugh Skeys in Ireland. He sent diplomatic messages to her estranged sister Everina in Dublin, requesting family letters and reminiscences. He assembled his own journal notes of their intimate conversations, and lovingly reconstructed others, such as the long September day spent walking round the garden where she had grown up near Barking, in Essex. Here Mary had suddenly begun reminiscing about her childhood.

Godwin recalled the moment tenderly, but with characteristic exactitude:

> In September 1796, I accompanied my wife in a visit to this spot. No person reviewed with greater sensibility, the scenes of her childhood. We found the house uninhabited, and the garden in a wild and ruinous state. She renewed her acquaintance with the market-place, the streets, and the wharf, the latter of which we found crowded with activity.

Godwin determined to tell each phase of Mary's short but turbulent life with astonishing openness. This was a decision that stemmed directly from the philosophy of rational enquiry and sincerity enshrined in *Political Justice*. He would use a plain narrative style and a frank psychological appraisal of her character and temperament. He would avoid no episode, however controversial.

He would write about the cruelty of her father (still living); the strange passionate friendship with Fanny Blood; the overbearing demands of her siblings; her endless struggles for financial independence; her writer's blocks and difficulties with authorship; her enigmatic relationship with the painter Henry Fuseli; her painful affair with the American Gilbert Imlay in Paris; her illegitimate child, Fanny; her two suicide attempts; and finally their own love affair in London, and Mary's agonising death. This would be a revolutionary kind of intimate biography: it would tell the truth about the human condition, and particularly the truth about women's lives.

As the biography expanded, Godwin's contacts and advisers began to grow increasingly uneasy. Everina Wollstonecraft wrote anxiously from Dublin, expressing reservations. She had been delighted at her clever elder sister's literary success, and been helped financially by it. But it now emerged that she had quarrelled with Mary after her Paris adventures, and disapproved of the marriage to Godwin. She had not been properly consulted by him, and feared personal disclosures and publicity. In a letter of 24 November 1797, she abruptly refused to lend Godwin any of the family correspondence, and informed him that a detailed biographical notice would be premature. She implied that it would damage her (and her younger sister Elizabeth's) future prospects as governesses:

When Eliza and I first learnt your intention of publishing immediately my sister Mary's Life, we concluded that you only meant a sketch ... We thought your application to us rather premature, and had no intention of satisfying your demands till we found that [Hugh] Skeys had proffered our assistance without our knowledge ... At a future date we would willingly have given whatever information was necessary; and even now we would not have shrunk from the task, however anxious we may be to avoid reviving the recollections it would raise, or loath to fall into the pain of thoughts it must lead to, did we suppose it possible to accomplish the work you have undertaken in the time you specify.

Everina concluded that a detailed Life was highly undesirable, and that it was impossible for Godwin to be 'even tolerably accurate' without her help. On reflection, Godwin decided to ignore these family objections. He judged them to be inspired partly by sibling jealousy, partly by the sisters' desire to control the biography for themselves, but mostly by unreasonable fear of the simple truth.

Other sources proved equally recalcitrant. Gilbert Imlay had disappeared with an actress to Paris, and could not be consulted. He had not seen Mary for over a year, though he had agreed to set up a trust in favour of his little daughter, Fanny. When this was not forthcoming, Godwin officially adopted her. Godwin felt that it was impossible to understand Mary's situation without telling the whole story, and now took the radical decision to publish all her correspondence with Imlay, consisting of seventy-seven love letters written between spring 1793 and winter 1795. He convinced Johnson that these *Letters to Imlay* should occupy an additional two volumes of the *Posthumous Works*, bringing them to four in total. His *Memoirs* would now be published separately, but would also quote from this correspondence, openly naming Imlay.

The *Letters* gave only Mary's side of the correspondence, which Imlay had returned at her request. They thus left his own attitude and behaviour to be inferred. But they dramatically revealed the whole painful sequence of the affair from Mary's point of view, from her initial infatuation with Imlay in Paris to her suicidal attempts when he abandoned her in London. This was another daring, not to say reckless, publishing decision which sacrificed traditional areas of privacy to biographical truth. Godwin's own feelings as a husband were also being coolly set aside. In his Preface he described the *Letters* as 'the finest examples of the language of sentiment and passion ever presented to the world', comparable to Goethe's epistolary novel of Romantic love and suicide, *The Sorrows of Young Werther* (1774). They were produced by 'a glowing imagination and a heart penetrated with the passion it essays to describe'.

Henry Fuseli briefly and non-committally discussed Mary with Godwin, but having given him a tantalising glimpse of a whole drawer full of her letters, refused to let him see a single one. If he knew of Godwin's intentions with regard to Mary's letters to Imlay, this is hardly surprising. But it left the exact nature of their relationship still enigmatic. Years later the Fuseli letters were seen by

Godwin's own biographer, Kegan Paul, who claimed that they showed intellectual admiration, but not sexual passion. Yet when these letters were eventually sold to the Shelley family (for £50), Sir Percy Shelley carefully destroyed them, unpublished, towards the end of the nineteenth century.

Joseph Johnson was torn between a natural desire to accede to Godwin's wishes as the grieving widower, and his own long-standing professional role of defending Mary's literary reputation. He may also have entertained the very understandable hope of achieving a publishing *coup*. He at least warned Godwin of several undiplomatic references to living persons in the biography, especially the aristocratic Kingsborough children to whom Mary had been a governess in Ireland, and the powerful and well-disposed Wedgwood family. He also questioned the wisdom of describing Mary's many male friendships in London, Dublin and Paris so unguardedly. He felt the ambiguous account of Fuseli was particularly ill-judged, and challenged Godwin's characterisation of the painter's 'cynical' attitude towards Mary.

But Godwin would not give way on any of these issues. On 11 January 1798, shortly before publication, he wrote unrepentantly to Johnson, refusing to make any last-minute changes: 'With respect to Mr Fuseli, I am sincerely sorry not to have pleased you … As to his cynical cast, his impatience of contradiction, and his propensity to satire, I have carefully observed them …' He added that, in his view, Mary had actually 'copied' these traits while under Fuseli's influence in 1792, and this was a significant part of her emotional development. He was committed to describing this 'in the sincerity of my judgement', even though it might sometimes be unfavourable to her.

This idea that Mary Wollstonecraft's intellectual power grew out of a combination of emotional strengths and weaknesses was central to Godwin's notion of modern biography: 'Her errors were connected and interwoven with the qualities most characteristic of her genius.' He was not writing a pious family memorial, or a work of feminist

hagiography, or a disembodied ideological tract. He felt he could sometimes be critical of Mary's behaviour, while always remaining passionately committed to her genius. Godwin stuck unswervingly to his belief in the exemplary value of full exposure. The truth about a human being would bring understanding, and then sympathy: 'I cannot easily prevail on myself to doubt, that the more fully we are presented with the picture and story of such persons as the subject of the following narrative, the more generally shall we feel ourselves attached to their fate, and a sympathy in their excellencies.'

3

Godwin could not have been more mistaken. Most readers were appalled by the *Memoirs* when they were first published at the end of January 1798. There was no precedent for a biography of this kind, and Godwin's 'naïve' candour and plain speaking about his own wife filled them with horrid fascination.

Mary's old friend, the radical lawyer and publisher from Liverpool William Roscoe, privately jotted these sad verses in the margin of his copy:

Hard was thy fate in all the scenes of life
As daughter, sister, mother, friend and wife;
But harder still, thy fate in death we own
Thus mourn'd by Godwin with a heart of stone.

The *Historical Magazine* called the *Memoirs* 'the most hurtful book' of 1798. Robert Southey accused Godwin of 'a want of all feeling in stripping his dead wife naked'. The *European Magazine* described the work as 'the history of a philosophical wanton', and was sure it would be read 'with detestation by everyone attached to the interests of religion and morality; and with indignation by any one who might

feel any regard for the unhappy woman, whose frailties should have been buried in oblivion.'

The *Monthly Magazine*, a largely conservative journal, saw Mary as a female Icarus figure, who had burnt out her talents with pride and ambition: 'She was a woman of high genius; and, as she felt the whole strength of her powers, she thought herself lifted, in a degree, above the ordinary travels of civil communities ...'

The most even-handed verdict was that of Johnson's own *Analytical Review*, which observed that the biography, though remarkable, lacked intellectual depth. It contained 'no correct history of the formation of Mrs. G's mind. We are neither informed of her favourite books, her hours of study, nor her attainments in languages and philosophy.' Even more pointedly, it noted that anyone who also read the *Letters* would 'stand astonished at the fervour, strength and duration of her affection for Imlay'.

These initial criticisms, some written more in sorrow than in anger, and not necessarily bad publicity (at least for Johnson), were soon followed by more formidable attacks. The *Monthly Review*, previously a supporter of Wollstonecraft's work, wrote in May 1798 with extreme disapproval of Godwin's revelations: 'Blushes would suffuse the cheeks of most husbands if they were *forced* to relate those anecdotes of their wives which Mr Godwin voluntarily proclaims to the world. The extreme eccentricity of Mr Godwin's sentiments will account for this conduct. Virtue and vice are weighed by him in a balance of his own. He neither looks to marriage with respect, nor to suicide with horror.'

The *Anti-Jacobin Review* delivered a general onslaught on the immorality of everything that Wollstonecraft was supposed to stand for: outrageous sexual behaviour, inappropriate education for young women, disrespect for parental authority, non-payment of creditors, suicidal emotionalism, repulsive rationalism, consorting with the enemy in time of war, and disbelief in God. It implied that the case was even worse than Godwin made out, and that Mary was generally

promiscuous – 'the biographer does not mention her many amours'. Finally it provided a helpful index entry to the more offensive subject-matter of the *Memoirs*:

Godwin edits the Posthumous Works of his wife – inculcates the promiscuous intercourse of the sexes – reprobates marriage – considers Mary Godwin a model for female imitation – certifies his wife's constitution to have been amorous – Memoirs of her – account of his wife's adventures as a kept mistress – celebrates her happiness while the concubine of Imlay – informs the public that she was concubine to himself before she was his wife – her passions inflamed by celibacy – falls in love with a married man [Fuseli] – on the breaking out of the war betakes herself to our enemies – intimate with the French leaders under Robespierre – with Thomas Paine …

James Gillray, quick to sense a public mood, produced one of his most savage cartoons in the *Anti-Jacobin* for August 1798. Mockingly entitled 'The New Morality', it showed a giant Cornucopia of Ignorance vomiting a stream of books into the gutter: they include Paine's *Rights of Man*, Wollstonecraft's *Wrongs of Women*, and Godwin's *Memoirs*. Godwin looks on in the guise of a jackass, standing on his hind legs and braying from a copy of *Political Justice*.

The Gothic novelist Horace Walpole described Wollstonecraft as 'a Hyena in petticoats'. The polemicist and antiquarian Richard Polwhele leapt into print with a lengthy poem against her, entitled 'The Unsexed Females' (1798):

See Wollstonecraft, whom no decorum checks,
Arise, the intrepid champion of her sex;
O'er humbled man assert the sovereign claim,
And slight the timid blush of virgin fame …

The Reverend Polwhele goes on piously to enumerate her love affairs, her illegitimate child, her suicide attempts, and her lack of religion. Furthermore, he accuses Wollstonecraft of leading astray a whole generation of 'bluestockings' and female intellectuals. They are 'unsex'd' (presumably like Lady Macbeth), in the sense of having abandoned their traditional role as wives and mothers. They are a 'melting tribe' of vengeful, voracious and intellectually perverted women authors who have been seduced by Wollstonecraft's principles.

Polwhele cites them by name, in what is intended as a litany of shame and subversion: among them Mary Hays, Mrs Barbauld, Mary Robinson, Charlotte Smith and Helen Maria Williams. This was also, perhaps more sinisterly, intended as a kind of blacklist of politically suspect authors, whose books no respectable woman should purchase. Many of these were of course friends of Godwin's, and they do indeed represent an entire generation of 'English Jacobin' writers, for whom the American and French Revolutions had been an inspiration, and against whom the tide of history was now ineluctably turning. For many of them the paths of their professional careers would henceforth curve downwards towards poverty, exile, obscurity and premature death.

It was now open season on Godwin. Yet paradoxically the *Memoirs* were selling briskly, for a second edition was called for by the summer of 1798. There were also printings in France and America. After anxious discussion with Joseph Johnson, Godwin made a series of alterations in the text, most notably rewriting (or rather, expanding) passages connected with Henry Fuseli, Mary's suicide attempt in the Thames, and the summary of her character with which the biography concludes.

He also suppressed the references to the Wedgwood family, and rephrased sentences that had been gleefully taken by reviewers as sexually ambiguous. But the overall character of the *Memoirs* was unchanged, and it remained an intense provocation. Other events

also served fortuitously to keep up the sense of a continuing outrage against public morals. One of Mary's ex-pupils from the Kingsborough family was involved in an elopement (and murder) scandal, while Johnson himself was imprisoned for six months for publishing a seditious libel, though one quite unconnected with the *Memoirs*. The sentence broke the elderly Johnson's health, and effectively ended his career as the greatest radical publisher of the day.

The *Anti-Jacobin* and other conservative magazines felt free to keep up their attacks for months, and indeed years, descending to increasing scurrility and causing Godwin endless private anguish. Three years later, in August 1801, the subject was still topical enough for the young Tory George Canning to publish a long set of jeering satirical verses, entitled 'The Vision of Liberty'. It was not even necessary for Canning to give Godwin and Wollstonecraft's surnames. One stanza will suffice:

> William hath penn'd a wagon-load of stuff
> And Mary's Life at last he needs must write,
> Thinking her whoredoms were not known enough
> Till fairly printed off in black and white.
> With wond'rous glee and pride, this simple wight
> Her brothel feats of wantonness sets down;
> Being her spouse, he tells, with huge delight
> How oft she cuckolded the silly clown,
> And lent, o lovely piece! herself to half the town.

Wollstonecraft's name was now too controversial, or even ridiculous, to mention in serious publications. Her erstwhile supporter Mary Hays omitted her from the five-volume *Dictionary of Female Biography* that she compiled in 1803. The same astonishing omission occurs in Mathilda Bentham's *Dictionary of Celebrated Women* of 1804. Satirical attacks on Godwin and Wollstonecraft continued

Zélide

Margaret Cavendish

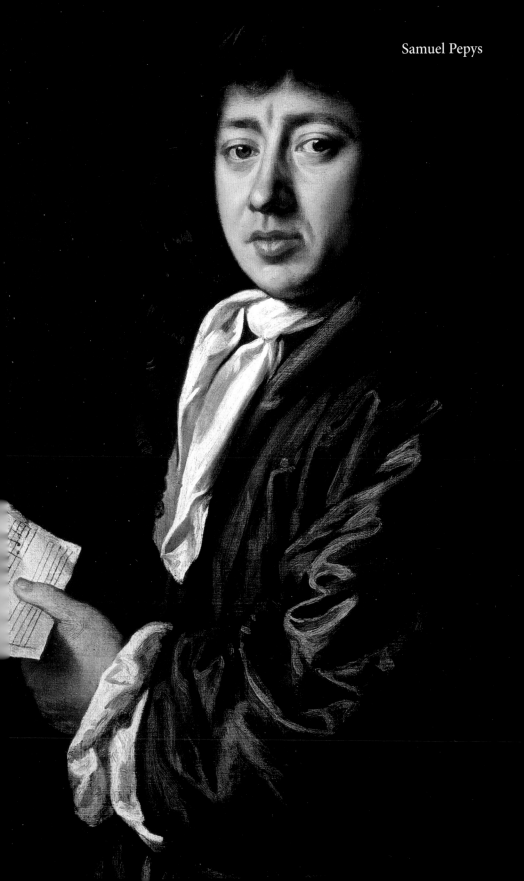
Samuel Pepys

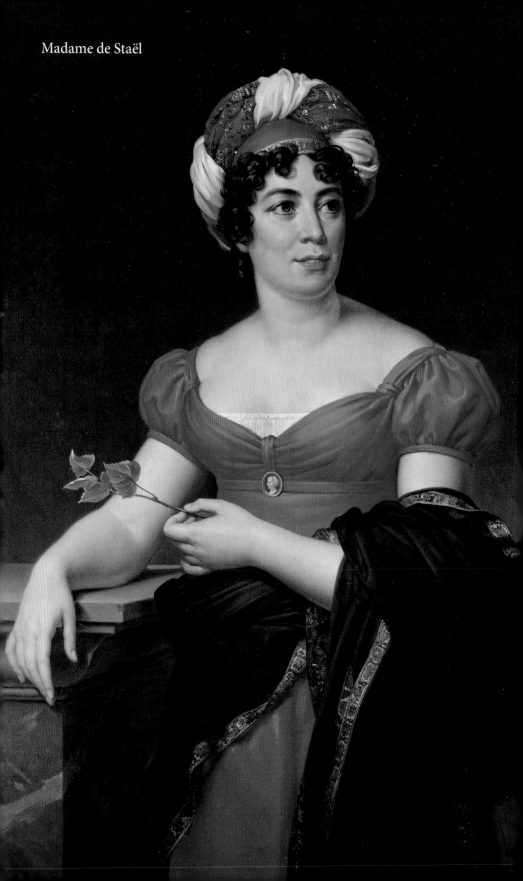

Madame de Staël

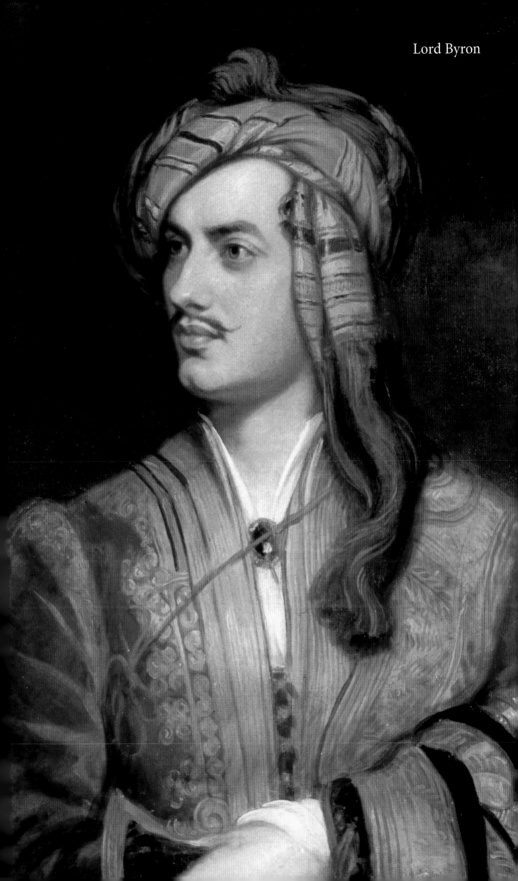
Lord Byron

William Godwin

Mary Wollstonecraft

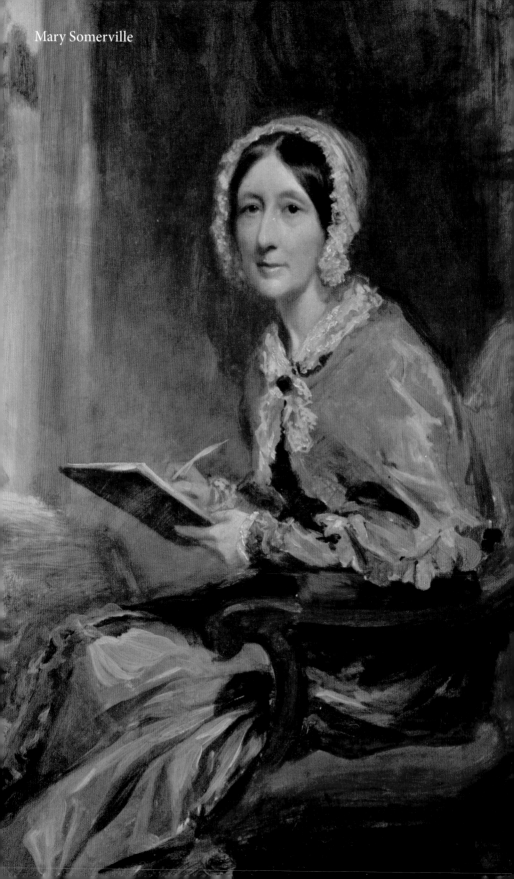

Mary Somerville

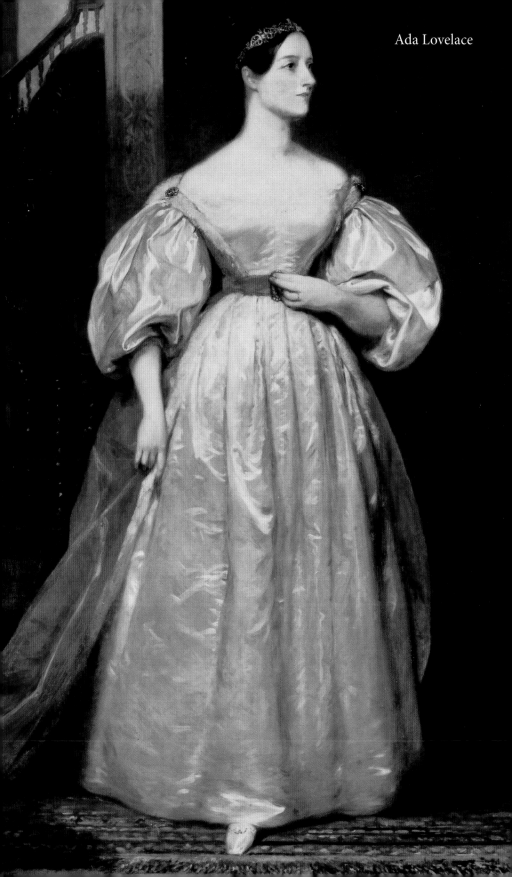

Ada Lovelace

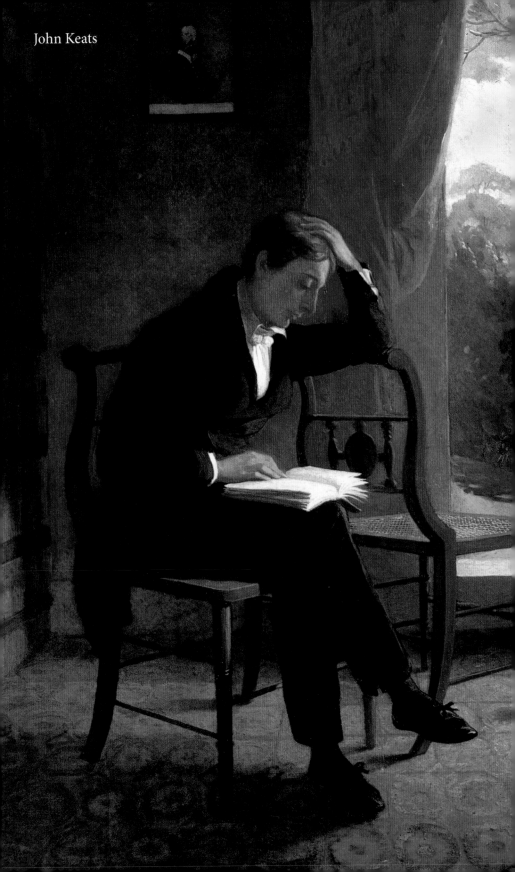

John Keats

Thomas Lawrence

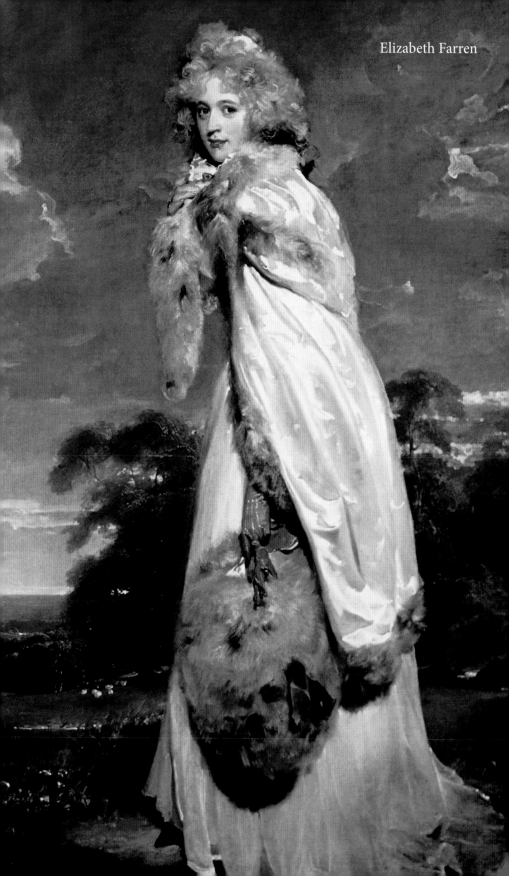

Elizabeth Farren

William Blake

throughout the next decade, though many were now in the form of fiction.

Maria Edgeworth wrote a satirical version of the Wollstonecraft type in the person of the headstrong Harriet Freke, who appears in her novel *Belinda* (1801): she promulgates casual adultery, smart intellectual repartee and female duelling. The beautiful and once-flirtatious Amelia Alderson, now safely married to the painter John Opie (who had executed the tender portrait of Wollstonecraft that hung in Godwin's study), reverted to the most traditional values of secure and happy domesticity. Using Wollstonecraft's story, she produced a fictional account of a disastrous saga of infidelity and unmarried love in *Adeline Mowbray* (1804). Much later Fanny Burney explored the emotional contradictions of Wollstonecraft's life in the long debates on matrimony and love which are played out like elegant tennis rallies (more *raquette*) between the sensible Juliet and the passionate Elinor in *The Wanderer; or Female Difficulties* (1814).

Alexander Chalmers summed up the case against Wollstonecraft in his entry for *The General Biographical Dictionary*, which appeared in 1814, at the very end of the Napoleonic Wars. This was a time when patriotic feeling was at its height, and distrust of subversive or vaguely French ideologies at its most extreme. Mary Wollstonecraft was accordingly dismissed as 'a voluptuary and a sensualist'. Her views on women's rights and education were stigmatised as irrele-vant fantasies: 'She unfolded many a wild theory on the duties and character of her sex'. Her whole life, as described by Godwin, was a disgusting tale, and best forgotten: 'She rioted in sentiments alike repugnant to religion, sense and decency'. It is perhaps no coinci-dence that less than two years later Jane Austen's *Emma* (1815) was published to great acclaim. A new kind of heroine was being prepared for the Victorian age.

4

From this time on Mary Wollstonecraft's name remained eclipsed in Great Britain for the rest of the nineteenth century. There was only one further Victorian reprinting of *The Rights of Woman* until its centenary in 1892; and no further editions of the *Memoirs* until 1927. Respectable opinion was summed up by the formidable Harriet Martineau in her *Autobiography*, written in 1855 and published in 1870: 'Women of the Wollstonecraft order ... do infinite mischief, and for my part, I do not wish to have anything to do with them.' She concluded that the story of Mary's life proved that Wollstonecraft was neither 'a safe example, nor a successful champion of Woman and her Rights'.

The force and endurance of these attacks, and the sense of shock and outrage that they express, suggest that the *Memoirs* had touched a deep nerve in British society. The book had arrived at a critical moment at the end of the 1790s, when both political ideology and social fashion had turned decisively against the revolutionary hopes and freedoms that Wollstonecraft's life represented. It was a time of political reaction and social retrenchment. It was also wartime.

As William Hazlitt later wrote of Godwin: 'The Spirit of the Age was never more fully shown than in the treatment of this writer – its love of paradox and change, its dastard submission to prejudice and the fashion of the day ... Fatal reverse! Is truth then so variable? Is it one thing at twenty and another at forty? Is it at a burning heat in 1793, and below zero in 1814?'

It is now possible to see a little more clearly what made the *Memoirs* so provocative and so remarkable. No one had written about a woman like this before, except perhaps Daniel Defoe in the fictional Lives of his incorrigible eighteenth-century heroines, like Moll Flanders or Roxana. But Godwin was writing strict and indeed meticulous non-fiction, using a plain narrative style and a fearless psychological

acuity. He signally ignored, or even deliberately aimed to provoke, proprieties of every kind, especially political and sexual ones.

Beginning with her uncertain birth in 1759 (Mary was unsure whether she was born in Spitalfields or Epping Forest), Godwin unflinchingly describes her restless and unhappy childhood, dominated by a drunken, bullying and abusive father and a spoilt elder brother. His account gives the famous and iconic picture of Mary sleeping all night on the floor outside the parental bedroom, hoping to protect her mother from her father's assaults. This upbringing left her the victim of lifelong depressive episodes, alternating with periods of reckless energy and anger: 'Mary was a very good hater.' But she was determined on a lifelong project of 'personal independence', and revealed an instinctive desire to control and manage those around her.

He next recounts her overwhelming and 'fervent' friendship for the beautiful Fanny Blood, 'which for years constituted the ruling passion of her mind'. Godwin has no reservations in proclaiming how deeply those feelings shaped Mary's emotional life in her twenties, and it is here that he first makes the notorious comparison between her and Goethe's lovelorn young Werther. The friendship took Mary on her first remarkable voyage, to Portugal in 1785, where Fanny died in childbirth. This passionate attachment was never subsequently forgotten.

The atheist Godwin also sympathetically describes and analyses Mary's religious beliefs. He treats them in a strikingly modern and psychological way, less as the product of Christian dogma or 'polemical discussion', and more as an imaginative expression of her temperament and character: 'She found inexpressible delight in the beauties of nature, and in the splendid reveries of the imagination … When she walked amidst the wonders of nature, she was accustomed to converse with her God.'

Next comes her combative experiences as a governess in Ireland, and the discovery of her charismatic talents as a teacher, and gifts as

an educational writer. This is followed from 1788 by the excitement of her early freelance work in London, and her professional friendship with the publisher Joseph Johnson, during which an intense period of self-education takes place. At the same time she takes responsibility for the careers and financing of most of her family, including her sisters and her father.

Then in 1792, at the age of thirty-three, and at a climactic moment in revolutionary history, she achieves the rapid and triumphant writing of *The Rights of Woman*, in which she brings both her wide reading and her bitter personal experiences to bear, and makes herself, in Godwin's words, 'the effectual champion' of her sex. Yet in the very midst of this long-dreamt-of literary success, she is frustrated and humiliated by her ill-judged affair with the married (but bisexual) painter Henry Fuseli, whose exact nature Godwin leaves for once unexpectedly ambiguous and ill-defined.

It is exactly at this crucial halfway point in his narrative, and significantly just out of chronological sequence, that Godwin ironically places his own first and deeply unsatisfactory meeting with Mary, at the dinner party with Johnson and Tom Paine in November 1791. Far from being love at first sight, they quarrel so fiercely that Paine hardly gets a word in edgeways. It is typical of Godwin that he does not omit this memorable scene, and it remains an exemplary demonstration of both his honesty and his modesty.

From now on the biography seems to accelerate and intensify. Mary sets out on her own to observe events in revolutionary Paris, and as the Terror begins, falls in love with the handsome American adventurer Gilbert Imlay. Godwin's description of her sexual awakening by Imlay, using the beautiful pre-Freudian imagery of 'a serpent on a rock', is another of his triumphs as a biographer, and one wonders how much it must have cost him. Here the comparison with the suicidal young Werther is also repeated.

Mary is registered as Imlay's wife, and in 1794 bears his illegitimate child – named Fanny (after Fanny Blood) – in Le Havre-Marat. She

embarks on a desperate journey to Scandinavia, transforming a secret business venture for Imlay into a captivating Romantic travelogue, sharpened with brisk passages of social comment (about contemporary attitudes to women, education and domestic work), contrasted with moments of intense loneliness and deep self-questioning. Godwin's emotional account of his personal reaction to this work prepares the ground for the unexpected love match that will follow:

> If ever there was a book calculated to make a man in love with its author, this appears to me to be the book. She speaks of her sorrows, in a way that fills us with melancholy, and dissolves us in tenderness, at the same time that she displays a genius which commands our full attention.

On Mary's return to London in 1795 she discovers that she has been abandoned and betrayed by Imlay, and twice tries to commit suicide, first with an overdose of opium, and then by jumping into the Thames. Godwin's vivid and moving account of this second attempt includes another unforgettable image: that of Mary all alone at night in the pouring rain, pacing back and forth on Putney Bridge, hoping that by soaking her clothes she will drown more quickly when she summons the courage to leap from the parapet. Paradoxically, it opened Godwin to the charge of trying to make a moral defence of suicide.

The remaining two chapters become increasingly confessional. Yet they are written in the same admirably limpid and economic style, in which tight understatement is deliberately used to contain overwhelming emotion. Godwin describes how they fell in love in the spring of 1796, and began sleeping together in August, long before their mutual decision to marry – which was only taken after Mary became pregnant. Such a candid admission opened Godwin to further mockery and abuse, although he refused to alter it in the second edition.

Finally, at great length and in almost gynaecological detail, without the least reference to the traditional comforts of religion, Godwin painfully and minutely describes Mary's death, eleven days after bearing her second child. It was the first time a deathbed had been described in this intimate way, including such unsettling details as Mary being given puppies to draw off her breast-milk, and being dosed with too much wine in a vain attempt to dull her pain.

5

Some two centuries later it is still possible to find the *Memoirs* shocking, and to question the picture it draws of Wollstonecraft. Many feminist critics believe that it miscasts her as a Romantic heroine, and fatally undervalues her intellectual powers. Most of her modern biographers freely use Godwin as wonderful source material, but condemn him as a hopelessly biased witness.

Even an outstandingly perceptive and measured writer like Claire Tomalin is uneasy about the effect of his work. She writes in her early, groundbreaking biography of 1974, *The Life and Death of Mary Wollstonecraft*: 'In their own way, even the *Memoirs* had diminished and distorted Mary's real importance: by minimising her claim to be taken seriously for her ideas, and presenting her instead as a female Werther, a romantic and tragic heroine, he may have been giving the truth as he wanted to see it, but was very far from serving the cause she had believed in. He made no attempt to discuss her intellectual development, and he was unwilling to consider the validity of her feminist ideas in any detail.'

This has weight, and is curiously close to the criticism originally made by the *Analytical Review* in 1798. But it has to be set against Godwin's extended analysis and celebration of the significance of *The Rights of Woman* in his Chapter 6: 'Never did any author enter into a cause, with more ardent desire to be found, not a flourishing

and empty declaimer, but an effectual champion ... When we consider the importance of its doctrines, and the eminence of genius it displays, it seems not very improbable that [her book] will be read as long as the English language endures ...'

Much criticism has also been directed against Godwin's attempt, at the very end of his biography, to summarise Mary's 'intellectual character', and apparently to draw a 'gendered' distinction between masculine and feminine intelligence. He contrasts his own cool, rational delight in 'logic and metaphysical distinction' with her strong, warm emotional instincts and 'taste for the picturesque'. This is easily ridiculed. But it is overlooked that Godwin, the faithful biographer, was actually paraphrasing one of Wollstonecraft's own letters to him of August 1796. This is what Mary herself wrote on the subject:

> Our imaginations have been rather differently employed – I am more a painter than you – I like to tell the truth, my taste for the picturesque has been more cultivated ... My affections have been more exercised than yours, I believe, and my senses are quick, without the aid of fancy – yet tenderness always prevails, which inclines me to be angry with myself when I do not animate and please those I love.

The problem of the intimate biography which seems to violate certain codes of family loyalty and trust is still with us, though the boundaries shift continually. Over forty years ago, it was Nigel Nicolson's *Portrait of a Marriage* (1973), revealing his mother Vita Sackville-West's lesbian relationships, and his father's homosexual ones, which raised such questions, though it might not do so now. Some twenty-five years later, John Bayley's account of his wife Iris Murdoch's relentless destruction by Alzheimer's disease, in *Iris* (1998), left many readers and reviewers deeply troubled. Yet both of these are fine books, and it seems likely that biography as a form is

destined continually to challenge conventions of silence and igno-rance. Moreover, recent developments in the intimate family memoir, such as Rachel Cusk's *Aftermath: On Marriage and Separation* (2012), or the growing number of confessional blogs on the internet (including the experience of terminal illness or gender transfer), suggest that the very notion of what is biographically private, or ultimately confidential, has profoundly altered, and will continue to do so.

One also has to consider the historical effect of such a powerful biography in a more oblique way. The fact, for example, that Mary Wollstonecraft's life inspired so many Romantic novels suggests Godwin had also made her something of a legendary figure. The emotional intensity of Marianne Dashwood in *Sense and Sensibility*, the novel which Jane Austen originally drafted at just this time (1797–98), might owe more than has been suspected to Mary's flam-boyant example.

The outrageous or confrontational element implicit in her person-ality still contained heroic or exemplary possibilities. Harriet Freke might yet be reincarnated as J. S. Mill's feminist companion Harriet Taylor, who was largely responsible for Mill's great work *The Subjection of Women* (1869). Wollstonecraft was championed by the reformer Robert Owen, and written about admiringly in a little-known essay by George Eliot, comparing her with the American Margaret Fuller, published in 1855 in the pages of the *Leader* maga-zine. In 1885 Wollstonecraft was one of the first figures to be included in the 'Famous Women' series, published in London and Boston by the Walter Scott Publishing Company, alongside lives of Elizabeth Fry and Mary Lamb. So there is an alternative tradition in which Mary Wollstonecraft's reputation runs underground through the nineteenth century. It has been traced in a classic of feminist schol-arship by Clarissa Campbell, *Wollstonecraft's Daughters* (1996).

The underground tradition eventually resurfaces in the superb essay on Wollstonecraft by Virginia Woolf of 1932. Inspired by the

tone of the *Memoirs*, she describes Gilbert Imlay not as a villain but as a callous fool: 'Tickling for minnows he hooked a dolphin'. She celebrates Mary's relationship with Godwin as the 'most fruitful experiment' of her life. Their marriage was 'an experiment, as Mary's life had been an experiment from the start, an attempt to make human conventions conform more closely to human needs'. In a striking and prophetic conclusion, Woolf sees the story and example of Mary's tempestuous life blossoming again among her own contemporaries: 'She is alive and active, she argues and experiments, we hear her voice and trace her influence even now among the living.'

6

Perhaps it was there from the beginning. A year after the publication of the *Memoirs*, the poet and novelist Mary Robinson released her *Letter to the Women of England, on the Injustice of Mental Subordination* (1799). Originally a Shakespearean actress (known as 'Perdita' Robinson for her renowned performance in *The Winter's Tale*, which famously seduced the teenage Prince of Wales), Robinson later produced literary work in the 1790s that brought her the friendship of both Godwin and Coleridge. Her *Letter* initially appeared under the pseudonym 'Anne Randall', but it was published by Longman, the biggest bookseller in London, and received wide circulation.

Robinson refers openly and admiringly to *The Rights of Woman*, and salutes Wollstonecraft as 'an illustrious British female ... to whose genius Posterity will render justice'. In a militant footnote she describes herself proudly as 'avowedly of the same school' as Mary Wollstonecraft, and prophetically foresees her embattled life as having initiated a long campaign for women's rights which would stretch far into the nineteenth century: 'For it requires *a legion of*

Wollstonecrafts to undermine the poisons of prejudice and malevolence.'

One of Mary Robinson's most striking conclusions at the end of her hundred-page *Letter* is that Wollstonecraft's commitment to female education (emphasised by Godwin) led logically to the idea of women going to university: 'Had fortune enabled me, I would build a UNIVERSITY FOR WOMEN.' Only then would women truly be equal.

In the year after Wollstonecraft's death, a new biographical series entitled 'Public Characters' (dedicated to the King) was launched, and would continue for the next decade. It carried some thirty 'living biographies' per annual issue, and featured such figures as Nelson, Wilberforce, Humphry Davy, Sheridan and Castlereagh. Its second volume (1799) included a twenty-page contemporary biography of William Godwin. It was warmly favourable, and gave a sympathetic four-page account of his marriage to Mary Wollstonecraft ('that most celebrated and most injured woman'), and unstinting praise for both editions of the *Memoirs*. It concluded with a remarkable passage that has never been reprinted since:

It was in January 1798 that Mr. Godwin published his *Memoirs* of the Life of Mrs. Godwin. In May of the same year a second edition of that work appeared. A painful choice seems to present itself to every ingenuous person who composes Memoirs of himself or of any one so nearly connected with himself as in the present instance. He must either express himself with disadvantage to the illiberal and malicious temper that exists in the world, or violate the honour and integrity of his feelings.

Yet that the heart should be known in all its windings, is an object of infinite importance to him who would benefit the human race. Mr. Godwin did not prefer a cowardly silence, nor treachery to the public, having chosen to write. Perhaps such works as the *Memoirs* of Mrs. Godwin's Life, and Rousseau's

Confessions, will ever disgrace their writers with the meaner spirits of the world. But then it is to be remembered, that this herd neither confers, nor can take away, fame.

Most moving of all, the revolutionary influence of Mary Wollstonecraft's life continued through the next generation of her own family, the family she never knew. It was a powerful and unsettling example. Her love child, Fanny Imlay, eventually committed suicide. But when her daughter Mary Godwin and Shelley eloped to France in 1814, they carried the *Posthumous Works* and the *Memoirs* with them in their tiny travelling trunk, and read them during their first nights in Paris. Shelley's poem *The Revolt of Islam* (1818) contained a heroic portrait of Wollstonecraft. The triumphant chorus from his late verse drama *Hellas* (1821), written about the Greek War of Independence, drew on Godwin's memorable snake imagery of hope and revival:

> The world's great age begins anew,
> The golden years return,
> The earth does like a snake renew
> Her winter weeds outworn ...

Mary Shelley's entire literary career was inspired by her mother's example, and especially perhaps her desire to write novels of ideas. Both *Frankenstein, or The Modern Prometheus* (1818) and *The Last Man* (1826) can be seen as part of the complex Wollstonecraft inheritance. After her father William Godwin's death, she always intended to write a combined biography of both her daring literary parents. A few scattered manuscript notes alone have survived, probably dating from the early 1840s. Here is what the subdued, widowed, middle-aged Victorian Mary Shelley wrote about her outrageous mother Mary Wollstonecraft:

Her genius was undeniable. She had been bred in the hard school of adversity, and having experienced the sorrows entailed on the poor and oppressed, an earnest desire was kindled within her to diminish these sorrows. Her sound understanding, her intrepidity, her sensibility and eager sympathy, stamped all her writings with force and truth, and endorsed them with a tender charm that enchants while it enlightens. She was one whom all loved, who had ever seen her.

But of course Mary had never seen her mother. She only knew and loved her through her own writings and her father's intrepid and controversial *Memoirs*. Such is the dangerous, enduring power of biography.

Mary Somerville

1

We are now living in a brilliant age of popular science writing. So it is strange to think that less than two hundred years ago the genre barely existed. The very idea that science could actually be explained, in meaningful terms, to a general public was gleefully parodied by Charles Dickens in his comic serial *The Mudfog Papers* (1837–38) as an instructive delusion of 'The Society for the Explanation of Everything'.

Yet in 1830 the leading astronomer John Herschel was writing to the physicist and future Master of Trinity College, Cambridge, William Whewell, about the urgent need for just such accessible, explanatory and contextualising books. These should be 'digests of what is actually known in each particular branch of science ... to give a connected view of what has been done, and what remains to be accomplished in every branch'.

The remarkable writer who first achieved this 'connected view' of ongoing science, and arguably launched the whole popular genre, was a self-taught mathematician and mother of three from Scotland, Mary Fairfax Somerville (1780–1872). Her book *On the Connexion of the Physical Sciences* was published by John Murray in 1834, in his 'Family Library' series alongside works by Walter Scott, Jane Austen and Lord Byron. It contained no equations, few diagrams, and little mathematics. But it was a masterpiece of descriptive explanation and

familiar analogy, which unfolded a complete scientific worldview, from the most distant stars to the humblest insects on earth. It was Murray's bestselling scientific publication up to Darwin's *On the Origin of Species* (1859), and would eventually run to ten editions in Britain, also appearing – translated or pirated – in France, Italy, Germany and America.

The five-hundred-page book was presented in thirty-seven short chapters, which reduced the traditional vague panorama of 'natural philosophy' to a much tighter field of hard sciences – astronomy, physics, chemistry, geology, geography, meteorology and electro-magnetism. It pioneered a particular style of clear, logical explanation, in a plain, low-key prose which occasionally opened out into passages of sublime perspective.

For example, Somerville vividly introduced the notion of universal gravity, as a force which is equally present 'in the descent of a rain drop as in the falls of Niagara; in the weight of the air, as in the periods of the moon'. But more than this, she observed that gravitation not only bound up the planets and the sun in the ordered system made familiar by Newton, but was also, more surprisingly, the cause of continual 'disturbances' in nature. In this it gave new meaning to the old Pythagorean idea of the music of the spheres: 'Every tremour it excites in any one planet is immediately transmitted to the farthest limits of the system, in oscillations ... like sympathetic notes in music, or vibrations from the deep tones of an organ.'

Individual chapters were given up to patient, step-by-step descriptions of certain key scientific concepts, and how they had evolved. For example: stellar parallax (Chapter 8); the formation of the earth's atmosphere and climate (Chapter 15); the polarisation of light (Chapter 21); the effects of solar radiation (Chapter 24); Voltaic electricity (Chapter 28); the new science of electromagnetism (Chapter 34); the tracking and identification of comets (Chapter 35); or the sublime magnificence of shooting stars (Chapter 36).

Chapter 16, on acoustics, was characteristically brilliant. It opened with the plain but memorable comparison: 'The propagation of sound may be illustrated by a field of corn when it is agitated by the wind ...' It then went on to explain a vast range of acoustic phenomena, from birdsong and musical instruments to waterfalls and thunder. Finally Mary Somerville made another of her striking analogies, suggesting the 'connexion' between the various kinds of wave propagated in the different mediums of water, atmospheric air and solar light: 'Anyone who has observed the reflection of the waves from a wall on the side of a river after the passage of a steam-boat, will have a perfect idea of the reflection of sound and of light.'

Chapter 24, on the solar spectrum, contained one of the earliest descriptions of infra-red and ultra-violet rays, 'undulations beyond the human optic nerve', at the extreme ends of the known spectrum. Yet Somerville speculated that these might also have many possible functions in the animal kingdom: 'We are altogether ignorant of the perceptions which direct the carrier pigeon to his home, or those in the antennae of insects which warn them of the approach of danger ...' Once again the sublime mystery of nature was emphasised.

The most original sections, drawing successively on the work of Oersted, Ampère, Arago and Faraday, were those on electricity and electromagnetism, appearing towards the end of the book, in Chapters 32 to 34. Here Somerville wrote thrillingly of Faraday's latest work with the 'horse-shoe magnetic' generator, and established the general principle that magnetism and electricity must have complex links, in what Faraday was beginning to define as 'fields'. These sections would be particularly praised by Whewell and David Brewster, and they clearly predicted the decisive 'connexion' between all electromagnetic phenomena which would be mathematically established a generation later, by James Clerk Maxwell in his famous four equations.

The *Connexion* appeared at a time when the scientific disciplines were beginning to define their separate territories, and to pull apart

into the different specialisms we know today. Nothing could show this more clearly than the sudden explosion of separate scientific societies founded in Britain at this period. Beginning with the Geological Society in 1807, this was followed by the Astronomical in 1820, the Zoological in 1826, the Geographical in 1830, the Entomological in 1833, the Statistical in 1834, and the Meteorological in 1836. Thus the idea of establishing a vital and imaginative 'connectivity' between disciplines was timely but also challenging. All the more so, perhaps, because it was proposed by a woman, and addressed to a general reader.

Yet the book's reception proved enthusiastic, among both journalists and academics. On the one hand, the *Athenaeum* greeted it languidly as 'a delightful volume ... for the philosopher in his study and the literary lady in her boudoir'. On the other, David Brewster, a fierce scientific reviewer in the *Edinburgh Review*, praised everything except the lack of diagrams; while William Whewell gave it an in-depth technical scrutiny in the *Quarterly Review* for September 1834, concluding that it was a '*masterly* survey – if Mrs Somerville will excuse that word'. For Whewell, the book performed a vital task of intellectual unification. It arrived at a critical moment when the expanding body of science had been in danger of professional disintegration, 'like a great empire falling to pieces'. Moreover, it was Whewell's essay which prompted the creation of the new professional concept, and a new umbrella word to define it: 'scientist'.

Abroad, the book was praised by Jean-Baptiste Biot in Paris, saluted by Joseph Henry in Washington, and 'deeply admired' by Alexander von Humboldt in Berlin. Yet perhaps most satisfactorily of all, the popular large-circulation journal the *Mechanics' Magazine* for March 1834 advised its many readers against putting Mary Somerville's *Connexion* on their shelves: 'Instead of that we simply say – *read it! read it.*'

2

How did Mary Somerville come to write it? The daughter of a naval officer, Vice-Admiral William Fairfax, she grew up 'a savage' in the little port of Burntisland on the Firth of Forth, wandering the seashore, collecting shells and studying seabirds, and fascinated by the legend of the Kraken (that Tennyson soon put into poetry). Growing up with an elder brother, she soon learned to hold her own. It was reported that a visiting military uncle taught her to swear, and that when asked by a lady in the street what her name was, replied in her strong Scottish accent, 'Wha's your business, you damned Bitch?'

Unexpectedly, the glimpse of a mathematical competition in the back of a woman's fashion magazine, with mysterious references to 'algebra', seized her imagination at the age of fifteen. She begged her brother's tutor to include her in his lessons on Euclid, and with some misgivings, this was permitted. The fascination with Euclidian geometry soon led her on with astonishing rapidity to Newton's optics, and then Laplace's astronomy and mathematics. Forbidden candles at night, she would lie in bed listening to the sea and solving equations in her head.

How remarkable this was for a young woman of Somerville's time and social background is vividly illustrated by an incident in George Eliot's *The Mill on the Floss*. The novel was published a generation later, in 1860, but it is set in England around the early 1800s, and draws on Mary Ann Evans's decided views of the historic short-comings of female education. Like Mary Somerville, the young Maggie Tulliver is sharing lessons with her beloved elder brother Tom. Tom is constantly teasing her about her total inability – as a silly girl – to master subjects like Latin or geometry. These things are only for boys. Maggie appeals to their tutor, the strict but kindly Reverend Walter Stelling, hoping for his support.

'Mr. Stelling,' she said, that same evening when they were in the drawing-room, 'couldn't I do Euclid, and all Tom's lessons, if you were to teach me instead of him?'

'No, you couldn't,' said Tom, indignantly. 'Girls can't do Euclid; can they, sir?'

'They can pick up a little of everything, I dare say,' said Mr. Stelling. 'They've a great deal of superficial cleverness; but they couldn't go far into anything. They're quick and shallow.'

Mary Somerville was quick and deep, and went far in everything. Launched upon Edinburgh society at eighteen, and now a notable beauty, she mixed with the liberal *Edinburgh Review* set, flirted with the elderly geologist William Playfair ('I did not dislike a little quiet flirtation'), and continued her studies under the serious tuition of William Wallace, the future Professor of Mathematics at Edinburgh University. At this time she described herself as 'intensely ambitious to excel in something, for I felt in my own breast that women were capable of taking a higher place in creation than that assigned to them in my early days, which was very low'.

A disastrous first marriage to the dashing but unreliable Samuel Greig, who held the post of naval attaché to the Russian consulate in London, was curtailed by Greig's early death, possibly from alcoholism, in 1807. After a liberated period of widowhood back in Edinburgh, supporting her baby son Woronzow (a Russian name that had been insisted on by Greig), Mary found her true soulmate. This was her cousin William Somerville FRS, a genial physician who had travelled halfway round the globe in naval service. He was a handsome, kindly and experienced man in his mid-forties, who perfectly understood Mary's scientific gifts, and evidently adored her. They married in 1812, when Mary was thirty-one, and quickly had four more children, though only two daughters survived. They settled in London, and through William's connections with the Royal Society, soon got to know all the leading scientific men both there

and in Paris, including Herschel, Babbage, Faraday and François Arago.

Mary first put her mathematics to work by completing a translation of Pierre-Simon Laplace's highly technical *Méchanique Céleste*. After immense and covert labour ('I hid my papers as soon as the bell announced a visitor, lest anyone should discover my secret') she completed an outstanding translation and interpretation of Laplace's difficult astronomical book on the structure and mathematics of the solar system, retitling it *The Mechanism of the Heavens* (1830). It was an extraordinary *succès d'estime*. Her translation became the standard textbook for science postgraduates at Cambridge (unheard of for a woman author), and the 'Preliminary Dissertation', republished separately in 1832, made her known to a general reading public.

Characteristically, the well-disposed *Edinburgh Review* picked out the gender of the translator: 'Mrs Somerville is the only individual of her sex in the world who could have written it.' She was referred to in a parliamentary debate on scientific education. Her friend, the novelist Maria Edgeworth, described Mary admiringly: 'She has her head in the stars, but feet firm upon earth ... intelligent eyes ... Scotch accent ... the only person in England who understands Laplace.'

Encouraged by John Herschel and her supportive husband, William, Mary then launched upon a general science book for Murray. Much of *The Connexion* was in fact researched and written during a long visit to Paris in 1832–33. By now their two daughters, Martha and Mary, were in their teens, and Mary's son Woronzow was studying law in London, so the Somervilles were free to travel. Taking an apartment off the Champs-Élysées, they set out to develop all their scientific contacts. Here the importance of the new social networking in science was vital, as was Mary's excellent French (apparently spoken with a 'captivating' Scottish accent).

Laplace himself was now dead, but they were received as honoured guests by his influential widow, the Marquise. They dined frequently with Arago, Biot and Joseph Louis Gay-Lussac, and were taken on

special visits to the Paris Observatory, the Anatomy Theatre, the Institute, the Museum of Natural History and the Jardin des Plantes. They were given privileged access to the private laboratories of the pioneers of electrical theory, Ampère and Becquerel, which meant that Mary was soon up-to-the-minute in the latest work on magnetism. She was in effect becoming an expert reporter on the latest developments of both British and European science. She sent her proofs back to London in the diplomatic bag.

The Connexion emphasised, in a wholly new way, the teamwork and communal nature of science as a global project. Mary referred to the varied, and often heroic, endeavours of its pioneers across the whole globe. She mentions Sir John Franklin exploring in the Arctic regions; Biot and Gay-Lussac flying a balloon to altitudes over twenty thousand feet above Paris; John Herschel observing the nebulae in South Africa; Humboldt investigating plant distribution in South America, or descending into the silver mines of Mexico; Professor Joseph Henry building massive electromagnets in Albany, New York State; a dozen European astronomers making their separate observations of the return of Halley's Comet; and even a certain Mrs Graham courageously staying to make notes on a massive earthquake in Valparaiso.

The great physicist James Clerk Maxwell wrote retrospectively in 1870: 'It was one of those suggestive books which put into definitive, intelligible and communicative form the guiding ideas that are already working in the minds of men of science, so as to lead them to discoveries, but which they cannot yet shape into a definitive statement.' He must have had in mind particularly Somerville's Chapter 34, on electromagnetism, in which she refers to the 'occult connection' between electricity, magnetism and light, which 'opens a noble field for experimental research for philosophers of present, perhaps of future ages!'

The immediate success of the book was measured in personal recognition, to a degree hitherto quite exceptional for a British

woman in science (and utterly different from the scandalous notoriety of Margaret Cavendish). Mary wrote: 'We are much out. I am a kind of tame Lioness at present.' She added characteristically that even her daughters, Martha and Mary, basked in her reflected glory and were much 'cubberized' in society.

To emphasise this approval, Mary and William were invited to spend a whole week in the male stronghold of Cambridge in April 1832. They were treated as celebrities, given rooms in Trinity College, provided with a four-poster bed ('a thing utterly out of our regular monastic system'), wined and dined by all the leading science professors including Sedgwick and Whewell, and taken on a tour of the University Observatory. 'We have no cannons at Trinity,' wrote Sedgwick, 'otherwise we would fire a salute on your entry.'

Though she was barred by statute from becoming a Fellow of the Royal Society, a formidable marble bust of Mary was commissioned from Sir Francis Chantrey, and finally installed in the Society's Great Hall. She had poems dedicated to her, and a merchant sailing ship – a racy tea-clipper – named after her, with her wooden figurehead carved at the prow.

She received a government Civil List pension of £200 (increased to £300 in 1837), Membership of the Royal Academy at Dublin (1834), the Genevan Société de Physique et d'Histoire Naturelle (1834), and Honorary Membership of the Royal Astronomical Society in 1835, a quiet triumph she shared with none other than Caroline Herschel.

3

A second, and greatly augmented, edition of *The Connexion* appeared in 1835. Mary now meticulously incorporated additional material and comments sent in by Herschel, Faraday, Arago and several other researchers. This practice continued in all subsequent editions,

thereby making the book a new kind of science publication, regularly subject to 'referee' and updated. In an essay of 1962 Thomas Kuhn picked it out as 'a new look' in contemporary British science. The book was steadily republished throughout Mary's lifetime, running to ten editions and shaping the progressive idea of science for more than half a century. The last, posthumous, edition of 1877 was specially edited for Murray by Charles Lyell's assistant, the brilliant popular science writer Arabella Buckley.

Mary Somerville had become a 'Whig icon' of female abilities, modest in public, but in private unorthodox, witty, with a sharp sense of the ridiculous. She was popular among the young and progressive. One of the many people she attracted was the nineteen-year-old Augusta Ada Byron, who had read *The Connexion* with admiration, and found in Mary a role model for women in science. Mary took her under her wing, collecting her regularly in her coach, and helping to liberate her from her formidable mother Lady Byron's apron strings. In 1834 she began introducing Ada to her lively circle of scientific friends, among whom was Charles Babbage. So began their famous collaboration on the presentation of Babbage's analytical engine.

The relationship between the fifty-year-old Mary and her aristocratic young protégée was partly one between mathematical mentor and pupil, and involved the exchange of mathematical problems. Mary also took Ada to Dionysus Lardner's scientific lectures, and chaperoned her early visits to Babbage, which produced breathless excitement. Ada wrote: 'I am afraid that when a machine, or a lecture, or anything of the kind, comes in my way, I have no regard to time, space, or any ordinary obstacles.'

Ada even felt confident enough to tease Mary about the marble bust presented to the Royal Society: 'I'm afraid I shall never like Mr Chantrey, & declare I won't admire his bust of you, out of spite.' In turn, Mary solemnly praised Ada for her knitting skills, and joked about her cat, Puff. When Ada, married and known as the Countess

Lovelace, later published her historic paper on Babbage's prototype computer, *Sketch of the Analytical Engine invented by Charles Babbage Esq*, Mary's friend the bestselling Scottish author Joanna Baillie wrote to the Somervilles on 25 March 1844: 'The Lady whom we know so well as *little Ada*, whose chief conversation used to be about a Persian cat, Puff by name, is beginning to be known in the literary world.'

Despite all this social success and professional recognition, the Somervilles' private life was unsettled. Mary still wished to pursue her own science, and published two small technical papers in 1835 and 1845, both on the impact of sunlight on certain chemicals and plants (not unrelated to the invention of photography). Yet she found that domestic life made it impossible to return to prolonged original research or mathematics. In 1835 William sustained financial losses through loans he had made to a cousin, and despite his salary from the Chelsea Hospital, and Mary's own pension and book royalties, they struggled to live more economically. When the smaller house to which they moved in Chelsea, near the Thames, proved unhealthy, and William, now in his mid-sixties, became ill, they considered retiring to a warmer climate.

In 1838, like many of their generation, they decided to try Italy, at first intending to stay for only a year. In 1839 William resigned from the hospital, and they struggled to put down permanent roots, first in Rome and then in Florence (just before the Brownings also arrived there). It was not easy. In 1841 William wrote to his son that he was now seventy years old, but had not achieved 'a quiet and undisturbed life', had no real home, and because of finances, was 'without prospect of being able to return to England!' Yet throughout all these upheavals he remained his wife's 'generous and kind-hearted' supporter and assistant, never jealous, never impatient, copying manuscripts and searching out books, accompanying her in society. 'No trouble seemed too great which he bestowed upon her,' observed their daughter Martha; 'it was a labour of love.'

Mary Somerville went on to complete two more survey-style science books in Italy. The first, *Physical Geography*, appeared in 1848, the year of the European revolutions, reflecting the new comprehensive discipline of global geography which had been largely pioneered by Alexander von Humboldt. The first volume of Humboldt's own celebrated *Cosmos* had been published three years previously, but Humboldt was lavish in his generous praise of Mary's work. She had in fact begun the book before she and William left London, and its final chapters gave a hopeful, panoramic view of the civilising role of science in the rapidly expanding British Empire.

Mary made several brief returns to England, largely to see her son, Woronzow, now a successful barrister in London, but also to discuss the updating of *The Connexion* with Murray, and to visit the studios of the aged J. M. W. Turner, whose later paintings she had come to admire greatly. She supported women's suffrage, and her signature was the first on J. S. Mill's 1866 petition on that subject to Parliament. She campaigned against vivisection, just as Margaret Cavendish and Anna Barbauld had done before her, and also against black slavery in America. Her portrait was hung in her publisher John Murray's 'Lions' Gallery', alongside Byron and Walter Scott.

4

Mary Somerville had become an outstanding model for the next generation of younger women in science. This was particularly true of the first great American woman astronomer, Maria Mitchell. Born in 1818 in the remote Massachusetts whaling station of Nantucket, Maria had a Quaker upbringing, and her scientific interests were encouraged by her schoolmaster father. Like Caroline Herschel she initially made her name by the discovery of a new comet, in 1847, for which she received an international Gold Medal, presented by

the King of Denmark. Recognition followed with startling speed. By the time she was thirty-two, Maria had been elected the first woman member of the American Academy of Arts and Sciences, and then the first woman member of the American Association for the Advancement of Science.

Modestly revelling in this newfound American celebrity, Maria toured all the great observatories of Europe, subjecting their various astronomers to her candid Nantucket eye and salty humour. She visited Greenwich Observatory and the Royal Society, bringing with her as a calling card the first known photograph of a star. For the most part she was enthusiastically received, especially by the kindly John Herschel, though she was 'riled' by Whewell's chauvinist teasing while dining at Trinity College high table. She was also amazed to be told by Sir George Airy FRS, the British Astronomer Royal: 'In England, there is no astronomical public and we do not need to make science popular.'

Undaunted, Maria pressed on to meet Mary Somerville in Italy, the great object of her European tour. In Rome, she was disconcerted to find the Vatican observatory closed to women after dark, a distinct setback for a professional astronomer. ('I was told that Mrs Somerville, the most learned woman in all Europe, had been denied admission – she could not enter an observatory that was at the same time a monastery.') When she finally reached Florence, she was captivated by Mary Somerville, both by her directness and by her fantastic range of interests.

While William Somerville now appeared as a kindly, stout, shuffling valetudinarian, his head bound up in a red scarf, his wife by contrast delighted Maria with her directness, her apparent youth, and her crisp Scottish tones: 'Mrs. Somerville came tripping into the room, speaking with the vivacity of a young person. She was seventy-seven years old, but appeared twenty years younger. Her face is pleasing, the forehead low and broad, the eyes blue ... she spoke with a strong Scotch accent.'

Maria Mitchell was also impressed by Mary Somerville's encyclo-paedic enthusiasms. She was in the midst of updating a new edition of her bestselling *Physical Geography*. She talked easily and simply, 'with no tendency to the essay style'. She touched upon 'the recent discoveries in chemistry, of the discovery of gold in California, of the nebulae, of comets, of the satellites, of the planets ...' To Maria's satisfaction she also 'spoke with disapprobation of Dr Whewell's attempt to prove that our planet was the only one inhabited by reasoning beings'.

Maria wrote a fine biographical essay on Mary Somerville inspired by this visit, later published in the *Atlantic Monthly* in 1860, empha-sising the significance of her books, as well as describing the domes-tic details of her Italian exile. She noted approvingly that the mathematician had retained her delight in growing roses in her secluded English garden. In retrospect she viewed Mary Somerville as one of 'the few women of genius' of the age, who had been 'the successful rivals of man' in their chosen field.

She also made the shrewd comparison of Somerville's place in Victorian science with that of Elizabeth Barrett Browning in Victorian poetry. The 'authoress' was also resident in Florence, at the Casa Guidi, and her most popular poem, *Aurora Leigh*, published in 1856, would make her famous among the English expatriates. Mary Somerville herself later met 'Mrs Browning' at several receptions, and thoroughly approved of her runaway romance with Robert Browning ('I can imagine no happier or more fascinating life than theirs'). She admired her 'poetical genius as well as her modesty and simplicity', though she did gently mock the Brownings' tendency to believe in spiritualism and 'spirit-rapping', as not quite sufficiently scientific.

Like her heroine, Maria Mitchell also remained firmly progressive in her views. She identified with the anti-slavery cause, the female suffragist movements, and the future of women in science. 'The laws of nature are not discovered by accident,' she wrote; 'theories do not come by chance, even to the greatest minds, they are not born in the

hurry and worry of daily toil, they are diligently sought ... and until able women have given their lives to investigation, it is idle to discuss their capacity for original work.'

When she returned to America to be appointed the first Professor of Astronomy at Vassar in 1865, aged forty-seven, she installed a symbolic bust of Mary Somerville in her famous teaching observatory. It was modelled on the Chantrey bust, but it was also perhaps a silent rebuke to the Royal Society's refusal to elect Mary Somerville to its Fellowship. Beneath its gaze Mitchell mentored a brilliant circle of devoted female students to take up the baton of astronomy. Among them she was renowned for her pithy Nantucket sayings: 'Study as if you were going to live forever; live as if you were going to die tomorrow.'

5

To begin with Mary Somerville had adapted well to her exile, for she had her family around her, and was still part of the international community of science. But time took its toll. Work on her final book was interrupted by the death of her beloved husband, William, in 1860; and even more by that of her adored son, Woronzow, in 1865, at the height of his legal career in London. She moved further south to the warmth of Naples, still with her two faithful daughters, who never married but managed to pursue adventurous and independent lives, which included climbing Mount Vesuvius, travelling on ponies through Vallombrosa and sailing their own twenty-eight-foot yacht in the bay of Spezia – in the wake, so to speak, of Shelley. Finally, in 1869, indefatigable, Mary published *Molecular and Microscopic Science*, written in her late eighties. Admittedly, this was largely a compilation volume, not fully up to date, yet successfully published through the goodwill and endlessly patient fact-checking of Murray's faithful editors.

After the death of William, and despite the presence of her daughters, Mary was evidently lonely, and was tempted by the fashionable consolations of Victorian spiritualism. But the scientific rationalist in her, and perhaps something of the old Scottish rebel instinct, successfully resisted such superstitious blandishments. She nevertheless continued to believe in a benign Creator, the existence of the human soul, and personal immortality. Even more remarkably, her old lifelong love of birds and other animals reasserted itself, and her house became an asylum for many stray creatures, both wild and domestic. She came to believe in immortality for them too, writing: 'Since atoms of matter are indestructible, as far as we can know, it is difficult to believe that the spark which gives union to their life, memory, affection, intelligence, and fidelity, is evanescent.'

Mary drew final inspiration from a scientific concept of the persistent life force, or *vis viva*, evident from its microscopic beginnings on earth right through to animal and human life. She celebrated this in *Molecular and Microscopic Science*, with its epigraph unexpectedly from St Augustine: 'God, who is mighty in mighty things; but mightiest of all in the very smallest.' She believed there was both a material world and an invisible one, in which 'our nervous system is the bond of connection'. But how the brain produced the mind, or consciousness, or the soul, she thought was 'probably inexplicable' by science, and this was just as it should be.

Her attitudes to natural theology, as for many of her scientific generation (excluding diehards like Whewell), adapted and modernised as she grew older. She accepted the new theory of evolution by natural selection, and applauded its bold simplicity. Nonetheless, she rejected Darwin's strictly materialist version of it, believing that ultimately evolution still demonstrated the workings of God's Divine laws and purpose in Nature. A similar view also came to be held by Darwin's colleague Alfred Russel Wallace. This version of evolution, within a theological and teleological context, is still held today by

many scientists, and is quite separate from Creationism. Its essential idea is that evolution, not only in the natural world on earth, but throughout the cosmos, has a Divine purpose which can be dimly perceived and felt, but never rationally – or scientifically – proved. These contrary reflections on Darwinism were removed from the manuscript by her daughter Martha when the first edition of Somerville's autobiography, *Personal Recollections*, was published posthumously in 1873.

Towards the end of her life Mary Somerville grew deaf and frail, but her mind remained sharp. Her memory was bad for names and dates, but impressive for music and mathematics, a fact she found scientifically suggestive in itself. She contemplated the future of science optimistically, but frequently worried about the growing and thoughtless impact of man on Nature. As she had written in *Physical Geography*: 'Man, the lord of Creation, will extirpate the noble creatures of the earth, but he himself will ever be the slave of the cankerworm and the fly.'

She also thought sadly of her own failure to go back to original scientific work, and especially mathematics, in the successful years after publishing *The Connexion*. She wrote in Chapter 11 of her *Personal Recollections*: 'I had recorded some of the most refined and difficult analytic processes and astronomical discoveries. But I was conscious that I had never made a discovery myself, that I had no originality. I have perseverance and intelligence but no genius.'

Reflecting on this, she was inclined to conclude, at least in her old age, that it was a limitation common to all women who attempted to take up science, rather than the arts or literature: 'That spark from heaven is not granted to [my] sex, we are of the earth, earthy; whether higher powers may be allotted to us in another state of existence, God knows; original genius in science at least is hopeless in this.' But Somerville evidently had second thoughts about this, for she added to the manuscript: 'At all events it has *not yet* appeared in the higher branches of science.' This was another passage which was

edited out by her daughter Martha before the book's publication in 1873, and it was not restored until 2001.

Mary Somerville died peacefully in Naples, attended by her daughters, and was buried in the English cemetery there, in a large, plain marble tomb. Though sadly neglected, this still survives today, topped by a full-size statue of Mary tranquilly seated on a mathematical throne (evidently awaiting restoration). Lacking Margaret Cavendish's aristocratic connections, she was refused burial in Westminster Abbey, although many Fellows of the Royal Society urged it. But she received a different kind of living memorial when Somerville College, Oxford, was founded in her memory in 1879. Originally for female students only, it has now become co-educational. Her popular reputation is spreading once again, as is her symbolic image. The Chantrey bust has been moved into the Royal Society's research library, alongside busts of Faraday and Darwin. In 2014 she made a dramatic cameo appearance in Mike Leigh's award-winning film *Mr. Turner*, advising the painter on the scientific analysis of light as a form of electromagnetic wave. In 2016 her head appeared on the Scottish £10 note. Perhaps this too is biography by other means.

AFTERLIVES

John Keats the Well-Beloved

1

Forty years ago this autumn I spent a week working at a small wooden table on a tiny ironwork balcony in Rome. The balcony was directly above the Spanish Steps. The apartment was that on the second floor of 26 Piazza di Spagna. It was the apartment where John Keats died at 11 o'clock at night on 23 February 1821, with the famous injunction to his faithful companion, the painter Joseph Severn: 'Severn – Severn – lift me up for I am dying – I shall die easy – don't be frightened – thank God it has come.'

My balcony was built onto the room at the back of number 26 (to the left as you look up from the Steps): the room where Severn, Keats's nurse through those last four agonising months of tuberculosis, sometimes managed to snatch a few hours of exhausted sleep. It was not Keats's own room, the famous bedroom with the marble fireplace and the daisies 'growing over him' on the ceiling and the sound of the Bernini fountain plashing in the piazza, which every visitor rightly remembers. It was the back room, the proper place for a biographer.

I was actually working on my life of Shelley. But for those six days it was the life of Keats, or rather his death, which haunted me. Every creak that ran through the old polished wooden floorboards of the apartment behind me broke my concentration and made me think, painfully and uneasily, of the dying man, and the letters from Fanny Brawne he would not open, and the opium painkiller that was taken

from him, and the poems he was forbidden to write. Finally, as a sort of protective charm, I turned to Shelley's 'Adonais' (1821), the famous Olympian elegy inspired by Keats's death, lifting it into the less painful stratosphere of myth:

> Peace, peace! he is not dead, he doth not sleep –
> He hath awakened from the dream of life ...

It was only while reading this poem that the idea, not of Keats's death but of its exact opposite, Keats's awakening, his *extraordinary survival after death*, first struck me. The imaginative impact of Keats's life – his 'orphaned' childhood, his letters, his poetry, his friendships, his illness, his agonising love affair – has continued unbroken for nearly two hundred years. It has retained a magnetic force not really matched in its personal immediacy by any other Romantic poet – neither by Shelley nor even by Byron. During that week, below me on the Spanish Steps there always seemed to be some young figure standing or sitting beyond the buckets of the flower-sellers, similarly reading from a book, and looking anxiously up at the second floor of number 26. I cannot believe it has changed to this day. Why should this be?

The 'living hand' of his famous late fragment, possibly the last poem Keats ever wrote, really does reach out towards us and make an immediate appeal:

> This living hand, now warm and capable
> Of earnest grasping, would, if it were cold
> And in the icy silence of the tomb,
> So haunt thy days and chill thy dreaming nights
> That thou would wish thine own heart dry of blood
> So in my veins red life might stream again,
> And thou be conscience-calm'd – see here it is –
> I hold it towards you.

In part, this must be because his poetry is so richly embedded in his wonderful letters, so that the two together form a natural autobiography of haunting power. Many of his most celebrated short poems simply rise out of the pages of the long letters he dashed off, appearing, as he put it, 'as naturally as the Leaves to a tree'.

'To Autumn', for example, perhaps his most perfectly achieved poem, simply sprouts from a description of warm-looking stubble fields outside Winchester – 'Aye better than the chilly green of spring' – which concludes with a smiling, throwaway comment: 'I hope you are better employed than in gaping after weather.'

The youthful animation of these letters is constantly astonishing. Who could resist the way he frames his early life-plan, to put a knapsack on his back, and 'to write, to study, and to see all Europe at the lowest expense. I will clamber through the Clouds and exist.' Or his explanation of why he never intends to marry: 'The roaring of the wind is my wife, and the Stars through the window pane are my Children' – with the added pathos that this was written approximately two months before he meets Fanny Brawne.

His gift for entering imaginatively into physical objects is equally beguiling. The way he hoisted himself up, looking 'burly and dominant', when he first met Spenser's description of '*sea-shouldering whales*'; or mimed the 'pawing' of a dancing bear; or the rapid flurry of a boxer's punches, like 'fingers drumming' on a window pane.

Or those famous moments of imaginative attention and empathy: 'If a Sparrow come before my Window, I take part in its existence and pick about the Gravel.' Or simply eating a ripe nectarine: 'It went down soft, pulpy, slushy, oozy – all its delicious embonpoint melted down my throat like a large beatified Strawberry.' Or even entering into the spirit of a billiard ball, so he could feel 'a sense of delight from its own roundness, smoothness, volubility and the rapidity of its motions'. As he summarised this power: 'Imagination may be compared to Adam's dream – he awoke and found it truth.'

Besides these matchless letters (a primer in what would now be called Creative Writing), his contemporaries also wrote vividly about Keats in short formal memoirs – his school friend Charles Cowden Clarke on his childhood and medical apprenticeship; his editor Leigh Hunt on his early poetry; his friend and amanuensis Charles Brown on his Hampstead days; or Joseph Severn on his dying. In particular, Brown's description of Keats writing 'Ode to a Nightingale' (1819) on a kitchen chair under a plum tree has achieved an iconic image of creativity not dissimilar to William Stukeley's description of Isaac Newton conceiving of 'universal gravity' under an apple tree.

In the spring of 1819 a nightingale had built her nest near my house. Keats felt a tranquil and continual joy in her song; and one morning he took his chair from the breakfast-table to the grass-plot under a plum-tree, where he sat for two or three hours. When he came into the house, I perceived he had some scraps of paper in his hand, and these he was quietly thrusting behind the books. On inquiry, I found those scraps, four or five in number, contained his poetic feeling on the song of our nightingale. The writing was not well legible; and it was difficult to arrange the stanzas on so many scraps. With his assistance I succeeded, and this was his *Ode to a Nightingale*, a poem which has been the delight of every one.

2

Yet John Keats's survival in the popular imagination, his 'posthumous existence' as he called it (angrily, to his doctor in Rome), has achieved an altogether different kind of life of its own. This is already stirring, long before the modern biographies, in the many paintings of the English Pre-Raphaelites, notably John Everett Millais's *The Eve*

of St Agnes (1863) and John William Waterhouse's *La Belle Dame Sans Merci* (1893), which drew so richly on Keats's imagery. He floats back quite unexpectedly in a science-fiction short story by Rudyard Kipling, called 'Wireless' (1910), in which his voice is poignantly resurrected across the airwaves.

Equally unexpectedly, Scott Fitzgerald revealed a lifelong obsession with Keats, which produced not only the theme and title of *Tender Is the Night* (1934), but also inspired his late pedagogic attempt to become a literature professor, as movingly recounted in Sheilah Graham's *College of One* (1967), which began when Fitzgerald started reciting Keats to her as they drove back from a Hollywood film preview in his ancient Ford.

There are numerous recent reappearances. His conversational encounter with the middle-aged Coleridge is subtly replayed in Thom Gunn's teasing sonnet 'Keats at Highgate', from *The Passages of Joy* (1982). After Coleridge has anxiously described Keats as 'Loose, slack, and not well-dressed', Gunn evokes the younger poet's departure:

> He made his way toward Hampstead so alert
> He hardly passed the small grey ponds below
> Or watched a sparrow pecking in the dirt
> Without some insight swelling the mind's flow
> That banks made swift. Everything put to use.
> Perhaps not well-dressed but oh no not loose.

His nightingale flutters into the scientific study by the evolutionary biologist Richard Dawkins, *Unweaving the Rainbow* (1998), in which the bird's intoxicating song is analysed biochemically, as an 'auditory drug' altering hormone levels. Keats does literally survive in the novella *The Invention of Dr Cake* (2003) by the one-time British Poet Laureate Andrew Motion, slipping back to England as an anonymous country doctor, living with a woman who may or may not be Fanny Brawne. In Ian McEwan's novel of fatal attraction, *Enduring*

Love (1997), Keats's lost love letters appear as a thematic prelude in the opening chapters, as the subject of the heroine Clarissa's PhD researches.

Keats, perennially popular with students, has emerged as a cult figure in the recent Anglo-American fashion for literary tattooing. Quotations from the odes, and even *Endymion* – 'A thing of beauty is a joy forever' – are gracefully emblazoned around naked arms, wrists and ankles; or in the case of a certain South American lady called Cassandra, a whole stanza from 'La Belle Dame Sans Merci' is permanently inked in cursive script from the nape of her neck to the small of her back. He can also be found as a reassuringly life-size bronze statue, sitting casually on a bench in the medical students' garden of his old alma mater, Guy's Hospital in London. He is particularly popular in panicky exam times and surgical demonstrations.

Most influential of all has probably been his glamorous, willowy, unshaved reincarnation by Ben Whishaw in Jane Campion's 2009 film *Bright Star*. Here the centre of the myth is firmly relocated in the final Keats–Fanny Brawne love story. Or, more unconventionally, in the emotional triangle formed between them and Keats's best friend and faithful amanuensis, Charles Brown. (Incidentally, this triangular geometry of attraction, rivalry and jealousy bears a curious resemblance to the emotional plotting of Campion's earlier 1993 film *The Piano*.)

In biographical fact this love story, or love triangle, occupies only the last twenty months of Keats's life – essentially between July 1819 (the first love letters to Fanny) and his death in Rome in February 1821. It is often forgotten that so many of the major poems – *Endymion*, *Hyperion*, 'The Eve of St Agnes', 'La Belle Dame Sans Merci', and the five great odes – were already written by the time of that first declaration of love. Thereafter, Keats was increasingly ill and emotionally unstable, and writing comparatively little poetry. 'To Autumn', dated 19 September 1819, really does mark a kind of

envoi or farewell to the great flowering of his poetic muse. He sailed
to Italy almost exactly a year later, on 13 September 1820. During
those last four Italian months the lovers were agonisingly apart, and
Keats had stopped writing altogether, except for a few brave and
tragic letters, mostly to Brown, but none to Fanny.

So the literary space and significance to be allocated to this brief,
but unconsummated, love affair is one of the great interpretive chal-
lenges facing all Keats's biographers. Put one way, it means deciding
just how important was Fanny Brawne in the overall, imaginative
sweep of Keats's life? Or put another way, how truly significant is the
lover's story for the writer's story? Or, a rather different matter, how
important for the poet's popular survival?

3

There have been at least ten major literary biographies of Keats over
the last fifty or so years, and several of them remain classics of the
genre. The American scholar Walter Jackson Bate's large, stately,
old-fashioned study of 1963 is still unsurpassed in its tender, patient
treatment of the poetry. Aileen Ward (also 1963) brings unrivalled
emotional insight into the poet at work. Robert Gittings, a British
radio producer who spent half a lifetime editing the manuscripts of
Keats's odes, fitted them into the most captivating of all the straight
biographical narratives (1969), and later wrote poems dedicated to
Keats, such as 'Conjunction, 1980', which imagines himself and the
poet gazing up at the same alignment of planets across two centuries,
'Though no one looks or wonders/But we and a few astronomers'.

Andrew Motion (1997), who inspired Campion's film as well as
writing the survival novella, is perhaps the most perceptive about
Keats's mysterious love life, including the long shadow cast by his
wayward mother, Frances, and the complex, agonising emotional
end-game of the Fanny Brawne affair. Motion's own poetry, so much

of it concerned with the early death (in a riding accident) of his own beloved mother, also seems to give him an intense, intuitive understanding of Keats's longings.

It is hard not to conclude that each of these biographers, in their different ways, fell deeply in love with their subject. As Fanny Brawne herself once observed, 'I am certain Keats has some spell that attaches his friends to him, or else he has fortunately met with a set … that I did not believe could be found in the world.'

Fresh but equally passionate approaches to Keats remain possible 'in the world', and will evidently continue long into the future, a form of deep biographical ripple or emotional aftershock. The American poet Stanley Plumly achieved an unusually rich and wide-ranging meditation on the myth in his *Posthumous Keats* (2008) by carefully avoiding the hypnotic pull of what he called the traditional 'linearity' of Keats's story, and producing instead an acute, observant biography in the shape of a personal 'walk around' Keats's life, and particularly his many friendships: 'This is a book of reflection, contemplation, meditation. Thus the structure of its thinking tends to be circular rather than linear … Keats is not a poet one reads in half-portion, nor a man one comprehends without love … I needed to find a little bit of Keats in myself.'

More recently, Denise Gigante, in *The Keats Brothers* (2012), shifted the focus again, by giving us the story as seen essentially from the outside, through the loving eyes of Keats's younger brothers Tom and especially George, the least like the poet. George Keats, born in 1797, was the brother who married and prospered. He and Georgiana Wylie emigrated in 1818 to America, where they struggled to establish themselves as pioneers along the Ohio River. They met the naturalist John James Audubon, lived briefly in his *de luxe* log cabin (silver tea set, piano, Turkey carpets), and got entangled in his steamship and sawmill businesses, which almost bankrupted them. But by 1836 they had established themselves and their children in Louisville, and built a large mansion with six Doric pillars,

known as 'the Englishman's Palace'. They are an adventurous and attractive couple, but the real fascination of their story lies in the transatlantic perspective, as it were, that they bring to brother John.

The contrast in the brothers' characters is especially revealing. George is a natural entrepreneur, straightforward, cheerful, outgoing and businesslike, a man – as Audubon observes – who can learn to chop logs. The poetical John, on the other hand, has an essentially dreamy, evasive temperament. Outside his own circle he is seen as moody, unreliable, and something of a spendthrift; he is also 'melancholy and complaining'. Even his publisher John Taylor calls him 'a man of fits and starts'. Significantly, George gets on well with Richard Abbey, the family solicitor, while John always finds him obtuse and untrustworthy. Abbey is invariably presented as a villain in previous Keats biographies; but here with George he is honest, kindly and even gracious in his own fashion.

Keats himself of course recognises these differences, and writes movingly of George as his first protector:

> George is in America and I have no Brother left ... [He] always stood between me and any dealings with the world – now I find I must buffet it ... I must begin to fight – I must choose between Despair and Energy – I choose the latter.

We see their different views on marriage, or on money, or on children. Keats wishes that one of Georgiana's offspring will be 'the first American Poet', and later writes delightfully that her daughter is the '"very gem" of all Children – Ain't I its Unkle?'

He also sends George and Georgiana across the Atlantic some of the most memorable letters in English literature. (They now reside in the Houghton Library, Harvard, so worn by admirers' fingers that I found them piously encased in plastic, like religious relics.) For example, the forty-page journal letter written between 14 February and 3 May 1819 includes the first version of 'La Belle Dame Sans

Merci'; Keats's memorable disquisition on life as 'a vale of Soul-making'; the comic-epic meeting with Coleridge on Hampstead Heath ('I walked with him at his alderman-after-dinner pace for near two miles I suppose'); an encomium on fine claret; his mocking verse satire on his ebullient friend Charles Brown ('a melancholy Carle'); an erotic dream and sonnet inspired by Dante ('Pale were the lips I kiss'd and fair the form/I floated with about that melancholy storm'); and the first of the great odes, 'To Psyche'.

This transatlantic perspective on Keats is revealing in many other ways. Favourable American reviews of his poems appear as early as 1821, and George and Georgiana always took huge expatriate pride in what they confidently saw as his growing reputation. Far from reducing Keats, George's brisk but affectionate fraternal view of a more vulnerable man has the paradoxical effect of making him even more striking and vivid. As George reflected fondly of his older brother: 'John was open, prodigal, and had no power of calculation whatsoever.'

4

Nonetheless, the familiarity of the Keats story, the sense of its looming tragic inevitability, presents a particular challenge for any contemporary biographer. Nicholas Roe, for example, confronts this in *John Keats: A New Life* (2012) by adopting an apparently cool narrative style, combining meticulous scholarship with a strongly visual, almost photographic manner of presentation.

Roe has the biographer's vital gift for picking out the mundane but sharply revealing detail. He notes that at the very time he was writing his unfinished epic *Hyperion*, Keats got a black eye – during his first-ever game of cricket. He was batting, and as he was making a wild stroke, the ball flew up and hit him 'directly on the sight'. It's a wonderfully odd, even ludicrous, moment. But at once we glimpse

the poet anew: game for anything, a team player among friends, enthusiastic but always vulnerable.

Roe also uses his deep knowledge of Keats's wide and raffish circle of London friends – Leigh Hunt (about whom he wrote a previous biography), Benjamin Haydon, William Hazlitt, Charles Lamb, John Reynolds, Joseph Severn and especially Charles Brown – to produce something like a group biography. The affection everyone feels for Keats – that 'spell' – warms the whole book. He makes us see the poet from multiple angles, in all his fierce contradictions, so sympathetic and so strangely modern. Dramatising this contingent, shape-shifting quality is one of Roe's unique strengths among Keats's biographers. He adds in a typical, combative Preface that 'the great Romantic poet was also a smart, streetwise creature – restless, pugnacious, sexually adventurous'.

Biography needs constantly to re-alert us, in this way, to the unexpected and the unfamiliar. Keats's literary life was not only short, but remarkably uncertain. He only published three books in his lifetime: *Poems* (1817), *Endymion* (1818) and *Lamia, Isabella, The Eve of St Agnes, and other Poems* (1820). The first two were virtually destroyed by the critics, and Keats died believing he had failed: 'Here lies one whose name was writ in water.'

From the age of fourteen he was always trying to decide on a professional career. His ambition constantly altered, and only in retrospect (when he was dying) was it uniquely that of a lyric poet. At one time or another he seriously considered becoming a physician at Edinburgh Hospital; a ship's surgeon aboard an Indiaman; a professional dramatist at Drury Lane; a literary journalist for the *London Magazine*; a tea merchant in the City of London; a freedom fighter with Simón Bolívar in Venezuela; and most bizarre of all, as advised (surely provokingly) by the family solicitor Abbey, a hat-maker in the West End.

In this context, Keats's 1818 tour of the Scottish Highlands with his new friend Charles Brown now seems unexpectedly formative.

They footslogged 614 miles with backpacks and notebooks, scaled Ben Nevis, and had a notable liquid encounter with the spirit of Robert Burns, and the weird Celtic hallucinations of Fingal's Cave. All the time Keats was harvesting sounds and images, making a physical preparation for the huge creative effort he was about to undertake. The trip also produced a particular emotional bond between the two young men.

Keats came back to the daily and nightly bed-nursing of his tubercular brother Tom in a tiny, claustrophobic apartment at Well Walk, Hampstead. This calvary, a premonition of his own to come, dominated the three long months of autumn 1818, and prepared him for the composing of the great odes. Robert Gittings considered this 'the single most significant experience' of Keats's life. Roe links it skilfully to *Hyperion*, which Keats was writing in a corner of the sickroom even as his brother lay dying. With this setting in mind, the opening of this unfinished epic poem, in the form of a blank-verse sonnet, takes on a stunning new visual and psychological force:

> Deep in the shady sadness of a Vale,
> Far sunken from the healthy breath of Morn,
> Far from the fiery noon, and Eve's one star,
> Sat grey hair'd Saturn quiet as a stone,
> Still as the silence round about his Lair.
> Forest on forest hung above his head,
> Like Cloud on Cloud. No stir of air was there,
> Not so much life as on a summer's day
> Robs not at all the dandelion's fleece:
> But where the dead leaf fell, there did it rest.
> A stream went voiceless by, still deadened more
> By reason of his fallen divinity
> Spreading a shade: the Naiad 'mid her reeds
> Press'd her cold finger closer to her lips.

Against this, and in extraordinary contrast, one might set 'The Jealousies, or the Cap and Bells', a late poem that has been studiously overlooked by most biographers (except Motion and Roe), and by almost all anthologists too. This is Keats's strange, late Byronic satire of summer 1820, written when he himself was desperately ill, after his first tubercular haemorrhages. It was faithfully encouraged by Charles Brown, in an effort simply to keep Keats at work – to keep the poet alive, so to speak. Astonishingly, despite the grim circumstances, Keats comes up with a witty, nimble form of light verse that is weirdly nonchalant and even flippant.

Here he is on his favourite subject of claret, but now put into the hands – or rather the throat – of his fanciful invention the Emperor Elfinan, who is preparing to swallow down a bumper:

> Whereat a narrow Flemish glass he took,
> That since belong'd to Admiral De Witt,
> Admir'd it with a connoisseuring look,
> And with the ripest claret crowned it,
> And, ere one lively bead could burst and flit,
> He turn'd it quickly, nimbly upside down,
> His mouth being held conveniently fit
> To catch the treasure: 'Best in all the town!'
> He said, smack'd his moist lips, and gave a pleasant
> frown.

5

All modern biographers – but especially Gittings, Motion and Roe – are thoughtful on the ambiguous subject of 'Keats's women'. That is, on the dream women who haunted him before the overwhelming reality of Fanny Brawne. These shadowy, seductive figures seem almost to evade biography altogether, subtly sliding from life and

letters directly into poetry. They become mysteriously 'transformed' into the fatal Belle Dame, the cruel Isabella, the sensuous Madeline, the sinuous Lamia, the icy Moneta ... even, it has been suggested, into the 'full-throated' nightingale. Long before Fanny Brawne, there is the unknown beauty glimpsed at Vauxhall Gardens; there is Jane Cox, the bold, exotic parlour 'Leopardess' who probably became the 'Lamia' ('striped like a zebra, freckled like a pard'); there is the 'shape of a woman' who haunted Keats for several days in October 1818; there is 'one of the most beautiful Girls I ever saw' at a party in April 1819; above all there is the mysterious Isabella Jones, about whom almost nothing is known for certain – neither her dates, her education, her voice, or even the colour of her eyes.

Keats may possibly have had some kind of affair with her before meeting Fanny Brawne. He wrote an amusing, seductive account of her 'very tasty' apartment in Islington, which he visited alone and unchaperoned in October 1818. It had 'an Aeolian Harp, a Parrot, a Linnet, a Case of choice Liquers etc etc'. He certainly kissed her, and what's more recorded it (though not quite in terms of the nectarine). She loaded him with grouse and other treats for the dying Tom (a psychologically acute gesture), and according to his friend Benjamin Bailey supplied the informing idea for both 'The Eve of St Agnes' and 'The Eve of St Mark'. Chronology would suggest that the sexual force of these poems was probably inspired by Isabella, rather than Fanny Brawne. There is even the possibility that the signature sonnet 'Bright Star' was originally written for her, not Fanny.

Gittings believed Isabella Jones was Keats's lost first love; Motion is less certain. Roe investigates her in forensic detail, establishing a slightly *louche* but attractive background, a seductive personality, unattached but with a rich Irish 'patron', and an interest in young literary types. It seems that she 'collected' promising young poets, flirted with Keats's publisher Taylor, and had a simultaneous interest in the young author Barry Cornwall. Significantly, Keats burned Isabella's letters soon after he had met Fanny Brawne. He appears to

mock her, retrospectively, in a love letter to Fanny of July 1819: 'I have met women whom I really think would like to be married to a Poem and be given away by a Novel.' Perhaps it was a passing infatuation, or merely a fancy; a cold pastoral on both sides? In a letter to Taylor of 1821, having read the terrible accounts of Keats's death in Rome, Isabella criticised Severn for making a fuss about it all, and coolly referred to Keats as 'the fine-hearted creature we both admired'. She remains ultimately puzzling and mysterious to all biographers.

Even Keats's passionate love for Fanny Brawne seems more significant to some biographers (and film-makers) than to others. They first met in December 1818, when the dark-haired Fanny was just eighteen, 'pale and thin', much taken up with clothes, parlour games and dancing, pretty and animated and flirtatious, but evidently very young for her age. It was certainly not love at first sight. Keats described her as 'beautiful, elegant, graceful, silly, fashionable and strange'; but added impatiently that she was childish and 'ignorant', and 'monstrous in her behaviour, flying out in all directions, calling people such names'. He called her, quite frankly, a 'Minx'. Of course it is difficult for biography to trace the exact inner evolutions of the heart, but their love story does not really begin to express itself openly until the following year, in July 1819, when Keats was away on the Isle of Wight, alternately writing *Lamia* and the first of his twenty or so passionately declarative letters to Fanny. It is only now that he suddenly bursts out: 'Love is my Religion.'

Their love remains, essentially, a drama of absences, longings and withholdings. It continues, more and more painfully, until Keats's death eighteen months later. It expresses itself in some striking erotic poetry, not only 'Bright Star' but also the palpitating sonnet 'The Day is Gone ...'

The day is gone, and all its sweets are gone!
Sweet voice, sweet lips, soft hand, and softer breast,
Warm breath, light whisper, tender semi-tone,
Bright eyes, accomplish'd shape, and lang'rous
 waist!
Faded the flower and all its budded charms,
Faded the sight of beauty from my eyes,
Faded the shape of beauty from my arms,
Faded the voice, warmth, whiteness, paradise,
Vanish'd unseasonably at shut of eve,
When the dusk holiday – or holinight –
Of fragrant-curtained love begins to weave
The woof of darkness thick, for hid delight;
But, as I've read Love's missal through today,
He'll let me sleep, seeing I fast and pray.

Andrew Motion gives up nearly a fifth of his six-hundred-page biography to the affair, quoting extensively from Keats's heartbreaking letters to Fanny, and all five of his desperate late poems to her. Both Bate and Gittings are rather less effusive. Bate is evidently uneasy with the love poems, considering them either 'tired and flat' or embarrassingly 'frantic'. Gittings is understanding, but avuncular: 'In all his poems to her, Fanny appears as the "sweet foe", an exact expression of Keats's complicated feelings towards her …'

By comparison Nicholas Roe is positively austere, covering the whole period in less than forty pages (compared to Motion's 120). He quotes from only one of the 'Fanny' poems, and almost nothing from the love letters. Once Keats is in Italy, Fanny's presence seems to fade, and Roe narrates the final illness in the form of a diary, a plain record of the sickroom, almost without commentary. Emotionally, the effect is undoubtedly powerful. Yet it is almost as if Roe were retrospectively trying to protect Keats from Fanny Brawne. Or as if the biographer were – unconsciously of course – jealous of the lover.

For beneath the scholarly objectivity, Roe too reveals an intensely personal commitment to his subject. Throughout his fine biography there is a tell-tale trail of 'photographs by the author', faithfully following in Keats's footsteps through southern England, Scotland, and finally out to Italy. There is a particularly dreamy, evocative study of the Old Mill House, Bedhampton, on the Chichester estuary, where Keats started work in January 1819 on 'The Eve of St Agnes', a poem especially dear to Roe. All Keats biographers go to Rome. Robert Gittings drove there, and Andrew Motion actually sailed there in a small boat reminiscent of the *Maria Crowther* on which Keats took his passage. But Roe's passionate researches took him not merely to Rome, but as far as New Zealand, on the trail of the later life of Charles Brown. Here, the local papers reported, Roe delivered a gallant oration on Keats's great friend, while standing at Brown's forgotten graveside.

6

Despite the familiarity of the Keats story, this points to one of the most remarkable biographical enigmas that still remain. What was the true nature of that unlikely friendship with the apparently bluff, cynical, womanising Charles Armitage Brown? They were very different personalities. Brown was nearly nine years older than Keats, large, outgoing, noisy and self-confident, with considerably more experience of the world. Born in Lambeth, the son of a small businessman, he had gone with his elder brother to St Petersburg, and made a quick fortune in the fur trade, which he then promptly lost in high living, and returned to London penniless. Nothing daunted, Brown transformed his Russian adventure into a comic opera, *Narensky*. Unlikely as it sounds, this was successfully staged at Drury Lane in 1814, restored his fortunes, and turned him towards literature.

According to Brown, he first met Keats quite by chance while walking across Hampstead Heath in the summer of 1817. Brown's first impressions of the shy, self-contained twenty-one-year-old poet were never forgotten, and were vividly physical:

> He was small in stature, well proportioned, compact in form, and, though thin, rather muscular;– one of the many who prove that manliness is distinct from height and bulk … His full fine eyes were lustrously intellectual, and beaming (at that time!) with hope and joy. It has been remarked that the most faulty feature was his mouth; and, at intervals, it was so. But, whenever he spoke, or was in any way excited, the expression of the lips was so varied and delicate, that they might be called handsome.

Brown slipped effortlessly into the role of Keats's genial, easy-going, extrovert companion: a sort of substitute elder brother, both teasing and encouraging. The friendship was deepened in 1818, by the humour and high spirits of the athletic Scottish summer tour, and then by the grim tragedy of Tom Keats's agonising death from tuberculosis the following winter. This formed an intimate emotional bond, though a largely unexpressed one. Except that Brown insisted that Keats come and live with him after Tom's death. As Brown later narrated it, the moment was unforgettable:

> Early one morning I was awakened in my bed by a pressure on my hand. It was Keats, who came to tell me his brother was no more. I said nothing, and we both remained silent for awhile, my hand fast locked in his. At length, my thoughts returning from the dead to the living, I said – 'Have nothing more to do with those lodgings, – and alone too. Had you not better live with me?' He paused, pressed my hand warmly, and replied, – 'I think it would be better.' From that moment he was my intimate.

Brown's home was Wentworth Place, a large, airy, newly-built house of white stucco, set back from the road amidst gardens on the western edge of Hampstead Heath (and later known as Keats House). One half of it was rented out to temporary tenants, and in April 1819 these became Mrs Brawne and her family of three children, including of course Fanny.

The seventeen months that followed Tom's death, between December 1818 and May 1820, were the period of Keats's greatest creativity. In this respect Brown's influence significantly antedates that of Fanny Brawne, who became the girl next door. On many occasions Brown and Keats worked opposite each other, at the same table or in the same garden, and discussed poetry (and claret) late into the night. They collaborated on a play, *Otho the Great*, with Brown hoping to bring Keats another Drury Lane success. During the ominous summer of 1820 Brown helped Keats combat the terror of his tubercular symptoms ('that drop of blood is my death warrant'), and kept alive the possibility that he might expand the range of his writing into theatre and journalism, and even make a living from it.

Theirs now became a truly intimate friendship, emotionally more intense than either would quite admit. Keats hesitatingly uses the word 'heart' in expressing his feelings of gratitude to Brown: 'I wish, at one view, you could see my heart towards you. 'Tis only from a high tone of feeling that I can put that word upon paper – out of poetry.' In turn, Brown later said he had not realised how far Keats had 'tightly wound himself' about his own heart.

Brown often drew sketches and made silhouettes of Keats, especially one very striking and romantic chalk drawing of him, sitting sideways on a chair, his hair a bramble of curls, and his closed fist resting thoughtfully on his cheek. The finely finished work of this drawing seems an act of special care and devotion, revealing feelings which could not otherwise be expressed. The friendship was only shaken by jealousy and misunderstanding in May 1820, when Keats

bitterly reproached Fanny Brawne (still a 'minx' perhaps) for her 'habit of flirting with Brown …'

It is clear that both Brown and Fanny always felt guilty that they had not accompanied Keats to Rome. Perhaps in some way they were rivals in love. Fanny wore mourning for years, though she did eventually marry. A later ambrotype photograph of her, probably in her late forties, shows her 'thin and pale', still astonishingly young for her age, but now self-contained, her long, aquiline face poised and darkly beautiful. She has become, in retrospect, a romantic heroine.

Brown became a Victorian. He married and almost immediately abandoned his wife, Abigail O'Donohue, a young Irish serving girl employed at Wentworth Place, whom he had casually made pregnant. He took responsibility for their son, Carlino Brown, and drifted with him through expatriate Italy, trying to write novels, reminiscing with other Romantic survivors – Trelawny, Landor, Leigh Hunt and Severn. But Brown was psychologically prevented from writing his friend's full biography, the one thing he longed to do, by some unspoken form of regret. The short memoir which he finally pulled together just before he and his son emigrated to New Zealand in 1841 has many of the features of a delayed love letter. In it Brown wrote:

> Often have I been urged to write a biography of Keats, and almost as often have I urged a promise of every information in my power to others. Earnestly wishing it done, I have myself recoiled from the office; for it is painful. He was dearly beloved, and honoured as a superior being by me. Now that twenty years have passed since I lost him, his memory is still my chief happiness; because I think of him in the feeling of Shelley's lines [from *Adonais*].

In this, Charles Brown set the tone for most of these subsequent modern biographies. It explains why they are all so different, yet all so excellent; and why Keats has survived so vividly. He has survived because he has been so variously, yet so greatly, loved.

12

Shelley Undrowned

1

For his biographers, the subject of Shelley's death is a strangely haunting one. In my own biography of 1974, I stopped the main narrative the moment the waves closed over his head in the Gulf of Spezia. I could not bear to witness the long-delayed recovery of his battered body, or the fantastic rigmarole of the beach cremation which Trelawny stage-managed, or the grotesque tangled history of his heart (or was it his liver?), which was apparently snatched from the funeral pyre. My strategic retreat was later noticed in a perceptive essay by my fellow biographer Hermione Lee, in a witty chapter entitled 'Shelley's Heart and Pepys's Lobsters', from her fine book *Body Parts: Essays on Life-Writing* (2005).

Leaving aside that other deep-sea question (that of Pepys's lost lobsters), Lee correctly remarked that Holmes would have 'no truck with any of the versions of Shelley's death', and that my refusal to deal at all with Shelley's lost heart ('a body part that goes missing') was my way of escaping a particular 'biographical trap'. She was quite right about this trap, although at the time it was a purely instinctive escape on my part. I think it must have arisen at some level from my subliminal identification with Shelley: we were both twenty-nine at the time. Now, many years later, and in calmer (but perhaps shallower) waters, I have reflected further upon it.

2

In the summer of 1822 the *Courier*, a leading Tory newspaper in London, carried a brief obituary that began: 'Shelley, the writer of some infidel poetry, has been drowned: now he knows whether there is a God or no.' From this moment on, the dramatic death of Percy Bysshe Shelley in the Gulf of Spezia was set to become one of the most powerful of all Romantic legends. And also perhaps the most misleading.

Shelley perished in his own sailing boat, the *Don Juan*, while returning from Livorno to Lerici in the late afternoon of 8 July 1822, during a violent summer storm. He was a month short of his thirtieth birthday. Like Keats's death in Rome the year before, or Byron's at Missolonghi two years later, this sudden tragedy set a kind of sacred (or profane) seal upon his reputation as a youthful, sacrificial genius. But far more comprehensively than theirs, Shelley's death was used to define an entire life, to frame a complete biography. It produced not hagiography, but what might be called thanatography.

Through an astonishing array of pictures, poems, inscriptions, memoirs and Victorian monuments, this death spun a particular image of Shelley's character more effectively than any modern PR campaign. It projected a writer who was unearthly, impractical and doomed. In Matthew Arnold's notorious summation, Shelley was 'a beautiful and ineffectual angel, beating in the void his luminous wings in vain'. Shelley could always fly, but he could never swim.

The legend of his death transformed his life almost beyond recovery. Here for instance is what was inscribed (in Italian) on the wall of his last house, the skull-like Casa Magni, with its five gaping white arches and open terrace, gazing out to sea at San Terenzo, on the bay of Lerici:

Upon this terrace, once protected by the shadow of an ancient oak tree, in July 1822, Mary Shelley and Jane Williams awaited with weeping anxiety the return of Percy Bysshe Shelley, who, sailing from Livorno in his fragile craft, had come to shore by sudden chance among the silences of the Elysian Isles. – O blessed shores, where Love, Liberty and Dreams have no chains.

This unearthly legend had been built up steadily throughout the nineteenth century. Shelley's wife, Mary, herself launched it, writing immediately after his death: 'I was never the Eve of any Paradise, but a human creature blessed by an elemental spirit's company & love – an angel who imprisoned in flesh could not adapt himself to his clay shrine & so has flown and left it.'

Shelley's friend and champion, the incorrigible myth-making Edward John Trelawny, set the metamorphosis literally in stone. His inscription for the tablet above Shelley's ashes in the Protestant Cemetery in Rome was taken from *The Tempest*: 'Nothing of him that doth fade/But doth suffer a sea change/Into something rich and strange.'

This inscription gathered its own irony. In his journal for 1822, Trelawny had written a simple graphic description of the seasonal storm that had overwhelmed Shelley's boat, and the cremation of Shelley's body on the beach at Viareggio, which Trelawny had brilliantly stage-managed as a pagan ceremony, with libations of wine, oil and spices.

But he obsessively rewrote his account nearly a dozen times over the next fifty years, accumulating more and more baroque details, like some sinister biographical coral reef. He raised the possibility that Shelley's boat had been rammed, or alternatively that Shelley had been suicidally unseamanlike. 'Death's demon,' he intoned delphically in his *Records of Shelley, Byron, and the Author*, the final version of which was published in 1878, 'always attended the Poet upon the water.'

By 1889 Louis Fournier's celebrated painting *The Cremation of Shelley* showed a miraculously undamaged corpse offered up to heaven on a martyr's pyre, with Trelawny and Byron striking solemn Romantic poses (actually they went swimming), and a pious Mary kneeling on the windswept beach in floods of tears (although in fact she was never there at all).

3

These myths became funereal monuments. A marble tomb commissioned by the Shelley family from Horatio Weekes (1854) was based on an Italian *pietà*, with the poet's Christlike body lovingly cradled in Madonna Mary's arms, and tenderly installed in Christchurch Priory, Dorset. Forty years later another monument by E. Onslow Ford, paid for by the Shelley Society, was piously placed in the quad of University College, Oxford (from where the poet had once been dismissed for atheism). It shows a white, supine Shelley draped like a fallen angel across a green sacrificial altar, with a weeping sea nymph below the plinth. It has now had to be protected by iron bars.

Such mythic echoes are still resonant. Germaine Greer, in her study *The Boy* (2003), relates Shelley's death to the tradition of the beautiful vulnerable male, linking him to the classical death of Bion, the erotic drowning of Leander, and the masochistic martyrdom of St Sebastian.

So Shelley's whole life, in retrospect, seemed to be fleeting, angelic, ephemeral, and doomed. It was a natural extension to suggest that it was also probably suicidally 'driven', or contained unmistakable prophecies of his own death. Again, it was Mary who was the first to pick out this theme. She wrote in her 'Note to the Poems of 1822' how Shelley had, 'as it now seems, almost anticipated his own destiny; and, when the mind figures his skiff wrapped from sight by the thunder-storm, as it was last seen upon the purple sea, and then,

as the cloud of the tempest passed away, no sign remained of where it had been – who [would not] regard as a prophecy the last stanza of the "Adonais" [1821]?'

> The breath whose might I have invoked in song
> Descends on me; my spirit's bark is driven,
> Far from the shore, far from the trembling throng
> Whose sails were never to the Tempest given;
> The massy earth and spherèd skies are riven!
> I am borne darkly, fearfully, afar;
> Whilst, burning through the inmost veil of Heaven,
> The soul of Adonais, like a star,
> Beacons from the abode where the Eternal are.

The shadow of prophecy, the sense of 'fatal destiny', subtly shaped the way Shelley's work was selected and read. He was a cloud, a skylark, a hectic leaf blown before the wild west wind. Boats and storms become evident everywhere in his poems: from the tiny skiff driven through the 'boiling torrents' described in 'Alastor' (1816) to the battered vessel swamped by 'a chaos of stars' in 'A Vision of the Sea' (1820).

The nightmare imagery of his last unfinished poem, *The Triumph of Life* (1822), seemed to set a seal upon metaphysical despair. An enormous Chariot of Death advances like a huge storm-wave, engulfing the whole of human history, all youth and idealism:

> So came a chariot on the silent storm
> Of its own rushing splendour, and a Shape
> So sate within, as one whom years deform ...

From the earliest references to his childhood love of paper boats (often made of large-denomination banknotes) to his last Faustian letters from the unearthly beauty of the bay of Lerici, these inti-

mations of death seem to extend everywhere: 'My boat is swift and beautiful, and appears quite a vessel ... We drive along this delightful bay in the evening wind, under the summer moon, until earth appears another world ... If the past and the future could be obliterated, the present would content me so well that I could say with Faust to the passing moment, "Remain thou, thou art so beautiful."'

Biography is caught and frozen, so to speak, in the glamorous headlights of Shelley's death. But if we set that death aside, if we switch off its hypnotic dazzle for a moment, maybe quite different patterns and trajectories can emerge from Shelley's life.

First of all, the circumstances of his drowning can be shown to involve prosaic bad luck, and bad judgement, as much as ill-starred destiny. Despite what Trelawny implied, Shelley had considerable previous experience with sailing boats, from schoolboy expeditions up the Thames to sailing single-handed (or with his ex-Royal Navy friend Edward Williams) down the Arno, the Serchio, and beyond Livorno harbour out to sea.

He had successfully survived perilous incidents on the Rhine (with Mary) in 1814, on Lake Geneva (with Byron) in 1816, and on the Pisan canal (with Williams) in 1821. Mary always recognised his 'passion' for boating, encouraged it as exercise, and observed that 'much of his life was spent on the water'. His courage and coolness afloat was also remarked on by Byron.

It is true, however, that Shelley was a river sailor. The *Don Juan* was his first ocean-going boat, although it was not the 'skiff' or 'fragile craft' of legend. It was a heavy twenty-four-foot wooden sailing boat, based, according to Williams, on a scaled-down model of an American schooner (twelve metres reduced to eight). It had a lot of canvas: twin masts carrying main and mizzen sails, and a bowsprit flying three jibs. It was sleek, fast, with little sheer and, most significantly, no decking. Yet because of its unusual spread of sail, it had to be heavily ballasted with 'two tonnes' of pig iron. It cost Shelley £80, or about one-tenth of his annual income. The local Italians were

impressed with it, and even the experienced Lerici harbourmaster, Signor Maglian, was delighted to sail aboard it with him and Williams, in the open sea as far as Massa, in rough weather conditions.

The *Don Juan* had been delivered to Lerici on 16 May 1822, 'a perfect plaything for the summer'. After trials mostly spent racing Italian feluccas ('she passes the small ones as a comet might pass the dullest planets of the Heavens') the boat was refitted by its designer, Captain Roberts, helped by Williams, in the last days of June. The aim was clearly increased speed through the water, though in fact this largely depends on hull length, which could not be altered. Instead, adaptations included two new topmast sails (gaff topsails), an extended prow and bowsprit, and a false stern. In some accounts Williams also included shelves for Shelley's books inside the gunwales, a sporting concession.

But unknown to Shelley, the *Don Juan* had a more fundamental design fault. A twin-masted schooner could not simply be scaled down to a small, undecked open boat. The marine proportions became all wrong. The sail-to-hull ratio was far too high; it was ballasted with too much pig iron; and it floated with too little free-board. The narrow beam made it 'very crank', that is, likely to capsize, and so dangerously unseaworthy in a real squall. The refit, which everyone thought so handsome, appears to have exaggerated all these defects: more sail, more ballast, less clearance, less stability. As it was undecked and carried no buoyancy aids, the *Don Juan* was now in danger not simply of capsizing, but of foundering. In heavy seas it might fill with water from the stern or leeward side, and go straight down. It had become a nautical death trap.

Shelley set sail for Livorno (approximately forty-five miles south of Lerici) on 1 July 1822. Mary, who was ill and depressed, did not wish him to go. But the trip was neither solitary, nor suicidal in intent. On the contrary, it was full of hope and high spirits. It was made to greet Shelley's old friend Leigh Hunt, who had just arrived in Italy to found a new literary journal. Four of them (including

Captain Roberts) made the outward leg, a smooth swift reach, in perfect weather conditions.

On the return trip there were only three aboard: Shelley, Williams and Charles Vivian, an English boatboy aged eighteen. It was intended as a single fast seven-hour voyage to Lerici, under their full glorious spread of canvas, that would race them home by dusk. Mary and Jane Williams were waiting impatiently on the terrace of the Casa Magni for their men.

But now their luck ran out. After three hours a violent squall came up from the west. They had started too late to outrun it. There was no shipping nearby to come to their aid. Trelawny had intended to accompany them in Byron's full-size schooner, the *Bolivar*, but at the last moment was prevented by Italian port authorities because of quarantine regulations. Had he been alongside, he would undoubtedly have saved them.

The *Don Juan*'s final moments are still disputed. Later rumours of a pirate ramming, fostered by Roberts and Trelawny (both carrying an uneasy sense of blame), evaporate on examination. But there are persistent reports of a failure to take down the new gaff topsails (which required Vivian to climb the masts), or to reef the mainsails in time. They were clearly undermanned, but still attempting to run for home.

The unseaworthy *Don Juan* was engulfed by enormous waves, had its false stern and rudder ripped off, lost both masts, and foundered in ten fathoms of water about fifteen miles off Viareggio. These details became clear when the wreck was salvaged by Italian fishermen two months later. It did not capsize, and was not looted, as books, papers, wine bottles, a telescope (broken), a cash bag, some teaspoons and a sea trunk were all found lying within the open hull when it was pulled from the seabed. They were half entombed in blue mud.

The boat went down so quickly that Williams did not have time to kick off his boots, and Shelley thrust a new copy of Keats's poems

into his jacket pocket so hard that it doubled back and the spine split. This much (but not much else) was clear from the three bodies cast up along the coast ten days later: they could be identified by their clothes, but not by their faces, which had been eaten away by fishes.

There might have been one last chance. Williams had constructed an eight-foot coracle, or dinghy, made of reeds and canvas, which was used as the *Don Juan's* 'pram', or tender, and towed behind the boat. Shelley had frequently used this cockleshell for exploring Lerici bay, and had so often capsized it in the surf that it is difficult to believe he hadn't at least learned to dog-paddle. This dinghy was the one thing that remained afloat after the shipwreck, and it was soon washed up on Viareggio beach. So the troubling question arises: did Williams (or Vivian) cut it loose? Did they (the good swimmers) attempt to push Shelley onto its upturned hull? Or did Shelley (the weak swimmer) gallantly resign it to them? These questions suggest haunting images of a different kind.

With better luck, or less gallantry, Shelley could well have survived. But did he have reason to survive? He sometimes claimed to have abandoned writing, overwhelmed by Byron's aristocratic self-confidence and continuing literary success: 'I do not write – I have lived too long near Lord Byron & the sun has extinguished the glow-worm.'

Actually Shelley had a huge amount of work in hand. He had written over 180 stanzas of *The Triumph of Life* by the end of June, and its last lines – 'Then what is Life? I cried' – herald a continuing vision. He had started a political verse play about Charles I and the struggle for a republican England, featuring Cromwell and Hampden. He had begun an erotic drama, *The Indian Enchantress*. He was working on major verse translations from Goethe and Calderón. He was writing many beautiful lyrics and songs, though significantly they were addressed to Jane Williams, and not to Mary.

Nor had he abandoned his fundamental radicalism. He still thought of himself as 'atheist, democrat, philanthropist' – the

provocative self-description he had entered in the hotel registers in Switzerland under 'occupation' long ago in 1816. His remarkable but little-known essay 'A Philosophical View of Reform', written in 1820 (but not published for a century), promulgates universal suffrage, radical reform of the Houses of Parliament, women's rights, the disestablishment of the Anglican Church, the formation of trade unions and the reform of marriage laws and conventions (including the promotion of contraception). It was here he first declared that 'poets and philosophers' were the unacknowledged legislators of mankind.

He greeted the new liberation movements throughout Europe (in Spain, southern Italy, Greece) with enthusiasm, and celebrated them with 'Odes to Liberty'. When the Greek War of Independence was declared in 1821, he immediately wrote his verse drama *Hellas* to salute it. In his Preface he announced triumphantly, 'We are all Greeks', and described his vision of an entire generation of young men, 'the flower of their youth, returning from the universities of Italy, Germany, and France', flocking to assist it. The choruses he composed were apocalyptic with hope, not despair:

> The world's great age begins anew,
> The golden years return,
> The earth doth like a snake renew
> Her winter weeds outworn:
> Heaven smiles, and faiths and empires gleam,
> Like wrecks of a dissolving dream.

Above all, Shelley now had the scheme for the new journal, *The Liberal: Verse and Prose from the South*. The original title was *Hesperides*, and it was set to be the great literary mouthpiece of Romantic opposition. It was to be managed by Leigh Hunt, the leading liberal newspaper editor of the day, and printed in England by his brother John. As editor and printer of the *Examiner*, both men

had previously gone to prison for seditious libel, and were ready for a fight. Leigh Hunt was to be financed by Byron and Shelley, his main contributors, producing a phalanx of literary radicals that was deliberately intended to affront and outrage Tory opinion. Other contributors were to include Mary Shelley and William Hazlitt.

Four issues did eventually appear between October 1822 and July 1823. They carried Shelley's superb translation from *Faust*, Byron's scathing 'Vision of Judgement', Mary's intriguing short story 'The Bride of Modern Italy', and one of Hazlitt's finest essays, 'My First Acquaintance with Poets'. It was an astonishing constellation of talents, promising a new instalment of Romantic history. It was dissolved only by Shelley's death.

<p style="text-align:center">4</p>

Such a reflection makes us look into the underlying patterns of his life, or its trajectories. It also raises some subtle questions about the nature of biography itself, and what we can learn from the notion of an alternative biography – or counter-factual history. If Shelley had indeed survived the shipwreck, how might his life have continued?

In 1821 Mary still treasured a dream of going to live with Shelley and their one surviving child (Percy Florence) on a Greek island after the War of Independence: 'If Greece be free, Shelley and I have vowed to go, perhaps to settle there, in one of those beautiful islands where earth, ocean and sky form the Paradise.' There is a touching hint of Club Med in this fantasy, but practical and domestic considerations would surely have intervened. They would never have embarked (like the freebooting Trelawny) under Byron's banner.

It seems inevitable that at some point they would have returned to England, where Shelley fully expected to inherit the family estate in Sussex, and to take up a seat in Parliament. In the event, his father, Sir Timothy, survived an unconscionable time, although Shelley

would surely have become involved with the Great Reform Bill of 1832. After serving modestly on the London Greek Committee, he might have starred in the radical *Westminster Review*, and sharpened up the young liberal philosopher John Stuart Mill. He might have hobnobbed with Coleridge at Highgate ('A little more laudanum, Bysshe?'), compared notes on their translations of *Faust*, grown heated about 'atheism', and cool again about that damn Laureate Southey. Later still might have come the famous 'Odes to Electromagnetism', the seditious verse play about Chartism, the suppressed 'Essay on the Variety of Sexual Intercourse'. Finally, perhaps, we can imagine him being scandalously elected as the first Professor of Poetry and Politics at the newly founded, and strictly secular, University of London.

Mary too, despite her love of Italy, would eventually have been drawn back to England, with or without (a different counter-factual story) Shelley. In the 1820s she was anyway to become famous in her own right through no fewer than five different stage productions of *Frankenstein* in London. Her long-awaited third novel, *The Last Man* (1826), might well – in other circumstances – have been her second masterpiece. Based on another brilliant and prophetic science-fiction idea, she imagined the entire human race relentlessly destroyed by a global plague or pandemic, a conception that has lost none of its sinister power today. But lacking the intellectual stimulation of the lost Shelley–Byron circle, the novel became diffuse, mawkish and nostalgic. It was dominated by wish-fulfilment portraits, rather than the intense psycho-drama of *Frankenstein*.

In their own way, these novels were also Mary's version of counter-factual biography. Byron is resurrected as the glamorous Lord Raymond, the commander of a liberated Constantinople; Shelley as the withdrawn but altruistic Adrian, the protector of a republican England (a real legislative office). Mary herself changes sex to become the intrepid Verney, the eponymous Last Man, a born survivor and solitary wanderer who returns undaunted to a deserted

Rome. In the penultimate chapter, the most powerful of the entire novel, Mary restages the wreck of the *Don Juan*, overwhelmed by a summer storm, reanimating her painful imaginings of Shelley's drowning in agonising and self-lacerating detail.

Of course it is also true that if Shelley had lived, Mary would not have had to spend nearly twenty years editing his papers, and writing fashionable journalism. Instead of sending her son to Harrow, and turning her husband into a posthumous angel, she could have given her mind to developing her fiction. Her novels – *The Fortunes of Perkin Warbeck* (1830), *Lodore* (1835), *Falkner* (1837) – might have rivalled Bulwer-Lytton, or at least Harrison Ainsworth.

What do these counter-factual speculations reveal about our implicit assumptions (and delusions) about the nature of biography itself? Perhaps that, for all our sophisticated theories of interpretation, we still have an unconscious hunger for simple explanatory myths, for improving models in the Victorian manner. It is still dangerously easy to wish 'Lives' to conform to archetypes, or fables, or even fairy tales. Built out of understandable piety, admiration or regret (but also out of guilt, embarrassment or remorse), such biographical myths are easily formed but difficult to change. They may sometimes require the irreverent shock, the cleansing impiety, of sceptical enquiry, mocking revision, or even inappropriate laughter.

This suggests the constant need to consider alternative versions. For instance, a Shelley who was reckless rather than ineffectual; generous rather than angelic; self-centred rather than suicidal; intellectually isolated rather than politically despairing. A Shelley firework, say, more than a Shelley jelly. Above all, we might consider a Shelley who was a writer of genius still at the outset of his career, rather than at its end. And, with double irony, the same possibility for his wife, Mary.

With this goes the infinitely puzzling difference between chance and destiny in biographical narrative: between the contingent and

the inevitable, between the phrase 'and then ...' and the phrase 'and because ... ', which each advance the story in such different ways. The underlying trajectory of a life, the balance between the 'driven' and the 'driving', is always so hard to gauge. Mary herself came to reflect on this, puzzling over why she and Shelley ended up at Casa Magni at all: 'But for our fears on account of our child, I believe we should have wandered over the world, both being passionately fond of travelling. But human life, besides its great unalterable necessities, is ruled by a thousand Lilliputian ties that shackle at the time, although it is difficult to account afterwards for their influence over our destiny.'

Finally, there remains the constant need to re-examine the role of time in biography. We know that 'once upon a time' is fantasy; but what about 'at this time', or 'in this age'; or even more, 'among his contemporaries'? What is 'a lifetime'? What is 'the time of death'? (Shelley's watch, now preserved in the Bodleian Library at Oxford, is stopped at precisely thirteen minutes past five.) Is human time different from historical time? Is historical time different from biographical time? To repeat Virginia Woolf (once again): 'It's a diffi-cult business, this time-keeping. The true length of a person's life, whatever the *Dictionary of National Biography* may say, is always a matter of dispute.' The twenty-nine-year-old Shelley remarked to Hunt at Livorno, just before he died, that he felt he had lived to be older than his grandfather – 'I am ninety years old.'

Shelley's theory (based on the philosophy of Hume) was that human time is not experienced uniformly, but is controlled by the speed and intensity of impressions and ideas. As he had written ten years earlier, in *Queen Mab*: 'The Life of a man of virtue and talent, who should die in his thirtieth year, is – with regard to his own feelings – longer than that of a miserable priest-ridden slave, who dreams out a century of dullness ... Perhaps the perishing firefly enjoys a longer life than the tortoise.' And perhaps this was Shelley's own version of the 'Lifespan Litany'.

Certainly biographical time is not divided into equal chapters. Nor is the 'death scene' the true end of any significant human story. We need to be aware that many lives change their shape as we look back on them. The dead may always have more life, more time, to give us. Shelley may forever be 'unextinguished', undrowned. The dead may always be biographically immortal.

Thomas Lawrence Revarnished

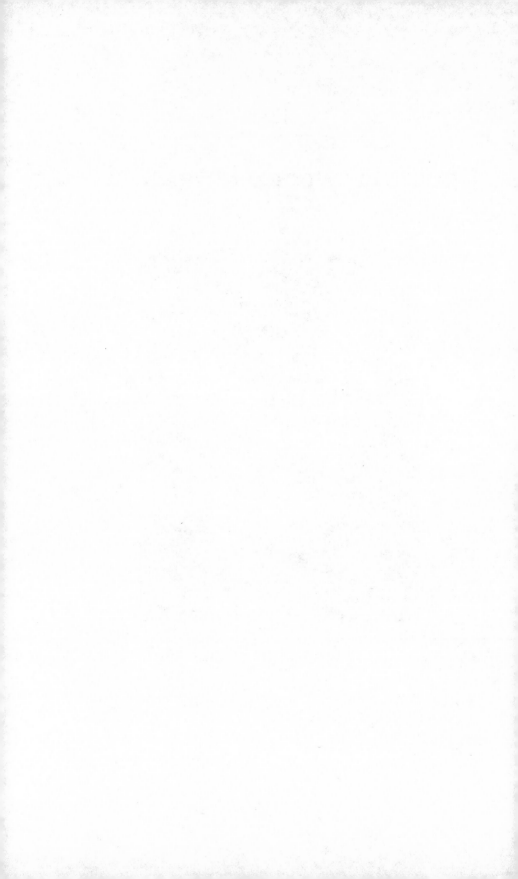

1

In the grey autumn of 2010, at the height of the European financial crisis and recession, I walked in from a bleak, gloomy, rainswept Trafalgar Square, to a dazzling exhibition at the National Portrait Gallery. It was entitled 'Thomas Lawrence: Regency Power and Brilliance'. For me it was a completely unexpected and hugely cheering experience. Lawrence's pictures flooded the rooms with colour, energy and spectacular self-confidence. As I went round, I felt a kind of spreading, inward glow. I noticed that the other gallery-goers responded in the same way, their faces steadily lighting up as they circulated, and when they left they seemed to walk out with a new spring in their step. By my calculation, one in three of them also carried away under their arm, as a trophy, one of the huge, exuberant Lawrence catalogues. That included me.

Sir Thomas Lawrence (1769–1830) belongs to the genial 'Golden Age' of British portrait-painting – the age of Gainsborough, Northcote, Hoppner, Phillips, Beechey and Sir Joshua Reynolds. But his reputation, unlike theirs, has fluctuated in a remarkable way. Sometimes he has been regarded as the dazzling, bravura master of Regency portraiture; at others as a brash and sentimental commercial artist – with the distinction of having invented the Chocolate Box School of Portraiture. On closer inspection, Lawrence's whole biography, as well as his art, reflects something of this intriguing dilemma.

His luscious treatment of edible young Regency debutantes, sugar-frosted grenadiers and apple-cheeked babies has frequently provoked sly amusement, if not outright derision. His jealous contemporary Benjamin Robert Haydon observed: 'Lawrence ... was suited to the age, and the age to him. He flattered its vanities, pampered its weaknesses, and met its meretricious taste.'

One of his most famous paintings, *Charles William Lambton*, subsequently known as *The Red Boy* (1825), has frequently graced tins of toffees and shortbread, and in 1969 appeared on the British 4d postage stamp. Wordsworth, the great poet of remembered childhood, said of *The Red Boy* when it was first exhibited: 'Lawrence's portrait of young Lambton is a wretched histrionic thing; the public taste must be vitiated indeed, if that is admired.' A modern art critic in the *Observer* once noted dryly: 'Lawrence does for children what Disney does for deer.'

This trail of mockery has pursued Lawrence into the twenty-first century. It has been said that his only true artistic successor was the raffish fashion photographer Cecil Beaton. Even the mild-mannered 'Oxford History of Art' *Portraiture* (2004), by Shearer West, chose to praise Lawrence by burying him. Though there are thirteen references to his immediate predecessor Sir Joshua Reynolds, Lawrence's name does not appear even in the index.

The National Gallery exhibition set out to change all this, and succeeded with such a flourish that it eventually transferred across the Atlantic to the Yale Center for British Art in New Haven. It set out to show how Lawrence defined and celebrated the most exuberant aspects of the English Regency: its flamboyant high society, its glittering soldiers and statesmen, its glamorous women, its elegant actors and dandies, and – yes – its well-fed children. Admittedly it found little room for any images of the poor, the maimed or the starving, even though this was the period of the Napoleonic Wars and their bitter aftermath.

The catalogue was one of the most splendidly illustrated I have seen, with over a hundred full-page plates, and numerous details and drawings. These were accompanied by three fine critical essays: a subtle exploration of Lawrence's changing ideals of Regency 'masculinity' (from the foppish to the martial) by Peter Funnell of the National Portrait Gallery; a scholarly defence of his child portraits and an examination of the shifting historical conventions of 'innocence' (drolly entitled 'Charming Little Brats') by Marcia Pointon; and a wonderfully deft and perceptive analysis of his female portraits by a curator of paintings and sculptures at the Yale Center, Cassandra Albinson.

Albinson's essay is carefully titled 'The Construction of Desire'. It reveals hitherto quite unexpected depths in Lawrence's play between ideal mythic women (Psyche, the Sibyl) and his actual, extremely worldly sitters, like the celebrated actress Sarah Siddons, the notorious Countess of Blessington, or the gorgeous Lady Frances Hawkins, the Irish mistress of his friend Lord Abercorn. It meditates tactfully on 'the conflicting messages of brazenness and softness'. There are brilliant passages on Lawrence's brush techniques, such as his special method of illuminating female eyes, his way of capturing a flirtatious gaze, or his 'flurry of white highlights' on romantically disordered hair, which 'indicate visually the underlying intimate encounter between artist and sitter'. As the banker-poet Samuel Rogers was rumoured to have quipped: 'If I wanted my mistress painted I would go to Lawrence; if my wife, I would go to [Thomas] Phillips.'

2

Lawrence himself was no product of the London high life. He was born in Bristol in April 1769, the son of a tavern-keeper, and grew up at his father's celebrated coaching inn, the Black Bear, on the

Devizes road in Wiltshire. A beautiful and gifted child, he was considered a prodigy by his parents, able to recite Milton's *Paradise Lost*, act scenes from Shakespeare plays, and dash off astonishing pastel drawings of his father's customers as they sat at table, all by the time he was five years old.

His instinctive skill as a draftsman at catching 'likenesses' of his father's customers (it was noted that he usually took 'about seven minutes'), especially the fashionable female ones, was soon remarked on by influential visitors, such as the novelist Fanny Burney. So too was his precocious ability to charm and seduce. By the time Lawrence was ten, his father was already charging for the boy's drawings and pastels.

Evidently he did not charge enough. When Lawrence was eleven, his father went bankrupt. More keen than ever to exploit his gifts, his parents took the precocious boy first to Oxford and then to fashionable Bath (the city of Beau Brummell), where characteristically he caught the attention of both Sarah Siddons and the fashionable socialite the Duchess of Devonshire. It is possible to sense the kind of obsessive parental grooming that we might now associate with a young tennis star.

Next his parents launched him in London, at the age of seventeen, from rooms off Leicester Square. Here he met the ageing President of the Royal Academy, Sir Joshua Reynolds, who was said to have taken one look at his portfolio and immediately prophesied a great future. Another flattering rumour (young Lawrence was already collecting them) had Reynolds pronouncing: 'In you, Sir, the world will expect to see accomplished what I have failed to achieve.' Lawrence briefly attended the Royal Academy Schools, but it is thought this apprenticeship lasted less than three months – the only institutional training he ever had.

From then on Lawrence's professional success was, in his own phrase, 'truly meteoric'. He was elected associate of the Royal Academy of Arts at the age of twenty-two, Painter-in-Ordinary to

the King George III at twenty-three, a full member of the Royal Academy at the age of twenty-five, made a baronet in his mid-forties, and elected President of the Royal Academy in 1820 at the age of fifty-one. His earliest pastel portraits at the Black Bear Inn had been sold for half a guinea. Some of his last portraits in oils went for nine hundred each.

Lawrence had almost no serious artistic apprenticeship as a boy. Yet one of the most striking revelations of the exhibition is that, from the very beginning, he was a brilliant delineator of the human face in chalk, crayon, pencil or pastel. He had already been mentioned in an essay on 'child prodigies' by the critic Daines Barrington as early as 1781, when he was a mere twelve. One can see why. His teenage drawings show him confident, exuberant and psychologically acute, often witty and even mischievous. He has extraordinary facility. Images of every kind simply flow or spin onto the paper. There is no real explanation of this phenomenon, though one is reminded that this was, after all, the age of youthful genius *par excellence*: Chatterton, Coleridge, Byron, Shelley, Keats, and even the chemist Sir Humphry Davy.

Indeed, Davy's upwardly mobile career in science almost exactly parallels that of Lawrence in the arts. From obscure West Country roots in Cornwall, Davy was knighted for his revolutionary work in chemistry by the age of thirty-three, and was elected President of the Royal Society in 1820, at the age of forty-one. Appropriately enough, he was then painted by Lawrence to commemorate that very achievement: two provincial boys made good, gleefully celebrating their mutual triumph over the cultural establishment.

What young Lawrence was capable of is demonstrated by the exquisite, witty, sophisticated drawing of his early friend and mentor Mary Hamilton and her amazing Bo-Peep hat. It was executed in 1789, at the age of nineteen, when he was first starting to exhibit at the Royal Academy. It is part fashion plate and part romantic mood study. To the fine mesh of black chalk he has added flushed high-

lights in sanguine (a favourite technique), like too much excitement rising into his subject's lips and cheeks.

The effect is deliberately theatrical, dressy and provocative. Mary's pose is self-conscious, and curiously teasing. It may have been inspired by the pre-Revolutionary aristocratic fashion for playing pastoral shepherdesses, much favoured by Marie Antoinette. But it could also be a sly satire on this already dated French fad, bearing in mind that the Bastille fell that same year. In fact, is the beautiful Mary Hamilton about to burst out laughing?

A similar teasing ambiguity attends Lawrence's sparkling and mischievous drawing of Mrs Papendiek (also 1789). It was executed at Windsor Castle, where he was officially painting the ageing Queen Charlotte. One morning, abruptly refused further sittings by the impatient and irritable monarch, the nonchalant young Lawrence asked her lady-in-waiting, Mrs P, to model the royal jewels in her stead. He carefully posed her in a nearby anteroom, getting her to sit with daringly bared arms. To amuse the pretty Mrs P, and probably to flirt with her as well, Lawrence suggested she put on her own fashionable new hat, and for good measure include her little boy in the portrait too. The result is a brilliant, witty study in Regency style and manners. It deliberately prompts the question: Is Mrs P more proud of her child, or of her hat? Is motherhood or millinery more important?

For his first fifteen years in London, between 1790 and 1805, Lawrence's portraits were continuously prominent at the Royal Academy exhibitions. Although sometimes mocked and criticised, he continued to develop what was in effect a new Romantic look. He plunged into the heady Regency world of aristocracy, fashion and theatre, but also found time for one daring piece of political reportage. This is his dramatic drawing of the young radical Thomas Holcroft and his supporter, the anarchist philosopher William Godwin, at the celebrated Treason Trials of 1794, held at the Old Bailey. Lawrence has chosen an intensely theatrical moment.

Holcroft – on a capital charge – is stoically waiting for the jury to deliver its verdict: death, transportation, or liberty. He sits leaning slightly backwards, his hand coolly on his hip; while Godwin sits staunchly by his side, peering intensely forward through his spectacles. Male friendship in adversity had great emotional significance for Lawrence, and the double portrait became a favourite motif. In this case, the verdict was not guilty.

For the young women of the time, Lawrence's sense of Romantic style and flamboyance often outran the tastes of even the most fashionable. The dazzling, airy portrait of the thirty-year-old actress Elizabeth Farren announced his triumphant arrival at the Royal Academy exhibition of 1790. Her fresh, seductive figure is offset by an astonishing and virtuoso display of textures: muslin, fur, satin and silk, and above all, perhaps, her limp, fine leather kid gloves. Each is rendered with sharp, voluptuous appreciation. At first the portrait drew only mocking reproach from its subject. Mr Lawrence had actually made Miss Farren *far too thin* (a criticism difficult to imagine today): 'You might blow me away,' she groaned to him, 'in short you must make me a little *fatter*, at all events diminish the *bend* you are so attached to, even if it make the picture itself look ill ...' Despite these unconvincing protests, Elizabeth Farren was shortly to become Lady Derby, for which achievement Lawrence undoubtedly took not a little credit.

During these same momentous years, following the French Revolution and the outbreak of the Napoleonic Wars in Europe, Lawrence also identified a new swaggering masculine style emerging among the young men of the Regency. Significantly it was 'Byronic' some ten years before Byron actually adopted it himself. Dark, dandyish, dashing, brooding, it combined an extraordinary mixture of male arrogance and almost feminine beauty, emphasised by vivid clothes, peacock hairstyles, and smouldering glances. This can be seen most strikingly in the glowering, explosive sketch of Lawrence's fellow artist Richard Westall, or the tempestuous portraits of the

Etonian school-leaver Arthur Atherley, or the swarthy aristocratic traveller Lord Mountstuart.

Here Lawrence was painting his own generation, and effectively bringing it onto the stage of history. The images are powerful, confident and confrontational. He supplied his subjects with stormy or melodramatic backgrounds, dashed in with fast, free brushstrokes as if liberating them from an old world of conventions. In contrast to the previous generation of artists – the smoothness of Reynolds or the feather-light touch of Gainsborough – he rendered their clothes with thickly applied paint, strongly contrasted colours and glittering, almost metallic highlights. With these techniques Lawrence expressed a new age of patriotism, flamboyance and bold individuality.

3

For all the wonderful extravagance of his portraiture, Lawrence's own life appeared – on the surface at least – curiously reserved and restrained. He repeatedly said he never bet on cards, never gambled on horses, never got drunk with friends (all proper Regency male pastimes). Instead, he claimed his favourite reading was Jane Austen and his most extreme sport was billiards. He never married. Yet he was handsome, flirtatious and charming to a perilous degree. His great friend and confidant, the painter and diarist Joseph Farington, bluntly called him a 'male coquet'. But this does not seem quite to explain the case. An anonymous female admirer wrote more perceptively:

He could not write a common answer to a dinner invitation without it assuming the tone of a billet-doux. The very commonest conversation was held in that soft, low whisper and with that tone of deference and interest, which are so unusual and so calculated to please.

While a male friend referred to him, with a certain admiration, as 'an old flirt'.

This insidious gift for intimacy, for making everyone feel special, which Lawrence practised on both his male and female subjects, was evidently an essential part of his magic as a portrait painter. It was his actor's ability to enter into all their characters and moods; and also that instinct to charm and flatter, which he had learned as a child. His drawing expressed this same swift and sometimes teasing empathy; while his paintings added those theatrical elements of glamour and gusto that became his trademark.

In an unexpected moment of self-revelation, Lawrence once summed up his own character as a combination of 'Genius ... infected by Romance ... and wasted by Indolence ... and Languor'. He added, with suggestive emphasis, that he had the mark of 'the Voluptuary' about his person, and that playing around his mouth were 'Passions powerful [enough] to ruin, to debase or to elevate the Character'. Luckily, there was at least 'some appearance of Fortitude in the Chin'. It is not quite clear what Lawrence meant by all this mystification. But as suits a Romantic figure, there remains a strange doubleness about his identity, a secretive and possibly bisexual quality that runs through both his life and his art. He once wrote a curious, camp little poem, 'On Being Left Alone after Dinner', which contains these lines:

> I wish the sex was kinder grown,
> And when they find a man alone,
> Would treat him like a woman ...

For all his success as a society painter, Lawrence always claimed that his real wish was to execute large historical and mythological paintings, and he repeatedly said he had betrayed his own genius by abandoning such epic themes as *Satan Summoning his Legions* (1797). Although this sensational scene from Milton answered the academic

demands of history painting, the most prized of all artistic genres at that period, Lawrence was perhaps also haunted by more private and autobiographical motifs, going right back to his childhood and his triumphant performances from *Paradise Lost*.

This same year, 1797, was an unusually turbulent one for Lawrence. Then approaching thirty, he suddenly lost both of his supportive and adoring parents, and clearly had some kind of emotional breakdown. What exactly this involved remains obscure, except that he embarked on a strangely melodramatic affair with both of Sarah Siddons's daughters simultaneously, and then threatened to commit suicide. It was precisely at this time that he produced one of his most beautiful and haunting Miltonic drawings, *Satan as a Fallen Angel*. Continuing the intensely personal theme of a Lost Paradise, this is a study of two friends, two golden and androgynous young men, standing shoulder to naked shoulder, who appear to share some secret knowledge or guilty burden. Perhaps, as in the earlier double portrait of Holcroft and Godwin, they are on trial together.

Subsequently Lawrence was the subject of endless tittle-tattle and gossip. His name was linked romantically with many of his sitters, although only the female ones have come down to us. They include Mrs Siddons and her daughters, the Duchess of Devonshire, Mrs Papendiek, the Honourable Miss Upton, the actress Fanny Kemble, and even the unhappy Queen Caroline herself. (Indeed, Lawrence had to sign a legal deposition disclaiming adulterous opportunity before Queen Caroline's trial for divorce in Parliament.) Most problematic of all was his relationship with the beautiful Isabella Wolff (another divorcée), who may indeed have genuinely been his mistress.

Lawrence met Mrs Wolff in 1803, after the long and hysterical entanglement with the two Siddons girls was over. (André Maurois wrote an entire novel about this, *Mape: The World of Illusion* (1926), shrewdly suggesting Lawrence was not really in love with them at all, but was in thrall to their mother.) His extensive, gossipy corre-

spondence with the maternal Mrs Wolff was subsequently censored by his first biographer. An odd, amorous fragment from a letter written in Rome in June 1819 has survived. It gives a glimpse of Lawrence's billet-doux style: 'My Bed Room Window is so small that only one Person can conveniently look out of it, but it looks over St Peter's ... and as sweet Evening closes I often squeeze you into it, though it does hurt you a little by holding your arm so closely within mine ...' But this is all imaginary, as in fact Isabella was in London at the time.

Lawrence's magnificent silvery portrait of Mrs Wolff – the most Sibylline he ever painted – conveniently took him some thirteen years to complete. It is large, glowing, statuesque, and opulent. Cassandra Albinson shrewdly points to the luxurious silks bulging over Isabella's stomach – 'the painting betrays an anxiety about pregnancy and generation'. She even suggests that they had a child together, Herman St John Wolff, though the documentation she refers to remains inconclusive.

Another mystery is Lawrence's finances. Despite his ever-increasing fees, he remained in debt for his whole life. By 1807 his bankers, Coutts, reckoned he owed some £20,000. Exactly what he spent his money on remains an enigma. Perhaps it was his excellent collection of Old Masters – eventually sold to Queen Victoria to pay his creditors on his death. His bankers – after Coutts it was Barings, both of whose families he painted – were always trying to get him to budget, and always failing to do so. His friend Farington mildly suggested that he was no good at accounting for his money, and probably gave much of it away anyway.

Certainly Lawrence had an acute and generous eye for his fellow artists, and his letters show the encouragement and support that he gave to J. M. W. Turner, Richard Parkes Bonnington, John James Audubon and William Blake. Lawrence was one of the very few contemporaries who praised and actually purchased a copy of Blake's *Songs of Innocence and of Experience*. He also said Blake's *The Wise*

and Foolish Virgins was his 'favourite drawing', and kept it on a special table in his bedroom.

Lawrence's studios were always ultra-fashionable. His first, at 41 Jermyn Street, is now appropriately occupied by the tradesmen's entrance of Fortnum & Mason. The demand for portrait sittings was as relentless as consultations with a modern Harley Street specialist (and similarly priced). He would undertake as many as five two-hour sittings a day, charging a 50 per cent deposit. Consequently, much of his correspondence was concerned with the failure to deliver finished portraits, sometimes drawn out over many years. Lord Ellenborough once threatened to prosecute him in the courts for refusing to complete a painting of his wife. Another aggrieved client challenged Lawrence to a dawn duel in Hyde Park.

Alfred, one of Lawrence's most faithful assistants, slyly suggested that unfinished portraits had their own uses, especially with female clients of a certain age:

> Some of them do come in a huff, but they always go away pleased, for my master brings out the picture, and says it needs only be altered in the dress, and then they think they are hand-somer than ever. One old lady came the other day and asked to see a picture of her begun twenty years ago ... Do finish it Sir Thomas, it is such an excellent likeness.

4

Much changed for Lawrence after 1810, with the death of his arch-rival John Hoppner. He soon executed his first portrait of the Prince Regent (later George IV), became the official court painter, and moved into grandiose apartments in Russell Square. In 1814 he was commissioned by the Prince to paint all the European leaders of the wartime coalition against Napoleon. This took him intermittently to

Paris, Vienna and Rome over a period of five years. He embarked on his huge, ambitious portraits of the mighty soldiers, statesmen, monarchs, clerics and self-important princelings of the age, and these made him an international star. He was knighted, and began to move in exalted social circles, hobnobbing with the grand and wealthy (the charming Prince Metternich was a particular favourite) and writing long, excited letters to Mrs Wolff about it all. He even painted the Pope. To top it all, he was appointed President of the Royal Academy in 1820.

To this heady period belong the great series of 'swagger portraits', as they were once dismissively called. Here Lawrence's natural sense of theatre and dynamic style strive for a new dimension of historic resonance. Three of these enormous portraits, each about nine feet tall, were eventually absorbed into the Royal Collection. Each is closely associated with the defeat of Napoleon on the battlefield. One can practically hear the bellicose roar of Field Marshal von Blücher sending his troops into the fray; while the quiet, resolute elegance of the Archduke Charles of Austria commemorates one of the master strategists of the allied coalition. Both are still swathed in the smoke of battle, glamorously celebrating a defining international victory. But perhaps most subtly impressive of all is the shrunken figure of Pope Pius VII, the man who endured Napoleon's prisons for four years but survived as a moral centre of European opposition and eventually brought back all the plundered art treasures to Italy. It is a complex, masterly study of both fortitude and cunning.

However, even here, Lawrence's decorative and diplomatic talents were not without his detractors. The glamorised portraits of the obese Prince Regent particularly attracted mockery. The republican critic William Hazlitt slyly observed that Lawrence had skilfully transformed the Prince into a 'well-fleshed' Adonis: 'The portrait goes far beyond all that wigs, powders, and pomatums have been able to afford over the last twenty years.'

On his return home, Lawrence performed the same magical stagecraft on government figures such as the Duke of Wellington, Sir Robert Peel and George Canning. Although sometimes undoubtedly stagey, these pictures reflect the rhetoric of the Regency, and serve their proper purpose as official 'portraits of record', splendid and monumental. Lawrence's original graphic genius wonderfully informs the best of these later works. It is fascinating to see how the fixed, hawk-like glare of his hypnotic portrait of Wellington has emerged from the softer and more psychologically subtle drawings of the same subject.

Equally, the powerful but startlingly unfinished portrait of William Wilberforce, the great Evangelical Christian reformer and campaigner against the slave trade, is brilliantly worked up from a charcoal under-drawing. It seems to have been painted in a single afternoon session, on 28 May 1828. This speed was required because Wilberforce was in continuous physical pain at the end of his life, his body encased in a steel and leather girdle for support. Even holding his head upright during the studio sitting was exhausting. As usual Lawrence adapted to his sitter, and rapidly produced this extraordinary image of moral determination combined with tenderness. Wilberforce's gentle smile triumphs over his cruel pain, and this is the story of his life. Here too Lawrence's rhetorical skill is evident in the dark, dashed-in background behind the head, so Wilberforce's face seems radiant with inner light, achieving the dramatic suggestion of a secular saint with a halo.

Lawrence's old sense of freedom and daring was developed even more fully in his later portraits of women. He had previously shown the glowing sexual radiance of Frances Hawkins, shamelessly reflected in the hot, loving glance of her illegitimate child and the panting of her large pet dog – a triangular short-circuit of passion. Now he gave the pert, seductive charm of Lady Selina Meade, the arch amusement of the Princess Sophia, or the tender, teasing melancholy of Rosamund Croker a rich and sumptuous life all their own.

The ravishing portrait of Margaret, Countess of Blessington (originally a working girl, just like Nelson's Emma, Lady Hamilton), is one of the most glorious, brazen pictures Lawrence ever painted. Lord Byron, when he first met Lady Blessington in Italy, instantly identified her as the subject of Lawrence's picture and the archetype of the English Regency belle. All London was 'raving' over it, and over her, the author of *Don Juan* noted appreciatively. Even better, she gave his own mistress, Countess Guiccioli, 'a furious fit of Italian jealousy'.

When Lawrence first began to exhibit in Paris, towards the end of his meteoric career in the 1820s, he was greeted as one of the great, liberating harbingers of British Romanticism, and awarded the Légion d'Honneur. His art was seen as part of that movement that overturned all the old restrictions of classicism: the poetry of Lord Byron, the experimental science of Sir Humphry Davy, the novels of Sir Walter Scott, the landscapes of Constable, and the portraits of Lawrence. 'The English manner enjoys a triumph in Paris,' wrote the young Stendhal. 'Mr. Lawrence's name is immortal.' Delacroix enthused: 'Nobody has ever painted eyes, women's eyes particularly, so well as Lawrence ... He is inimitable.' Théophile Gautier later said Lawrence had single-handedly invented the 'English rose' type, with a complexion finer than 'rice-paper, or the pulpy petal of the magnolia, or the inner pellicle of the egg, or the vellum of the gothic miniaturists'.

Lawrence's pictures of children also took his Continental viewers by storm. His ebullient *Laura Anne and Emily Calmady*, in which the younger girl is practically kicking out of the picture frame, suggested a whole new, uninhibited approach to childhood. Jean-Jacques Rousseau, the French critics proclaimed, was vindicated. And as for *The Red Boy* in his scarlet velveteens? This was not simply a beautiful chocolate-box image, as is now so easily assumed. In fact it was the portrait of a beautiful doomed child, the young Charles Lambton, who would die aged thirteen. He is the boy who will never

live to grow up. But he became immortal, because he was quickly assumed to be an imaginary portrait of the dreaming youthful Byron, the very soul of English Romanticism. This was partly why he was reproduced across Europe, and then America, as a symbol of eternal hope and youthful promise. With him, Lawrence had transcended personal portraiture, and captured the spirit of the age.

From this professional and social high point, the swift collapse of Lawrence's reputation after his death in 1830, partly as the result of Victorian prudery, is an interesting matter of social history as much as art history. Thackeray, for instance, ridiculed Lawrence's flashy values in *Vanity Fair* (1847), and attacked his female portraits as 'tawdry'. The modern art critic William Vaughan derided him as a painter 'in a state of permanent adolescence', much as Dr Leavis once criticised Shelley.

But the longer, historical perspective is possible once again. Charles Baudelaire in his *Salon* of 1845 contrasted Lawrence's work with the cold, exacting '*portrait historique*' of David and Ingres, and compared it favourably to the warm '*portrait romantique*' of Reynolds and Rembrandt. It was a shrewd observation. Sir Thomas Lawrence belongs in such company, and is worthy of renewed popular appreciation. The English Regency would be impossible to understand without his flamboyant work; and the history of Romanticism would be poorer and plainer without his strange, colourful and provoking story. Lawrence himself, contrary to any idea of easy facility, always spoke with disarming modesty about his own art of portraiture, which he felt he had never entirely mastered: 'I am perpetually *mastered by it* ... as much the slave of the picture I am painting, as if it had a living personal existence, and chained me to it.'

Coleridge Misremembered

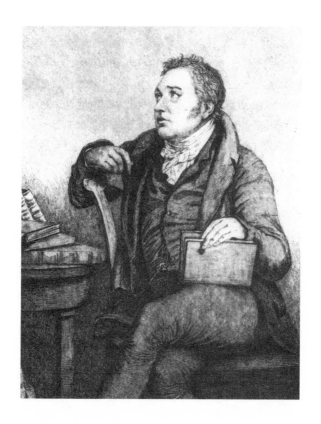

1

I was once asked to give a lecture at the Royal Institution, Albemarle Street, London, in the very same lecture theatre where both Samuel Taylor Coleridge and Humphry Davy had lectured two hundred years previously. This was a particular challenge for a Romantic biographer, so I decided that the Romantic lecture itself must be my topic. That evening, quivering with nerves like an aeolian harp, I mounted the wooden steps to the sacred dais, clutching awkwardly in both hands a large leather-bound folio volume. From the scattered headings in my notebooks, the following is a rough reconstruction of what I then said.

2

Young Coleridge is remembered as an epic walker, both in the West Country and the Lake District. He was also an eccentric one. He once said that he had walked for the whole of a hot summer's day from Bristol to Stowey, a distance of forty miles, 'carrying Baxter's folio *On the Immortality of the Soul* – and a plucked goose – and the giblets – for my supper'.

The older Coleridge is equally remembered as an epic lecturer, and his carefully edited Shakespeare Lectures now fill two volumes.

But here too he was to some degree eccentric, and indeed his contemporary reputation was little short of catastrophic. I would like to present another kind of 'immortal' folio which may throw light on the actual experience of his lecturing, and what it was really like. Here in my hands is the original minute book of the Royal Institution for the period 1807 to 1809, which is still preserved in the Institution's archives, in its battered cloth and leather binding. This is the entry for 7 December 1807:

> Mr Bernard reported that Mr Coleridge will give in the ensuing Season five courses of five Lectures each on the distinguished English Poets in illustration of the General Principles of Poetry ... from Shakespeare to the Moderns ... to begin immediately, and to give one or two lectures a week as may be convenient, for a compliment of £140, of which £60 is proposed to be paid in advance.

These twice-weekly lectures began in February 1808. But four months later we find this dramatic entry in the Royal Institution minute book for 13 June:

> William Savage, the assistant secretary, laid before the Managers the following letter from Mr Coleridge. Dear Sir, Painful as it is to me almost to anguish, yet I find my health in such a state as to make it almost Death to me to give any further Lectures. I beg that you would acquaint the Managers that instead of expecting any remuneration, I shall, as soon as I can, repay the sum I have received. I am indeed more likely to repay it by my Executors, than myself. If I could quit my Bed-room, I would have hazarded every thing rather than not have come, but I have such violent fits of Sickness and Diarrhoea that it is literally impossible.

My question is: what happened to Coleridge (and his biography) between these two entries? The invitation to lecture had originated with his friend Davy, who had been trying to bring him to the lecture dais ever since the poet's return from Malta in the summer of 1806. He wrote to Coleridge's West Country friend the radical tanner Tom Poole in August 1807, promising to relaunch Coleridge's public career, both for his own good and for the good of the nation: 'The Managers of the Royal Institution are very anxious to engage him; and I think he might be of material service to the public, and of benefit to his own mind ... In the present condition of society, his opinion in matters of taste, literature, and metaphysics must have a healthy influence ...'

Considering Coleridge's reputation at this date, such an invitation could be considered as one of Davy's most daring experiments in chemical combustibles. He knew Coleridge not only as a visionary poet, but also as a man suffering from opium addiction, unrequited love, and a prolonged writer's block. After numerous delays Coleridge began to lecture on Friday, 15 January 1808. He broke off, and started again on Friday, 5 February. He broke off again – and began once more on Wednesday, 30 March. He eventually completed eighteen, or possibly twenty, lectures, but they appear to be remembered as nothing but a catalogue of disasters and disappointments.

The lecturer frequently postponed at the last minute, and in dramatic terms:

Dear Sir, I have been confined to my Bed, with intervals of a few hours, since Saturday last ... But today my illness becoming more serious, and the very possibility of my removing from my Bed or being able even to stand in a Public Room tomorrow, becoming utterly unlikely, I am obliged to advertise you thereof – whatever expenses may be incurred I shall most cheerfully pay, if indeed I live to pay ...

When he did appear, the lecturer arrived almost speechless, as he was then in the habit of consuming a pint of laudanum – opium dissolved in brandy – a day. The young Thomas De Quincey recalled:

His appearance was generally that of a person struggling with pain and overmastering illness. His lips were baked with fever-ish heat, and often black in colour; and, in spite of the water which he continued drinking through the whole course of his Lecture, he seemed to labour under an almost paralytic inabil-ity to raise the upper jaw from the lower – Most unfortunately he relied on his extempore ability to carry him through.

The lecturer was often unprepared and chaotic in appearance. Coleridge himself tells the story of how he prepared three clean white lecture shirts, but found he had slept in the first, dried his face on the second, and used the third as a foot mat. Many years later a fourth shirt, marked 'STC' on the collar, was found on a poor man hanging from a tree in Hyde Park.

The lecturer often digressed from his announced topics, or never touched on them at all. The *Times* journalist Henry Crabb Robinson recorded: 'Coleridge's digressions are not the worst parts of his Lectures, or rather he is always digressing – (and they are the *only* parts).'

The lecturer lost his lecture notes in mysterious circumstances, as sceptically noted by another journalist, Edward Jerningham:

To continue the History of this Lecturer … He looked sullen and told us that He previously had prepared and written down Quotations from different Authors to illustrate the present Lecture. These Quotations he had put among the Leaves of his Pocket Book which was stolen as he was coming to the Institution. This narrative was not indulgently received, and he went through his Lecture heavily … The next day he received

an Intimation from the Managers that his Lectures were no longer expected.

Finally, the lecturer was officially censured by the Committee of the Royal Institution. The minute book for May 1809 reads: 'Resolved, that the personal attack made by Mr. Stephen [sic] Coleridge on Mr. Joseph Lancaster, in a lecture delivered by him at the Royal Institution on Tuesday 3rd May 1808, was in direct violation of a known and established Rule of the RI prohibiting any personal animadversions in the Lectures there delivered.'

Accordingly it took more than a year for the Committee to pay the balance on Coleridge's fees. The disaster was summed up in an unpublished note by Davy which is still held in the Royal Institution archives:

He has suffered greatly from Excessive Sensibility – the disease of Genius. His mind is a wilderness in which the Cedar and Oak which might aspire to the Skies are stunted in their growth by underwood Thorns, Briars and parasitical plants. With the most exalted Genius, enlarged views, sensitive heart and enlightened Mind, he will be the victim of want of Order, Precision and regularity. I cannot think of him without experiencing mingled feelings of admiration, regard and pity.

So this is how the 1808 lectures have gone down in history. They gained the reputation of being the most disastrous series ever delivered there. As the great Coleridge scholar Kathleen Coburn noted in a paper delivered in 1973 at the same dais in the Royal Institution: 'We know a little about these lectures but no full report has been found. And some of the details are best passed over.' It would seem that Davy's great Coleridge Experiment was a resounding failure.

3

But history may be rewritten by biography. One of the methods of biographers, in their search for truth, is to alter our conventional perceptions of historical time. They may challenge superficial chronology, and seek to place events in a new sequence or a deeper context of ideas. So I want to wind back this extraordinary story, as we used to wind back a video tape, by some ten years. Let us start the narrative again in 1799, and look at it afresh.

A portrait of Coleridge painted in 1799 shows a strikingly youthful figure, who might be a hippy from the 1960s with his long hair, huge thoughtful eyes, and hungry mouth. This is a man of astonishing intellectual intensity and imaginative power. This is the man who had just written some of the greatest Romantic poems in the language – *The Ancient Mariner*, 'Kubla Khan' and 'Frost at Midnight'. He had also written 'To a Young Ass' (1794), which is perhaps the first animal rights poem. (Though this was not universally appreciated at the time: Byron christened him 'the Laureate of the long-eared kind'.)

Coleridge believed all knowledge, both scientific and artistic, could be included in poetry, and this would produce a new kind of epic. He put his wonderful idea of such a polymathic poem in a letter written to his publisher Joseph Cottle in 1796:

I should not think of devoting less than 20 years to an Epic Poem. Ten to collect materials and warm my Mind with universal Science. I would be a tolerable Mathematician, I would thoroughly know Mechanics, Hydrostatics, Optics, and Astronomy, Botany, Metallurgy, Fossilism, Chemistry, Geology, Anatomy, Medicine – then the mind of Man – then the Minds of Men – in all Travels, Voyages and Histories. So I would spend ten years – the next five to the composition of the Poem

– and the five last to the correction of it. So I would write haply not unhearing of that divine and rightly-whispering Voice, which speaks to mighty minds of predestined Garlands, starry and unwithering.

It should perhaps be pointed out that Coleridge had just missed his publisher's deadline at this date.

The 1799 picture was painted in Germany, where Coleridge was studying the latest in poetry (Schiller, Lessing), Biblical criticism (Eichhorn), philosophy (Kant) and life sciences (Blumenbach) at the University of Göttingen. He came back to England breathing the heady intellectual gas of Schelling's *Naturphilosophie*. This influential movement was an extraordinary blend of early evolution theory, Pantheism and German Idealist philosophy. Only a quick sketch is possible here. *Naturphilosophie* regarded the hard Newtonian universe of material mechanisms – the clockwork of planetary orbits, the celestial billiards of atomism – as theoretically inadequate. Instead it proposed the concept of a fluid, dynamic, unified Nature, driven by invisible 'powers' to which chemistry and electricity provided the key. Scientific theory could be advanced through analogy, metaphor and speculation as well as through empirical observation and controlled experiment.

Naturphilosophie produced a distinctive language of German scientific mysticism. Schelling and his circle spoke of 'vitalism', 'organicism' and 'galvanism'. All observable activity in life-forms was the result of invisible 'polarities' in Nature. There was a 'world-soul' constantly 'evolving' higher life-forms, and 'levels of consciousness' in all matter, animate or inanimate. All Nature had a tendency to move towards a 'higher state'. Several distinguished European scientists were connected with this movement: Lorenz Oken, who postulated cell theory; Johann Wilhelm Ritter, who discovered ultra-violet rays; Henrik Steffens, the Scandinavian geologist who proposed a curious form of psychic evolution, making the famous observation

that 'the diamond is a piece of flint that has come to its senses,' to which a hard-headed British geologist was reported to have replied, 'A quartz must therefore be a diamond run mad.'

Coleridge was reading all these new European sources, as well as earlier British scientists like Erasmus Darwin (author of *The Botanic Garden* and *The Loves of the Plants*) and Joseph Priestley (whom he described in a poem as 'Patriot, Saint and Sage'). We might consider Priestley as a precursor of the brain drain, as he emigrated to Philadelphia when a patriotic mob burnt down his house and laboratory in Birmingham in 1791. A crucial idea appeared in Priestley's *History of Electricity* (1775):

Hitherto philosophy has been chiefly conversant about the more sensible properties of bodies; electricity, together with chemistry and the doctrine of light and colours, seems to be giving us an inlet into their internal structure, on which all their sensible properties depend. By pursuing this new light, therefore, the bounds of natural science may possibly be extended, beyond what we can now form an idea of, new worlds may open to our view, and the glory of the great Sir Isaac Newton ... be eclipsed.

Both Coleridge and Davy were full of these ideas, in which new German Romantic science challenged the eighteenth-century British empirical tradition. One can almost hear the *bang* when the two young men first met, at Dr Thomas Beddoes' Pneumatic Institute, Clifton, in the summer of 1799. Here took place the famous experiments with nitrous oxide, laughing gas. Davy saw both the psychological interest of the work, as a revelation of the unconscious mind, and the medical one, as a possible form of anaesthetic. There are various accounts of their experiences, of which my favourite is by one Peter Roget, who said there were 'no words' to describe accurately what he felt, and then went on to compile his celebrated *Thesaurus*.

Davy's own experimental notes provide this memorable description:

By degrees as the pleasurable sensations increased, I lost all connection with external things; trains of vivid visible images rapidly passed through my mind and were connected with words in such a manner, as to produce perceptions perfectly novel. I existed in a world of newly connected and newly modified ideas. I theorised; I imagined that I made discoveries. When I was awakened from this semi-delirious trance by Dr. Kinglake, who took the bag from my mouth, indignation and pride were my first feelings ... My emotions were enthusiastic and sublime; and for a minute I walked round the room perfectly regardless of what was said to me ... With the most intense belief and prophetic manner, I exclaimed to Dr. Kinglake, – 'Nothing exists but Thoughts! – the Universe is composed of impressions, ideas, pleasures and pains!'

It is fascinating to compare this with Coleridge's account of writing 'Kubla Khan' under opium in 1797:

The Author continued for about three hours in a profound sleep, at least of the external senses, during which time he has the most vivid confidence, that he could not have composed less than from two to three hundred lines; if that indeed can be called composition in which all the images rose up before him as *things*, with a parallel production of the correspondent expressions, without any sensation or consciousness of effort. On awaking he appeared to himself to have a distinct recollection of the whole, and taking his pen, ink, and paper, instantly and eagerly wrote down the lines that are here preserved. At this moment he was unfortunately called out by a person on business from Porlock ...

Davy was also writing poetry, and was quite at home in the literary world. He corrected the proofs to the second edition of Wordsworth and Coleridge's *Lyrical Ballads* (1800), and even parodied Wordsworth's revolutionary plain style of verse:

>As I was walking up the street
>In pleasant Burny town,
>In the high road I chanced to meet
>My cousin Matthew Brown.

>My cousin was a simple man
>A simple man was He
>His face was of the hue of Tan
>And sparkling was his – Eye.

Coleridge formed a passionate alliance with Davy in these years, endlessly discussing the links between science and poetry. When Coleridge moved to the Lakes (1800), he proposed setting up a chemical laboratory, bought a microscope, and imagined transmitting a chemical vision of the Lake District landscape to Davy by wrapping it up in 'a pill of opium'. He teasingly called Davy 'the founder of Philosophic Alchemy', and invited him to join a later Pantisocratic community in Italy – 'what a Colony might we not make!' When, instead, Davy was appointed to lecture at the Royal Institution in 1801, Coleridge congratulated him with evident delight: 'Success my dear Davy, to Galvanism – and every other Schism – and Ism.'

When the philosopher William Godwin attacked Davy's scientific work as a form of naïve materialism, Coleridge defended Davy in boisterous terms:

Godwin talks evermore of you with lively affection. – 'What a pity that such a Man should degrade his vast Talents to Chemistry' – cried he to me. – Why quoth I, how Godwin! can you thus talk of a science, of which neither you nor I understand an Iota? etc etc. And I defended Chemistry as knowingly at least as Godwin attacked it. – Affirmed that it united the opposite advantages of Immaterializing the mind without destroying the definiteness of the Ideas – nay even while it gave clearness to them. And eke that being necessarily performed with the passion of Hope, it was Poetical ... You and I, and Godwin, and Shakespeare and Milton, with what an Athanasiophagous Grin we shall march together, – We Poets! – Down with all the rest of the World! (By the word *Athanasiophagous* – I mean devouring Immortality, by anticipation! – Tis a sweet word!) God bless, you my dear Davy! Take my nonsense like as pinch of snuff – sneeze it off, it clears the head ...

When Davy gave his First Series of Chemical Lectures at the Royal Institution in the spring of 1802, Coleridge rushed up to London to listen and 'to enlarge my stock of Metaphors'. We find the results everywhere in his letters. When describing Dorothy Wordsworth's extraordinary poetic sensibility – so evident in her wonderful journals – he deliberately used a laboratory image, drawn from the action of the filament of gold leaf in an electrometer registering tiny shifts in electrical charges: 'Her manners are simple, ardent, impressive ... Her information various – her eye watchful in minutest observation of Nature – and her Taste a perfect electrometer – it bends, protrudes, and draws in, at subtlest beauties and most recondite faults.'

At Davy's 1802 lectures Coleridge made over sixty pages of notes, and remarked: 'Every subject in Davy's mind has the principle of Vitality. Living thoughts spring up like Turf under his feet.' Many of

these notes convey a peculiar magical excitement, in which scientific data and precise observation can be seen fusing and flashing in Coleridge's mind with poetic suggestion and imaginative delight (and sometimes mischief):

Note f.4 'Experiment. Quart of Oxygen in a bladder breathed by Davy 2 minutes. Did not at all hurt the flame of the Candle. He breathed the same quantity of common air in a bladder for a less length of time – at the end of which it immediately extinguished the Candle. NB hold the end of the breathing pipe against the flame of the Candle.'

Note f.5 Ether burns bright indeed in the atmosphere, but O! how brightly whitely vividly beautiful in Oxygen gas.

Note f.8 Hydrogen pistol … electric spark detonates … applied to a Leyden phial – BANG!

Note f.9 Hydrogen Gas employed for Balloons – this illustrated by Soap Bladders, filled with a mixture of Hydrogen and Oxygen Gas. Blow up soap into Bubbles by means of a BLABBER filled with mixed Gas. [In his excitement Coleridge has appropriately mistranscribed the word.]

Note f.31 Sulphuric acid pour upon hyperoxygenated muriate of Potash. NB Be sure to hold your face close to the glass. First reddens, and then destroys, vegetable Blues.

Note f.31 If all aristocrats here, how easily Davy might poison them all – 15 parts Oxygen, 85 muriatic acid Gas …!

When Coleridge left for Malta in 1804 – seeking health, an escape from his unhappy married life, new forms of writing, and a cure for his growing opium addiction – Davy wrote him a kind of valediction which insisted on the intellectual work still to be done on the borders of science and poetry: 'In whatever part of the World you are, you will often live with me, not as a fleeting Idea but as a recollection possessed of creative energy, as an IMAGINATION winged with fire, inspiriting and rejoicing. You must not live much longer without giving to all men the proof of your Power ... You are to be the Historian of the Philosophy of feeling. – Do not in any way dissipate your noble nature. Do not give up your birth-right.'

<div align="center">4</div>

This rapid sketch may suggest just a little more clearly what Coleridge and Davy had come to mean to each other over the previous decade, and why Davy took the risk of inviting Coleridge to the public dais. Davy would always remember especially that thought-provoking phrase: that as science was 'necessarily performed with the passion of Hope, it was Poetical'.

Having wound back the tape of biographical time, I return to our point of departure, the lectures in 1808. Here the biographer can make a second chronological adjustment – slow time down, and freeze-frame it. Or, to put it a different way, place the episode under the microscope, and look down into its deeper structure.

Coleridge in the summer of 1807 was hiding away in the Quantock Hills in Somerset (where ten years before he had written 'Kubla Khan'). Those triumphant youthful days seemed long past: aged thirty-four, he was ill, depressed, opium-addicted, and writing very little. He could not see how his literary career could develop. But then he read, with the first stirrings of the old excitement, the accounts of Davy's famous Second Bakerian Lecture at the Royal

Society, given in November 1807. Here Davy first isolated and named the elements of potassium and sodium, making brilliant and dramatic use of huge sets of Voltaic batteries to decompose potash and soda, the hitherto unresponsive 'caustic alkalies'.

The old *Naturphilosophie* fascination bubbled up through Coleridge, touched by admiration – and perhaps a certain refreshing jealousy – for his old friend's success. Davy had found a key to those deep powers and 'internal attractions' hidden mysteriously within the material world. Coleridge wrote with something of his old enthusiasm:

> His March of Glory … has run for the last six weeks – within which time by the aid and application of his own great discovery, of the identity of electricity and chemical attractions, he has placed all the Elements and all their inanimate combinations in the power of man; having decomposed … and discovered as the base of the Alkalies a new metal … Davy supposes there is only ONE POWER in the world of senses; which in particles acts as chemical attractions, in specific masses as electricity, and on matter in general, as planetary Gravitation … when this has been proved, it will then only remain to resolve this into some Law of vital Intellect – and all human Knowledge will be Science, and Metaphysics the only Science.

The crucial and engendering idea here for Coleridge was that of the unifying ONE POWER. What Davy was doing for the world of Matter, Coleridge aimed to do for the world of the Mind. He would 'isolate, decompose and name' the one power of the Imagination in his poetry lectures. He would analyse, demonstrate and define the imaginative force at work, as in a laboratory. Alongside chemical attraction and gravitation, he would place creativity.

When we look at their circumstances more closely, the apparently unique chaos of Coleridge's lectures takes on a different dimension.

For a start, interruptions at the Royal Institution were not that unusual – we find that Davy himself had also been ill and postponed his own series. (He had caught gaol fever, while investigating the ventilation systems at Newgate prison with characteristic enthusiasm.) It was the early talks that went so wrong, when Coleridge was nervous, and still a novice lecturer, at least as far as London audiences were concerned. Davy's dismayed note on Coleridge's 'Excessive Sensibility' was written immediately after the sharp disappointment of Coleridge's second lecture. His remarks do not seem to have applied to the other lectures that eventually followed. Indeed, Davy shortly after composed a fine poem clearly inspired by the vision of a dynamic Nature that they still both shared, and which ended with an obvious tribute to his friend:

> All speaks of change: the renovated forms
> Of long-forgotten things arise again;
> The light of suns, the breath of angry storms,
> The everlasting motions of the main.
>
> These are but engines of the Eternal will,
> The One intelligence, whose potent sway
> Has ever acted, and is acting still,
> While stars, and worlds, and systems all obey;
>
> Without whose power, the whole of mortal things
> Were dull, inert, an unharmonious band,
> Silent as are the Harp's untuned strings
> Without the touches of the Poet's hand.

These final lines make clear reference to Coleridge himself, and specifically to his influential poem 'The Eolian Harp' (published in the *Monthly Magazine* in 1796, and then again in his *Poems* of 1797). They suggest that Davy could still have confidence in Coleridge's

visionary power, and could still share the same continuing belief in the 'harmonious' fusion between science and poetry.

In the same way, Thomas De Quincey's account of Coleridge's opium-wrecked presence at the dais turns out to be based on the two early lectures only. In the event the lectures gathered strength and coherence as they went on. Coleridge quickly learned to turn his spontaneous, digressive style to dramatic advantage. His very peculiarities and risky performance manner could rivet his audience, who never knew what to expect next. It was an intellectual tightrope act. This appears in the appreciative response from a quite different kind of witness: an eleven-year-old schoolgirl. Katharine Byerley never forgot the extraordinary impact of the wild and fascinating figure who came distractedly to the dais, and then proceeded to keep his audience completely in his thrall. Years later she put down her impressions:

He came unprepared to lecture. The subject was a literary one, and the poet had either forgotten to write, or left what he had written at home. But his locks were now trimmed, and a conscious importance gleamed in his eloquent eyes. Every whisper was hushed ... and I began to think, as Coleridge went on, that the lecture had been left at home on purpose; he was so eloquent – there was such a combination of wit and poetry in his similes – such fancy, such a finish in his illustrations ...

Edward Jerningham, the journalist who had sceptically mocked the story of the 'stolen' notes during the first lectures, now gave a rather more nuanced and appreciative overview of the whole series. Remarking on the peculiarities of Coleridge's lecture style, he also made an intriguing and unexpected comparison:

My opinion of the Lecturer is that he possesses a great reach of mind; that he is a wild Enthusiast respecting the objects of his Elogium; that he is sometimes very eloquent, sometimes para-doxical, sometimes absurd. His voice has something in it particularly plaintive and interesting ... He spoke without any assistance from a manuscript, and therefore said several things suddenly, struck off from the Anvil, some of which were en-titled to high Applause ... He too often wove himself into the Texture of his Lecture ... He was in some respects, I told him one day, like Peter Abelard.

This gives pause for reflection. The great French medieval lecturer Peter Abelard was renowned for his personal manner of lecturing, and for attracting a great following among the younger students at the Sorbonne. So it seems possible, from what Jerningham said, that Coleridge was already attracting a similar mixed and youthful audi-ence, to whom a certain dangerous whiff of scandal and notoriety was not exactly a disincentive. De Quincey himself was, after all, only twenty-two.

It used to be thought that almost nothing of the 1808 lectures had survived. But substantial fragments have now been recovered: from Coleridge's recently published notebooks, from the Egerton Mss in the British Library, and from a set of drafts unearthed in the New York Public Library. From these we can identify four snapshot moments which show Coleridge working towards his great theory of the Imagination, and steadily using scientific vocabulary and meta-phors to explore it. They also show the special gift he had for vivid, homely anecdotes, which we might consider as the equivalent of Davy's use of desktop demonstrations with gas bladders and bell jars.

Coleridge proposed that the critical language used to discuss all the arts must be philosophically based, and scientifically sharpened. Take the concept of beauty. When someone could describe the great waterfall of Lodore as 'sublimely beautiful, & indeed absolutely –

pretty, there was a total confusion of terms. ('I have never mentioned this without occasioning a laugh.') The idea of beauty must be part of a philosophic 'system', a strict hierarchy of forms and perceptions. The aesthetic behind this was in fact Kantian, but the explanation Coleridge gave was drawn from Davy's calorific experiments, when he proved that ice could be melted by friction:

> If our language have any defect, it is in want of Terms express-
> ing KIND, as distinguished from degree – thus we have Cold
> and Heat – but no words that instantly give the idea of Heat
> independent of comparison – if we say to persons who have
> never studied even the Elements of Chemistry, there is heat in
> Ice, we should appear to talk paradoxes.

He suggested that Imagination was an active process, like an electri-
cal current pulsing between objective and subjective polarities. The mind does not stand passively outside its experience, registering and recording, but enters dynamically into what it sees, reads or hears. To explain this, Coleridge used the example of stage illusion (a favourite of Dr Johnson and other eighteenth-century critics), and illustrated it characteristically with a tender anecdote of his son Hartley looking at a painting of a seascape:

> As Sir George Beaumont was showing me a very fine Engraving
> from Rubens, representing a storm at sea (without any Vessel
> or Boat introduced), my little Boy (then about 5 years old)
> came dancing and singing into the room, and all at once (if I
> may dare use so low a phrase) *tumbled in* upon the Print. He
> instantly started, stood silent and motionless, with the strong-
> est expression of Wonder and then of Grief in his eyes and
> countenance, and at length said – 'And where is the Ship? But
> that is sunk! – and the men all *drownded*!' – still keeping his
> eye fixed on the Print.

Now what Pictures are to little Children, Stage Illusion is to Men, provided they retain any part of a Child's sensibility. Except that in the latter instance, this Suspension of the Act of Comparison, which permits this sort of Negative Belief, is somewhat more assisted by the will.

A proper commentary on this remarkable passage would take us very far into the new Romantic theory of imagination. It proclaims the childlike part of the creative sensibility, ever fresh and spontaneous, which both the scientist and the poet must retain. It enacts the emotional energy – the passion of Hope – which accompanies the imaginative impulse. It employs the metaphor of electrical polarity in the striking idea of 'Negative Belief' – an image which recurs in a central passage in Coleridge's *Biographia Literaria* (1817) – 'that willing suspension of Disbelief for the moment that constitutes poetic faith'. And arguably it prepares the way for Keats's brilliant definition of 'Negative Capability' as the crucial power of the poet to enter into other 'modes of being' outside himself.

Later, Coleridge rose to another brilliant invocation of the poet's imaginative gift, in terms of a special visual force. This was the capacity to project multiple images on the human mind, and fuse them into a single impulse of feeling and vision. Quoting Wordsworth's 'Daffodils', he observed that great writers have 'that power and energy of what a living poet has grandly and appropriately described as: "To flash upon that Inward Eye, which is the Bliss of Solitude" and to make everything present by a Series of Images. – This an absolute Essential of Poetry ...' He found its purest expression in the 'fusing' power of Shakespeare's poetry:

> ... A sort of fusion to force many into one ... Even as Nature, the greatest of Poets, acts upon us when we open our eyes upon an extended prospect. – Thus the flight of [Shakespeare's] Adonis from the enamoured Goddess in the dusk of the Evening:

'Look! how a bright star shooteth from the Sky
So glides he in the night from Venus' Eye'

How many Images and Feelings are here brought together
without effort and without discord: the Beauty of Adonis – the
rapidity of his Flight – the yearning yet Hopelessness of the
enamoured gazer (Venus) – and a shadowy, Ideal character
thrown over the whole.

Here the creation of poetry seems to share in the dynamic process of
the continuous creation of the physical universe itself. The one is in
harmony with the other. That is exactly what Coleridge would later
argue, with more technical philosophic language, in his theory of
Primary and Secondary Imagination in the *Biographia Literaria*.

Finally, there is the lecture for which Coleridge was 'censured' by
the Committee of the Royal Institution. The subject at first appears
completely peripheral to the topic of the Imagination. It was
Education, and a particular controversy over appropriate educa-
tional methods. Two opposing pedagogic systems were espoused by
Dr Andrew Bell (an Anglican) and Dr Joseph Lancaster (a Quaker).
The central issue in dispute was that of the use of punishments in
teaching children. Dr Lancaster – an early Pavlovian – promulgated
an astonishing arsenal of correctives: the use of pillories in the class-
room, the shackling of legs with wooden logs, trussing dunces up in
a sack, making them walk backwards through the school corridors,
and suspending them in 'punishment baskets' from the ceiling. It
was this system that Coleridge attacked with such passionate
vehemence.

Robert Southey, a latecomer to the Royal Institution series,
another sceptic who had at first doubted Coleridge's ability even to
appear in public, dramatically recalled the scene:

When Mr. Coleridge in a Lecture at the Royal Institution, upon the New System of Education, came to this part of the subject [punishments], he read Mr. Lancaster's account of these precious inventions verbatim from his own book, and throwing the book down with a mixture of contempt and indignation, exclaimed, 'No boy who has been subject to punishments like these will stand in fear of Newgate, or feel any horror at the thought of a Slave Ship!'

This was probably one of Coleridge's finest performances. He drew upon his own childhood experiences, his early Bristol lectures against slavery, the imagery from *The Ancient Mariner*, and effortlessly turned the subject back to his central theme. He argued that 'true Education comes from Love and Imagination'.

Thirty-three-year-old Crabb Robinson, lawyer and journalist, soon to be war correspondent for *The Times*, enthusiastically reported Coleridge in action against his critics:

The extraordinary Lecture on Education was most excellent, delivered with great animation and Extorting praise from those whose prejudices he was mercilessly attacking. And he kept his audience on the rack of pleasure and offence two whole hours and 10 minutes, and few went away during the lecture ... The cardinal rules of early Education: 1. to work by love and so generate love; 2. to habituate the mind to intellectual accuracy and truth; 3. to excite imaginative power ... He concluded: 'Little is taught by contest or dispute, everything by sympathy and love.'

5

Having wound back and slowed down time, the biographer can now fast-forward it.

In view of subsequent events, the 1808 series should be considered as a triumph snatched from the jaws of disaster, and one of the eccentric glories of the Royal Institution. Against all the odds, Davy had succeeded in launching Coleridge's career as public lecturer. It saved Coleridge from intellectual paralysis and despair, it helped to see him through the worst of his opium addiction, it earned him some much-needed income, and most important of all, it eventually set him writing again. Between 1811 and 1813 he gave over 120 lectures in London and Bristol, and his great reputation as the foremost English Romantic critic began. Taken up again in 1818–19, the lectures were eventually collected to produce his two volumes of *Shakespeare Criticism*, which is still studied in schools and universities, and shapes the thinking behind many modern stage productions. It also formed the basis of his aesthetic theories in the *Biographia Literaria*, which he published in 1817, the most influential book of Romantic critical philosophy ever published.

The interplay between science and poetry continued to fill Coleridge's later notebooks, and to shape his broadest speculations for the rest of his life. It is typical that in one later lecture he compares the poetic cosmology of Milton's *Paradise Lost* with Erasmus Darwin's scientific one, and gives a vividly coherent account of the Big Bang Theory. He then raises an objection which might still give us pause for thought: the Big Bang Theory is not *beautiful* enough to be entirely explanatory.

He also grappled with evolution – what he called the Orang-outang Theory – and gave an Idealist interpretation of it in *The Theory of Life* (1816): 'I define Life as the Tendency to Individuation; and the degrees or intensities of Life, to consist in a progressive real-

isation of this tendency.' Again he raises a philosophical problem which still haunts us: does the mechanism of evolution necessarily exclude the notion of purpose, of teleology? (Charles Darwin thought it did, but Mary Somerville and Alfred Russel Wallace concluded that it did not.) Coleridge remained friendly with a wide circle of scientists, and it is no coincidence that his last amanuensis at Highgate, J. H. Green, later became President of the Royal College of Surgeons.

It is heartening to remember the great tribute that Coleridge paid to Davy and science much later, in an essay published in his philosophical collection *The Friend* in 1818:

> This is, in truth, the first charm of Chemistry, and the secret of the almost universal interest excited by its discoveries ... the propounding and the solving of an Enigma. It is the sense of a principle of connection given by the Mind, and sanctioned by the correspondency of Nature. Hence the strong hold which, in all ages, Chemistry has had on the Imagination. If in Shakespeare we find Nature idealized into Poetry, through the creative power of a profound yet observant meditation; so through the meditative observation of a Davy, a Wollaston, or a Hatchett ... we find Poetry, as it were, substantiated and realised in Nature.

6

So what, in sum, did I try to demonstrate in my lecture? Simply that Coleridge has been misremembered. As so often in biography, the legend or the myth, especially if it has some scandalous charm attached to it, has subtly distorted the historical record. Seen in a revised biographical perspective, Davy's daring 'Coleridge Experiment' at the Royal Institution can be reinterpreted and

revalued as an important success. It bore rich intellectual fruit for the poet himself, not the 'thorns, briars and parasitical plants' that Davy had feared. It also marked a historic development in the Institution's own record of lecture programming and research sponsorship, which proceeded to expand throughout the nineteenth century. The Institution could, in a word, be proud of Coleridge. 'In fact,' I remarked as I gently closed the great leather folio volume of the 1808 minutes, 'it might consider another serious piece of biographical time-adjustment. It might invite Coleridge back to give one of its celebrated Christmas Lectures. On television. He would be – unforgettable.'

William Blake Rediscovered

1

There are many William Blakes, but mine arrived with the tigers in the 1960s. The first line I ever read by Blake was not in a book, but laid out (or should I say *illuminated*) in thick white paint along a brick wall in Silver Street, Cambridge, in 1968. It was not poetry, but prose: 'The tigers of wrath are wiser than the horses of Instruction.' The words sent a strange shiver down my spine, as they did for thousands of other university students in England and America that year.

It turns out that, according to the *New York Times* for 28 December 1968, exactly the same line from Blake's 'Proverbs of Hell' appeared on big posters at the annual conference of the Modern Language Association in New York. According to the *Times* it signified that 'Radical Agitation Among Scholars Grows', and it led to several arrests.

This was the time of radical disturbances in university campuses right across Europe, as well as the Vietnam and Civil Rights protests in America. Very quickly we all seemed to be reading Blake's Preface to *Milton*. This contains the great radical hymn now known as 'Jerusalem', with which we identified; although in England, paradoxically, it was also sung at the patriotic Last Night of the Proms amidst much flag-waving, and still is:

I will not cease from Mental fight
Nor shall my sword sleep in my hand,
Till we have built Jerusalem
In England's green and pleasant land.

We also found at the start of the Preface a thrilling exhortation that seemed to speak to us with extraordinary force and immediacy: 'Rouze up, O Young Men of the New Age! set your foreheads against the ignorant Hirelings! For we have Hirelings in the Camp, the Court & the University, who would, if they could, for ever depress Mental & prolong Corporeal War.'

Later this passage was used to set the theme and temper of Theodore Roszak's influential *The Making of a Counter Culture* (1969). Penguin produced a popular anthology inspired by Blake: *Children of Albion: Poetry of the Underground in Britain* (1969), while Allen Ginsberg began hypnotically chanting Blake at huge public readings, sometimes accompanied by what appeared to me (at the Royal Festival Hall, at any rate) to be a small, droning, portable harmonium.

In those days we didn't tackle *Milton* itself, which seemed a strange production, one of the so-called 'Prophetic Books', long and labyrinthine, and apparently requiring beforehand a total immersion in Northrop Frye's equally labyrinthine study of Blake's symbolism, *Fearful Symmetry* (1947). But we did find and celebrate Blake's two great explosive revolutionary chants from the *Songs of Experience* (1794), 'The Tyger' and 'London'.

The first seemed an invocation of pure Energy (with unsettling hints of the atom bomb):

In what distant deeps or skies
Burnt the fire of thine eyes?
On what wings dare he aspire?
What the hand dare seize the fire?

The second seemed like a piece of furious contemporary street protest. The following year I found myself discussing it with two young GIs as we stood together on the top platform of the Leaning Tower of Pisa, in Italy. They were on European leave, but were expecting to fly back to Vietnam sometime in the near future. Our encounter led to a brief and totally unexpected meeting of minds – and hearts – which I have never forgotten. Looking down at the ornate Pisan baptistery, we quoted Blake to each other:

> How the chimney-sweeper's cry
> Every black'ning church appals;
> And the hapless soldier's sigh
> Runs in blood down palace walls.

All this seems a long time ago. The poem 'London' is now carved for tourists into the pavement on the south side of Westminster Bridge. Anyone can walk into the new British Library (past Eduardo Paolozzi's great bronze Newton) and find Blake's 'Rossetti Notebook' on display under the quiet lamps, and read a digital projection of the original version of 'The Tyger', with its many haunting manuscript variations:

> In the well of sanguine woe
> In what clay and in what mould
> Were thy eyes of fury rolled ...

My Blake, the radical visionary poet of the 1960s, seems almost old-fashioned now. I realise how many other Blakes there have been, both before and since. They include the bardic mystic popularised by the poets Swinburne (1868) and Yeats (1893); the Marxist protester championed by the scientist Jacob Bronowski (1944); the inspired London dreamer summoned up by the biographers Mona Wilson (1927) and especially Peter Ackroyd (1995); the great

psychological mythmaker analysed by the critics Northrop Frye (1947) and Harold Bloom (1963); the agitator and revolutionary of the political historians E. P. Thompson and David Erdmann (*Prophet Against Empire*, 1974); and the man of 'minute particulars' slowly and meticulously assembled by the inexhaustible scholar-researcher G. E. Bentley Jnr, author of two editions of *Blake Records* (1969, 1988) and a monumental compilation-biography, aimed to subdue 'the factual Laocoön' of the life, *A Stranger in Paradise* (2001).

Added to these, we can find Blake as the protagonist of innumerable Freudian, Swedenborgian, Neoplatonist, Zen Buddhist and more recently excellent, refreshing feminist studies (*Woman Reading William Blake*, 2007, including essays by Germaine Greer, Tracy Chevalier and Helen Bruder). Nor can we overlook the author of *Why Mrs Blake Cried* (2006), Marsha Schuchard, with her detailed explorations (and illustrations) of Blake's supposed excursions into ecstatic tantric sex.

Yet there is a sense in which the first popular Blake emerged 150 years ago, in the 1860s, as a radical engraver and illustrator, or *Pictor Ignotus*. This was the subtitle – 'The Unknown Painter' – of the great Victorian biography by Alexander Gilchrist, first published in 1863, that saved Blake from almost total obscurity.

It has to be remembered that when William Blake died in London in 1827, he was already a forgotten man. He had been living in two-room lodgings in Fountain Court, in the Middle Temple, off Fleet Street. His engraved and hand-painted *Songs of Innocence and of Experience* had sold fewer than twenty copies in thirty years. His 'Prophetic Books' had disappeared almost without trace. A single mysterious poem – 'The Tyger' – had reached the anthologies. As a poet – once read in manuscript by Coleridge, Wordsworth and Charles Lamb – he was virtually unknown outside a small circle of disciples, a group of young men who pointedly called themselves 'The Ancients'. Robert Southey, the Poet Laureate, magnanimously dismissed him as 'a man of great, but undoubtedly insane genius'.

As an artist, Blake's reputation was little better. He was chiefly remembered as a one-time commercial engraver and illustrator of grimly improving texts: Edward Young's *Night Thoughts*, Robert Blair's *The Grave*, the dark Biblical drama of *The Book of Job*, and Dante's *Inferno*, still unfinished at the time of his death. In 1830 he was given a short and gently patronising entry in Alan Cunningham's *Lives of the Most Eminent British Painters*. The illuminations to *The Songs of Innocence* and *The Book of Job* were mildly admired. 'The Tyger' was reprinted as an example of fascinating eccentricity.

Cunningham damned him with faint praise. Blake was a lovable minor eccentric: unworldly, self-taught and self-deluded. He produced work that was 'unmeaning, mystical and extravagant'. He was a man 'overmastered' by his own imagination. He confused 'the spiritual for the corporeal vision'. But for the stabilising influence of his faithful – but 'illiterate' – wife Kate, William Blake would be remembered simply as 'a madman'.

Three years later, in March 1833, the *Monthly Magazine* wittily celebrated his lunacies: 'Blake was an embodied sublimity. He held converse with Michael Angelo, yea with Moses; not in dreams, but in the placid still hour of the night – alone, awake – with such powers as he possessed in their full vigour ... He chatted with Cleopatra, and the Black Prince sat to him for a portrait. He revelled in the past; the gates of the spiritual world were unbarred at his behest, and the great ones of bygone ages, clothed in the flesh they wore on earth, visited his studio.'

Blake was diagnosed as a sufferer of extreme and persistent visual hallucinations, a man who 'painted from spectres', and had lost his grasp on reality: 'His may be deemed the most extraordinary case of spectral illusion that has hitherto occurred. Is it possible that neither Sir Walter Scott nor Sir David Brewster – the authors of *Demonology and Witchcraft* and *Natural Magic* – ever heard of Blake?'

This article had great success, and was reprinted by the smart Parisian magazine *La Revue Britannique* the following year. The

translation was a little hurried, and opened with the assertion that not only was the 'spectral' William Blake still alive, but that he was incarcerated in an asylum: 'The two most celebrated inmates of the madhouse of Bedlam in London are the arsonist Martin, estranged elder brother of the painter John Martin, and William Blake – nick-named "The Seer".'

Twenty years after his death, 'mad' Blake's reputation was barely taken seriously at all. A large manuscript collection of his work was offered for private sale by a keeper at the British Museum in 1847. It consisted of a foolscap quarto sketchbook of fifty-eight leaves, packed with Blake's unpublished poems and drawings. It would now be considered priceless, but then it was sold for ten shillings and sixpence.

The purchaser was Dante Gabriel Rossetti. Vague plans to publish it by the Pre-Raphaelite brotherhood were mooted, and Dante's brother, the critic William Rossetti, expressed an interest. But on examination it was put reluctantly aside as too difficult and obscure to interest the public. A whole generation had now elapsed, the surviving 'Ancients' were indeed growing old, and the memory of 'mad' Blake was dwindling to nothing. It is possible that the author of 'The Tyger' might have been entirely lost.

Then, thirteen years later, on 1 November 1860, Rossetti wrote to his friend the poet William Allingham with surprising news: 'A man (one Gilchrist, who lives next door to Carlyle) wrote to me the other day, saying he was writing a Life of Blake, and wanted to see my manuscript by that genius. Was there not some talk of *your* doing something by way of publishing its contents? I know William thought of doing so, but fancy it might wait long for his efforts … I have not engaged myself in any way to the said Gilchrist on the subject, though I have told him he can see it here if he will give me a day's notice.'

When 'the said Gilchrist' finally visited in March 1861, Rossetti was surprised to encounter a long-haired, dreamy, moon-faced

young man who looked rather as if he had stepped out of one of his own Pre-Raphaelite paintings. Alexander Gilchrist was thirty-two, a writer and art critic, who announced quietly that he had been working on a life of William Blake for the last six years. Indeed, he had already signed a contract with the publisher Macmillan. He did not think Blake was mad; in fact he thought he was a genius. He was going to transform his reputation, however long it took him, and whatever it cost him.

<div style="text-align:center">

2

</div>

Who was Blake's unexpected champion? Born in 1828, the year after Blake's death, Alexander Gilchrist was the son of a Unitarian minister, and had trained as a barrister in the Middle Temple. Restless in his profession, bookish and not physically strong, but with great determination and independence of mind, he sought freedom in magazine journalism and freelance art criticism. From 1849, when he was just twenty-one, he began to write regularly for the *Eclectic Review*, and quickly made his name as a critic and reviewer. He was known for his fresh eye, his lively prose style, his meticulous background research, and his highly unorthodox views. He was also a young critic in search of a cause.

In 1850 he had produced an outstanding article on the derided and controversial artist William Etty (1787–1849). Etty had once been renowned as an exuberant painter of Romantic nudes, both male and female, and erotic scenes from classical history and mythology, such as *King Candaules shews his Wife by stealth to Gyges, as she goes to Bed* (1830) and *Venus and her Satellites* (1835). He had been admired by Regency critics, but Victorian taste and propriety had turned against him, rather as they had earlier turned against Thomas Lawrence, though for different reasons. Where Lawrence's portraits were now considered flashy, Etty's nudes were dismissed as

seedy. His paintings were scoffingly referred to in Academy circles as 'Etty's bumboats'. Gilchrist accepted a speculative commission from a provincial publisher, David Bogue, to write a full-length biography. He undertook to re-establish Etty's tarnished reputation, and turn back the tide of priggish mockery and misunderstanding.

On the strength of the £100 commission Alexander married his twenty-three-year-old sweetheart Anne Burrows in February 1851. They spent part of their honeymoon researching Etty's life in York, where the painter had lived and worked. They interviewed his friends, and examined his nude studies and historical pictures, now mostly housed in private collections. This unorthodox nuptial expedition greatly appealed to Anne, who was free-thinking in her views, and impatient with the conventions of her respectable Highgate upbringing. She too hoped one day to write.

Their first child was born in December 1851, and the large Etty biography was published in 1855, when Gilchrist was still only twenty-seven. The book, which was studiously written and safely deprived of all illustrations (apparently Bogue lost his nerve at the last moment), caused only a mild scandal in York. But in London it drew wholly unexpected praise from the sixty-year-old doyen of biographical writing, Thomas Carlyle. It was written, the Sage announced, 'in a vigorous, sympathetic, vivacious spirit', and gave the 'delineation, actual and intelligible, of a man extremely well-worth knowing'. This rare mark of approval from the author of *On Heroes, Hero-Worship and the Heroic in History* (1841) confirmed Gilchrist in his new vocation as biographer.

After several visits to Chelsea, Gilchrist established himself as Carlyle's confidant and to some extent his biographical protégé. The Sage had recently published his influential *Life of John Sterling* (1851), which by sympathetically recounting the career of an apparent failure, indeed a kind of anti-hero, gave the whole genre a fresh impulse. It was a time when biography was about to enter a new golden age, with John Forster's *Oliver Goldsmith* (1848, revised

1854), Mrs Gaskell's *Charlotte Brontë* (1857), Samuel Smiles's *Self-Help* (1859), G. H. Lewes's *Goethe* (1855) and Frederick Martin's *John Clare* (1866).

Carlyle noticed that Gilchrist's dreamy appearance was deceptive: the young lawyer had a capacity for relentless archival research, an almost forensic gift for tracking down rare books and documents. Carlyle was working, with many groans, on his multi-volume *Life of Frederick the Great*, and soon found Gilchrist bringing him numerous rare bibliographic finds. 'Beyond doubt you are one of the successfullest hunters up of Old Books now living,' beamed Carlyle, 'and one of the politest of obliging men!'

The studious Gilchrist also took unexpected delight in pursuing his open-air researches. With Anne he went for long walks in Kent, Dorset and the Lake District. With Carlyle he wandered after midnight about the back streets of Westminster, Soho, Lambeth or the City. He had an eye (not unlike the young Dickens) for old houses, forgotten buildings, crooked corners and disappearing communities. Faced with some old church, said Anne, he would 'scan every stone' until it yielded up its 'quota of history'. Over long evenings of black tea and tobacco, Carlyle encouraged him to talk, speculate and seek a daring new subject for his pen. A warm, if slightly wary, friendship also grew up between Anne and the older Jane Carlyle.

The subject of William Blake had probably been in Gilchrist's mind for more than a decade. As a young law student of the Middle Temple, he had heard rumours of Blake as the eccentric erstwhile occupant of Fountain Court, which he passed through every day on the way to his legal chambers. He wrote a highly characteristic evocation of this place, its sacred Blakean associations overlaid by mid-Victorian vulgarity, that eventually appeared in Chapter 31 of his biography:

Fountain Court, unknown by name, perhaps, to many who yet often pass it on their way through a great London artery, is a court lying a little out of the Strand, between it and the river, and approached by a dark narrow opening, or inclined plane, at the corner of Simpson's Tavern, and nearly opposite Exeter Hall. At one corner of the court, nearest the Strand, stands the Coal Hole Tavern, once the haunt of Edmund Kean and his 'Wolf Club' of *claquers*, still in Blake's time a resort of the Thespian race; not then promoted to the less admirable notoriety it has, in our days, enjoyed. Now the shrill tinkle of a dilapidated piano, accompaniment to a series of tawdry *poses plastiques*, wakes the nocturnal echoes, making night hideous in the quiet court where the poet and visionary once lived and designed the *Inventions of Job*.

Initially, being primarily an art critic, Gilchrist knew little of the poetry. It was a copy of Blake's illustrations to the *Book of Job*, found at the back of a London printshop, that first caught his eye. He never lost his sense of their astonishing power, and it was Blake's visual imagination which always remained for Gilchrist the key to his genius. In the summer of 1855 he decided to write to one of the surviving Ancients, the painter Samuel Palmer, by then aged fifty.

On 23 August 1855 Gilchrist received a long and engaging reply, which he later reprinted entire in Chapter 33 of his biography. While praising Blake's artistic integrity, Palmer carefully dispelled the notion of his madness, and replaced it with the figure of a gentle, almost Christ-like sage: 'He was a man without a mask; his aim was single, his path straight-forwards, and his wants few ... His voice and manner were quiet, yet all awake with intellect ... He was gentle and affectionate, loving to be with little children, and to talk about them. "That is heaven," he said to a friend, leading him to a window, and pointing to a group of them at play.'

At the same time Palmer hinted at a prophet from the Old Testament, rather than the New: a formidable Blake who could be highly 'expressive' and emotional, 'quivering with feeling', capable of deep anger, and with a flashing glance that could be 'terrible' towards his enemies – 'Cunning and falsehood quailed under it.' He summed up these contradictions with a painterly example from the Italian Renaissance: 'His ideal home was with Fra Angelico: a little later he might have been a reformer, but after the fashion of Savonarola.' Gilchrist was captivated, and he and Palmer became fast friends.

A year later, in 1856, the Gilchrist family moved in next to the Carlyles at number 6 Cheyne Row. The pursuit of Blake's trail through London galleries, local museums, antique bookshops and private collections now began in earnest. Gilchrist purchased Blake prints, and borrowed what he could not buy. Anne started her own collection of Blake's watercolours. Together they tracked down Blake's various lodgings and workshops north and south of the river, in Soho and Lambeth, and meticulously researched his three-year sojourn at Felpham, by the sea in Sussex.

Having established friendly contact with the affable Samuel Palmer, Gilchrist moved on to the other surviving Ancients. They were not all so easy to deal with. The painter John Linnell was helpful but bossy, suggesting the desirability of collaboration. He had eleven precious letters from Blake, written at the very end of his life, and held these out as a bargaining counter. The sculptor Frederick Tatham had written his own private memoir of the time, and then taken to religion, which made him strange and touchy about Blake's antinomian beliefs. The artist George Richmond (only fifteen when he first met Blake) was now a well-meaning but gushing middle-aged raconteur, who embroidered freely on the facts.

Gilchrist engaged all of them in correspondence and interviewed them where he could, minutely compiling anecdotes and stories, trying to sift the true from the apocryphal. He talked to Francis Oliver Finch, and to Maria Denman, the younger sister of the

recently deceased John Flaxman, the painter's one-time patron. He was particularly interested in the relations between Blake and his wife, Catherine. Original letters from Blake were the one thing Gilchrist found it almost impossible to discover, apart from Linnell's.

Gilchrist's greatest diplomatic triumph was to pierce the gruff reserve of the retired journalist Henry Crabb Robinson, then in his eighties. Robinson – once the intimate friend of Wordsworth and Charles Lamb, and the witness to Coleridge's lectures – had kept extensive diary accounts of the whole Romantic circle during his time. His notes were admiring, but sceptical and extremely shrewd. In 1811 he had written up a rare appreciation of Blake's work for a German magazine published in Hamburg: 'William Blake: Artist, Poet, and Religious Dreamer'. Moreover, his unpublished journals for 1825–27 contained a unique series of interviews with the older Blake. Robinson paid particular attention to the question of Blake's visions, the logic (or otherwise) of his explanations, and the significance of his eccentricities. Gilchrist managed to obtain all this material, and used it with brilliant effect in Chapter 36.

In the winter of 1859 Gilchrist submitted an outline draft of his *Life of Blake* to the publisher Macmillan. He was offered a £150 contract, and an advance on research expenses of £20. Compared with the Etty commission these terms marked a small but not very generous improvement. After all, this was a time when popular biographies by Mrs Gaskell and John Forster were being commissioned for well over £1,000. But Blake's name was still worth very little. Undeterred, Gilchrist worked on through 1860, continuing to support his family with freelance journalism. It must have seemed an increasingly quixotic venture.

In March 1861 he finally met Dante Gabriel Rossetti, and the pace and confidence of his long researches began to increase and bear fruit. The Blake manuscript notebook, purchased over fourteen years before, was at last revealed. Over several later meetings at the

Cheshire Cheese tavern in Fleet Street the new poems and drawings were discussed. Gilchrist quickly passed muster with the Pre-Raphaelite brotherhood, all of whom were suddenly excited by the prospect of his forthcoming book. Rossetti's friendship also brought him into contact with the twenty-four-year-old Algernon Swinburne, who now discovered a lifelong passion for Blake.

Most enthusiastic of all was Dante Gabriel's brother, the art critic William Michael Rossetti, who encouraged Gilchrist to think in terms of an even more ambitious project. After the biography, perhaps he could edit a companion volume of Blake's poems and a catalogue of his artwork? Spurred on by these new supporters, Gilchrist promised Macmillan to deliver the completed biography by spring 1862.

But after six years, the work was close to exhausting him. Money was short, and by now the Gilchrists had four children. Gilchrist's constitution, never strong, began to fail. He was frequently ill and depressed, harassed by the unrelenting deadlines for his weekly art reviews. Sometimes he collapsed, unable to work on Blake for days on end. It was during this growing professional crisis that Anne Gilchrist began quietly to assert herself.

Anne had been working as Alexander's part-time research assistant ever since the Etty days. But now she became his full-time amanuensis. She took dictation, copied Blake's manuscripts, checked facts and dates at the British Museum, and prepared an index. She admired her husband's perfectionism, always pursuing one more source or reference. But sometimes she felt he would never complete the book at all. Nonetheless, by late summer 1861, Gilchrist told Macmillan that he had a draft of the whole biography. Although he was continually slipping in extra materials and anecdotes, the basic structure was secure. With Anne's help, the book was lucidly organised in thirty-eight short chapters, and Gilchrist was ready to start sending it in batches to the printer for setting up in proof, the usual piecemeal procedure for such a large manuscript.

Macmillan was delighted, and urged him to begin. Accordingly, Gilchrist sent the first eight chapters to the printers in September 1861, taking Blake's life up to the *Poetic Sketches* and the 'Notes on Lavater' made when Blake had turned thirty. He promised to send in the next batch by November, with the aim of having the complete work in proof by the following spring. He was under great pressure, but believed that with Anne's help he could just about meet his deadlines.

On 20 November 1861, Gilchrist wrote to his publisher that he had been unable to send the promised 'big mass of copy', consisting of the next dozen or so chapters (taking Blake up to forty, and his most productive years). He explained that 'domestic troubles have during the last month stood in the way'. For six weeks his eldest daughter, seven-year-old Beatrice, had been lying dangerously ill with scarlet fever. Anne had insisted on a 'rigid quarantine', remaining alone in the child's sickroom to carry out all the nursing herself. There was great fear of infection. Gilchrist was only allowed in once an evening, to make up the fire, while Anne stood back by the window. Meanwhile, he tried to look after the other three young children with the help of one (frequently drunk) domestic.

At the end of his letter, Gilchrist unburdened himself to his publisher:

> We have been in great misery at times, aggravated by our having a doctor in whom we had not implicit confidence ... My wife has during all this time been confined to the sickroom, without help! ... Of hired nurses we have a horror; our friends have mostly children and others regard for whom makes them dread crossing the threshold of a scarlatina infected house. Forgive this closing matter.
> Yours faithfully,
> Alexander Gilchrist

A week later, just as his little daughter Beatrice began to pull through, Gilchrist was himself struck down. Jane Carlyle sent notes offering help to Anne, and Thomas Carlyle brought a fashionable physician, who looked at Gilchrist from the distance of the sickroom door and hastily departed. After that, events unfolded quickly. Ten days after he had sent his desperate, apologetic letter to Macmillan, Alexander Gilchrist slipped into a coma.

Anne later wrote: 'The brain was tired with stress of work; the fever burned and devastated like a flaming fire: to four days of delirium succeeded one of exhaustion, of stupor; and then the end; without a word, but not without a look of loving recognition. It was on a wild and stormy night, 30 November 1861, that his spirit took flight.'

Alexander Gilchrist died at the age of thirty-three. His great biography of Blake, his labour of love, had been wonderfully researched and written in draft. But only the first eight chapters were delivered; the rest was unfinished. With her peculiar force and independence, Anne Gilchrist immediately determined to complete the biography for him. Less than a week after Alexander's death, she wrote to Macmillan on 6 December: 'I try to fix my thoughts on the one thing that remains for me to do for my dear Husband. I do not think that anyone but myself can do what has to be done to the Book. I was his amanuensis ...'

She packed up his papers, returned a mass of borrowed pictures and manuscripts, refused Jane's invitation to move in with the Carlyles, and took the children and the unfinished book down to a clapboard cottage in the tiny village of Shottermill, a mile from Haslemere in Surrey.

3

To understand what happened next, we have to turn to Anne Gilchrist's own story. She had always been an independent spirit. She

was born Annie Burrows in February 1828 in Gower Street, London, but was partly brought up in the country, at Colne in Essex. Here, when she was nine years old, her beloved elder brother Johnnie saved her life. The incident, as she retold it, has a curious fairy-tale quality. While exploring a secret part of the garden, 'little Annie' fell backwards into a deep well, and would certainly have drowned, had not Johnnie reached down and just managed to hold her up by the hair until help finally came. Over twenty years later she put this strange tale of survival into a children's story, 'Lost in the Woods' (1861). The symbol of the rescue from death, or dark oblivion, haunted her.

Anne's father was a London lawyer, strict and demanding, who died aged fifty-one in 1839, when she was only eleven. From then on, the family were on their own, and Anne was in some sense a liberated spirit. They moved to Highgate, where Anne went to school, a handsome tomboy, clever and rebellious. She was musical, well-read and free-thinking. At seventeen she was surprised by the local vicar seated on a tombstone in Highgate Cemetery reading a copy of Rousseau's *Confessions*, a work regarded as far too sexually explicit for a well-brought-up Victorian young lady. Embarrassment was avoided (according to Anne) when the vicar conveniently misheard her give the book's title as St Augustine's *Confessions*.

At nineteen she became fascinated by scientific ideas, a further unladylike development. She announced to a friend that the intellectual world was divided between Emerson and Comte, between the spiritual and the materialist, and that she was tending towards the latter.

In 1847 (the year Rossetti bought the Blake manuscript) she was devastated by the death of her 'angel brother', Johnnie. A year later, aged twenty, she announced her engagement to one of Johnnie's friends, a handsome young law student, Alexander Gilchrist, 'great, noble and beautiful'. In a way, Gilchrist was probably a substitute brother. She deeply admired him, but from what she said later, she

was never truly in love. What he offered was the chance of freedom and independence. Their unorthodox Etty honeymoon was a promise of things to come.

After the birth of their four children – Percy, Beatrice, Herbert and Grace – she set herself to earn additional household money by writing small pieces for the monthly magazines and *Chambers Encyclopaedia*. The first of these, 'A Glance at the Vegetable Kingdom', was published in *Chambers* in spring 1857, shortly after they moved into Cheyne Row.

From then on, Anne made a specialty of popular science subjects, and she was remarkably successful at it. In 1859, the year of Darwin's *Origin of Species*, she wrote a controversial article on the newly discovered gorilla, provocatively entitled 'Our Nearest Relation', comparing its skills and habits to those of *Homo sapiens*. It was published in Charles Dickens's magazine *All the Year Round*. Next she wrote on 'Whales and Whaling', and in the following years produced several further young person's guides to scientific topics: 'What is Electricity?', 'What is a Sunbeam?', and 'The Indestructibility of Force'. Her ability to research, organise and explain technical subjects for the general reader was highly unusual.

Anne's role as Gilchrist's amanuensis was therefore far greater than it might superficially appear. She seems to have become a genuine literary partner, and perhaps something rather more. She claimed that the subsequent work on the biography came to her as a kind of posthumous and sacred collaboration: 'Alex's spirit is with me ever – presides in my home; speaks to me in every sweet scene; broods over the peaceful valleys; haunts the grand wild hill tops; shines gloriously forth in setting sun, and moon and stars.'

No doubt these feelings of Alex's supportive presence were authentic, but she was also driven by other, though no less powerful, emotions. Essentially, she seems to have felt guilty about her marriage, sensing that she had never been Gilchrist's true wife. Nearly a decade after his death, in September 1871, she wrote a

remarkable confession of her own: 'I think … my sorrow was far more bitter, though not so deep, as that of a loving tender wife. As I stood by him in the coffin, I felt such remorse I had not, could not have, been more tender to him – such a conviction that if I had loved him as he deserved to be loved he would not have been taken from us. To the last my soul dwelt apart and unmated, and his soul dwelt apart and unmated.'

Her drive to complete his biography of Blake was, therefore, far more than a show of pious sentiment, a widow's tender offering. It was a compelling debt of honour, the recognition of a difficult but sacred trust. Anne already knew much of Alexander's method of working, and his perfectionism. What she did not know was whether she could match it. She wrote to Macmillan: 'Many things were to have been inserted – anecdotes etc. collected during the last year, which he used to say would be the best things in the book. Whether I shall be able to rightly use the rough notes of these and insert them in the fittest places I cannot yet tell. He altered chapter by chapter as he sent it to the printers …'

Three months later, in March 1862, she wrote to the publisher that, to her surprise, she had completed sorting and arranging all of Alexander's remaining material for the book. It would be faithfully completed: 'You shall not find me dilatory or unreliable; least of all in this sacred trust.' Fiercely defensive of every word of Alexander's existing text, she carefully began to pull together the drafts of the outstanding chapters. She made regular visits to the British Museum, catching the London train up from Haslemere station. She checked his facts and polished his style. She defended him against Macmillan's charges of sometimes writing too flamboyantly, like Carlyle.

With some reluctance, she turned for help to the Rossettis. She did not want them to touch a word of the text of Alexander's biography, but she wanted help with the companion volume: the catalogue of Blake's pictures and an anthology of his poetry. She proposed to Macmillan that he commission a second volume, to consist of an

annotated catalogue of Blake's visual work compiled by William Rossetti, and a selection of his poetry edited by Dante Gabriel. This was agreed, and the whole project now advanced rapidly on its new footing.

The sudden death of Dante Gabriel's wife, Lizzie Siddal, in February 1862, added a peculiar intensity to the work of selection. 'I feel forcibly,' he wrote to Anne, 'the bond of misery that exists between us.' He moved back into bachelor lodgings, which he shared with George Meredith and Swinburne, and they too began to act as unofficial Blake readers and selectors. Christina Rossetti even came to stay at the Shottermill cottage to support Anne in the final stages of her sacred task.

So not only had the whole Rossetti family now rallied around Anne's 'Herculean labour', but the two-volume work had almost become a group enterprise, a Pre-Raphaelite project to restore Blake, and to do honour to his idealistic young biographer. As Dante Gabriel wrote to Anne, 'I would gladly have done it for Blake's or gladly for your husband's or gladly for your own sake, and moreover, had always had a great wish of my own to do something in this direction ...' The twin volumes were to be delivered twelve months later, in spring 1863.

4

Who, then, finally wrote Gilchrist's *Life of William Blake*?

It is clear from their correspondence that the Rossettis confined themselves almost entirely to the editorial work on the second volume alone. Dante Gabriel was asked to write a 'Supplementary' summary as a Postscript, and to fill in a missing description of Blake's *Book of Job* – ironically the very work that had first drawn Gilchrist to Blake. Apart from that, they touched virtually nothing in the first volume, because they were not permitted to. Anne

regarded the text of the biography as sacred to Gilchrist's memory. She was its sole guardian. 'I think you will not find it hard to forgive me a little reluctance,' she wrote to William Rossetti, 'that *any* living tones should blend with that voice which here speaks for the last time on earth.'

How far she herself added new material from Alexander's notes, or made stylistic changes, must remain problematic. In April 1862 she was speaking of 'incorporating *all* the additional matter contained in the notes' into a final draft, which sounds quite radical. But by the end of May the position was almost reversed: 'I am glad to say I find the Manuscript even more complete than I anticipated, and that a large mass of Notes which I had thought contained new matter, were merely for reference and verification.' To the end of her days Anne insisted that she was nothing more than her husband's 'editor'. But since Gilchrist's original manuscript has not survived, there is no way of knowing precisely how she understood this role.

It is difficult to find evidence of any large editorial additions or interventions. For example, Alexander had frequently lamented his failure to develop any proper critical commentary on the poetry (as opposed to the illuminations) of the 'Prophetic Books'. Anne was clearly tempted to remedy this: 'I found the only grave omission in the book – the only place where dear Alex had left an absolute blank that *must* be filled in – was for some account of Blake's mystic writings, or "Prophetic Books", as he called them.'

But although she consulted with Rossetti, she did not in the end attempt to add any significant commentary, writing ruefully: 'I could heartily wish the difficult problem presented by these strange Books had been successfully grappled with, or indeed grappled with at all. Hardly anything has now been attempted beyond bringing together a few readable extracts ... They are at least psychologically curious and important.' The omission is very clear, for example in the desultory remarks on the 'Prophetic Book' *Jerusalem* in Chapter 21, despite the fact that Anne had meticulously copied out the entire

text by hand, from a rare copy loaned with great reluctance ('only for a week') by Keats's devoted biographer Richard Monckton Milnes.

She seems to have conceived her main role as protecting what Alexander had written and quoted. There was some need for this. The genial Palmer was desperate to avoid anything that hinted at 'blasphemy', while Macmillan was acutely nervous of Blake's erotic writing. He anxiously read every sentence of the proofs, and questioned even single lines from the poems, especially those from the sexually explicit passages in *Visions of the Daughters of Albion* which recount the rape and humiliation of Blake's tender heroine Oothona. William Rossetti wrote to Anne: 'The pervading idea of "The Daughters of Albion" is one which was continually seething in Blake's mind, and flustering Propriety in his writings ... It is the idea of the unnatural and terrible result in which, in modern society, ascetic doctrines in theology and morals have involved the relations of the sexes ... in [this] cause he is never tired of uprearing the banner of heresy and non-conformity.'

Sexual explicitness had never alarmed the biographer of Etty. But here Anne was forced to compromise, and she replied to Rossetti on 3 October 1862: 'I am afraid you will be vexed with me ... But it was no use to put in what I was perfectly certain Macmillan (who reads all the proofs) would take out again ... It might be well to mention to Mr Swinburne that it would be perfectly useless to attempt to handle this side of Blake's writings – that Mr Macmillan is far more inexorable against any shade of heterodoxy in morals, than in religion ... in fact poor "flustered Propriety" has to be most tenderly and indulgently dealt with.'

She was beset by other diplomatic problems. One of the original Ancients, the painter John Linnell, offered to oversee all the proofs, but made it clear that he would alter the text where he did not approve of it. Anne knew that Alexander had already rejected this idea long before – the bare notion of it filled him with horror: 'I do not think he ever showed proof or manuscript to the most congenial

friend even.' This was a policy that Anne clearly intended to continue.

Alexander had made the 'most minute notes' of all Linnell told him, but believed there was 'considerable divergency' in their view of the facts. 'Besides,' concluded Anne, 'a biographer's duty often is to balance the evidence of conflicting witnesses.' To have acceded to Linnell would, she felt sure, have been 'a most imprudent, and indeed treacherous thing on my part'.

There were other difficulties among the keepers of the flame. Frederick Tatham had quarrelled with Linnell over the ownership of some of Blake's Dante drawings, and Anne believed that Tatham had also imposed on Blake's widow by silently selling off many of his engraved books over 'thirty years'. Such post-mortem disputes were peculiarly confusing to Anne. Yet she retained absolute confidence in Alexander's view of the situation: 'My husband, who had sifted the matter, and knew both parties, thought Linnell an upright and truthful, if somewhat hard man, and that towards Blake his conduct had been throughout admirable. He also inclined to think, that Mrs Blake retained one trait of an uneducated mind – an unreasonable suspiciousness ...' Here she was in fact quoting Gilchrist's own words from the biography.

She was, however, dismayed to discover that Tatham, in a fit of religious zeal, had much later destroyed many of Blake's manuscripts. For a biographer this was the ultimate sin, and would have appalled Alexander. She wrote angrily to William Rossetti that Tatham had come to believe that Blake was indeed inspired, 'but quite from a wrong quarter – by Satan himself – and was to be cast out as an "unclean spirit"'. This was a ghastly parody of Gilchrist's subtle, secular, psychological appreciation of Blake's profound eccentricity and originality. She would have nothing to do with it.

The most challenging editorial problem arrived last. In January 1863, when the biography was already printing, Anne was sent ten precious letters from Blake to his young publisher and patron Thomas Butts. At a stroke, this doubled the number of surviving

letters. They all dated from the crucial – and little-known – period of creative renewal when Blake retired to a tiny thatched cottage in Felpham, Sussex, between 1800 and 1804, and gave a wholly new insight into his character, his views of his art and patronage, and some wonderful examples of his most limpid but visionary prose:

> The villagers of Felpham are not mere rustics; they are polite and modest. Meat is cheaper than in London; but the sweet air and the voices of winds, trees, and birds, and the odours of the happy ground, make it a dwelling for immortals. Work will go on here with God-speed. A roller and two harrows lie before my window. I met a plough on my first going out at my gate the first morning of my arrival, and the ploughboy said to the Ploughman, 'Father, the gate is open.'

One letter even gave a long and detailed account, from Blake's point of view, of the fracas with a soldier in the garden at Felpham which led to his trial for 'seditious and treasonable utterance' in 1804. This was one of the most dramatic events in Blake's life, and perhaps a turning point in his professional career. Gilchrist had already given up a whole chapter to describing the incident. His account was based on Catherine's memories, the letters of Blake's patron at Felpham, the poet William Hayley, and a local Sussex newspaper report of the trial. While defending Blake as certainly not guilty of real treason, Gilchrist allowed it to be tacitly understood that he did treat the soldier with some violence, 'in a kind of inspired frenzy', and probably did shout some ill-advised political things at him: '"Damn the King, and you too," said Blake with pardonable emphasis.' Blake's own account was far more exculpatory, and intriguingly different.

How should Anne handle this unexpected biographical windfall? Macmillan claimed he was too far advanced with the printing to allow her to insert the letters at such a late stage. However, since they were discovered nine months before the book was finally published,

it seems that Anne herself was loath to disrupt Alexander's narrative. Yet the letters were extremely revealing, and she could not bear to omit them: 'I have all but finished copying Blake's letters; a task of real enjoyment, for they are indeed supremely interesting, admitting one as far as anything he ever wrote into the "inner precincts" of his mind ...'

In the end, the solution she chose was to print the 'Letters to Thomas Butts' separately, as an Appendix to the Life. This gives perhaps the clearest indication of the judicious way she saw her own editorial function. The solution (although evidently not ideal) allowed her carefully to retain Alexander's perceptive narrative of the Sussex period without interruption. But it enabled her to add Blake's own version. It also allowed her to appear modestly in her own role of editor, remarking on the light that the letters now threw on 'the under-currents of Blake's life', and wishing only that Alexander had seen them before he died.

By autumn 1863, Anne had surmounted all these difficulties. Far from finding the work burdensome, she later said characteristically that it had proved a support and a consolation to her in the time of mourning: 'That beloved task (the *Blake*) kept my head above water in the deep sea of affliction, and now that it is ended I sometimes feel like to sink – to sink, that is, into pining discontent – and a relaxing of the hold upon all high aims ...' The Life was finally published in two volumes in October 1863.

5

Two thousand copies were printed, and reviews appeared rapidly. There were some initial reservations that the biography would, as Anne put it, 'shock devout minds'. One reviewer observed evenly: 'a more timid biographer might have hesitated about making so open an exhibition of his hero's singularities'. But it was soon clear that the

book would be a triumph. It was widely admired by the entire Pre-Raphaelite circle. Robert Browning wrote a fan letter, and Samuel Palmer spoke for the Ancients when he described it as 'a treasure', adding thoughtfully, 'I do hope it may provoke a lively art-controversy in the periodicals, unless people have gone quite to sleep.' He had 'read *wildly* everywhere', and concluded tenderly, 'already it is certain to be an *imperishable monument* of the dear Biographer'.

It was loyally hailed by Carlyle in a letter to Anne: 'thankfulness is one clear feeling; not only to you from myself, but to you for the sake of another who is not here now'. He considered it 'right well done – minute knowledge well-arranged, lively utterance, brevity, cheerful lucidity'. Later he told her, with a tact clearly designed to praise her faithful editorial work, that the whole biography was remarkable for 'the acuteness and thoroughness with which the slightest clues had been followed out in gathering the materials, and with all this toil and minute accuracy on the writer's part, nothing but pleasure for the reader – no tediousness'.

The great strengths of the work, which Anne had so faithfully preserved, were quickly apparent. Gilchrist's approach is lively, personal, enthusiastic and often humorous – quite unlike much over-earnest mid-Victorian biography. The quick, informal, darting style of his prose lends a sense of continual discovery and excitement to the narrative, and yet allows for virtuoso passages of description and summary.

It is extraordinarily well-researched, especially in the use made of the previous memoirs by Malkin, Tatham, Linnell, Palmer, Crabb Robinson and several others. Although he lacked the Butts letters, Gilchrist draws effectively on some original correspondence with Flaxman in the early years, and the expressive series of short notes to John Linnell at Hampstead in the last years. He also quotes brilliantly throughout from Blake's own works, both prose and poetry, much of it quite unknown to contemporary readers, such as the

early 'Notes on Lavater' and the *Proverbs of Hell*. He was, too, the first Victorian writer to pick out and reprint in full Blake's great 'Jerusalem' hymn from the Preface to *Milton*, 'And did those feet in ancient time'.

There are two qualities in Gilchrist's writing which make him such an exceptionally vivid biographer. The first is his sense of physical place. He had a gift for evoking particular London streets, characteristic clusters of buildings or courtyards, and beyond them certain rural landscapes and secluded villages, where Blake had lived and worked. He captured their appearance, mood and atmosphere, and gave hints of their visionary meanings, or 'auras', for Blake.

Gilchrist had spent endless days researching and identifying them, following meticulously in Blake's footsteps. He could also add fascinating observations of how these sacred places had changed in the subsequent fifty or so years, giving a sense of historical continuity. In this way, the biography first gave Blake's extraordinary imaginative life 'a local habitation and a name'. The descriptions of the Gothic interior of Westminster Abbey, or of Hercules Buildings (and its garden) in Lambeth, or of the cottage and seashore at Felpham, and the last, hidden lodgings at Fountain Court, are especially evocative.

The second quality is his power to conjure up Blake's pictures and designs for the reader. Only a few of these were actually illustrated in the book, in black-and-white engravings, so a great deal depended on Gilchrist's verbal descriptions. He found a remarkable way of bringing them to life in virtuoso passages of exquisite prose 'dramatizations', the energy of his syntax matching the energy of Blake's line, which became a major feature of his biography. Here the young art critic comes into his own. This, for example, is how he brilliantly evoked the life and movement of the thirteen designs for 'A Memorable Fancy':

The ever-fluctuating colour, the spectral pigmies rolling, flying, leaping among the letters; the ripe bloom of quiet corners, the living light and bursts of flame, the spires and tongues of fire vibrating with the full prism, make the page seem to move and quiver within its boundaries, and you lay the book down tenderly, as if you had been handling something sentient. A picture has been said to be midway between a thing and a thought; so in these books over which Blake had brooded, with the brooding of fire, the very paper seems to come to life as you gaze upon it – not with a mortal life, but with a life indestructible, whether for good or evil.

Gilchrist made the defence of Blake's eccentricity, and the rejection of his supposed insanity, a commanding theme from the beginning:

On Peckham Rye (by Dulwich Hill) it is, as he will in after years relate, that while quite a child, of eight or ten perhaps, he has his 'first vision'. Sauntering along, the boy looks up and sees a tree filled with angels, bright angel wings bespangling every bough like stars. Returned home he relates the incident, and only through his mother's intercession escapes a thrashing from his honest father, for telling a lie ... If these traits of childish years be remembered, they will help to elucidate the visits from the spiritual world of later years, in which the grown man believed as unaffectedly as ever had the boy of ten.

Gilchrist reverts continually to these visions: calmly asking what exactly they were, how Blake described them, and how they should be accounted for. Much apparently outlandish behaviour, such as the 'scandalous' nude sunbathing incident at Lambeth, is given a reasonable and detailed explanation, in this case with an amusing reminder about Shelley's enthusiasm for the early Naturist movement, as well

as a reference to innocent Swedenborgian rituals. It is interesting that clearly Anne had been able to prevent Macmillan from censoring this particular account, which eventually became one of the most memorable and treasured incidents in Blake's popular biography (though paradoxically the one most vehemently challenged by his academic defenders).

> At the end of the little garden in Hercules Buildings there was a summer-house. Mr Butts calling one day found Mr and Mrs Blake sitting in this summer-house, freed from 'those troublesome disguises' which have prevailed since the Fall. *'Come in!'* cried Blake, *'it's only Adam and Eve you know!'* Husband and wife had been reciting passages from *Paradise Lost*, in character, and the garden of Hercules Buildings had to represent the Garden of Eden ...

Later, Blake's poverty, social isolation and professional difficulties are shrewdly shown to have exacerbated the oddities of his temperament. Of the quarrel with the commercial publisher Cromek in 1815, a frankly 'discordant episode', Gilchrist writes calmly but unflinchingly:

> In Blake's own mind, where all should have been, and for the most part was, peace, the sordid conflict left a scar. It left him more tetchy than ever; more disposed to wilful exaggeration of individualities already too prominent, more prone to unmeasured violence of expression. The extremes he gave way to in his designs and writings – mere ravings to such as had no key to them – did him no good with that portion of the public the illustrated *Blair* [*The Grave*, by Robert Blair] had introduced him to ... Now, too, was established for him the damaging reputation 'Mad'.

All this is summarised in the decisive Chapter 35, boldly entitled 'Mad or Not Mad'. In many ways this chapter is the psychological key to the entire biography. Here Gilchrist carefully defines the 'special faculty' of Blake's imagination, and vindicates the profound spiritual sanity of the 'gentle yet fiery-hearted mystic'. One after another, he calls as witnesses all Blake's circle of friends, from Flaxman and Fuseli to Palmer and Linnell. In a robust passage Gilchrist rejects any modish Victorian interpretation of Blake's visions: 'No man, by the way, would have been more indifferent or averse than he (wide and tolerant as was his faith in supernatural revelations) towards the table-turning, wainscot-knocking, bosh-propounding "Spiritualism" of the present hour.' Instead he champions Blake in terms that Carlyle would certainly have recognised: 'Does not prophet or hero always seem "mad" to the respectable mob, and to polished men of the world ...?'

The last chapters are structured around the unpublished *Reminiscences* of Crabb Robinson from 1825, and the interviews with Palmer, Richmond and Tatham, who knew Blake in the last years at Fountain Court. From here onwards ('Personal Details'), the biography is at its most intimate and moving. The final picture of Blake 'chaunting Songs' to Catherine as he lies on his deathbed in the little upper room in Fountain Court, with the golden light from the nearby Thames playing above him on the ceiling, is unforgettable.

6

Gilchrist's biography was immediately taken up by the Pre-Raphaelites and their circle. William Rossetti established himself as the leading nineteenth-century Blake scholar, and edited the first collection of Blake's *Poetical Works*, published in the Aldine series in 1874. Algernon Swinburne, inspired by Gilchrist, wrote the first detailed

assessment of Blake as a poet, which appeared as a long monograph, *William Blake: A Critical Essay*, in 1868. In his Preface Swinburne spoke with admiration of Gilchrist's 'trained skill' and 'sense of selection' as a biographer, and his 'almost incomparable capacity of research and care in putting to use the results of such long and refined labour'.

Like Palmer, Swinburne felt the biography would endure, despite the tragic circumstances of its composition: 'This good that he did is likely to live after him; no part of it is likely to be interred in his grave.' In saying this, Swinburne also gently reopened the question of the posthumous collaboration between Anne and Alexander: 'For the book, unfinished, was not yet incomplete, when the writer's work was broken short off. All or nearly all the biographical part had been carried through to a good end. It remained for other hands to do the editing; to piece together the loose notes left, and to supply all that was requisite or graceful in the way of remark or explanation.' Anne, however, remained strenuous in her denial of having contributed anything more than 'editorial' work.

Interest in Blake steadily revived, and within fifteen years Macmillan was ready to undertake a new edition. Anne Gilchrist had spent the previous four years in America with her children, writing about the work of Walt Whitman and forming an intense personal friendship with the poet. On her return to England in June 1879, almost her first act was to undertake the revision of the Blake biography desired by Macmillan. She had remained in close touch with the Rossettis, and with their advice began to correct minor errors of fact and dates. By March 1880 the work was being 'pushed energetically through', her main task being to find a place for another major cache of correspondence, some forty newly discovered letters from Blake to his patron William Hayley.

Anne made one further effort to enter the mysterious inner world of Blake's imagination, by adding newly extended citations from the 'Prophetic Books'. Though she still regarded any attempt to interpret

Blake's mythology as 'a reckless adventure', she hopefully read and reread *Jerusalem*, finding 'several more coherent and indeed beautiful passages', and relating the poetry to the 'sublime influence of the sea' on Blake at Felpham. She added half a dozen new extracts from both *Jerusalem* and *Milton*, with a brief commentary on Blake's extraordinary system of symbolic names, like 'Orc', 'Urizen' and 'Oothona'. She also referred the reader to Swinburne's critical essay, as a possible guide.

With the bulky addition of the new letters, together with Anne's expanded quotations from the 'Prophetic Books' (and also certain prudential cuts she made in final deference to 'flustered Propriety'), the biography became more like a standard late-Victorian volume of *Life and Letters*. It lost something of the passionate excitement and directness of its original youthful conception. Nonetheless, this second edition of 1880 continued the task of re-establishing Blake's reputation on both sides of the Atlantic. Praise for Gilchrist's heroic work was now universal, and Walt Whitman for one saluted the rise of a new informal English style of biography, comparing it to the work of J. A. Froude:

> The Blake book is charming for the same reason that we find Froude's *Carlyle* fascinating – it is minute, it presents the man as he was, it gathers together little things ordinarily forgotten; portrays the man as he walked, talked, worked, in his simple capacity as a human being. It is just in such touches – such significant details – that the profounder, conclusive, art of biographical narrative lies.

Anne would still make no claims other than that of being 'editor' of Alexander's work. Instead she added a long and passionate 'Memoir', praising his supreme dedication as a biographer. In it she made this thoughtful observation: 'If I could briefly sketch a faithful portrait of Blake's biographer, the attempt would need no apology; for if the

work be of interest, so is the worker. A biographer necessarily offers himself as the mirror in which his hero is reflected; and we judge all the better of the truth and adequacy of the image by a closer acquaintance with the medium through which it comes to us.'

In the careful use of that suggestive term 'medium', with all its Victorian overtones, Anne Gilchrist may have been making special claims for the biographer, and the nature of his – or her – mysterious collaboration with the subject. Alexander would surely never have admitted to these, but William Blake himself might have assented in his own fashion. Anne Gilchrist later wrote the Blake entry for Leslie Stephen's *Dictionary of National Biography* in 1882, and also a well-judged Life of Mary Lamb in 1883. She had other literary plans, including Lives of Wordsworth and Thomas Carlyle. But then her heart was broken by the tragic fate of her favourite daughter Beatrice.

This was the child she and Alexander had nursed through scarlet fever at Cheyne Row, while Alexander was struggling to complete the biography. She was always closely associated in Anne's mind with the early shared work on Blake. True to her mother's early leanings towards science, Beatrice had been training in Edinburgh to qualify as one of Britain's first women doctors. In July 1881, possibly as the result of an unhappy love affair, she committed suicide at the age of twenty-five by taking cyanide. Anne never really recovered from the death of Beatrice so shortly after the publication of the second edition of Blake. She developed breast cancer and died at Hampstead four years later, in November 1885, aged only fifty-seven, all her other literary plans unfulfilled.

Gilchrist's original *Life of William Blake*, with its combative sub-title *Pictor Ignotus* ('The Unknown Painter'), remains one of the most influential of all the great nineteenth-century biographies. It rescued its subject from almost total obscurity, challenged the notion of Blake's madness, and first defined his genius as both an artist and a visionary poet. It set the agenda for modern Blake studies, and remains the prime source for all modern Blake biographies. It is still

wonderfully readable today, and salvaged from death, it still vibrates with extraordinary life.

Yet like so many works of art, it was produced at great cost, and under mysterious conditions. In the absence of an original manuscript of the 1863 biography, the question will always remain just how much of this first, groundbreaking text we really owe to Alexander or to Anne Gilchrist; or to some indefinable, Blakean collaboration between all three of them.

Anne finally wrote this reflection about her husband's work and the art of biography: 'He desired always to treat his subject exhaustively: as a critic to enter into close companionship with his author or painter; as a biographer to stand hand in hand with him, seeing the same horizon, listening, pondering, absorbing.'

Acknowledgements

Despite my previous attempts, *Footsteps* (1984) and *Sidetracks* (2000), autobiography has always seemed to me a perilous enterprise. So this book (the third in the trilogy) has grown slowly and tentatively out of many drafts and revisions. Most chapters began as separate lectures, short articles or introductions, but finally I took courage and transformed them into something more extended and much more personal. They are offered as an inside account of one particular biographer at work, but also include the experience (and the history) of many others that I have admired. In the end the book has become a sort of eulogy: a celebration of a form, an art, and a vocation that I have intensely loved over more than forty years, and which I still do not entirely understand.

I have deliberately let it unfold without preface or comment, as a series of linked – and frequently overlapping – biographer's tales, which tell their own story but build towards a larger picture. Some are confessional, some scientific, some mischievous, some riskily pedagogic, some passionately concerned to restore or revalue controversial reputations. But all present reflections on the vital, elusive idea of biographical truth, and the many imaginative ways in which it can be pursued. The result, I hope, is a biographer's declaration of faith: the pursuer pursued.

A first version of 'Travelling' was tried out as the 2014 Leon Levy Biography Lecture at the City University of New York, and later in the *New York Review of Books*. 'Experimenting' had a typically long

gestation, beginning as a lecture for the Smithsonian Institution, Washington (2010); then expanded as a paper on 'Romantic Knowledge' for the Ludwig-Maximilians-Universität München (2014); then partly published in *The Era of Experiments and the Age of Wonder*, edited by Lilla Vekerdy, Dibner Library and the Smithsonian Institution, Scholarly Press (2015); then rewritten again for this book.

'Teaching' began as a brief essay for *Mapping Lives: The Uses of Biography*, edited by Peter France and William St Clair, British Academy Press, Oxford University Press (2002). 'Forgetting' first appeared in *Memory: An Anthology*, edited by Harriet Harvey Wood and A. S. Byatt, Chatto & Windus (2008). 'Ballooning' was first launched as a brief essay for *Intelligent Life*, edited by Maggie Fergusson, *The Economist* (2013), but inflated and finally landed here.

'Margaret Cavendish' began as a short article on women and the Royal Society for the *Guardian* in 2010. 'Zélide', 'Mary Wollstonecraft' and 'William Blake Rediscovered' drew on the Introductions to my series 'Classic Biographies', HarperPerennial (2004 and 2005). Early drafts of three chapters appeared in the *New York Review of Books* as 'Madame de Staël', 'John Keats' and 'William Blake'. 'Mary Somerville' began as a historical article on women and science in *Nature, The International Weekly Journal of Science*, Macmillan Publishers Ltd (2015).

'Shelley Undrowned' first appeared in *Interrupted Lives*, edited by Andrew Motion, National Portrait Gallery, London (2004). 'Thomas Lawrence Revarnished' began as an Introduction to *Thomas Lawrence Portraits*, National Portrait Gallery, London (2010). 'Coleridge Misremembered' is adapted from an early lecture, 'The Coleridge Experiment', in *The Proceedings of the Royal Institution of Great Britain* (1998), and is about lecturing itself.

For all kinds of encouragement and advice I am hugely grateful to Robert Silvers of the *New York Review of Books*; and also to Richard

Cohen, author of *Chasing the Sun* (2010); and William St Clair, author of *The Reading Nation* (2004).

My warmest personal thanks go to Dan Frank, my editor at Pantheon, New York, especially for his discussion of confessions; to my dear friend and colleague Professor Jon Cook of the University of East Anglia and the *Guardian* Masterclasses; Professor Kathryn Hughes, my one-time fellow tutor on the UEA Life Writing MA; Dr Lara Feigel, director of the Centre for Life Writing Research, King's College, London; Professor Hermione Lee, now President of Wolfson College, Oxford; Professor Christoph Bode of the Ludwig-Maximilians-Universität München; Barbara Kiser, my editor at *Nature*; and David and Heather Godwin, my spirited supporters at DGA. Thanks also to Douglas Matthews, my heroic indexer.

Above all I am grateful for my marvellous, patient, faithful team at William Collins: Arabella Pike, to whom this book is most affectionately dedicated; and to Helen Ellis, Robert Lacey, Joe Zigmond and Becky Morrison. Finally to my beloved novelist Rose Tremain, who has made the whole pursuit worthwhile, I send my truly heartfelt thanks (as also for the loan of Sir Robert Merivel).

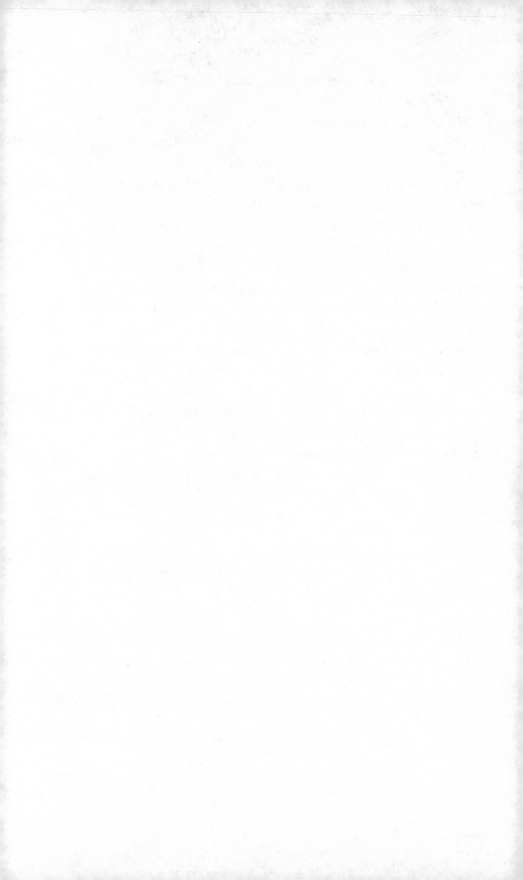

Illustrations

p. 169 – Mary Wollstonecraft, engraving by Opie, c. 1797. ©
Hulton Archive/Getty Images

p. 197 – Mary Somerville as a young woman, by John Jackson.
© Principals and Fellows of Somerville College, Oxford

p. 219 – John Keats, pencil drawing by Charles Armitage Brown,
1819. © NYC/Alamy Stock Photo

p. 243 – Monument to Percy Shelley in Christchurch Priory,
Dorset. © Hulton Archive/Getty Images

p. 261 – Lady Hamilton. © Trustees of the British Museum

p. 279 – Samuel Taylor Coleridge by C. Dawe, c. 1815, engraving
Leopold Lowenstam. © Hulton Archive/Getty Images

p. 305 – Frontispiece from 'The Grave' by Robert Blair, engraved by
Louis Schiavonetti (hand-coloured etching) after William Blake.
Private collection/Photo © Christie's Images/Bridgeman Images

Colour plates

Zélide, 'Belle van Zuylen', by Maurice Quentin de La Tour, 1766.
© Cabinet d'arts graphiques des Musées d'art et d'histoire,
Genève, legs William Henry Théodore de Carteret, inv. n° 1915-
0091. Photo: Nathalie Sabato

Margaret Cavendish, Duchess of Newcastle, attributed to Sir Peter
Lely or Abraham van Diepenbeeck, c. 1665. Private collection

Samuel Pepys by John Hayls, 1666. © DeAgostini/Getty Images

Germaine Necker, Madame de Staël, by François Gérard, 1753.
Photo by Imagno/Getty Images

Byron of Rochdale in Albanian Dress, by Thomas Phillips, 1813.
© Art Media/Print Collector/Getty Images

William Godwin, by James Northcote, 1802. © Granger, NYC/
Alamy Stock Photo

Mary Wollstonecraft, by John Opie, c. 1797. © The Print Collector/
Getty Images

Self-portrait by Mary Somerville. © Principals and Fellows of
Somerville College

Augusta Ada, Countess Lovelace, by Margaret Carpenter.
© Photo12/UIG via Getty Images

John Keats, by Joseph Severn, 1821. © Granger, NYC/Alamy Stock
Photo

Fanny Brawne, ambrotype taken c. 1850. © City of London:
London Metropolitan Archives

Sir Thomas Lawrence, later copy by Richard Evans of an unfinished
self-portrait by Lawrence, c. 1825, the palette and brushes added
by Evans, c.1868. © National Portrait Gallery, London

Elizabeth Farren, later Countess of Derby, by Sir Thomas Lawrence,
1790. © Francis G. Mayer/Corbis/VCG via Getty Images

Percy Bysshe Shelley, by Alfred Clint, 1819, after Amelia Curran
and Edward Ellerker Williams. © National Portrait Gallery,
London

Samuel Taylor Coleridge by James Northcote. © Dove Cottage and
The Wordsworth Museum/The Wordsworth Trust

William Blake, by Thomas Phillips, 1807. © Universal History
Archive/Getty Images

Index